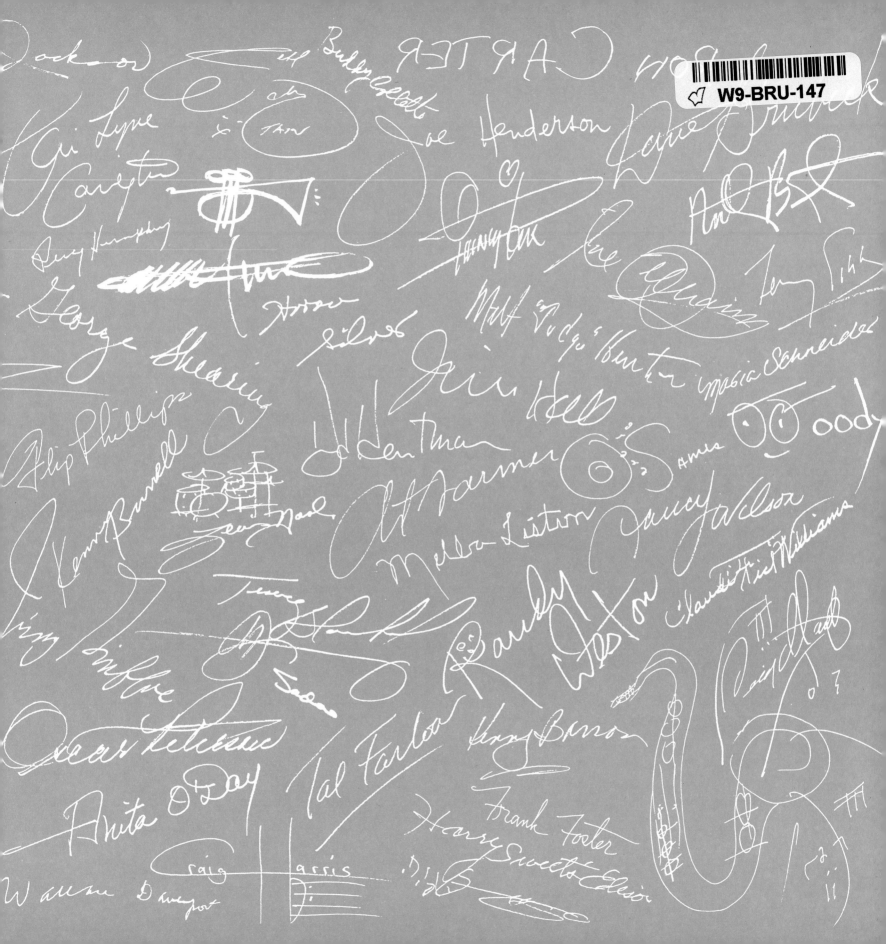

INTRODUCTORY ESSAYS

Bob Blumenthal

CAPTIONS

Cliff Preiss
Martin Johnson

ADDITIONAL CAPTIONS

Sid Gribetz

ARTIST COORDINATORS

Suzi Reynolds
Christine Nacion

J

ARTISAN *New York*

THIS BOOK, A

LABOR OF LOVE,

IS DEDICATED TO

ELLA FITZGERALD,

THE MOST ENDUR-

ING JAZZ LEGEND

IN THIS CENTURY

Editor: Marisa Bulzone

Designer: Jim Wageman

Production director:
Hope Koturo

Published in 1995 by Artisan,
A Division of Workman
Publishing Company, Inc.
708 Broadway
New York, NY 10003-9555

Library of Congress
Cataloging-in-Publication Data

Lowe, Jacques.
Jazz: photographs of the
masters / photographs by
Jacques Lowe; introductions
by Bob Blumenthal;
captions by Cliff Preiss
and Martin Johnson.
Includes index.
ISBN 1-885183-25-9
1. Jazz musicians—Portraits.
I. Preiss, Cliff. II. Johnson,
Martin, 1960–. III. Title.
ML87.L68 1995
781.65'092'2—dc20
95-24546

Printed in Italy
10 9 8 7 6 5 4 3 2 1
First Printing

C O N T E N T S

NOBODY REALLY KNOWS where or when jazz was invented, or who might claim responsibility. We can discount Jelly Roll Morton's boast that he made the discovery in 1902—historical sources suggest he was 12 years old at the time—while still acknowledging that New Orleans, home to Morton and most of the first wave of jazz innovators, was the site of the music's major early developments. The relative freedom that allowed nineteenth-century African-Americans to preserve significant aspects of African culture (especially the use of drums); the wide-open social life of the city's picnics, parades and less reputable establishments; and the extensive cultural exchange encouraged by New Orleans's status as a port city—and by the juxtaposition of uptown Creoles and downtown Blacks—created the perfect laboratory for musical synthesis. Marches and cakewalks, parlor piano and outdoor brass bands, string ensembles and lone guitarists provided the ingredients, with the formal and emotional textures soon to be identified with the blues as the prominent flavor.

If jazz's "R&D" was launched in New Orleans, however, the process took to the road before many realized that something new had been born. Morton, the brothel pianist who opened up ragtime's formalities with spontaneous breaks, riffs and rhythms, had roamed as far as Mexico prior to 1920. Kid Ory, tailgate trombonist supreme and an early New Orleans bandleader, was working in California around the same time, and recorded with his Sunshine Orchestra there in 1922. Joe "King" Oliver, the Crescent City's reigning cornetist after the legendary Buddy Bolden, traveled via riverboat to Chicago, where his Creole Jazz Band was a leading attraction in 1920.

White New Orleans musicians were traveling as well, displaying from the outset jazz's unprecedented power to destroy racial boundaries and incorporate diverse influences. This is part of the music's indigenous genius, and why it is best described as an American art form created primarily, but not exclusively, by African-Americans. One group of white acolytes, the misleadingly named Original Dixieland Jazz Band, reached New York in 1917, where it made what were acknowledged as the first jazz recordings. (Singer Mamie Smith would not cut the first blues record until 1922.) The ODJB not only created a sensation with its syncopated, polyphonic approach, but also revealed that the phonograph record would serve as an essential medium for spreading jazz beyond the confines of its original home.

It did not take long for the music to cross international borders, borne by great black artists touring in foreign countries. Sidney Bechet, the brilliant New Orleans soprano saxophonist and clarinetist, was disseminating jazz in Europe (and garnering rave reviews about the music of the future) as early as 1919; and other American stars such as Benny Waters made the Continent their primary arena in the following decade. These pioneers were like itinerant farmers planting seeds, ensuring that jazz would ultimately become an international hybrid. Foreign musicians with distinctive voices and contributions, like Django Reinhardt and Stéphane Grappelli, emerged in the 1930s as the initial harvest in this effort at worldwide cultivation.

The primary work of refinement and development, however, was taking place at home, and its leader was Louis Daniel Armstrong. As a young boy in New Orleans, Armstrong had idolized King Oliver; and, by the time Oliver invited Armstrong to Chicago to fill the second cornet seat in the Creole Jazz Band, the student had developed a

melodic fluency and rhythmic grace that surpassed the teacher. It was Armstrong's lyrically poetic imagination that made jazz a soloist's idiom, and his rhythmic agility that made all of American music swing. At every turn in the 1920s, Armstrong was transforming music: through his work with the previously stilted Fletcher Henderson Orchestra in New York, which featured the young cornet soloist between 1924 and 1925; the more compact combos he assembled in recording studios upon his return to Chicago under the names Hot Five and Hot Seven; and his brazen interpretations of popular songs, which Armstrong began recording with orchestral backing in 1929. There were other geniuses about in the 1920s (including Armstrong's white counterpart, the cornetist Bix Beiderbecke; Armstrong's colleague and leading student in the Henderson band, the tenor sax pioneer Coleman Hawkins; and Harlem's reigning orchestral genius, Duke Ellington), but the Jazz Age clearly belonged to Armstrong.

If the phonograph record was technology's first essential complement to jazz, it was quickly joined by the radio. "Remote" broadcasts, originating in ballrooms and nightclubs and sent by cathode tube across the country, delivered the latest innovations directly into the homes of a public growing ever more enamored of jazz's affirmative message. Ellington and Cab Calloway became stars because of nightly radio appearances transmitted from the Cotton Club, and other bandleaders found similar success once their music was aired. Even the bleakest trough of the Depression could not interrupt this instant delivery system, as Benny Goodman learned when his orchestra ventured west in 1935 and found a rabid coterie of fans, well versed in the music Goodman had featured on his New York remotes. Suddenly "swing,"

the essential verb in the jazz vocabulary, became a noun describing a pop-music phenomenon.

For the rest of the 1930s, and into the early years of World War II, swing reigned as America's dominant musical style. Bandleaders were kings, star soloists crown princes, and talented arrangers powers behind the thrones as the country found itself in a jitterbug frenzy. In segregated America, the rewards were still unevenly distributed: Goodman was called the King of Swing, though he relied largely on Fletcher Henderson's old orchestrations and lacked the depth and inspiration of black bandleaders like Ellington, Jimmie Lunceford and the truly supreme swinger who emerged from Kansas City, Count Basie. Yet when Goodman, Tommy Dorsey, Artie Shaw and the other swing stars presented jazz to a mass audience, they became important groundbreakers; and when, cautiously, they incorporated a few of the great black players into their presentations (beginning with Teddy Wilson and Lionel Hampton in the Goodman quartet), they signalled a new phase in the struggle for civil rights. It was a good time for musicians, with new stars emerging from the ranks of popular bands, then leaving to form their own orchestras. Great black soloists like Hawkins and Benny Carter, who had abandoned America during the Depression to seek more work and respect in Europe, found the turn of events encouraging enough to return home.

The swing phenomenon could not last. Rationing and wartime taxes made touring for the draft-depleted big bands difficult if not impossible. Singers, Peggy Lee in Goodman's band and especially Frank Sinatra with Tommy Dorsey, began to eclipse the bandleaders; and when a musicians' union ban in 1942 kept instrumentalists but

not vocalists out of the recording studio, the fate of the swing orchestras was sealed.

Yet if the war marked the end of the classic jazz era, it also presented a few alternatives. Traditionalists, seeking the rougher and more spontaneous sounds of earlier jazz, went back to New Orleans in search of founding fathers, or recreated what the original New Orleans musicians had documented on recordings in bands of dedicated younger musicians. The first great jazz revival was launched. On New York's 52nd Street, smaller combos introduced a more intimate and fluent style, fed by the daring harmonic and rhythmic notions created in the after-hours havens of Harlem. And in concert spaces as widely separated as New York's Carnegie Hall, where Duke Ellington presented annual concerts of new music, and Los Angeles's Philharmonic Auditorium, where Norman Granz first packaged the jam session in his popular Jazz at the Philharmonic events, the music began to find its way out of the nightclubs and ballrooms and into the concert halls.

These options were necessary when it became obvious that big bands, only recently the staple item of the music business, were becoming an unaffordable luxury. Audiences could satisfy their hunger for loud, extroverted sounds via a new invention: the electric guitar, which regenerated an interest in the blues and launched a shift from Tin Pan Alley standards to simpler original material—that is, if audience members had not abandoned live music entirely, preferring to stay at home and watch television.

While some big bands lingered, almost all of the leaders who had reigned prior to World War II downsized as the fifties began. It was the rare figure like Ellington or Lionel Hampton who could sustain a big band through personality, an ability to incorporate pop trends (or, in Ellington's case, rely on his own unique and growing body of work) and sheer stubbornness. Many others became combo leaders. Red Norvo excelled in the more intimate trio setting, introducing future giants Tal Farlow and Charles Mingus to the jazz world; Artie Shaw tried, but soon quit the music business for good out of frustration with the public's passion for music he deemed inferior. Yet the big band remained an ideal for many. The example of Ray Charles, who went from working with a seven-piece combo to a full orchestra once he crossed over from rhythm and blues and became a pop-music phenomenon, suggests what others might have done had economic circumstances permitted.

For the men (there were few women) who filled the sections of the big bands, there were other options to be found in the theater pits and network studios of New York and the film and television studios of California. Again, black musicians faced job discrimination; which is why the entry of Benny Carter into the ranks of film composers, and the emergence of Harry "Sweets" Edison's trumpet as one of the most recognizable voices on Hollywood's sound stages and recording studios, gave these already proven veterans a status akin to Jackie Robinson in baseball. They knocked down the color line, and slowly made more commercial work a viable and color-blind option.

There was an element of the assembly line about the studio and pit bands, which lacked the informality and sheer excitement of the barnstorming orchestras of earlier days; yet the work paid relatively well, and for a lucky few it provided security that life on the road could

never match. For some of the best, including Carter, Milt Hinton and J. J. Johnson, the studios provided a way station for their middle years, an opportunity to conserve creative and physical resources that could be more fully exercised at a point when many in other fields would consider retirement. For Doc Cheatham, a section trumpeter in his early professional life, the various gigs he worked for two decades after leaving Cab Calloway's band presented an opportunity to slowly nurture his more creative skills until he emerged, on the far side of age 75, as a major jazz soloist.

Prospects were less sanguine for musicians who did not settle in New York or Los Angeles. Even in the cradles of jazz, the combination of television and rock and roll was doing serious damage to the livelihood of professional musicians, which explains how Percy Humphrey could put down his cornet for a time in his native New Orleans and work in the insurance business, or how Kansas City stalwart Claude "Fiddler" Williams spent decades earning his living through an emphasis on more commercial styles. Others simply picked up and left America, persuaded that Hawkins and Carter had been right when they moved to Europe at the depths of the Depression. Money was not the only issue. There was also the pervasive second-class citizenship imposed upon all jazz musicians, who had yet to be acknowledged as creative contributors to an art form, and especially upon black jazz musicians, who still found themselves denied the most basic amenities as they toured through much of the United States. Foreign audiences heard the freedom and hard-earned joy of jazz more clearly; they sensed, as most Americans did not, that this music came closer to manifesting the ideals Americans prided themselves in than anything else the country had produced. Just because one got the blues in the States did not mean that it could not be best articulated when reflected in the relative tranquillity and dignity of an expatriate existence.

Over time, however, the importance of this music has slowly come to be realized. Younger players, for too long fixated only on what was new, began to seek out the elders, to rescue them from obscurity in order to tap a knowledge unobtainable elsewhere. Since this previously had not been the case, many older and younger musicians still addressed each other with wary distrust. Yet time has sealed the false fissures in jazz history, and stylistic distinctions have faded as the evolutionary continuum gained clarity. The presence of two or three generations in a single band is now a commonplace.

Not that older musicians were ever unwilling to share their discoveries with those who followed. Many veterans missed the opportunity (or lacked the conventional qualifications) to become involved in formal academic instruction, yet provided tutorial every time they led a rehearsal or presided over a club or concert set. The truly talented had always been "professors" to their followers, grooming future professors in the process. J. J. Johnson, a young trombonist in Benny Carter's 1943 band, learned both technical and esthetic lessons from his leader as well as an obligation to share such knowledge with future generations. Today, both Johnson and Carter, as well as Illinois Jacquet and other veterans, continue to educate musicians—and listeners—in this manner. For all of their past service, these and other surviving giants know that they remain responsible for sustaining jazz's never-ending crusade.

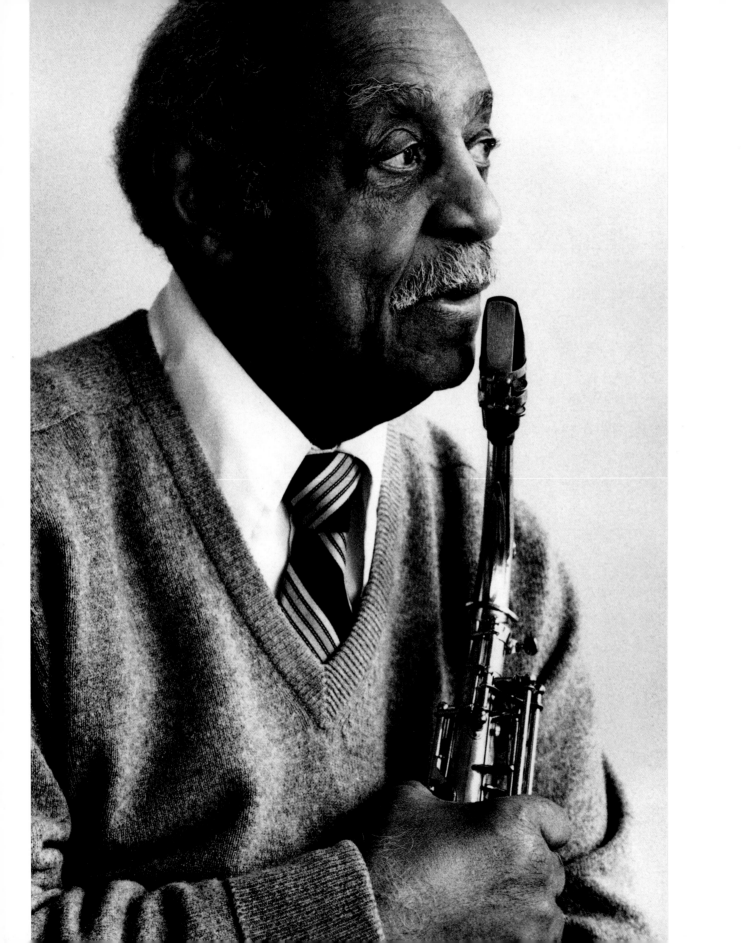

Benny Carter (b. Bennett Lester Carter 8/8/07) has shaped the course of jazz both as a primary alto saxophone soloist and as a trailblazing, big band composer-arranger. His luminous trumpet style combined with his rare (but recorded!) performances on clarinet, piano and trombone make Carter one of the true Renaissance men of jazz. Carter is a spellbinding performer; his poised solos of swooping runs and floating staccato phrases are the product of nothing less than genius.

Influenced by early recordings of Frankie Trumbauer, a C-melody saxophone player, Carter began jamming in Harlem nightclubs at the age of 15. He switched to alto saxophone while playing with Willie "the Lion" Smith's trio and established a hot alto reputation throughout the 1920s in brief stints with the likes of Fletcher Henderson, Duke Ellington and Charlie Johnson, as well as with his own bands.

When he rejoined Henderson's orchestra in 1930, Carter was at the crossroads of his career. Now recognized as a major jazz soloist, he had also come into his own as an arranger, contributing to jazz scoring his innovative block-chord writing for reed sections, which in effect multiplied a Carteresque saxophone solo line into three or four voices in clustered harmony.

Carter again started his own band in 1932, a superior ensemble that included many musicians who would go on to become major forces in the swing era.

In 1935, just as swing was about to sweep over the United States, Carter left for Europe, where he worked extensively. He returned home in 1938 to resume his big band career, and although he led a succession of fine ensembles through 1946, he gave up bandleading to begin a new career arranging and writing for the studios in Hollywood, first for feature films, then for television.

The fifties were a busy decade for Carter. Aside from his film work (he scored *Stormy Weather, The Gene Krupa Story* and *The Snows of Kilimanjaro,* among many other films), he played with the worldwide traveling jam session known as Jazz at the Philharmonic.

After years of concert appearances and festival tours, Carter resumed his regular nightclub appearances in 1976 and, in February of 1987, once again fronted a big band—the American Jazz Orchestra—for a concert at New York's Cooper Union. The performance was a retrospective spanning Carter's 54 years in music, including the debut of a new work, "Central City Sketches." Since that event, Carter has continued to challenge himself as both a performer and a composer. In February of 1992, he gave the premiere of his first composition for jazz big band and chamber orchestra, the five-movement *Harlem Renaissance Suite.* Harkening back to the Harlem of the twenties, it is a fitting reflection on a life rich with achievement.

Benny
CARTER

Harry "Sweets"
EDISON

A Hollywood studio regular since the 1950s, Harry "Sweets" Edison (b. 10/10/15) has often been sought out to add spice to vocal dates. As a result, his dry trumpet asides (which are sometimes simply repeated, pungent blue notes) are familiar to innumerable listeners who may not even be aware of his name. Edison's obbligato work with Frank Sinatra helped define many of the singer's classic recordings, and his sensitive backings added poignancy to some of Billie Holiday's most beloved sides. Edison's idol, now as always, is Louis Armstrong. However, Armstrong's trumpet is all sunshine, while Edison's can make cutting commentary.

Upon joining Count Basie's orchestra in 1938, Edison gained widespread recognition as a soloist, his exuberant playing contrasting with the warmly lyrical sound of Buck Clayton, the band's other major trumpet stylist. His youthful sweetness inspired his nickname; although he already had five years as a professional musician under his belt, Edison was still, as he put it, "the baby of the band," and tenor saxophonist Lester Young ribbed him by calling him "Sweetie-pie." He and Young were featured together in Gjon Mili's 1944 *Jammin' the Blues,* the most superbly executed synthesis of jazz and film ever made. Edison stayed with Basie until 1950 (when the pianist temporarily cut down to a small group) and occasionally returned to the band's fold in later years.

In Edison's own ensembles, his muted playing has produced solos of the utmost delicacy. He is also a superb bluesman, who through the years has found his best foils in strong tenormen like Ben Webster, Jimmy Forrest, Eddie "Lockjaw" Davis, and Buddy Tate. After 62 years of music making, Sweets's trumpet sounds as sweet as ever.

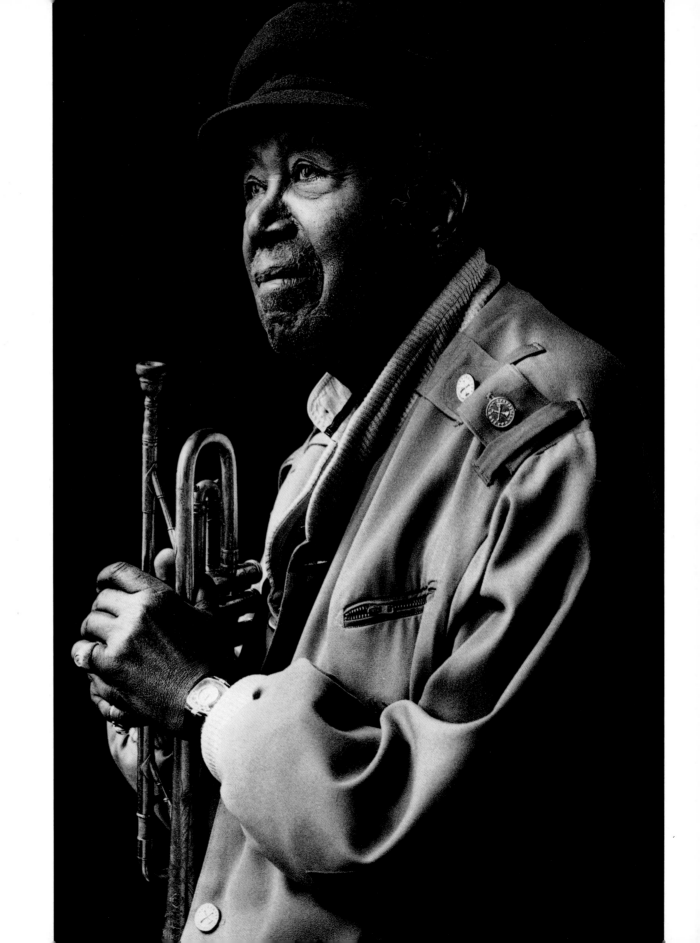

For more than six decades, jazz has benefited from the rock-solid time, full tone and firm swing of bassist Milt Hinton (b. 6/23/10). Hinton grew up on Chicago's South Side; his mother was a piano teacher (Nat "King" Cole was one of her students) who encouraged her son to take up the violin in his early teens.

Hinton dropped the violin in favor of the bass in his sophomore year of high school, and while he continued his classical education, he became a busy freelancer on the Chicago jazz scene. He admired the way the New Orleans players "slapped" the bass on the beat, and he sought to outdo them, developing a technique of double and triple slaps that he still uses to great effect today.

In 1936, Hinton joined Cab Calloway's orchestra and began a fifteen-year run with the King of Hi-de-ho. Calloway's band was already one of the most successful organizations in the music business; with the arrival of its tenor saxophone star Chu Berry in 1937, it began to develop into one of the greatest swing orchestras of its day. Dizzy Gillespie joined the trumpet section in 1939 (replacing Doc Cheatham) and Hinton became one of his closest companions. Gillespie's musical experiments made some of the old hands in the orchestra uncomfortable, but Hinton marveled at his knowledge and daring use of changes and chord substitutions. Gillespie and Hinton explored the possibilities of the trumpeter's new ideas when they played together on the roof of the Cotton Club during the Calloway band's set breaks.

Hinton performed with Calloway until the vocalist ceased touring in 1951. Based in New York, Hinton became one of the busiest players in the studio, a musician's musician who played bass at countless sessions of popular music. It was an occupation that at times threatened to crowd out his jazz activities, but the dean of jazz bassists is now more visible than ever. No group of musicians hold Hinton in higher esteem than his fellow bassists—his personal influence on generations of players, from Beverley Peer in the thirties to Christian McBride in the nineties, is unparalleled—and jazz musicians of all ages have sought out opportunities to play with "The Judge," as Hinton is affectionately known.

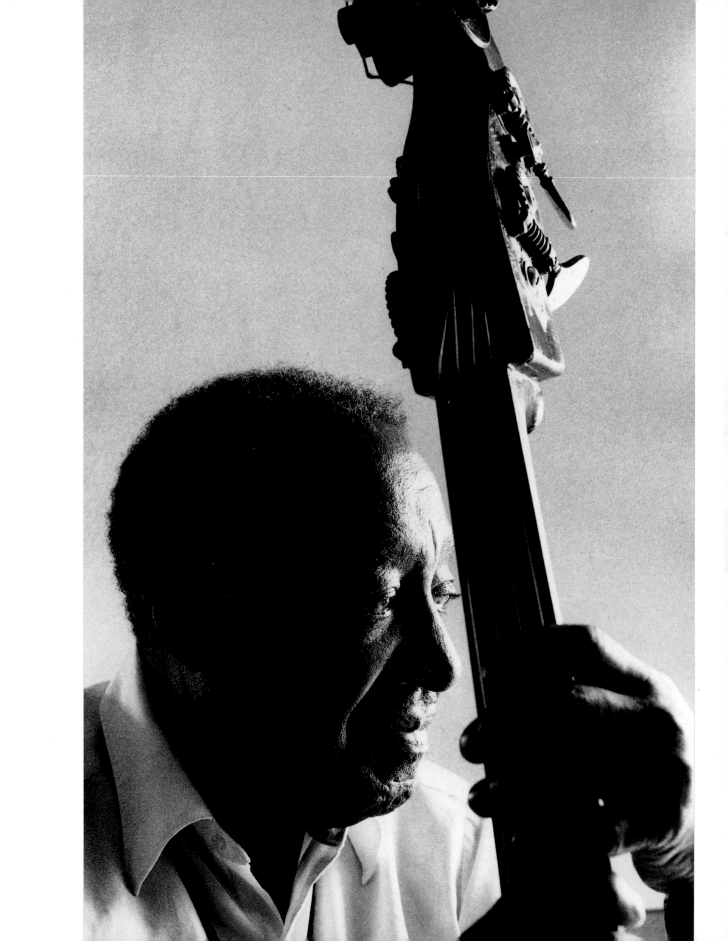

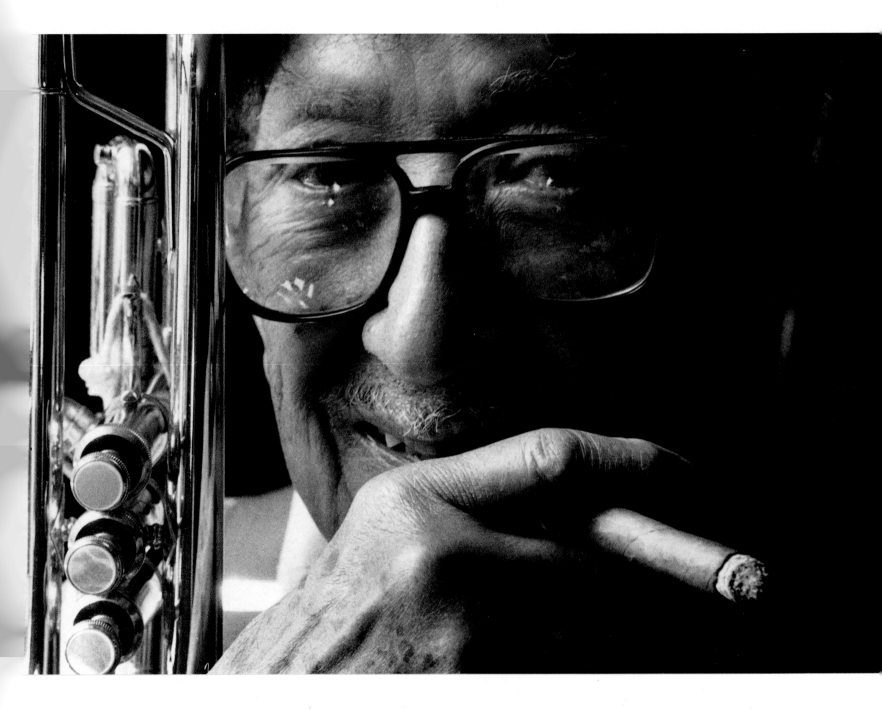

Fans of Adolphus "Doc" Cheatham (b. 6/13/05) and his trumpet have assembled on Sunday afternoons at New York's Sweet Basil club for more than a decade, turning every gig into a party and every party into a celebration of a living miracle of jazz. Cheatham's glorious tone is the envy of trumpeters half his age. He still produces solos dedicated to and worthy of Louis Armstrong's legacy. Doc also charms his audiences with his genteel vocalizing; the warmth of spirit he transmits through his oh-so-proper enunciations of the lyrics of "That's My Home" and other Armstrong-associated standards is utterly winning.

Cheatham has both witnessed and contributed to seven decades of jazz history. In the early 1920s he gravitated from his native Nashville to Chicago, where he followed idols like King Oliver and Freddie Keppard around town and established his lifelong friendship with Louis Armstrong (a charm with Armstrong's figure dangles from Cheatham's horn today in an enduring tribute). A consummate musician, Cheatham was in demand as a lead trumpeter in jazz orchestras: He toured Europe as a member of Sam Wooding's band in 1928 and played first trumpet for Cab Calloway from 1933 to 1939. In 1943, he joined Eddie Heywood's influential Sextet and backed Billie Holiday for a classic set of recordings the following year. You can see Cheatham providing stunning obbligato work for Lady Day's famous 1956 television appearance on the "The Sound of Jazz."

Cheatham revisited the classic sounds of New Orleans in Wilbur de Paris's popular band of the late fifties and early sixties, and in 1966, joined Benny Goodman's quintet, sharing the spotlight with the King of Swing for a year. But Cheatham's greatest achievement came when he established his present career as a soloist/bandleader, stepping out in front at an age when most men retire.

Doc
CHEATHAM

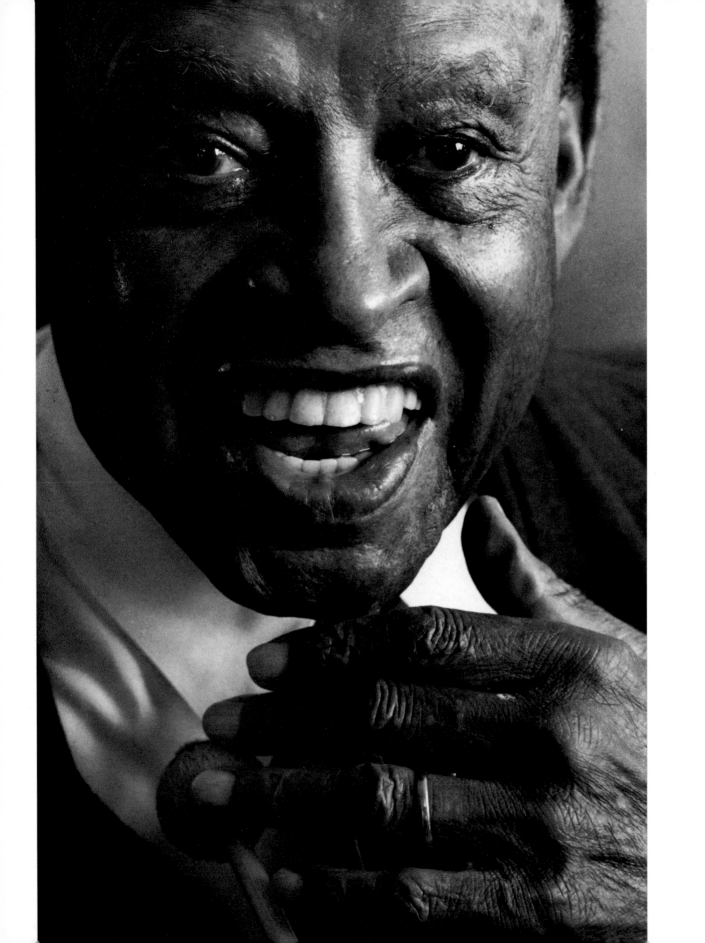

Lionel Hampton (b. 4/20/09) has been drawing crowds since the late 1920s, when he first received special billing as "The World's Fastest Drummer" with the Les Hite Orchestra in Los Angeles. Like most percussionists of the time, he had the xylophone in his arsenal, but Hamp augmented his harmony training by picking out solos by Louis Armstrong and Coleman Hawkins that he heard on records.

Armstrong went to the West Coast for an extended stay in 1930, and Hite organized a new band for him that included Hampton on drums. Hamp's playing so impressed Satchmo that the trumpeter declared, "You swings so good, I'ma call you Gates." The nickname stuck among his fellow musicians. In the studio where he and his band were making recordings, Armstrong spied a vibraphone and asked Hampton if he could play it. To everyone's astonishment, Hamp beat out one of Armstrong's famous solos. Later that same day, the jazz vibraphone had its recorded debut.

When Hampton gave up his own successful orchestra in 1936 to turn Benny Goodman's trio into a quartet, he gained national recognition as a vibraphonist. The bright timbres of Hamp's and Goodman's instruments meshed perfectly, their crisp attacks—synchronized to the driving beat of Gene Krupa's drums and the elegant piano of Teddy Wilson—producing some of the most breathtaking passages heard in small-group jazz.

Hampton formed another big band in 1940 (he would maintain a large ensemble into the 1960s) and introduced to jazz a remarkable array of talented young performers: Illinois Jacquet was barely twenty when he played his career-making tenor solo on "Flying Home" in 1942. That same year, Ruth Jones joined the band as an eighteen-year-old singer and began her rise to stardom with the new name of Dinah Washington. In 1948, Hamp hired another eighteen-year-old vocalist—a bop expert named Betty Carter. In 1951, Quincy Jones joined the band as a teenaged trumpeter, and Hamp was the first to record one of his arrangements. Many more names could be added to the list.

Hamp's orchestras have featured an eclectic mix of ballads, blues, boogie-woogie, and bebop. But in the studio, Hampton was waxing small group jazz masterworks as well, a remarkable series of dates with pianist Oscar Peterson foremost among them.

As a producer in the seventies, Hampton oversaw studio recordings of important summit sessions of jazz stars. Yet this elder statesman of jazz still feels most at home on the bandstand; today, when he gives his usual introduction—"And now, for the one millionth and one time . . . 'Flying Home'!"—he may not be so far from the truth.

Lionel
HAMPTON

There is no greater compliment a musician can receive than the seal of approval from an elder hero. Buddy Tate, sectionmate and fellow Texas tenor from the Count Basie band of the mid-forties, had the following to say about Jean Baptiste Illinois Jacquet (b. 10/31/22): "I've seen him take out more (people) than anybody. He's *mean!* I've seen him stop the show. I've seen him blow Hawk, Pres, Georgie Auld . . . Took 'em *all* out. 'Cos he also had his little high note thing, and when he did *that*, it was all over." That "little high note thing" Tate refers to was Jacquet's innovative use of harmonics, which took the tenor saxophone way over—by two and one-half octaves—its "legitimate" top range.

Jacquet first shook the house on July 2, 1944, at Jazz at the Philharmonic's inaugural concert. The immediate, overwhelming success of Jacquet's solo, issued on record as "Blues Part Two," helped to launch JATP, which took jazz music into concert halls around the world. This less-than-three-minute solo is the point of origin for every wailing rhythm and blues saxophone solo played ever since.

Jacquet had already made a name for himself at age 19, when he made the first recording of his career as a member of the Lionel Hampton Orchestra in 1942. Jacquet's solo, one of the most famous in jazz music, on "Flying Home" vaulted him to international fame and spawned his own big-toned, forceful style.

In 1947, Jacquet formed his own record-breaking eight-piece band, recording a string of best-sellers. More hits followed in the fifties, and Jacquet continued to tour with JATP through the end of its 1957 concert tour. In the sixties and seventies Jacquet worked as a trio, with drummer Jo Jones and pianist Milt Buckner, mostly in Europe, and then with a quartet featuring Slam Stewart on bass.

The next phase in Jacquet's career began in the early eighties, when he became the first jazz musician to obtain a long-term residency at Harvard University. There, the eagerness of his band students proved infectious to the teacher. In August of 1983, Jacquet's big band was born. Their first week at the Village Vanguard, according to its late owner, Max Gordon, broke all records in the fifty-year history of his club.

The essence of Jacquet and his music, as he tours and performs with his big band, is well-captured in Arthur Elgort's award-winning documentary *Texas Tenor: The Story of Illinois Jacquet.*

It's been fifty years since hotels and theaters have provided regular gigs for jazz orchestras. Happily, New York's Tavern On The Green gives Jacquet's band a home eight weeks out of the year. "I am going to keep this music alive," says Jacquet. "This is my life. I have played this music since I was born and I have no intention of stopping until the day I die."

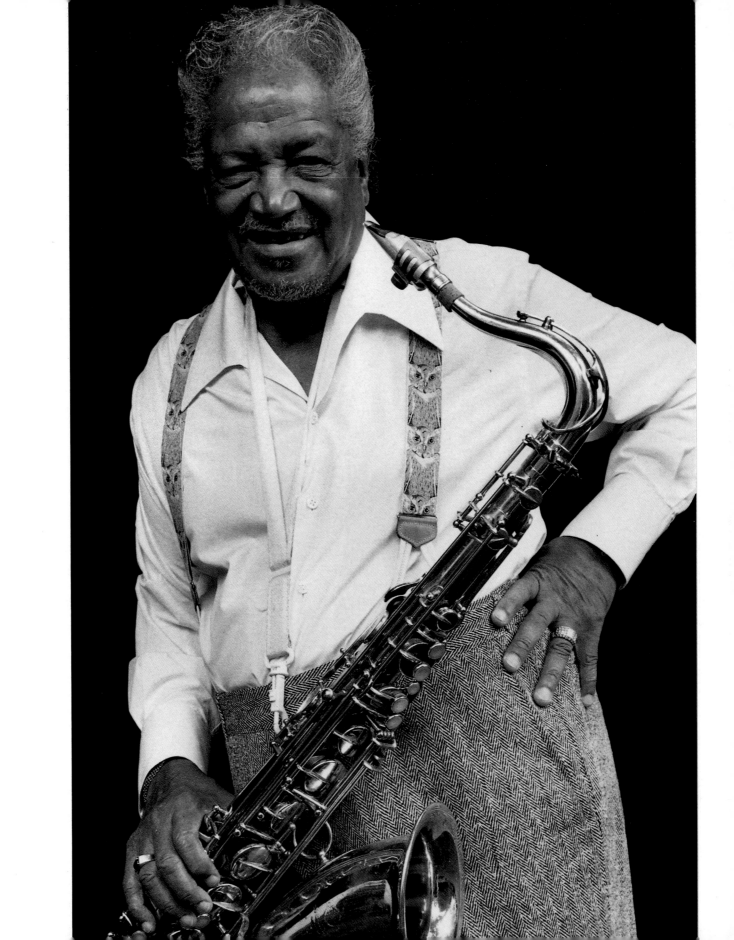

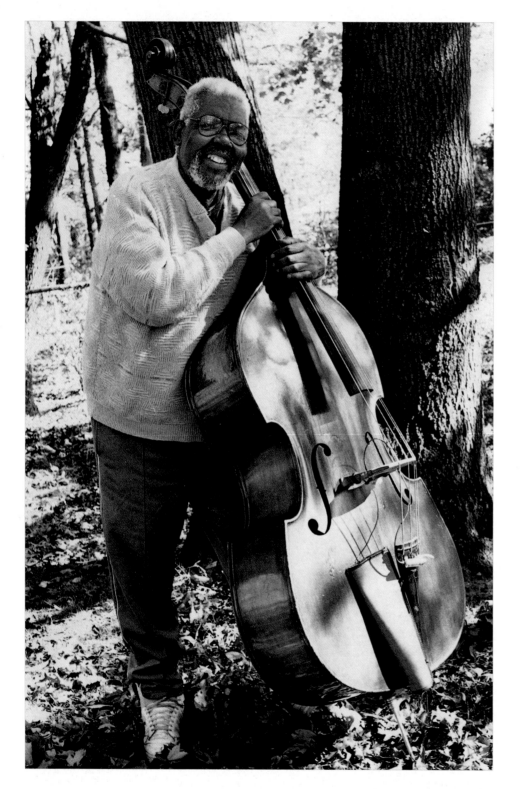

Arvell Shaw (b. 9/15/23) grew up in St. Louis, learning trombone and tuba in high school and the bass in a riverboat band in 1942. After a stint in the navy, Shaw came home in 1945 to find himself in the right place at the right time—he was offered the bass slot in Louis Armstrong's Orchestra. Shaw joined Armstrong just as he was making his transition to a small band, and Shaw's numerous tours of duty with the All Stars, as the new group was known, were unlike any other seen before in jazz. Armstrong had become "Ambassador Satch," crossing all geographic, linguistic, and cultural boundaries to become one of the world's most beloved figures, and Shaw's bass swung Armstrong hits like "Mack the Knife" and "Hello Dolly!"

Although no longer a regular member of the All Stars after 1965, Shaw played with Armstrong on many occasions until the trumpeter's death in 1970. As the leader of the Louis Armstrong Legacy Band, Shaw is now one of jazz's *éminences grises*. A commanding figure at the bass, a fervored, hard-driving performer, Shaw continues to be an important emissary of swing.

Arvell **SHAW**

"**F**iddler" Claude Williams (b. 2/22/08) began his life as a working musician when he was still a child in Muskogee, Oklahoma. His first instruments were guitar and mandolin, but when his brother-in-law's string band needed a bass player, they gave little Claude a cello they had strung with bass strings, and taught him how to play it. Soon after, Williams traded in his cello for a fiddle.

From 1929 to 1932, Williams's hot jazz violin was featured with Andy Kirk's Twelve Clouds of Joy, a pioneering ensemble in the emerging southwestern swing/Kansas City jazz tradition. He came painfully close to the big time when he hired on as rhythm guitarist for Count Basie's newly expanded orchestra in 1936, but by the time the band arrived in New York and made its first recording session, Williams had already received his notice so that Basie advisor John Hammond could bring Freddie Greene on board. He returned to his beloved Kansas City, where for many years he performed in relative obscurity.

In 1972, pianist Jay McShann's recording "The Man from Muskogee" helped bring both men back into the consciousness of the jazz public, and today, Fiddler Claude appears with his own ensembles whenever and wherever he is called upon to demonstrate the art of southwestern swing.

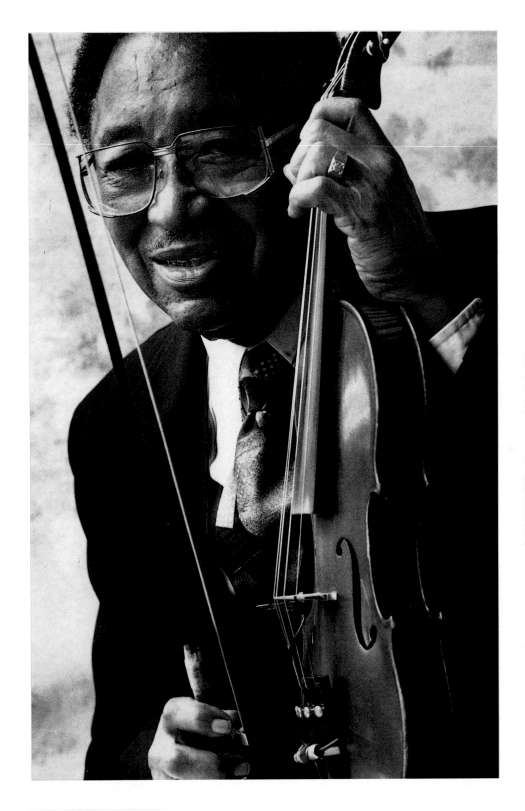

Claude **WILLIAMS**

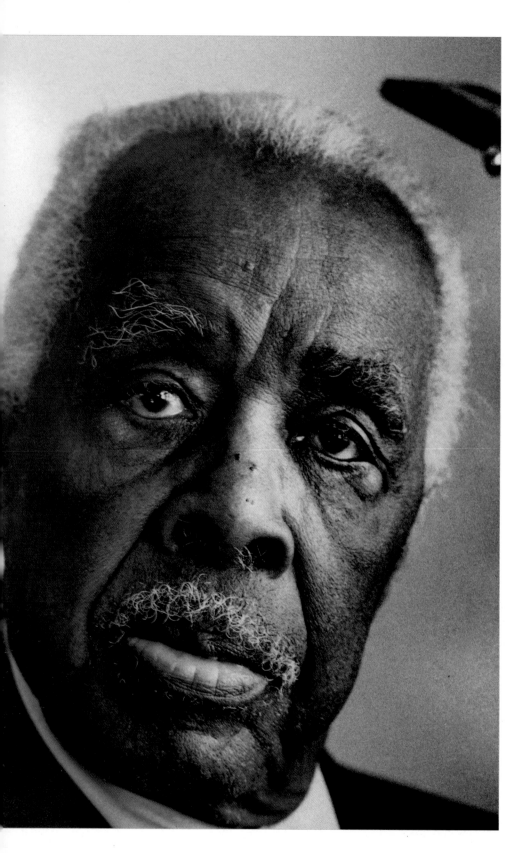

Buddy Tate (b. George Tate 2/22/15) is a member of the earliest generation of "Texas tenors," a lineage of big-toned, rough-and-ready sax soloists who emerged out of the Lone Star State's "territory bands"—the term used to describe jazz ensembles that formed in regional centers over the midwestern and southwestern portions of the United States. Tate first met a progenitor of this family tree, saxophonist Hershal Evans, in 1925; known for his soulful, wide-vibratoed sound, Evans was one of Tate's greatest influences, and over the years they became good friends as well.

Tate had his own forceful style, but its affinity to Evans's made him the natural choice to fill the chair left empty in the Count Basie Orchestra when Evans passed away in 1939. Tate's very first record session with the group produced a great solo on "Rock-a-bye Basie," and he remained a mainstay of the Basie band for the next ten years.

Buddy **TATE**

In 1950, Tate formed a small combo of his own. Performing at the Celebrity Club on 125th Street for over two decades, Tate's "little big band" became a Harlem institution and kept the art of swing dancing alive long after its heyday had passed. Although he rarely performs in public these days, Tate still enjoys the company of his friends, as is evidenced by his guest appearance on a 1994 all-star gathering of jazz elders by the Statesmen of Jazz.

Beverley Peer (b. 10/7/12) is an unsung hero of the bass. For many years, patrons of New York's intimate Café Carlyle have enjoyed his tasteful support of vocalist Bobby Short's renditions of classic American standards. Nearly sixty years ago, however, Peer beat out the pulse of the Chick Webb Orchestra, backing Ella Fitzgerald on virtually all her early hits and taking part in the band battles at the Savoy; if you ask him, Peer can still give you a blow-by-blow account of the thrashing Webb gave Benny Goodman on May 11, 1937.

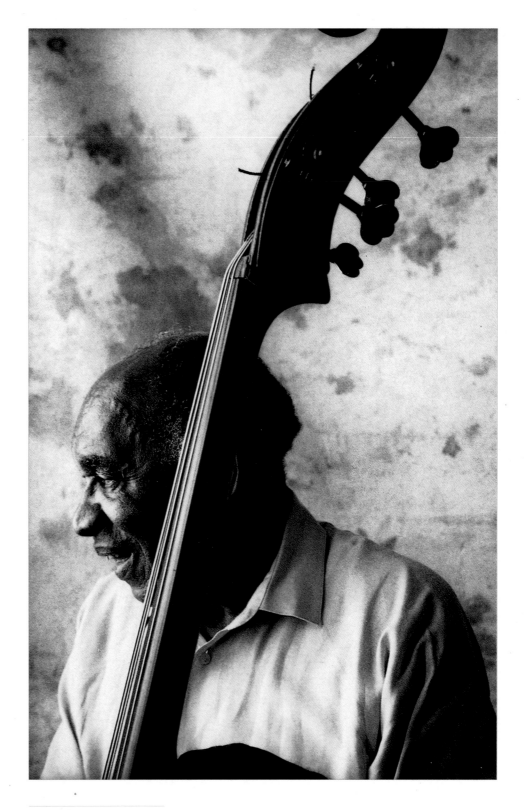

Beverley **PEER**

The pairing here of Ray Charles (b. Ray Charles Robinson 9/23/30)—the man who fused gospel, jazz and rhythm and blues to become the father of soul music—and Artie Shaw (b. Arthur Jacob Arshawsky 5/23/10)—one of the all-time big band giants and perhaps jazz's greatest-ever clarinet virtuoso—may seem an unlikely one, but Charles has been broadcasting his admiration for this elder statesman of jazz for years.

Both Shaw and Charles made their marks breaking through musical barriers. In 1936, the clarinetist was a nearly unknown session musician when his "Interlude in B-flat," performed with a string quartet and a jazz rhythm section, became a sensation as the first concert presentation of swing music. His bandleading career was powered by two monumentally popular hits, "Begin the Beguine" and "Frenesi," but Shaw often challenged popular dance band convention with his ensembles, whether defying prejudice by hiring Billie Holiday as his band vocalist or combining a string section with a full jazz big band.

Charles began the career that has since spiraled to superstardom with a trio that drew upon the styles of Nat "King" Cole and Charles Brown. By the mid-fifties, however, he had found his own, terrifically earthy sound, and today he remains one of the most explosive and effective performers in the music business. His exceptional piano playing is the perfect marriage of the church and the blues, and he's a capable saxophonist as well. But Charles's glory is his voice, which has infused soul into even "America the Beautiful" and country tunes.

Today, as always, Charles is forever on the road, forever performing, which is perhaps why he, like many others, was puzzled that Shaw gave up his career in the mid-fifties while still at the height of his powers. Shaw has said many times that he simply tired of the crowds endlessly calling for more performances of "Beguine" and "Frenesi," but Charles asked to take part in the clarinetist's photo shoot so that he could pose the question to his idol in person. By the time Jacques Lowe arrived, the two were already in deep conversation; if Charles received his answer, he kept it to himself.

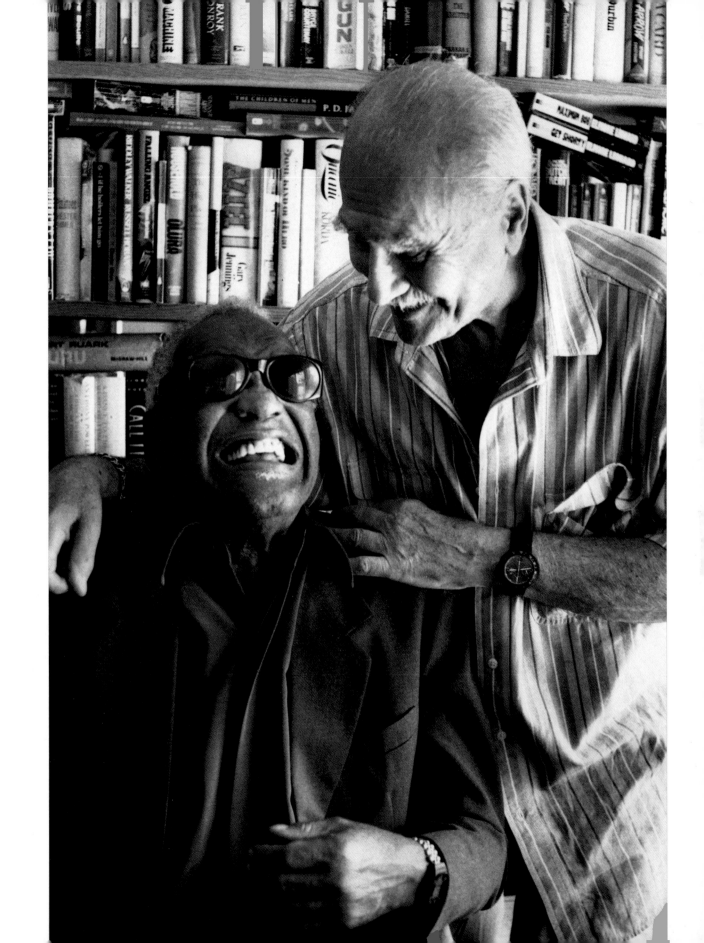

Stéphane Grappelli (b. 1/26/08) is in his second spring as a jazz artist. The violinist's love of melody and endless streams of invention continue to be matched by an indefatigable spirit.

Grappelli, born and raised in Paris, received his first violin from his father when he was twelve years old; at sixteen he was playing all-night sessions at a students' club. There he had the opportunity to play the music of American composers he admired, but, Grappelli has said, it was his discovery of Louis Armstrong's music that "changed my destiny."

Grappelli dates his first encounter with Django Reinhardt to an incident in 1931, when the Gypsy guitarist appeared out of the blue in a club in Montparnasse, said he was looking for someone who could play "hot violin," then disappeared, as was his wont. They met again as members of a hotel orchestra in 1934; the duo's backstage jams began their legendary partnership.

The brilliant compositions they wrote singularly and in tandem for their Quintette du Hot Club de France remain their most overlooked achievements: original ballads that integrated romantic European and Gypsy influences into jazz, the hotter vehicles ideal for swinging. Grappelli has said that they "found" the tunes together, sometimes from musical scraps; the line Grappelli used while tuning up the violin became "Minor Swing."

The Quintette was playing in London when World War II broke out in 1939, and Grappelli, stranded by ill health, remained there for the duration, working with George Shearing, among others, until his return to France in 1947. A series of postwar reunions with Reinhardt produced fine recordings, but their regular working collaboration had ended when they split in London. Although he was respected as much as ever by the jazz community, Grappelli was unduly neglected for much of the fifties and sixties.

In 1973, the tide began to turn. Canadian guitarist Diz Disley convinced Grappelli to perform with his trio in the "Hot Club" style at the Cambridge Folk Festival. He accepted with trepidation, nervous that the young audience wouldn't understand the music, but the concert was a triumph. Suddenly, the new Grappelli unit was in great demand, and his audience grew larger still with the popular success of his performances on records and television with classical violinist Yehudi Menuhin.

Proving that life really can begin again at sixty-five, Stéphane Grappelli embarked on an expanded schedule of concert tours and recording sessions, enjoying a career resurgence that has exceeded twenty years.

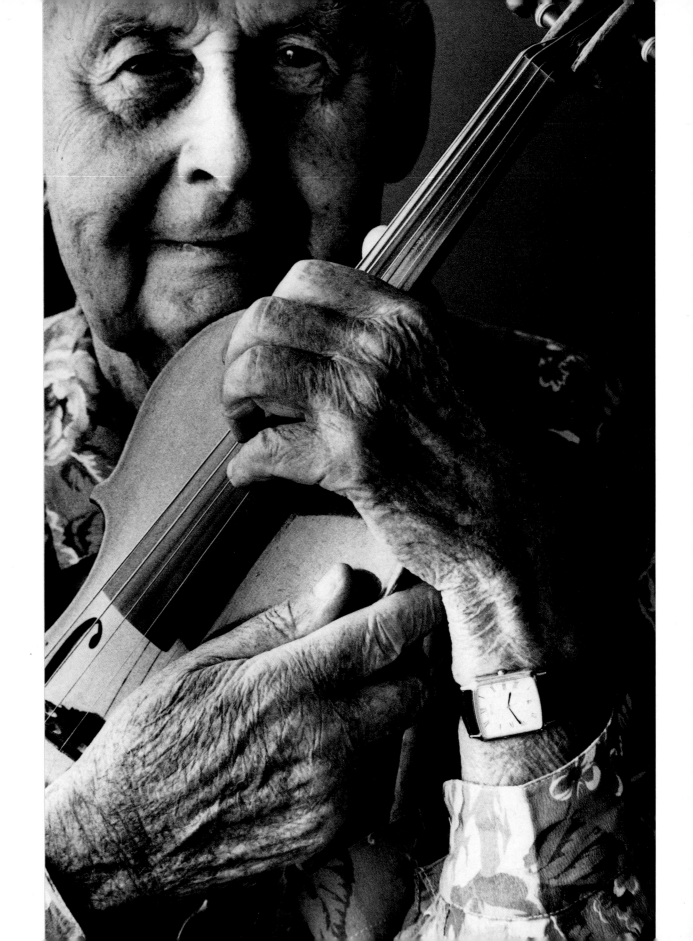

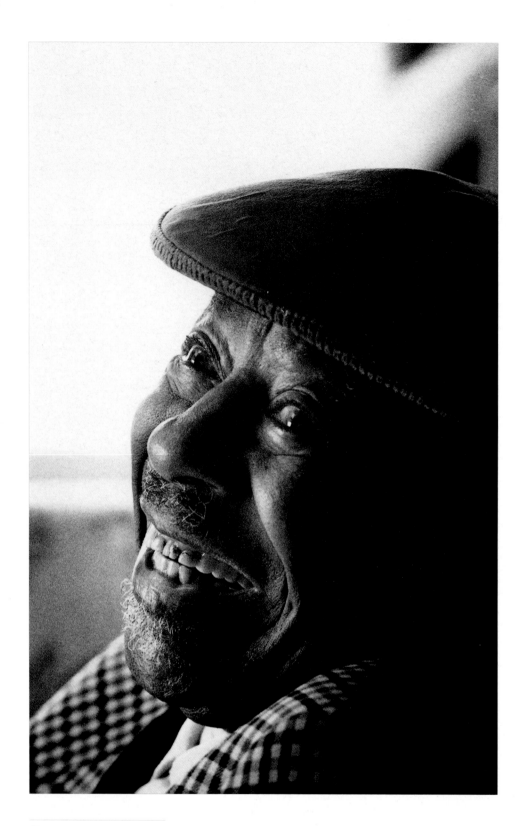

Benny **WATERS**

In the early 1920s, Benny Waters (b. 1/23/02) was a saxophone virtuoso living in Boston, Massachusetts, where his private students included Harry Carney and he gigged with a thirteen-year-old Johnny Hodges.

Waters came to New York in 1925 to join Charlie Johnson's orchestra; he would become one of its principal arrangers. Over the course of the big band era, Waters would hold a reed chair for: Fletcher Henderson, Hot Lips Page, Claude Hopkins, and Jimmy Lunceford.

At the beginning of the 1950s, Dixieland music was in vogue, and Waters learned the repertoire by participating in the jam scene at Jimmy Ryan's, a mecca for traditional jazz on Manhattan's 52nd Street. From that crowd, trombonist Jimmy Archey formed a band including Waters that booked a European tour in 1952. Paris seduced the reedman, who settled there for nearly four decades. During these years Waters developed his reputation as a soloist, playing mainstream jazz as the leader of the house band at the Cigale Club.

Waters's trips back to the United States were strictly vacations until the late seventies and early eighties, when he began making appearances at New York's West End Club, amazing its patrons with his vigor, his huge sound, his facility on a variety of reed instruments, and his seemingly inexhaustible reserves of energy.

Since the mid-1980s, television viewers of Manhattan's Public Access Cable programs have enjoyed the guitar of Lawrence Lucie (b. 12/18/07) as he swings through favorite standards with bassist/guitarist Nora Lee King, his partner in music and life for the last four decades. Probably few of those watching Lucie's program are aware of his contribution to the art of rhythm guitar and his close association with many of the giants of jazz.

Lucie belongs to the earliest generation of big band guitarists whose four-to-a-bar strumming added another layer of swing to the jazz rhythm section, replacing the banjo as the preferred string instrument in jazz bands. His most important regular gigs between 1933 and 1937 included stretches with Benny Carter, Fletcher Henderson and the Mills Blue Rhythm Band. Lucie established a close rapport with Henderson's trumpet star Henry "Red" Allen and provided a subtly swinging accompaniment on many of Allen's small-group sessions.

His longest and last stint in the big band era was his four-year run with Louis Armstrong. With the demise of the big bands, Lucie organized a series of small groups of his own that played both jazz and rhythm and blues. In recent years, he has taught privately, passing the jazz tradition on to younger generations.

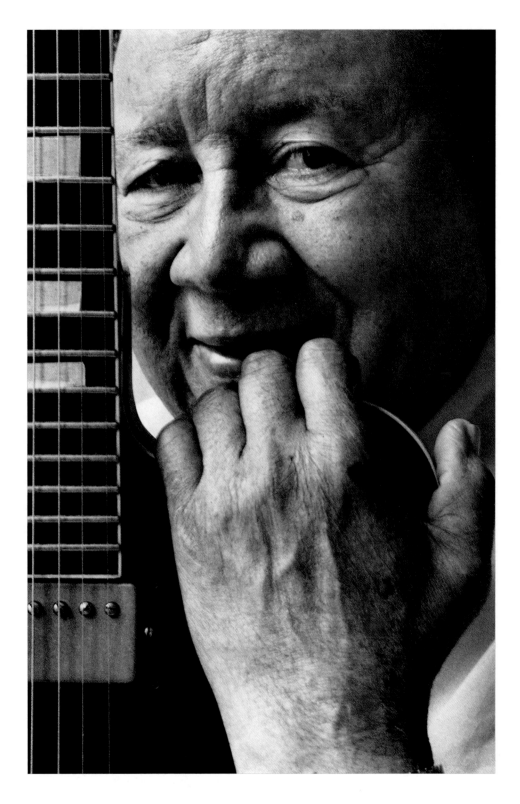

Lawrence **LUCIE**

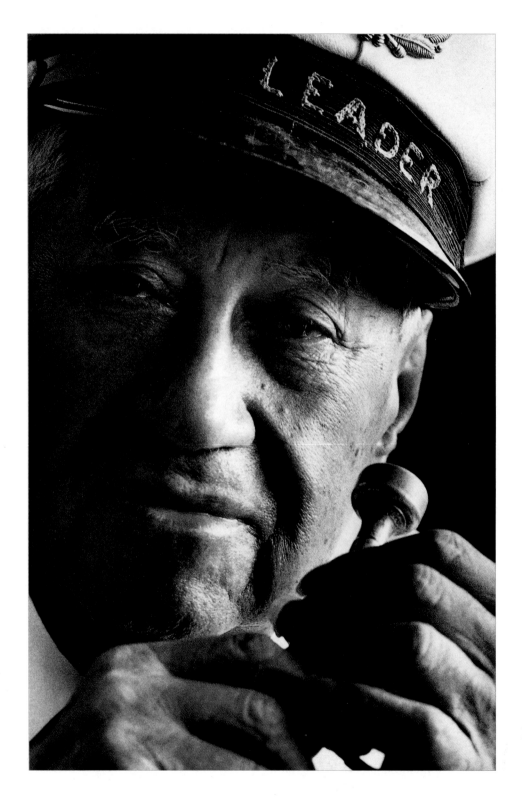

Percy Humphrey (b. 1/13/05), who gave the sounds of Preservation Hall to the world, is the grand old man of New Orleans jazz. Born into one of New Orleans's noblest musical families—his father and grandfather were both important music educators and performers in the Crescent City—he is the youngest of three musically gifted brothers.

Following the example of his granddad Professor Jim Humphrey, Percy mastered the trumpet and first attracted notice performing in the city's brass bands. In the 1940s, he ascended to first trumpeter of the Eureka Brass Band and the following decade assumed leadership of this venerable ensemble. His eldest brother, Willie, played clarinet alongside him in the group. Both men would lead bands of their own over the years, but when together they formed one of New Orleans's most formidable teams. It was a partnership that ended only with Willie's passing in 1994.

From the time Preservation Hall opened in 1961, the Humphrey Brothers' Band made the jazz landmark its most important stomping ground. Touring as the Preservation Hall Jazz Band, the Humphreys brought classic New Orleans jazz to the masses, introducing an international audience to its joyful sound.

Percy **HUMPHREY**

When one thinks of "New Orleans jazz," images of Dixieland bands and "When the Saints Go Marchin' In" come to the mind of most folk. However, there has long been a rich and vital modern jazz scene in the Crescent City, and this grouping of artists represents some of its most vital participants. Wallace Davenport (b. 6/30/25), seated in front of some of his younger associates, is a traditional trumpet king who has also felt comfortable in swing (and even bop) gigs; his most

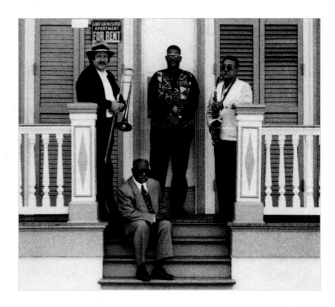

Standing, left to right
Steve **YOCUM**

Raymond **WEBER**

Warren **BELL, SR.**

Seated
Wallace **DAVENPORT**

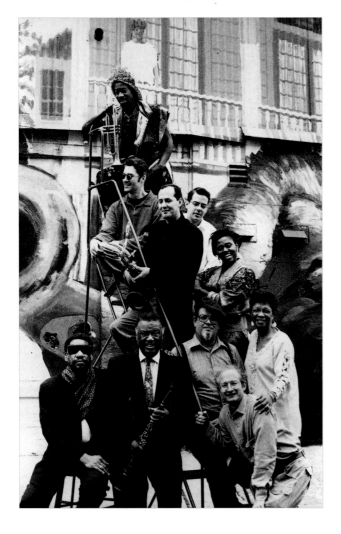

Top to bottom, left to right
Michael **RAY**

Victor **ATKINS**

Tony **DAGRADI**

Glen **PATSCHA**

Yolanda **ROBINSON**

Henry **BUTLER**

Alvin **BATISTE**

Loren **PICKFORD**

Germaine **BAZZLE**

Joel **SIMPSON**

important out-of-town tours were with the likes of Count Basie and "Panama" Francis.

Clarinetist Alvin Batiste holds the title of best-known unknown jazz master: long a legend among the jazz cognoscenti, Batiste was finally recognized by a major label as "a legendary pioneer of jazz" with the release of his brilliant 1993 album *Late.* Perched on high is trumpeter Michael Ray, who joined Sun Ra's Interplanetary Arkestra in 1976, becoming one of the most powerful new additions the group had seen in years (he stayed on with the Arkestra until Ra passed); reedman Tony Dagradi (at center) has also been heard with visionary big band leader Carla Bley when he isn't fronting units down home; while at bottom left is Henry Butler, whose piano links the Mardi Gras mayhem of Professor Longhair with the modal jazz expressions of McCoy Tyner.

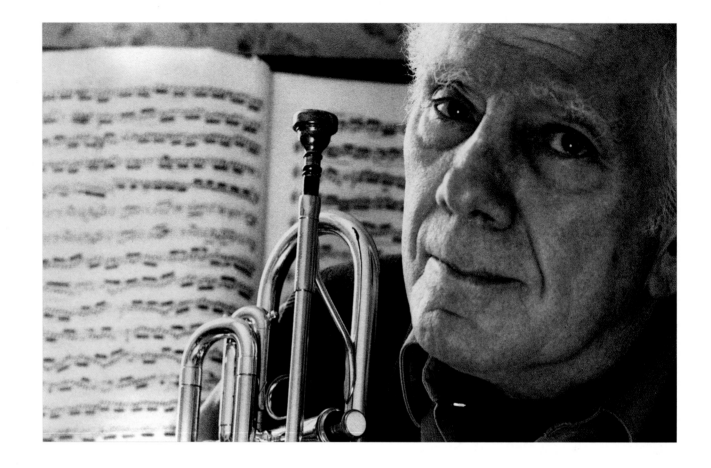

In concert, cornetist Ruby Braff (b. Reuben Braff 3/16/27) brings his audiences to laughter with his off-beat drollery as effortlessly and as naturally as he moves them with the piquant lyricism of his music. Performing at the Newport Jazz Festival in July of 1957, he began his set by announcing, "We're not going to play any psychological or psychotic music; no fugues, no nothing. Just plain jazz." At that time, Braff's straightforward and authoritative blowing of the Armstrong continuum was considered to be an anomaly among the musicians of his generation. Now Braff's sound, especially his poetic forays into his instrument's lower register, is considered just as what it is: one of the most beautiful sounds in jazz.

"I'm fortunate to have lived through the greatest period of the jazz age," says Red Norvo (b. Joseph Kenneth Norville 3/31/08) in assessing his long career. "I grew up in jazz, I migrated through it."

A childhood fascination with the sound of the marimba gave Norvo a bug he couldn't shake; he pur-

chased a xylophone at the age of fourteen and mastered it on his own.

Norvo was the first to play jazz on the instrument. In 1931, he became a featured performer with Paul Whiteman's Orchestra. Norvo's wife, Mildred Bailey, was Whiteman's (and jazz's) first female band singer and one of the finest jazz vocalists of the era; in the years to come, they would be known as "Mr. and Mrs. Swing."

Norvo was one of the original stars of 52nd Street, first with his remarkably subtle jazz orchestra and then with a series of small groups. Norvo gave up his own band in 1944 to join the Benny Goodman Sextet (he switched from xylophone to vibes at this time as well), and in 1946 he left Goodman to lead the "Woodchoppers" contingent of Woody Herman's fabulous First Herd band.

These were his last sideman adventures. For the next four decades, Norvo's ensembles, like the artist himself, were models of musicianship, taste and swing.

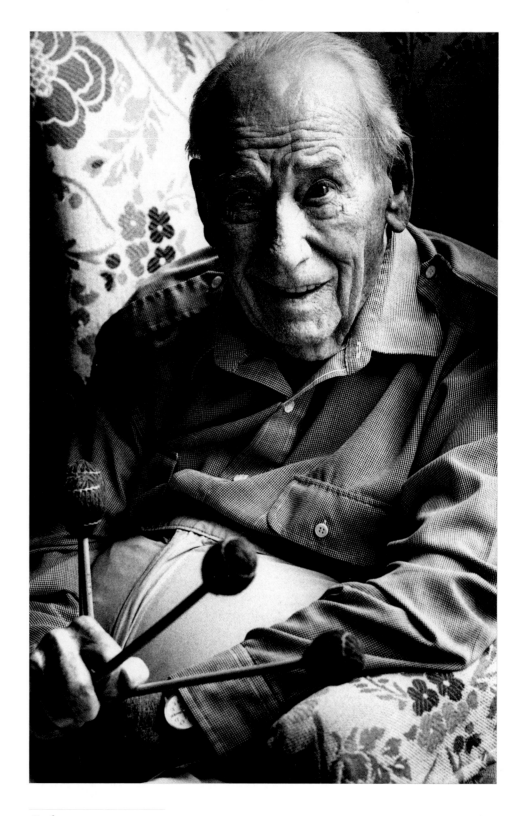

Red **NORVO**

Thanks to radio, the sounds of jazz were beamed to the most unlikely places, including an isolated stretch of North Dakota that included the hometown of Peggy Lee (b. Norma Jean Egstrom 5/26/20). Today, the sound of Bill Basie's piano as she first heard it on her family's five-dial Atwater-Kent remains powerfully etched in her memory. Lee's natural vocal talent was first recognized in her early childhood; by the time she was sixteen, she had made her first tour as a band singer, and before the end of the thirties, she was making radio broadcasts of her own.

One evening in 1941, Lee was appearing at a club in Chicago and saw Benny Goodman in the audience looking at her rather strangely, she thought. Lee had no idea that Goodman was looking for a singer to replace his popular thrush Helen Forrest, nor that he had decided upon hiring her before the set was over. The clarinetist had discovered a young vocalist who knew how to put over a song: Lee was the personification of "cool" long before the expression came into use. Just a few inflections in her low-key style made the difference between her demurely innocent ballads and the all-too-knowing sarcasm of her first big hit, "Why Don't You Do Right."

Lee gave notice to Goodman in March of 1943, intending to give up her singing career to be a wife and mother. The next year, despite reservations, she was convinced by Capitol Records to hire a baby-sitter and take a couple of hours to record two sides. Her sentimental rendition of "That Old Feeling" struck a chord with the nation; Lee was besieged with offers to work as a single, and the rest, as they say, is history.

She conquered all the arenas a star can conquer. When radio was at its most popular, Lee had her own program. She wrote not just songs, but hits ("Mañana" was the first). Her first major role in a Hollywood film garnered her an Academy Award nomination. Lee appeared regularly on television as she continued to produce best-selling records. The best known of these is the sultry "Fever," which Lee completely transformed from the Little Willie John original with her new lyrics and forever-hip arrangement of bass, drums and fingersnaps.

Her last big seller was 1969's "Is That All There Is?", but her 1993 release *Moments Like This,* made some fifty years after her debut with Goodman, is a poignant reminder of how rare it is today to hear singing straight from the heart.

Anita O'Day (b. Anita Belle Colton 10/18/19) is one of the most original vocalists to have emerged from the big band era. From her first days as a band singer, she was a startlingly creative musician: a marvelous interpreter of popular song and one of the boldest improvisers in the entire field of jazz singers.

In 1941, O'Day joined Gene Krupa's big band and became a nationally recognized performer. One of her first recordings was the instant classic "Let Me Off Uptown": there's some charming spoken interplay between her and the band's key soloist, trumpeter Roy Eldridge; then Krupa uses them like a two-punch combination, O'Day swinging her "hep" paean to the joys of nightlife followed by Eldridge's patented fireworks.

O'Day held rare status among band singers—she figured more as a fellow musician than the typical band vocalist. As described by jazz critic Dan Morgenstern, O'Day's persona was something different as well. Anita's singing exposed "the cutesy, kittenish mannerisms of so many of her contemporaries for what they were: pseudo sex. With Anita, it was the real thing. Her husky, throaty voice and sensuous phrasing communicated a female essence that only Billie Holiday could match."

During the war years, her peerless ballad performances ("Skylark" with Krupa is a special gem) and her novelty numbers (such as the million-seller "And Her Tears Flowed Like Wine" with Stan Kenton) were favorites on jukeboxes across the country. After the war, she had more difficulty in making her solo career fly. Yet O'Day's first recordings under her own name captured the work of a jazz musician at ease with tricky tempo changes and chord modulations, one who has the ability to phrase as an instrumentalist would.

Her real breakthrough as a solo artist came in 1956, with the release of *Anita,* an LP collection of classic popular songs expertly adapted for her by arranger Buddy Bregman. But for many, her greatest recorded appearance is not on record but film. Bert Stern's *Jazz on a Summer's Day* captured two selections from what may well have been the outstanding set of the 1958 Newport Jazz Festival. O'Day's incredible performance of the old chestnut "Sweet Georgia Brown" brings the song's subject to life as no vocalist has done before or since.

O'Day was never taken for granted by the jazz community again. In 1972, she began to document her work on her own record label, and in 1985 she produced a concert at Carnegie Hall, celebrating the fiftieth year of her career in jazz. A 1993 reunion with arranger Bregman brought O'Day back to the big band surroundings in which she thrives best.

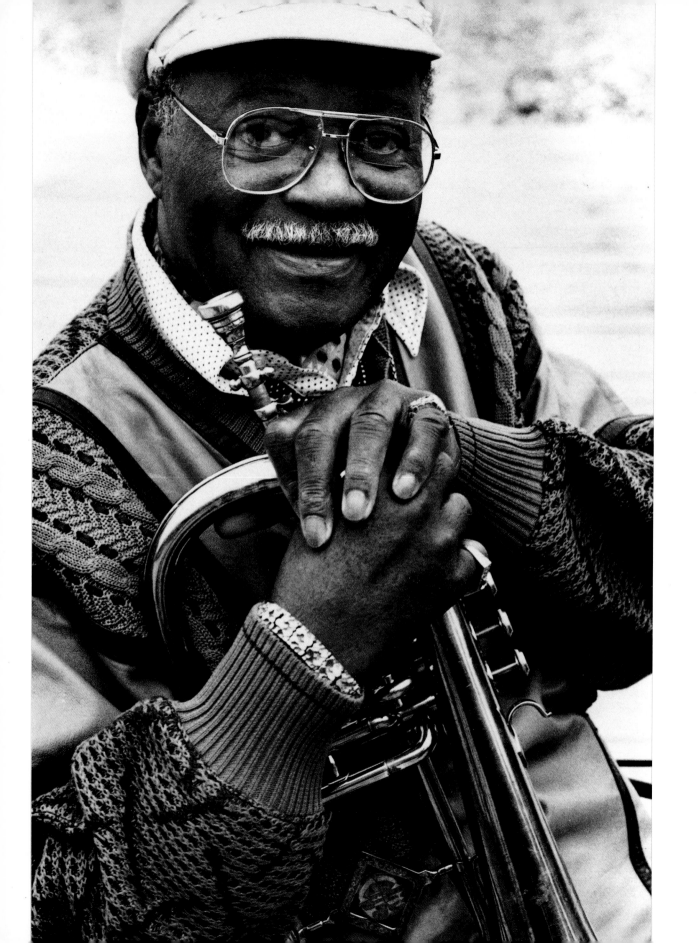

Those who meet the great trumpeter Clark Terry (b. 12/14/20) in person find that his music corresponds with his personality—warm, open, and filled with laughter and soul. The man has been an inspiration since his early days in St. Louis. In 1946, swing maven George T. Simon made a survey of the city that has played such an important role in the history of jazz trumpet and reported that Terry was its "most amazing man and one who is just about God to the local swing gentry." Terry's lyricism, gorgeous tone, and immaculate articulation are all in the St. Louis tradition, and another native, the young Miles Davis, counted as one of his biggest fans.

In 1947, the trumpeter made his name band debut with Charlie Barnet, and the tenorman was soon raving about Terry to his bandleader-idol Duke Ellington; in the words of the Duke (from his book, *Music Is My Mistress*), Barnet told him that " 'Clark Terry is the greatest trumpet player in the world. You wait and see. Or, better still, go get him for your band, but hurry, because soon everybody is going to be trying to get him.' I considered myself lucky indeed to get him in 1951."

But before Terry became an Ellingtonian, he was a Basie-ite for nearly three years, having played in both the pianist's big band and octet. Ellington's offer to join his orchestra would prove irresistible, however, and the trumpeter became one of Duke's key players for the remainder of the fifties. Terry's first recorded highlight from this period came in the summer of 1952, when the band waxed an extended arrangement of "Perdido"; Clark was slotted as one of a number of soloists, but after his double-time tour de force, the tune virtually belonged to him from then on. Other gems from the era include Terry's central role in a revamped version of "Harlem Airshaft" and an early flügelhorn feature on "Juniflip."

Terry left Ellington in 1959 to join Quincy Jones for a European tour; upon returning home to the States, Terry settled into a studio job at NBC and established an important quintet with trombonist Bob Brookmeyer. In the early seventies, Terry entered the big band field with his Big B-A-D Band, which utilized the talents of the likes of Phil Woods, Frank Wess, Joe Temperley, and the trumpeter's hometown friend Ernie Wilkins. Terry has since toured the world with his own ensembles and in scores of special packages: with a revived Jazz at the Philharmonic, with a band of Basie alumni and a tentet inspired by Ellington's Spacemen group of the fifties among them. Jazz legends are kept busy these days, and Clark Terry is no exception.

Clark
TERRY

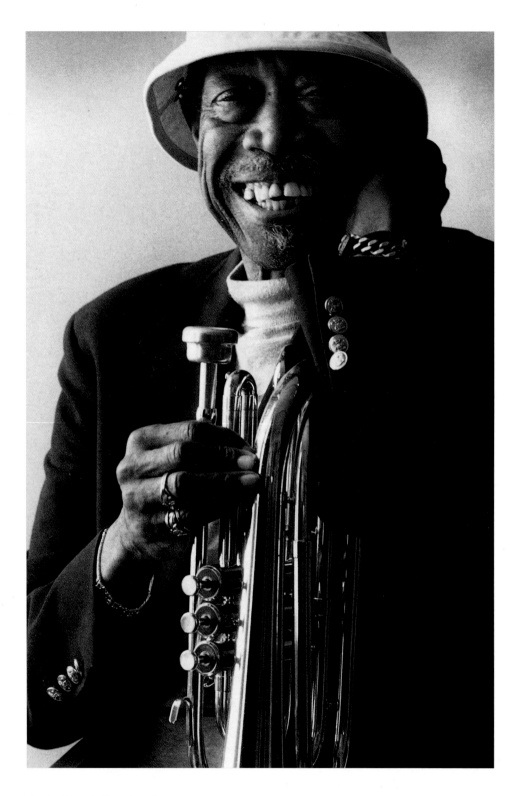

In 1943, Al Grey (b. 6/6/25) was playing trombone in a navy band. Half his day went to playing officer's dances or concerts, and then it was off to nearby Detroit to take part in its jamming scene. There he came to the attention of Benny Carter, and Grey had a job with the alto king's big band waiting for him upon his discharge.

Carter's orchestra broke up soon after, yet luckily for Grey, the great swing era bandleader Jimmy Lunceford needed someone to take the trombone chair. Grey jumped from Carter's band, but this phase of his career was also cut short with Lunceford's death in 1947.

Grey's next important big band association was with Lionel Hampton's raucous ensemble. It was also during these years that Grey first had the opportunity to feature the expressive plunger work that would become his trademark in Count Basie's band.

Although Grey would leave the Count from time to time to lead his own groups, once you're a Basie-ite, you're a Basie-ite for life. After having rejoined the band for the umpteenth (and last) time in 1976, his next two groups were co-led with two great tenors out of the Basie tradition: Jimmy Forrest and Buddy Tate, respectively. Now he leads a band with a two-trombone tandem featuring his son Mike, who is ably continuing the Grey family tradition of musicianship.

Al **GREY**

With no little irony, Joe Williams (b. Joseph Goreed 12/12/18) became a star singing the blues but had little opportunity to sing them in his early Chicago days on his first big-name band gigs. In 1941, as Williams recalls: "I was getting about forty-five dollars a week and singing the blues up at this joint, but in between shows the piano player and I would do all kinds of pretty tunes of the day, and Coleman [Hawkins] was listening. . . . 'I want you to come with me and travel with me as my vocalist,' he said, 'I don't want you to sing the blues, I want you to sing the pretty songs, and I'm gonna give you eighty dollars a week.' I lost my allegiance to the blues just like that! . . . Andy Kirk did the same thing: He had a singer, Beverly White; he said, 'Let Beverly sing the blues and you sing the pretty songs. You do the ballads so well.' " In 1943, it happened *again* when Williams sang with Lionel Hampton's orchestra; Dinah Washington was the blues specialist of that band, and the vibes player said, "Gates, you sing the pretty songs; let Dinah sing the blues!"

In 1954, Williams sat in with the Basie band and was immediately hired as its new band singer. When they hit New York and Williams lit into "Everyday I Have the Blues," it was the end of his journeyman days. He stayed with the Count until 1961, when he went solo again, this time as an international jazz star.

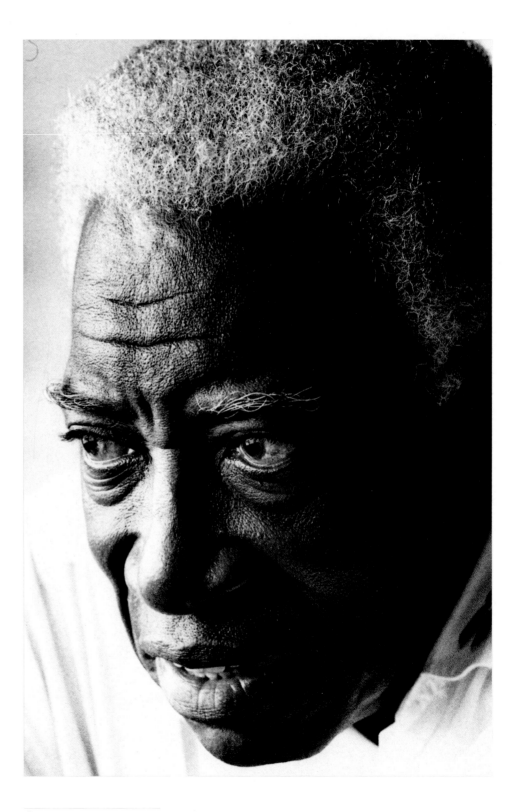

Joe **WILLIAMS**

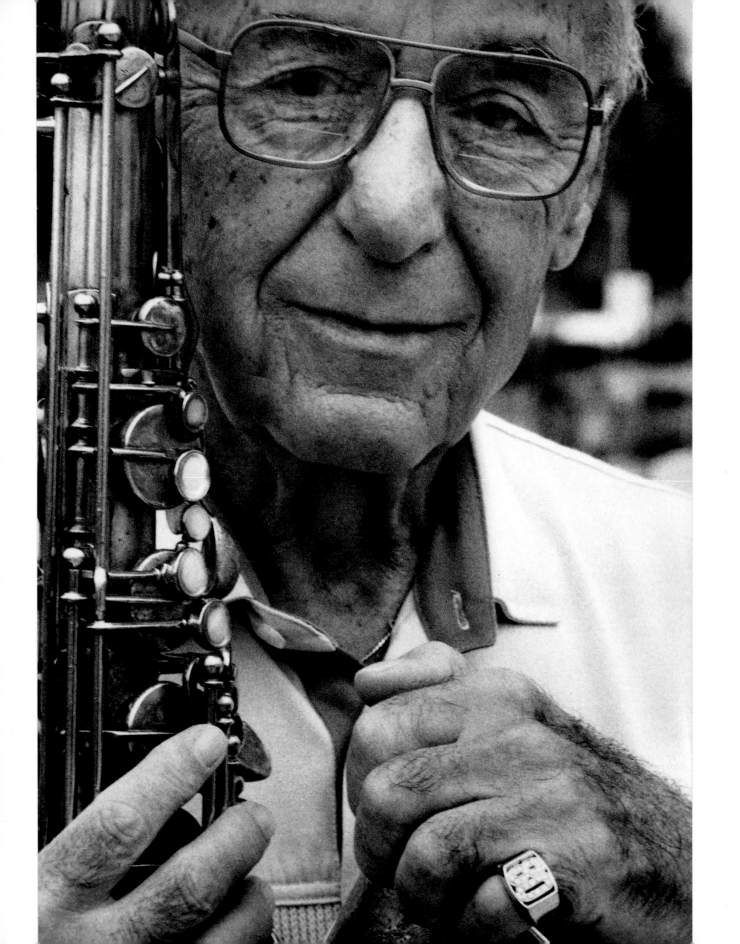

Flip Phillips (b. Joseph Edward Filipelli 3/26/15) began his professional career as a clarinetist in 1934. When Frankie Newton, one of the unsung heros of jazz trumpet, formed a new band in 1939, he caused a small stir by hiring Phillips. Although there had been instances when black jazzmen had joined white ensembles, the opposite scenario was all but unheard of. More important, Phillips was then a member of one of the leading combos on 52nd Street, the focal point for jazz in the world at that time.

Phillips had switched to tenor sax by 1942 and briefly played in the reed sections of Benny Goodman's, Wingy Manone's, and Red Norvo's orchestras; but he had no desire for the rough life on the road, so he took a local job with Russ Morgan's dance band.

Then Woody Herman knocked on his door with the opportunity of a lifetime, asking Phillips to join the band later known as the First Herd. In 1945, it was the most talked about band in the business, and its major soloists leaped from obscurity to jazz's front ranks. Flip's electrifying tenor helped make hits of Herman sides like "Apple Honey" and "Northwest Passage." Yet for all the acclaim, the First Herd came to an abrupt close in December 1946, when Herman shocked the jazz world by breaking up the band.

A free agent once again, Phillips joined the troupe known as Jazz at the Philharmonic and made history. It was September 27, 1947, the first day of JATP's second cross-country tour. Phillips let loose on the song "Perdido," riffing and riding on notes until all of Carnegie Hall was driven to pandemonium. When his solo was released on 78, JATP had its biggest hit. The saxophonist who didn't like the idea of being on the road became the only musician to make every JATP trip from 1947 to 1957, when the annual tours of the United States came to an end.

Off-season, Phillips led a small ensemble with Bill Harris, his old chum from the Herman band. In 1959, they played with a Benny Goodman unit, but once again, Phillips tired of the road. He settled in Pompano Beach, Florida, and led a house band at the Beowolf Jazz Club for three years. He was not coaxed out of the Sunshine State until the mid-seventies, when Phillips once again became a regular performer and recording artist. He scored a recent triumph with a critically acclaimed album of ballads combining his tenor and bass clarinet with a string ensemble. At eighty, Flip Phillips remains a remarkably versatile and moving artist.

Flip
PHILLIPS

J. J. Johnson (b. James Louis Johnson 1/22/24) set the standard for modern jazz trombone by which all succeeding artists on the instrument still measure themselves. Johnson came of age during the big band era, receiving most of his advanced musical education during the three years he played in the Benny Carter Orchestra. The trombonist already had a reputation among musicians as one of the finest young players when he left Carter to join Count Basie's band in 1945, but like so many other players of his generation, Johnson had come under the spell of the new music being made by Charlie Parker and Dizzy Gillespie. Despite the Basie gig's good pay and excellent musical experience, he knew where he had to cast his lot. "I couldn't help myself," he later said. "I left Basie's band so that I could get a grip on this new thing."

Johnson often sat in with Gillespie on 52nd Street, amazing people with his facility in the new musical language. With his clean, rapid-fire succession of notes, Johnson broke a technical barrier that had never been broached on the slide trombone; many who listened to his first bop recordings were convinced they were performed on a valve trombone.

A flock of modern jazz trombonists had followed in his footsteps by 1954, the year Johnson interrupted a two-year sabbatical from the music business to do a two-trombone record date with Danish trombonist Kai Winding. As sometimes happens, a presumably one-time combination turned into something altogether different: for the next two years, Johnson and Winding had one of the most popular ensembles in jazz. Johnson's later working quintets would be important springboards for such artists as drummer Elvin Jones and trumpeter Freddie Hubbard.

In 1956 came Johnson's first major work for orchestra: *Poem for Brass,* recorded with trumpeter Miles Davis and Johnson as featured soloists. In the sixties, Dizzy Gillespie commissioned Johnson to compose *Perceptions,* an extended suite. Important recordings featuring Johnson's big band compositions and arrangements also appeared during this time, but in the latter days of the decade, the trombonist turned to studio work.

In 1970, Johnson moved to California and gave up his work as a soloist to arrange and compose scores for films and television. In the last ten years enough major jazz soloists reemerged from studios and academia to suggest a trend, and Johnson was a part of it, making his own triumphant return to the jazz scene in 1988 with a new quintet. When an artist of J. J. Johnson's stature takes up performing again, it's a major boon for us all.

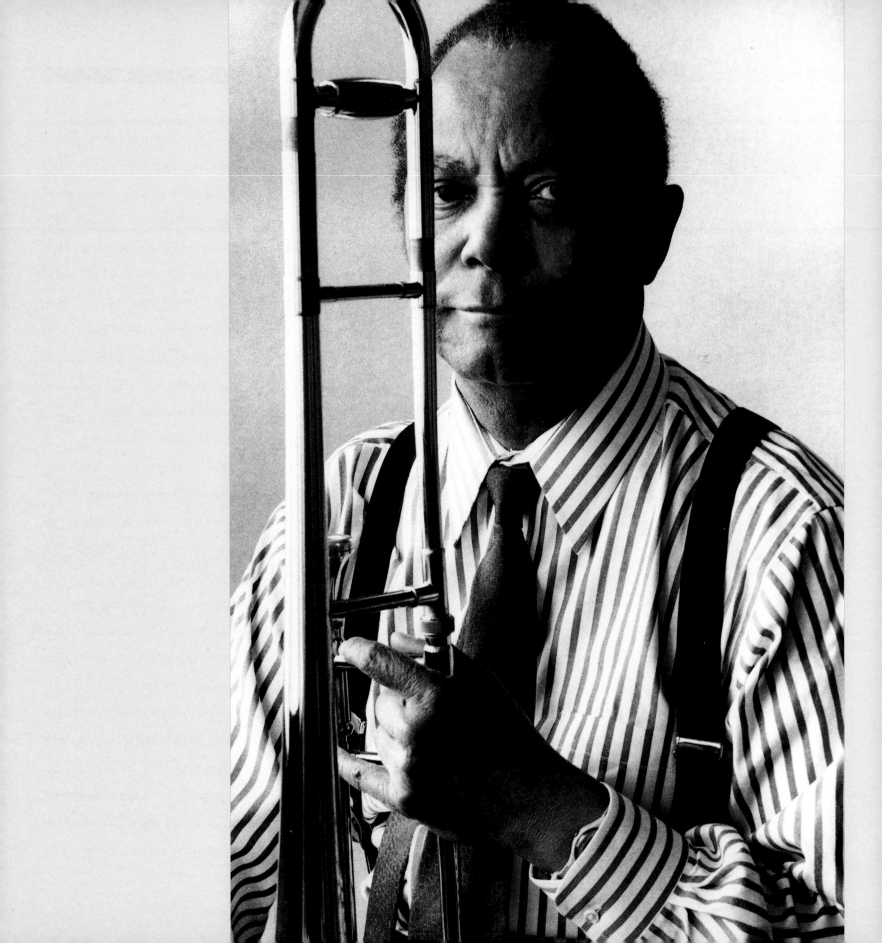

CHARLIE PARKER changed everything. Others brought the music to Carnegie Hall while Parker was still an unknown teenager, but it was the alto saxophonist from Kansas City, in the kitchen of a Harlem chili parlor and on the bandstands of such fabled after-hours haunts as Monroe's and Minton's, who delivered jazz irrevocably into the realm of high art.

Parker had his influences, especially the oblique, free-floating tenor saxophone solos Lester Young dispensed out of Count Basie's reed section. He was not alone, and he made his musical revolution among a coterie of path-breaking innovators. His primary accomplice was trumpeter Dizzy Gillespie, whose own advanced harmonic notions opened many ears, and whose big band would provide the meeting ground for jazz and Afro-Cuban music. Pianist Thelonious Monk's chords were even denser and more dissonant; and while Monk's angular, seemingly anti-virtuosic solo style took longer for the public to absorb, young pianists could follow the dazzling, Parker-like example of Monk's keyboard protégé Bud Powell. Benny Goodman's guitarist Charlie Christian, like Duke Ellington's bassist Jimmy Blanton, brought a background instrument into the forefront through his technical agility and melodic imagination. Drummer Kenny Clarke, a few years older than the others, had been elaborating rhythms for years, and may be the first modernist in a chronological sense. Yet the mercurial, darting attack, the comfort at racetrack tempos and the reassertion of blues as the primary element in the jazz vernacular were most completely joined in Parker, who became jazz's figurehead in the 1940s.

It was Parker's fate, however, to spread the pain and frustration of modern life as well as the glories of the modern style that came to be called bebop. He was an overwhelming presence who lived as hard and fast as he played. Those who came under the influence of the legendary Bird risked succumbing to both his unattainable example and his easily cultivated personal habits. Several alto saxophonists were so intimidated by Parker's musicianship that they switched to the tenor; too many other musicians thought that playing like Parker required adopting his voracious appetites for alcohol and drugs. These "personal problems" killed Parker in 1955, months before his thirty-fifth birthday. In his short span, he not only redefined the approach to improvisation on all instruments but also set the future standard of small-group jazz through his quintet's music, and suggested a range of further possibilities in his encounters with Latin bands, string orchestras and even vocal ensembles.

The need to keep expanding jazz's horizons was obvious to many young musicians long before Parker's passing. They sought new approaches to form, in the Lydian Chromatic Concept of George Russell and the free collective improvisations of Lennie Tristano, and new concepts in instrumentation, in the nonet with French horn and tuba that Miles Davis led, the pianoless quartet of Gerry Mulligan and an even more intimate Jimmy Giuffre 3 that dispensed with piano and drums. At the same time, Sonny Rollins, Art Blakey, Horace Silver, and others were moving toward a more percussive, extroverted style in which speed was tempered by a greater emphasis on blues and even gospel fervor.

Given the musicians involved, and the sites of their efforts, jazz appeared to become factionalized along a racial/geographic divide, with white musicians assigned to the cool West Coast while black players displayed a harder East Coast temperament. Such schematics ignore the inspirational crosscurrents and common sources that fueled all of the music surrounding Parker's death. Rigid categories cannot explain the

mellow poetry of Philadelphian Benny Golson's compositions, the baroque and blues synthesis of the Modern Jazz Quartet or the emotional intensity of Art Pepper. They cannot account for the peerless proficiency of multi-instrumentalists like Buddy Collette and Jerome Richardson or the searing authenticity of Phil Woods. The stylistic categories are still with us, yet hindsight long ago verified that those who immediately followed Parker were, in their diverse ways, creating one music.

A deeper gulf appeared to separate the modernists of whichever Coast from their elders, both those preserving the early traditional styles (often disparagingly called moldy figs) and the more contiguous generation of swing and big band players (who were suddenly deemed mainstream). Again, the divide was exaggerated, as several of jazz's rising young voices chose to invigorate established styles rather than function as absolute modernists. Clark Terry and Louis Bellson in Duke Ellington's band, Frank Foster and Al Grey with Count Basie, and Ruby Braff with various small combos expanded on familiar approaches by applying their talents to styles with longer histories. They participated in the regeneration of the music that preceded Parker, a phenomenon that allowed veterans like Ellington, Basie and Coleman Hawkins to emerge from periods of popular decline in the 1950s.

Once again, developments in all jazz styles received a critical assist from advancing technology, in this case the 12-inch, 33⅓ rpm record album. Solos grew longer and harmonies more complex in Parker's wake, and the remaining big bands took on added dynamic daring, and listeners could better appreciate these innovations when heard on a long-playing, high fidelity record.

The modern/mainstream distinction hid a growing equilibrium within jazz, which was best illustrated by the flood of talented pianists that emerged around the time of Parker's death. Bebop's long lines and dissonant chords were best expressed on the keyboard, where the music could be truly breathless; and indeed, by the early forties, the virtuosity of Art Tatum and the lean mobility of Nat Cole (in his period as a trio pianist) predicted much about where bop was heading. Even prior to Parker's death, the merging of technique and swing in Oscar Peterson, the felicitous voicings and clean ensemble sound of George Shearing and the polytonal complexities of Dave Brubeck won a popular audience for more modern piano styles. As the fifties progressed, pianists surfaced in stunning profusion: foreign-born stylists like Peterson and Paul Bley from Canada, Marian McPartland from England and Toshiko Akiyoshi from Japan, as well as many native players. Even Monk finally won acclaim in 1957, which ultimately spun jazz in other directions. Most of these players moved effortlessly between the modern and mainstream camps, calling the entire compartmentalization of jazz into question.

People complained that the audience couldn't dance to bebop, which was a nasty rumor with an undeserved long life. Jazz was still danceable, and singable; and singers, each of whom was at least touched by bebop, took the modern sounds every which way. Joe Williams belted, Shirley Horn whispered, Mel Tormé crafted multi-voice arrangements. Ella Fitzgerald, Sarah Vaughan and Betty Carter scatted in more daring arcs than ever before. Eddie Jefferson, King Pleasure and Jon Hendricks even got right inside the labyrinthine creations of the modern soloists by tailoring lyrics to famous recorded improvisations. Vocalese, as this last approach came to be called, was one more sign of Parker's aura, another reminder that Bird changed everything.

The quality of his touch alone imparts the beauty of the piano of Hank Jones (b. Henry Jones 7/31/18); whether he spins out a bop line or constructs a felicitous sequence of chords, Jones's playing has delicacy and cleanness, a sheen of gracefulness, sophistication, and taste. He is a brilliant solo performer who also possesses the sensitivity of an ideal accompanist.

Hank Jones began classical piano studies at an early age, but he also studied the classic jazz 78s by Duke Ellington, Earl Hines and Fats Waller played in his family home in Pontiac, Michigan, where he grew up with his younger brothers, Thad and Elvin. He came to New York in 1944 to take a job on 52nd Street and entered the thick of the musical paradise known as Swing Street.

Jones had arrived in time to experience the transition from swing to bop; he first jammed with Charlie Parker in 1945, not long after Bird first brought the new music down from Harlem to midtown. Although Jones was influenced by Bird and pianist Bud Powell, he integrated bop's harmonies into his playing in a way that transcended any singular style.

In 1947, Jones began touring with Jazz at the Philharmonic. The following year, Ella Fitzgerald joined JATP, and Jones would remain her accompanist for the next five years. In 1951, Jones gave up the road to be a freelance musician in New York, where he has since recorded hundreds of sessions. From 1958 to 1973, Jones was a staff musician at CBS Studios; later in the seventies he headed to Broadway to conduct and play piano for *Ain't Misbehavin'*, the hit revue of Fats Waller songs. Hank Jones has assembled countless credits over five decades as a working musician; today, for so many jazz artists, he remains *the* pianist of choice.

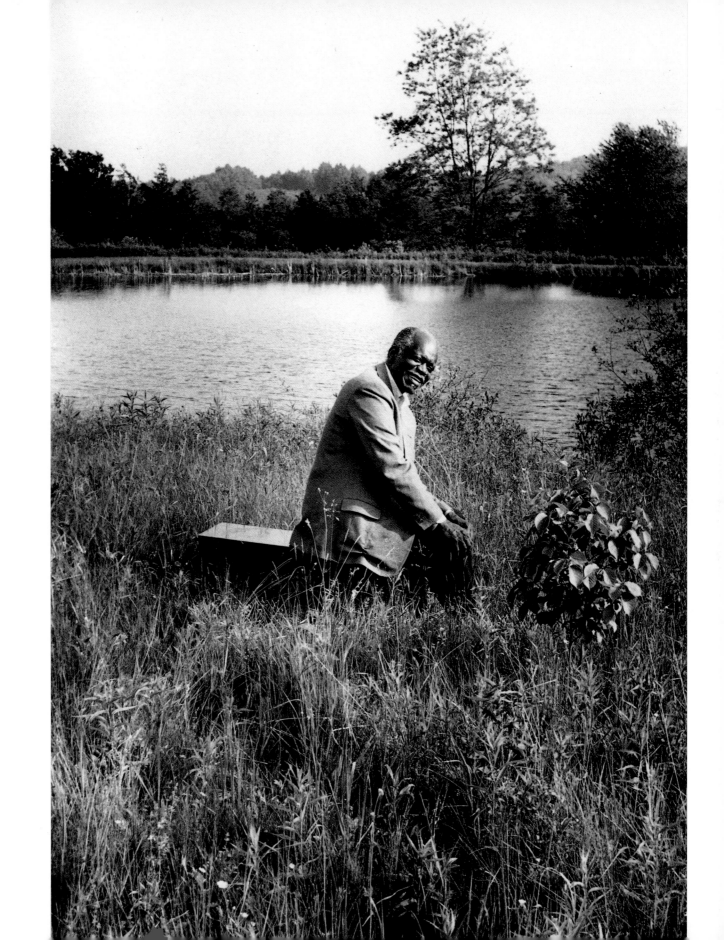

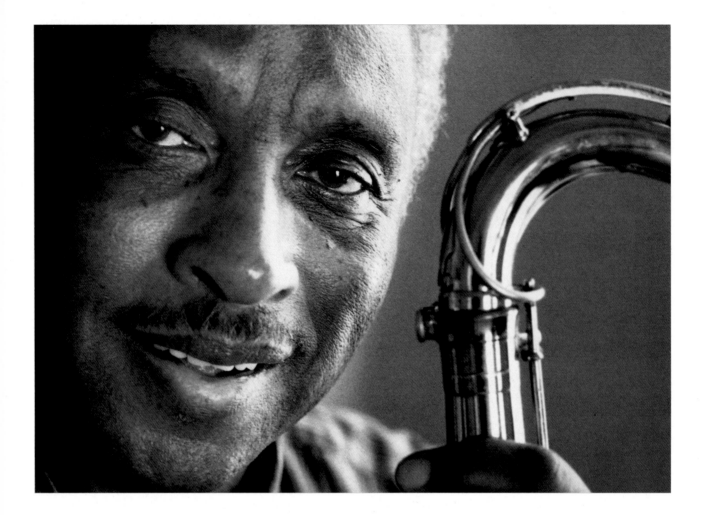

As a dedicated dweller in Los Angeles, Teddy Edwards (b. Theodore Edwards 4/26/24) has suffered from a lower profile in the jazz world than his talents deserve. Born in Mississippi to a musical family, Teddy Edwards began playing alto sax in his early teens. In 1946, after working his way to the West Coast, he switched to tenor in order to join a group led by Howard McGhee, one of bop's earliest trumpeters.

Edwards and his friends Dexter Gordon and Wardell Gray waged ferocious battles of music in the nightclubs on Central Avenue, the most vital jazz scene on the West Coast in the forties.

Edwards released critically acclaimed albums in the early sixties, but *Blue Saxophone,* recorded in 1992, demonstrates that his warm, robust tenor sound still provides one of jazz's greatest pleasures.

Teddy **EDWARDS**

Although the clarinet was a dominant instrument of the swing era, curiously, only a handful of champions played bebop on it. Buddy DeFranco (b. Boniface Ferdinand Leonardo de Franco 2/17/23) was the first to do so; he led bop groups on 52nd Street at the height of the movement and was a poll-winning favorite of jazz fans to boot.

The fifties saw DeFranco make star turns with Jazz at the Philharmonic, and in 1966 he found himself back in the big band business as the leader of the "ghost" Glenn Miller orchestra, which he toured and recorded with through 1974. In the eighties and nineties, DeFranco has made marvelous music with vibraphonist Terry Gibbs. He has also premiered new works as a featured soloist with Europe's leading radio big bands.

The clarinet continues to be a rare instrument for a jazz musician to take up—with the exception of players in the New Orleans and swing traditions—but DeFranco has directly encouraged some of the important players of younger generations. After hearing Eddie Daniels play a rare gig on the clarinet, DeFranco told him, "Put the tenor saxophone aside for a while. Come out as a clarinet player because you've got it. . . . There are a handful of clarinet players who are original. Everybody else is a clone." Words to remember, from a jazz original.

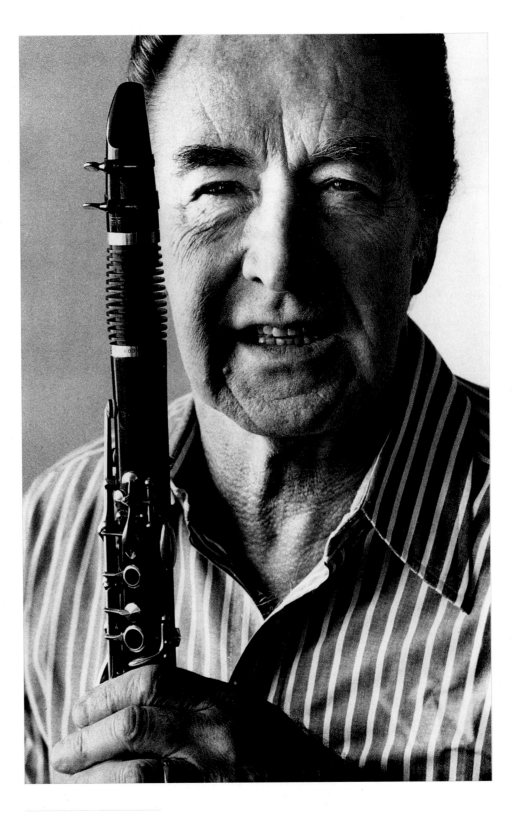

Buddy **DEFRANCO**

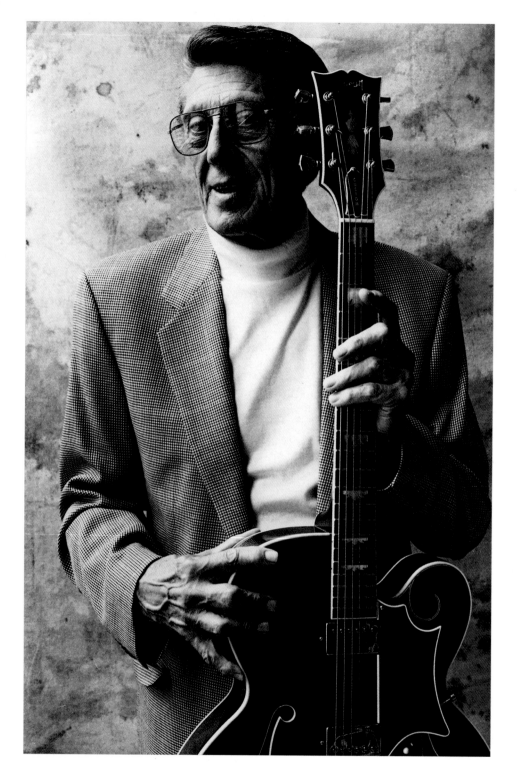

The innovations of Charlie Christian, Charlie Parker and Lester Young have inspired many followers: Guitarist Tal Farlow (b. Talmadge Farlow 6/7/21) built upon all three legacies to create his own solo style. He was among the first to fit bop's phraseology to the guitar.

Farlow had already made his way to 52nd Street when he was asked to join the Red Norvo Trio, one of the great chamber jazz units, in 1949. Farlow would become known as something of a speed demon on his instrument, developing his facility during his four years with the trio. In 1953 and 1954, he went with another chops-heavy small ensemble: one of the last editions of Artie Shaw's Gramercy Five. Farlow's own recordings from the fifties (on the Blue Note and Verve labels) continue to be studied religiously by guitar students everywhere.

Like Shaw, however, Farlow chose to take himself off the main stage. Withdrawing to his home in Sea Bright, New Jersey, after 1958, he performed locally and gave private music lessons. On rare occasions, he returned to the recording studio (his busiest spate of activity came in the early eighties). Farlow still pops up on the New York scene every now and again, leading jazz critic Lee Jeske to liken him to Halley's Comet; thankfully, sightings of Tal Farlow are more frequent.

Tal FARLOW

If music has a Thomas Edison, that man is Les Paul (b. Lester William Polsfuss 6/9/15). His creation of the first solid-body electric guitar in 1934 was a revolutionary advance in the history of an instrument, while his innovative sound wizardry in the recording studio made its mark on all forms of American popular music. His high-pitched, ringing tone and dexterous picking have been the envy of countless musicians, jazz and otherwise.

America would get to know Paul best through his "New Sound" recordings, first released in 1948, in which varied recording speeds and multiple recording techniques gave the impression that the music was being produced by a horde of superhuman Les Pauls. Combining his talents with those of vocalist Mary Ford, Paul became one of the biggest names in the popular music field.

In 1949 and 1950, Paul's radio series bridged his recordings with little playlets by himself and Ford, revolving around the conceit that he created his studio effects by hooking up his guitar to a device called a "Les Paulverizer." Of course, there ain't no such animal; for the performances Paul has made with his revived trio in the eighties and nineties at New York's Fat Tuesday Club, the guitarist has only had the benefit of his superb musicianship in real time.

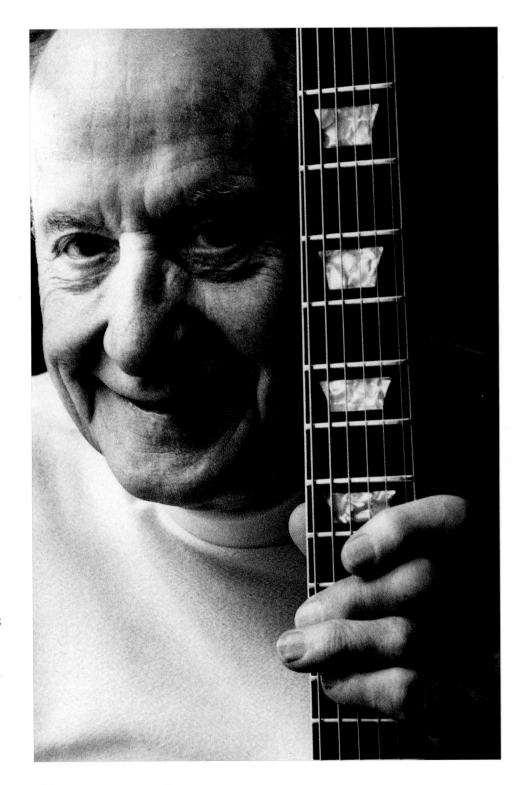

Les **PAUL**

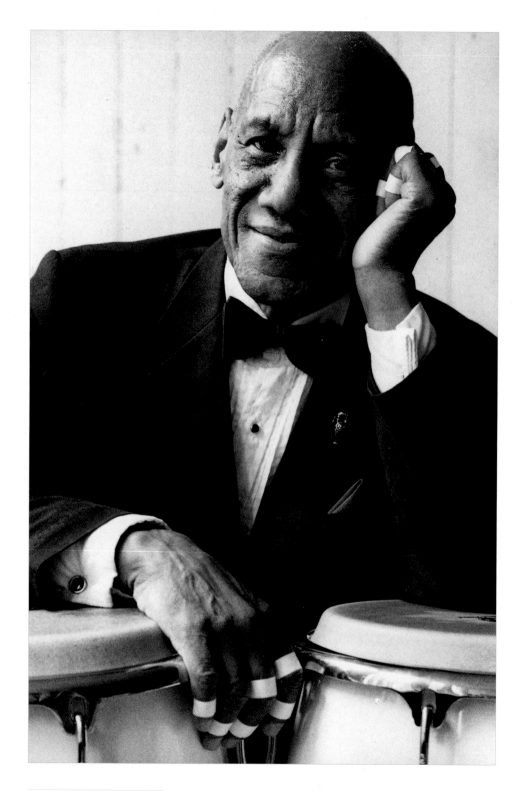

When Candido Camero (b. 4/22/21) moved to New York from his native Havana in 1952, the percussion master sought out Dizzy Gillespie. The trumpeter led him to 54th Street and the Downbeat club, where Billy Taylor was leading the house trio. At Gillespie's request, Taylor let the new arrival in town sit in; Candido wowed the audience and landed his first regular job stateside with Taylor's combo.

Camero's supercharged conga playing, steeped in the traditional Yoruba folk culture of his homeland, was the most exciting the Big Apple had seen since the untimely death in 1950 of the great Chano Pozo. In November of 1952, Candido made it to the stage of Carnegie Hall, where he appeared in concert with Gillespie and Charlie Parker; for the rest of the decade, his rhythms added spice to dozens of classic jazz combo dates (by artists ranging from saxophonist Gene Ammons to pianist Randy Weston), hi-fi percussion spectaculars (such as Art Blakey's *Drum Suite*) as well as Duke Ellington's "jazz fantasy," *A Drum Is a Woman*. Perhaps his finest jazz collaboration on disk is "Jungoso," from Sonny Rollins's LP *What's New?* waxed in May of 1962. His own popular albums from the period feature varied combinations of jazz, latin and calypso musics. After twenty years of club and concert tours, the percussionist has spent most of the last decade doing studio work.

Candido **CAMERO**

For a brief period at the end of the 1940s, bebop emerged from its jam session hothouse to become a popular force to be reckoned with. When Benny Goodman decided to keep up with the times, he hired an arranger who had recently moved to the United States from Cuba, Chico O'Farrill (b. 10/28/21), to write bop charts for his ensemble.

His five-movement *Afro-Cuban Suite* (1950), as recorded by the Machito Orchestra with added jazz soloists, is a masterpiece of brassy exuberance, percussive energy and sophisticated scoring. In 1954, O'Farrill created his second extended masterwork, this time for Dizzy Gillespie; his brilliant series of orchestral variations on the Chano Pozo–Gillespie–Gil Fuller composition "Manteca," the best-known theme of Afro-Cuban jazz, is heard over four movements, and inspired soaring work from the trumpeter.

O'Farrill then formed his own big band, which he took on a series of grueling one-nighters in the early fifties. He left the United States to become a central figure in the musical life of Mexico City, leading both dance and concert orchestras. When he returned to the States in the mid-sixties, he fulfilled a lifelong dream of writing for the Count Basie band. O'Farrill's activities since have been centered in the Latin music field; his last recorded grand collaboration with Dizzy Gillespie was in 1975.

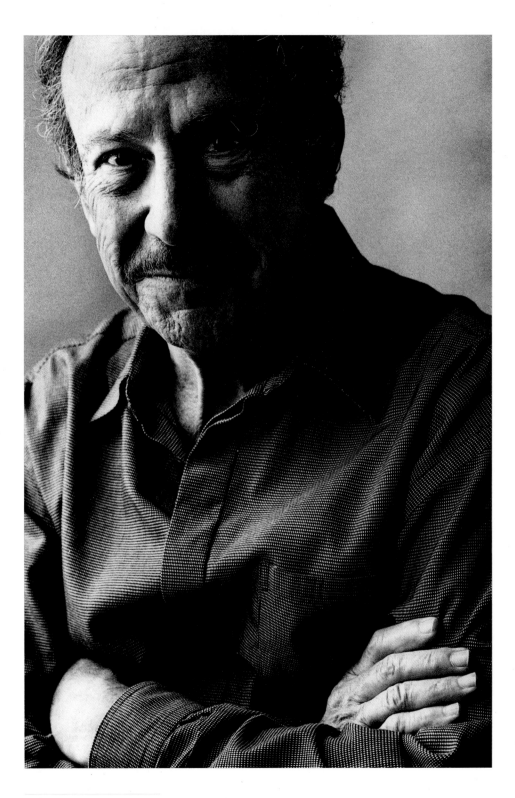

Chico **O'FARRILL**

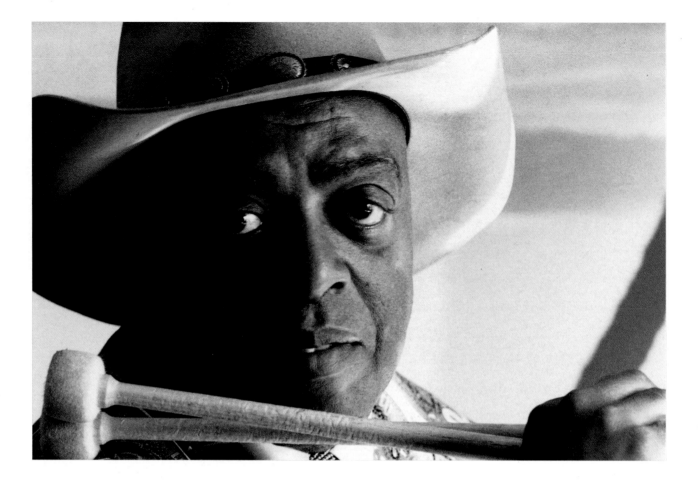

Roy **HAYNES**

Roy Haynes (b. 3/13/26) has rightly been called the most versatile drummer in jazz. His "snap, crackle" sound, as he has described it, has retained its currency over five decades of jazz: Haynes sounds as fresh and new to the young listeners of Pat Metheny as he did to audiences who saw him with Lester Young and Charlie Parker in the forties.

In the course of his career Haynes was to swing with the greatest names in jazz. In the bebop era, he gigged and recorded with Bird and Bud Powell; from 1953 to 1958, he backed vocalist Sarah Vaughan; in the sixties, he worked with two of the most provocative reedmen in jazz, Eric Dolphy and John Coltrane, as well as the coolly lyrical Stan Getz. "Did I cover the waterfront, or what?" Haynes has said.

Since the seventies, Haynes has concentrated on leading his own ensembles. "I don't like to pin compliments on myself," he told critic Mike Zwerin, "but I'm one of the last innovators of the forties who's still out there saying something new."

Johnny Griffin (b. 4/24/28) a.k.a. "the Little Giant," a.k.a. the "world's fastest tenor saxophonist," is one of the leading reedmen to emerge out of the Chicago scene in his generation. His professional career began in 1945, when he joined the ranks of the proficient youngsters that populated Lionel Hampton's orchestra. He left home with his *alto* saxophone to join the band three days after he finished high school, only to discover that it was a *tenor* chair that he had been hired for. Griffin switched instruments his first day on the job! He then paid his dues with the rhythm and blues trumpeter Joe Morris and an Arnett Cobb–led sextet before Uncle Sam took over as his employer for a two-year stint in the army.

After his discharge, Griffin returned home to Chicago, where he was still a local legend. His fiery performance on his extraordinary debut album for Blue Note in 1956 established a national reputation for him.

Griffin decided to join the ranks of expatriate U.S. jazzmen in 1963. He first settled in Paris, appearing regularly with Bud Powell and Kenny Clarke; from 1967 to 1969, the tenorman was a primary soloist in Clarke's big band co-led by Francy Boland. Griffin did not come back across the Atlantic until his triumphant 1979 tour. Although he is still based in Europe, Griffin now regularly returns to the States to perform.

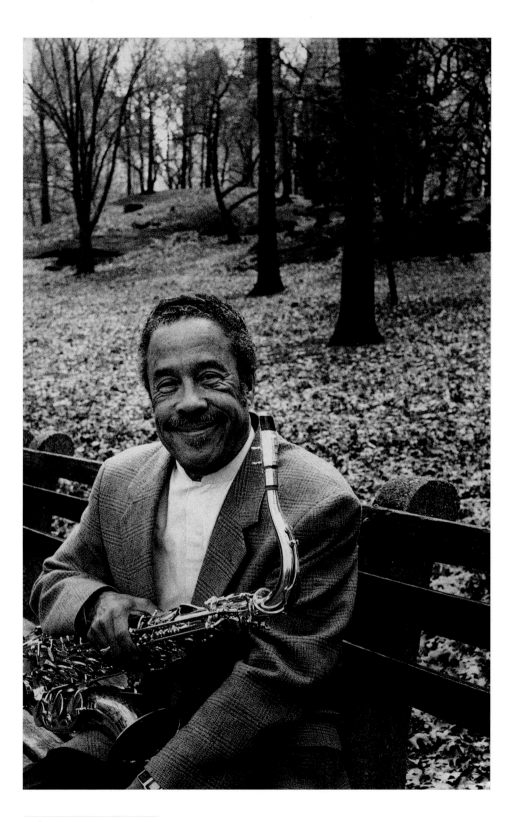

Johnny **GRIFFIN**

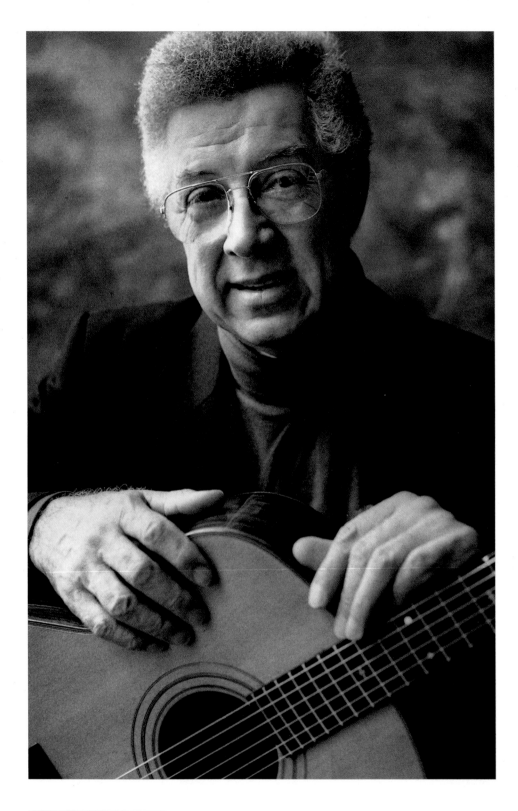

Kenny **BURRELL**

The Detroit jazz scene in the forties and fifties fostered a special camaraderie among its musicians: Kenny Burrell (b. Kenneth Burrell 7/31/31), the leading guitarist to emerge from the Motor City, was inspired by elder, hometown heroes such as Milt Jackson and Hank Jones and contemporaries such as pianist Tommy Flanagan (one of Burrell's lifelong friends and ideal musical partners).

Although he had listened closely to the music of Charlie Christian and Django Reinhardt in his formative years, the creation of Burrell's own sound and the development of his polished, nimble touch also reflected his study of classical guitar. Burrell is a complete guitarist, as his authoritative *Guitar Forms* album from 1965 demonstrates; he's as comfortable with the blues as he is with his own transcription of George Gershwin's *Preludes (No. 2)* for piano.

In the late sixties Burrell's New York club, the Guitar, helped focus the consciousness of the listening public on the instrument and the ensuing decades have brought marked achievements. His seventies' recording project of the music of Duke Ellington produced the two-volume *Ellington Is Forever,* an unprecedented tribute in its scope and ambition, while his Guitar Band of the mid-eighties was a valuable project that brought Burrell together with talented young players of a new generation.

James Moody (b. 2/26/25) got his first professional job playing alto saxophone in the Dizzy Gillespie Orchestra. He performed as a prominent soloist with the group through 1948, then went to Paris for what was supposed to have been a two-week visit. It turned out to be a three-year stay. Appreciative of the personal freedom life in Europe offered him, Moody might well have never come back. Yet, as fate would have it, his entire life changed when he borrowed a beat-up alto saxophone during a recording date in Sweden.

Moody's classic solo on "I'm in the Mood for Love" is a prime example of how a new melody line, crafted by a jazzman over the changes of a standard tune, becomes a composition of its own in the fullest sense of the word. The solo was a hit twice over, first in 1949, when Moody's original was released, and then again in 1952, when vocalist King Pleasure created one of the first "vocalese" classics, singing the words Eddie Jefferson had written to the notes of Moody's solo.

On the strength of "Mood for Love," the reedman organized a hugely successful sextet, which crisscrossed the United States between 1951 and 1955. He reenlisted with Gillespie in 1962 and spent the majority of the decade in the trumpeter's quintet. They performed together at special reunions through 1993, Gillespie's final year on the planet.

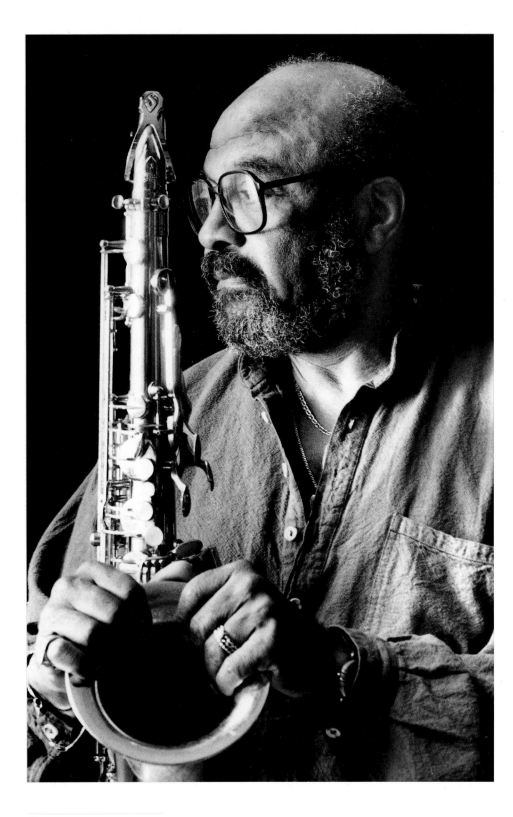

James **MOODY**

It has been 48 years since Lee Konitz (b. 10/13/27) came to New York from his hometown of Chicago and joined the Claude Thornhill Orchestra. With his solo on the Gil Evans arrangement of Charlie Parker's "Yardbird Suite," Konitz demonstrated that modern jazz offered other paths besides Bird's for the alto sax. He already had an original sound on his instrument: Konitz's tone was light and vibratoless, and his ideas were his own, although they reflected the influence of his mentor, pianist Lennie Tristano, the guru of an influential faction of progressive jazz whom Konitz had known since his mid-teens.

Konitz has been described as the first but most independent member of the Tristano school. What he took most to heart was its leader's sincere dedication to music and his particular outlook on jazz history and theory, yet playing Tristano's terrifically complex music and taking part in his unprecedented 1949 experiments in free improvisation also made an indelible imprint on the young saxophonist.

In all the talk of Konitz's dominance as the leading "cool" saxophonist, however, commentators have overstated the cerebral quality of his music. Konitz is an intelligent performer, but he also is an emotional, even impassioned player, and as he told interviewer Tom Everett in 1978, cool isn't supposed to mean cold: "The idea of cool is to be in control of what's happening. It's supposed to be a balanced expression."

Although he was headlining gigs and making a series of important recordings on his own in the fifties, Konitz maintained his ties with Tristano throughout the decade, performing with the pianist and otherwise taking part in the "Tristano project," as he calls it. But as Konitz has reflected, "that meant listening to the people we loved, but it was kind of limited to Lester Young, Charlie Parker, Roy Eldridge. . . . When I left Tristano in about 1964, it was because I wanted to know more about what was going on, and kind of reevaluate things for myself."

Among the things he reexamined were the possibilities of free music, which he had first touched upon with Tristano long before. (Konitz's free playing is better likened to spontaneous composition than to the "energy music" of the sixties' avant-garde.) He began to experiment with solo performance, and on his European tours, communed with an ever-widening circle of artists in varied musical circumstances.

Whatever project Konitz enters into, he continues to challenge himself and the artists with whom he plays. "This goes on until I stop breathing," he says.

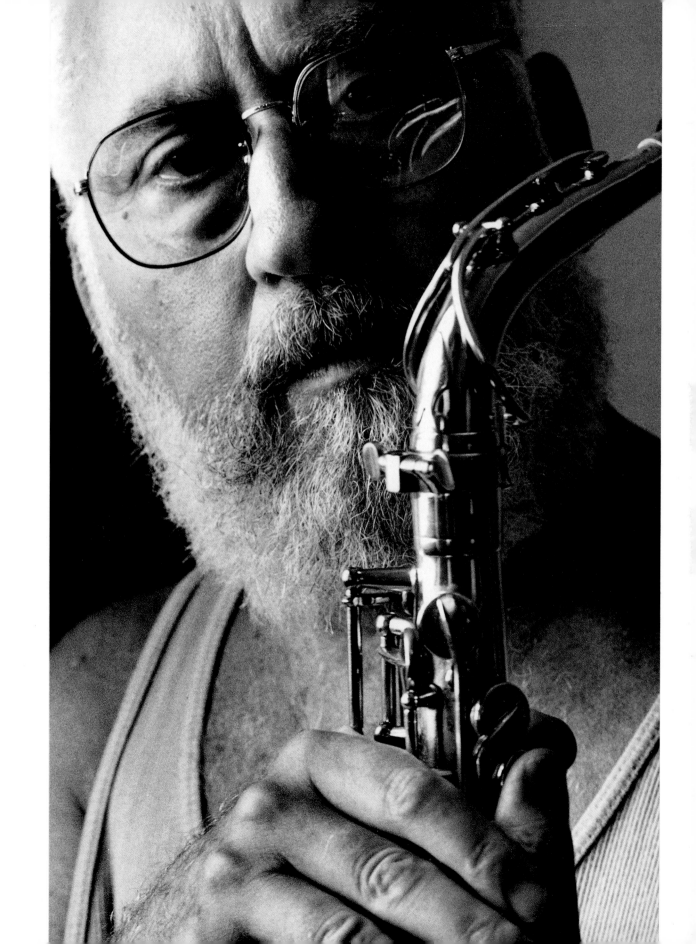

Of all the jazz groups that were formed in the 1950s, the Dave Brubeck Quartet may have sold more records and reached a wider audience than any other ensemble. Brubeck (b. 12/6/20) has always been a controversial figure in jazz. His critics sometimes seem to hold his very popularity against him, yet he attained his success without a whit of compromise.

The pianist has always cited the French classical composer Darius Milhaud as his greatest influence. Out of Milhaud's Mills College, California, classroom emerged Brubeck's experimental octet, which included in its ranks alto saxophonist Paul Desmond, who would later serve as Brubeck's alter ego in his Quartet.

Brubeck's music drew from both classical and jazz traditions: he arranged "The Way You Look Tonight" in the manner of a Bach invention, and the collective improvisations of Brubeck and Desmond from the earliest days of the Quartet owe more to European fugues than to New Orleans polyphony.

Yet Brubeck has always been a jazzman first and foremost, not a classical musician with jazz inflections. In the most adventurous playing of his early years, best captured in the recording of the Quartet's 1953 Oberlin College Concert, his solos spontaneously follow trains of thought through unexpected varieties of sonic textures, surprising modulations, and eccentric rhythms. Brubeck, Desmond and the Quartet gained a tremendous following and for the next twelve years, theirs was one of the best-known jazz ensembles in the world.

One day in 1955, Desmond offhandedly remarked that they should get someone to write original material for their Quartet, which, up to that point, had been playing standards almost exclusively. "Are you kidding me?" Brubeck responded, then sat down for a half an hour and penned two songs, including his classic "In Your Own Sweet Way." Brubeck's first album of time-signature experiments, *Time Out* (including Desmond's million-selling tune, "Take Five"), was released in 1959 and more than thirty years later is still one of the most popular of all jazz recordings.

Brubeck continues to tour and record with a quartet, although Desmond left the original group in 1967. Since then the horn chair has included Gerry Mulligan and Bill Smith (an original member of his octet from the forties). As a recording artist, Brubeck has made the eighties and nineties among the most active periods in his entire career.

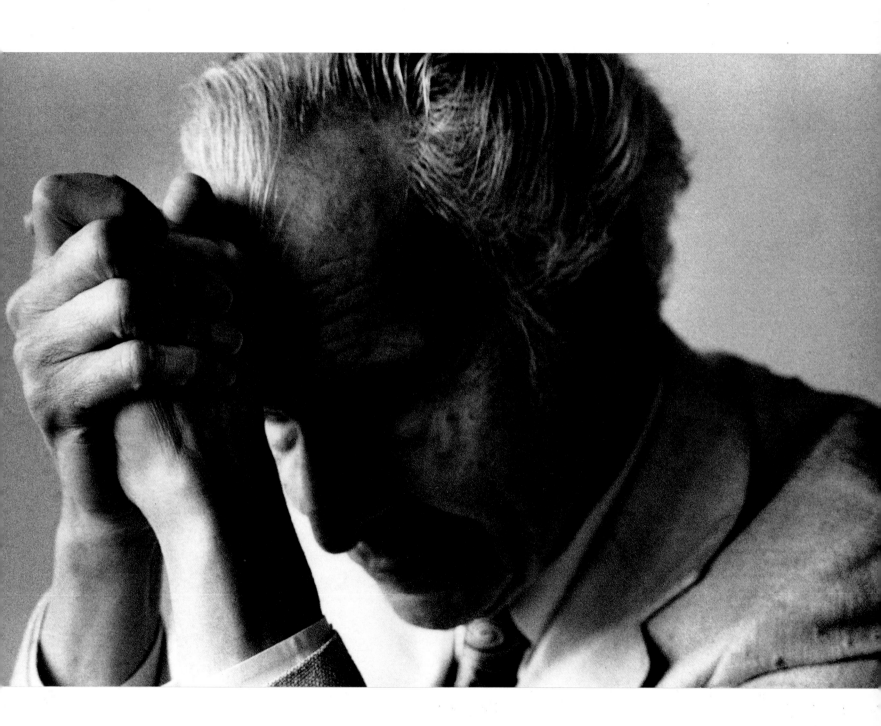

The career of Jimmy Giuffre (b. 4/26/21) has been marked by both adulation and undeserved neglect, but it certainly had a remarkable, early peak in 1947 with "Four Brothers," the composition he wrote and arranged for Woody Herman's Second Herd. This composition also gave birth to the "Four Brothers Sound" of the big band era, where a three-tenor, one-baritone saxophone reed section multiplied the floating-over-the-beat Lester Young style times four.

It wasn't until 1956, however, that Giuffre created the trio that put him in the spotlight as a performer. Consisting of reeds, guitar and bass, the original trio was perhaps the least flashy ensemble in jazz history. Like the Modern Jazz Quartet, this was cerebral music that swung.

The trio's interplay was unique. As its guitarist Jim Hall describes it: "Everybody in the group was responsible for the time feel—you couldn't rely on a rhythm section—and each part of the trio was also equal. Giuffre looked on it as a mobile, so that there would be a different facet showing all the time." For an ensemble without a drummer (in the third edition of the trio, featuring trombonist Bob Brookmeyer, the group didn't even have a bass player), this was a remarkable accomplishment.

Giuffre explained to writer Nat Hentoff in 1959 that "[I]t has to do with musicians not forcing each other. For some reason, a drummer or bassist often has a fixed idea that he has to *make* time. To my mind, once the leader stomps the tempo, the time is already made, and all we have to do is ride along with it—like a train."

Train rhythms have inspired many jazz masterworks over the years, and Giuffre's folksy-feeling "The Train and the River," tinged, no doubt, by the old-timey sounds Giuffre heard in his native Texas, was the group's most popular creation. But rather than ride on the trio's success, Giuffre felt compelled to move on to new musical terrain, or as he told writer Burt Korall, "I had to be free. I had to move beyond the fences, to the grazing land beyond."

Stimulated by his first explorations of totally free improvisation with Ornette Coleman at the Lenox Inn School of Jazz in 1959, Giuffre developed his own response to free jazz with his next working trio, which featured pianist Paul Bley.

In many ways this trio continued to explore the ideas behind Giuffre's popular first trios, but the music took a more challenging form that was beyond the understanding of many from his earlier audiences. However, recent reunions with Bley and bassist Steve Swallow (the original third member of this triad) suggest that the public may finally be catching up with Giuffre's music.

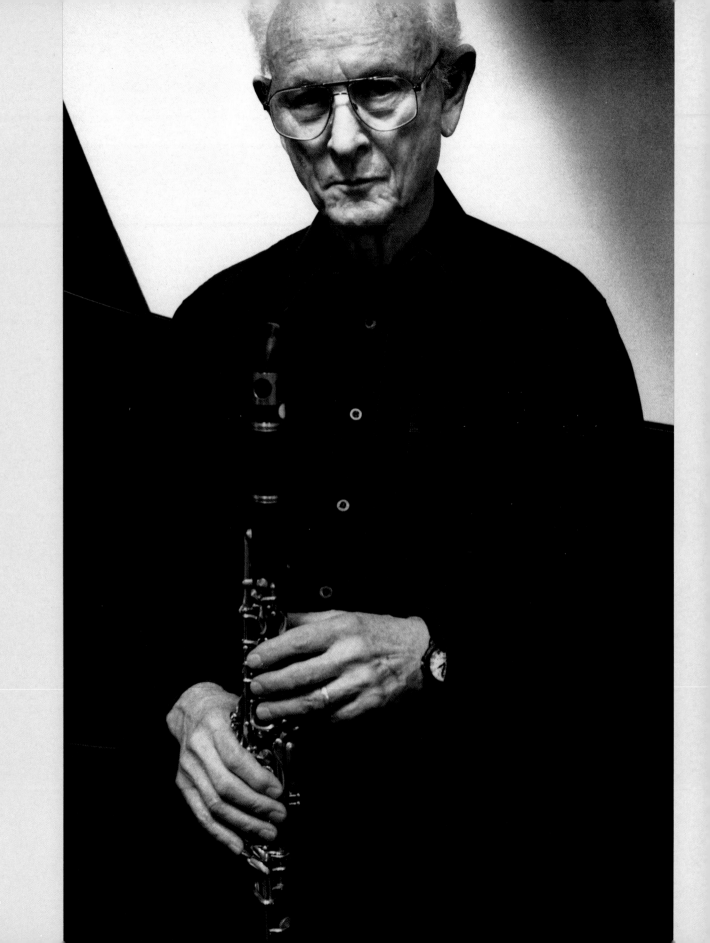

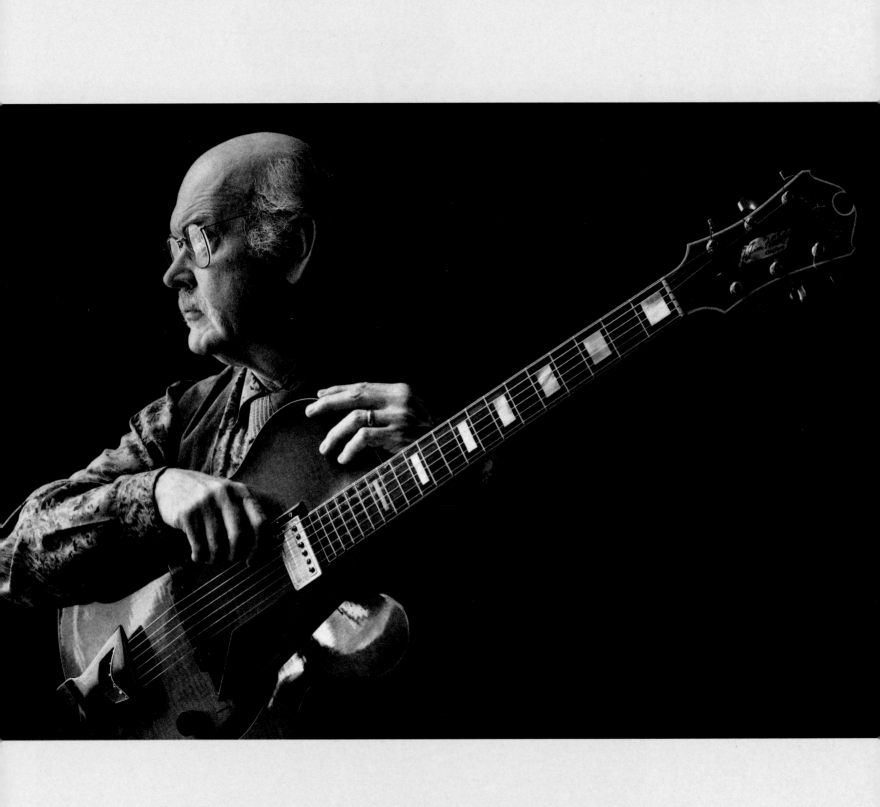

The warm glow of Jim Hall's electric guitar has cast a melodious luster over many great jazz performances; together with like-minded lyrical performers Ben Webster, Bill Evans, Paul Desmond, and Art Farmer, Hall (b. 12/4/30) has created some of the most exquisite conversations in music. The guitarist began his music career in Cleveland, where he developed his jazz chops working with local musicians. In 1955, he set out for the West Coast, where he landed his first prominent job with drummer Chico Hamilton's Quintet. Hall enjoyed the opportunity he had to write for the group, but the tightly structured charts Hamilton favored left little blowing room for its soloists; in the three years following, his voice countered Jimmy Giuffre's reeds in the latter's innovative trios as Hall refined his thoughtful legato phrasing and shimmering sound. For ten weeks in 1960, he saw the world touring as a member of Ella Fitzgerald's group, during which he took part in her legendary Berlin concert.

After his return to the States, Hall had a place in John Lewis's experimental ensemble Orchestra USA, but otherwise, work was scarce in the Big Apple. Out of the blue, a note placed in his mailbox by Sonny Rollins initiated an unusual correspondence between them—Hall couldn't afford a telephone, while the reclusive Rollins chose not to have one. The guitarist would walk to Rollins's Grand Street address to drop off his messages; Rollins's answers would show up in Hall's box soon after. The eventual result was Hall's yearlong membership in the tenorman's great pianoless quartet, formed when Rollins ended his self-imposed exile from public performances in 1961.

Hall's next important regular gig as a featured sideman was with trumpeter Art Farmer; in the latter half of the sixties, however, he paid the rent thanks to a steady job with the studio orchestra on television's "Merv Griffin Show." In 1970, Kenny Burrell booked the duo of Hall and bassist Ron Carter to perform in his New York club, the Guitar, beginning another significant and long-lasting musical partnership. Along with Carter, Desmond, Chet Baker, and pianist Sir Roland Hanna, Hall created the most popular showcase for his artistry with his 1975 album *Concierto*.

The last twenty years have been musically rich ones for the guitarist. At the helm of his own trios and quartets, Hall's sound has remained forever contemporary. A fascinating but unrecorded Village Vanguard engagement from the late eighties with cutting-edge guitarist Bill Frisell demonstrated Hall's ever-continuing influence, while the two disks of his 1990 retrospective concert at New York's Town Hall have preserved an all-star event celebrating four decades of Hall's achievements as a composer and improviser.

Jim
HALL

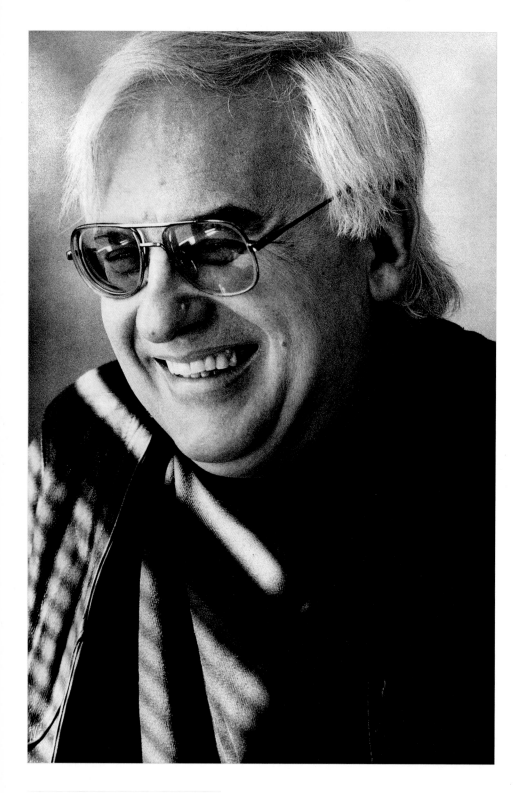

In the early fifties, pianist Paul Bley (b. 11/10/32) shuttled back and forth between New York and his native Montreal. Perhaps his most successful East Coast gig was with a group of hard boppers that included Jackie McLean, Donald Byrd and Art Taylor, but by 1957, when the pianist left for the West Coast, Bley was one of a number of musicians who were looking ahead to further developments in the music.

The pianist experimented with totally free improvisation in duets with a trumpet-playing friend, but the problem of how to play free with a rhythm section remained. One night, nearly two years into Bley's steady gig at L.A.'s Hillcrest Club, two men walked in with the answer. "I didn't have a clue until Ornette Coleman sat in with Don Cherry and explained in real-time that the procedure was playing A to Z instead of AABA." Bley was enthralled.

Bley returned to the East Coast, where he joined Jimmy Giuffre to create the ultimate edition of the original Giuffre trios. He spent a year with Sonny Rollins at a time when the tenorman was experimenting with stretching out song forms; then the pianist formed the first of his sixties trios, which over the course of the decade provided a redefinition to the usual interplay between members of the rhythm section. A prolific recording artist, Bley has returned to recording standards and bebop classics in recent decades.

Paul **BLEY**

George Russell (b. 6/23/23) is a brilliant music theo-retician (his Lydian Chromatic Concept of Tonal Organization is a major contribution to the field) and a brilliant practicing musician. From his first charts, it was apparent that Russell was ahead of his time. The title alone of his 1949 chef d'oeuvre "A Bird in Igor's Yard" (as in Charlie Parker and Igor Stravinsky) reveals Russell's desire to integrate the most modern elements of two spheres of music. The piece was recorded for Capitol Records by the Buddy DeFranco Orchestra, but the label considered it too demanding to be released. They kept it in the vault for twenty years.

Russell's best-known work is his extended sound picture of the Big Apple from 1958, *New York, N.Y.,* recorded by a fantastic lineup of jazz giants, including John Coltrane, Bill Evans, Art Farmer, and Benny Golson. From its rhythmically delivered opening narration by Jon Hendricks (prehistoric rap, really), Russell captured the moods and beat of the city.

Originally a drummer (he played with the Benny Carter Orchestra in the forties), Russell took the piano chair when he formed his sextet, which produced some of the most adventurous small group jazz of the sixties. He has since become an academician, further refining his Lydian Chromatic Concept, and only sporadically producing recording projects of his later works for jazz orchestra.

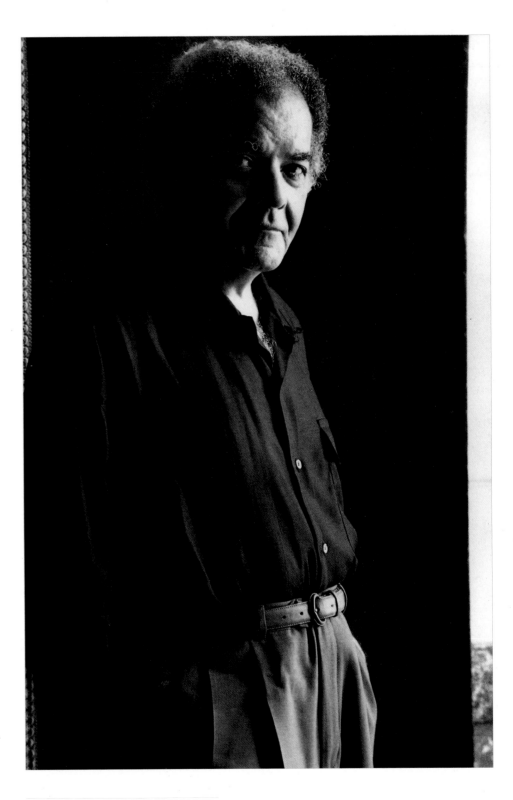

George **RUSSELL**

The "Shearing Sound" and the George Shearing Quintet provided one of the aural definitions of the 1950s. The pianist's initial success in his native London came from his performing in the manner of the leading American players of the day. "I'd been told that I would kind of knock 'em out over here, and I was told this by the likes of Fats Waller and Mel Powell and Glenn Miller," says Shearing (b. 8/13/19). "When I came over, I had some ability to play in the styles of Art Tatum and Teddy Wilson, but it didn't do me much good because why would they want the English Art Tatum if they had the real one? And so it was very rough the first two years, especially because the hopes were so high and the dreams were so high."

But Shearing landed on 52nd Street, where he became a proficient bebopper. The Quintet was assembled in 1949 simply as a one-shot recording group, with vibes and guitar supplementing his regular rhythm section. However, Shearing found an ensemble sound in his arrangements that captured his and the public's fancy: the vibraphone states the melody, the guitar doubles the line an octave lower and Shearing's "locked hands chords" (a style first popularized by pianist Milt Buckner) fills up the space in between. "When I got my sound, I knew what I could sell and it sold very quickly," says Shearing, whose cooler-than-cool rendition of "September in the Rain" was a massive hit, beginning the Quintet's seventeen-year run.

In a move that is sure to please his many fans, Shearing is reviving his Quintet after a sixteen-year hiatus. The pianist originally decided to cut his group down to a duo because, as he put it, "I was getting the quintet on automatic pilot—I could play the arrangements half-asleep, as it were. But I suppose, inevitably, that absence does make the heart grow fonder."

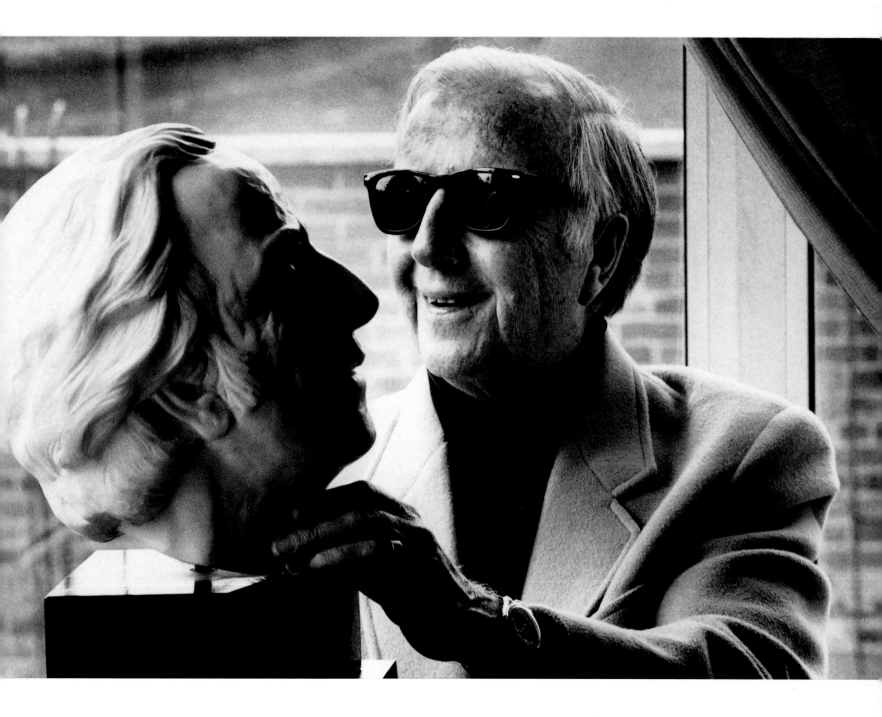

Gerry Mulligan's career with the big bands was primarily as a writer; he made his first attempt at putting a chart together while he was still in high school, but he ran into an unexpected problem. "I tried to write an arrangement of a melody that fascinated me, Richard Rogers's 'Lover,' for this school band," he recalls. "And of course it was a Catholic school, and like a damn fool, I put 'Lover' on the title page of the thing. That was the end; I never did get to hear that chart!"

But this proved to be a small stumbling block for Mulligan (b. 4/6/27), who began his professional career soon after; he had already added individual charts to Elliot Lawrence's, Gene Krupa's and Claude Thornhill's books when he became a central figure among the artists who hung out at Gil Evans's basement apartment on Manhattan's West 55th Street: a one-room, windowless flat that was a focal point for the best and brightest of the music's modernists. Charlie Parker, Miles Davis and Lee Konitz were frequent visitors, and John Lewis, Johnny Carisi and Mulligan worked out new arrangements on Gil's piano. In 1948, Davis organized a nonet to perform their music. The mellow blend of Davis's trumpet, Mulligan's baritone and Konitz's alto, along with trombone, French horn, and tuba, has since been dubbed "the birth of the cool," and from its inception, Mulligan was responsible for many of cool jazz's seminal themes.

Mulligan by then had already dropped all of the other reeds to concentrate on the baritone saxophone. He was writing important charts for Stan Kenton and had begun to make inroads as a leader during this period, yet Mulligan was still struggling as a freelancer in New York. A move to California in 1952 found him both an ideal setting and a wide audience for his fresh sound. His pianoless quartet, which featured the late trumpeter Chet Baker, was at once a point of origin and an apex of West Coast jazz.

For the remainder of the decade, the quartet would appear in different guises (with valve trombonist Bob Brookmeyer or trumpeter Art Farmer in later editions), as Mulligan attained his proper stature as a jazz heavyweight. At times, the group was expanded into a sextet, and Mulligan's piano came into play as well; in 1960, he formed the Concert Jazz Band, the first of an intermittent series of working big bands. He has continued to retool all of these combinations to the present day.

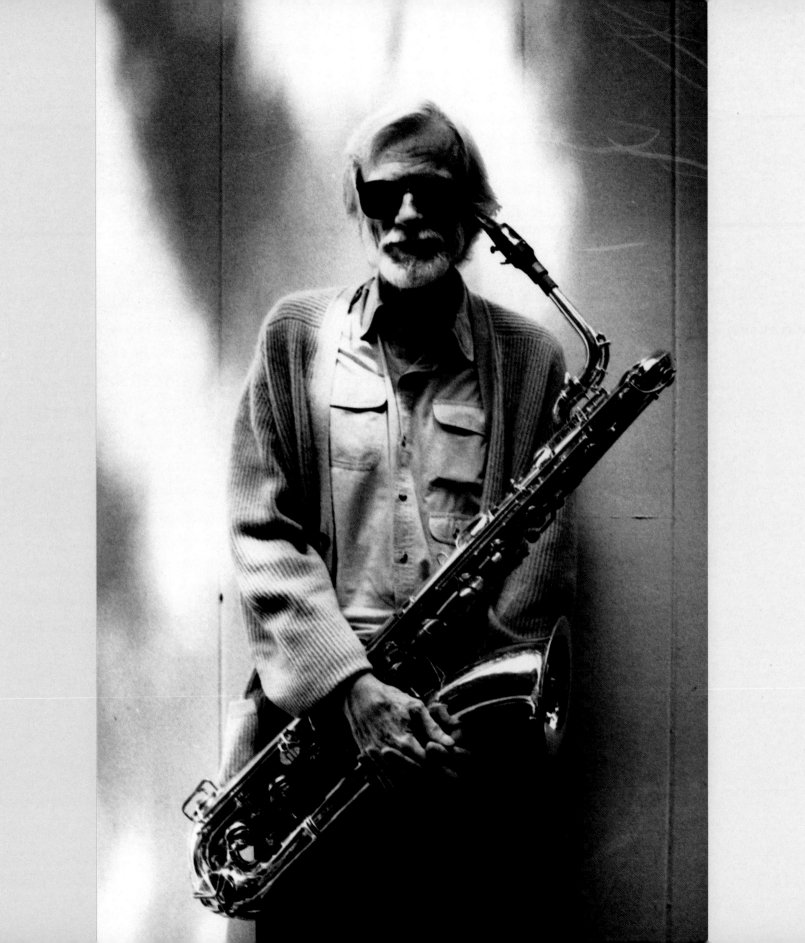

April 30, 1995, marked the fiftieth anniversary of the first recording session of Oscar Peterson (b. 8/15/25), who may well be the most prolifically recorded jazz pianist. The tale of Peterson's debut performance in America could have been ripped out of a Hollywood screenplay: A virtually unknown virtuoso pianist appearing at a small club in his home town of Montreal, Canada, is heard by a producer who is so taken by his playing that he decides to spring the young artist on an unsuspecting audience as an extra, unbilled attraction at an upcoming concert—at Carnegie Hall. Yet that's precisely what happened to Peterson when Norman Granz asked him to play at his September 19, 1949, Jazz at the Philharmonic bash.

But despite his warm reception, Peterson, a perfectionist first and foremost, felt that he needed an extra year's preparation before he was ready to go on tour as a solo artist; he returned to JATP (and Carnegie Hall) in 1950, and has been on the road ever since.

For the next sixteen years, bassist Ray Brown would be his regular partner, first in a duo, then in a succession of trio ensembles in the piano-bass-guitar mold. The tricky and elaborate head arrangements Peterson worked out for his drummerless trio can be compared to the chamber jazz efforts of the fifties, but there was nothing effete about Peterson's music; just playing by

himself, the pianist could be a rhythmic juggernaut. The phenomenal drive (and greatness) of the edition from 1953 to 1958, with guitarist Herb Ellis, was the result of their absolute synchronization. After Ellis's departure, Peterson reverted to the more traditional piano-bass-drums combo, once again achieving a perfect integration of talents with the arrival of drummer Ed Thigpen. There is an art to making great *albums* of music that is quite separate from the task of creating their component parts, and this was the ensemble that produced *Night Train, West Side Story, Affinity,* and many other LPs of comparable value. The flood of recordings continued with new trios and new projects. In the seventies, Peterson made scores of sessions.

In 1993, the jazz world gasped when Peterson suffered a stroke that affected his left side; the persistence and discipline that he had applied to his music over the years was then put to work as physical therapy; as he recently told Bob Blumenthal, "Fortunately, I've had some dedicated people working with me. They've been able to bring it back to about normal, except for some small things—*not* the piano, thank God!" So fifty years after he made his first Canadian 78s, Peterson was in a recording studio in Toronto along with his friends Benny Carter and Clark Terry, once again making music and making history.

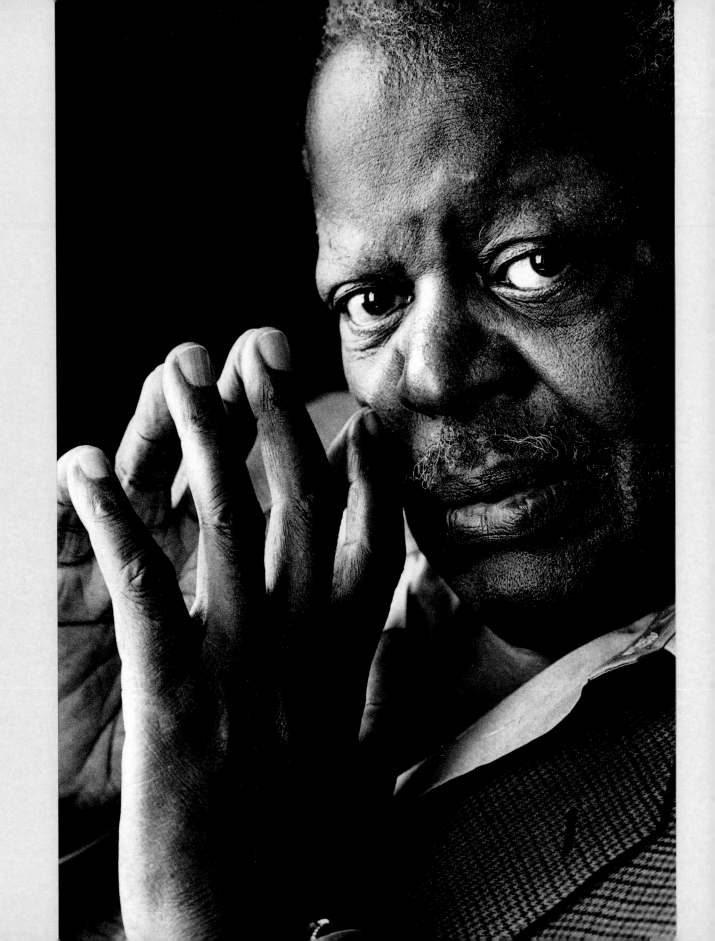

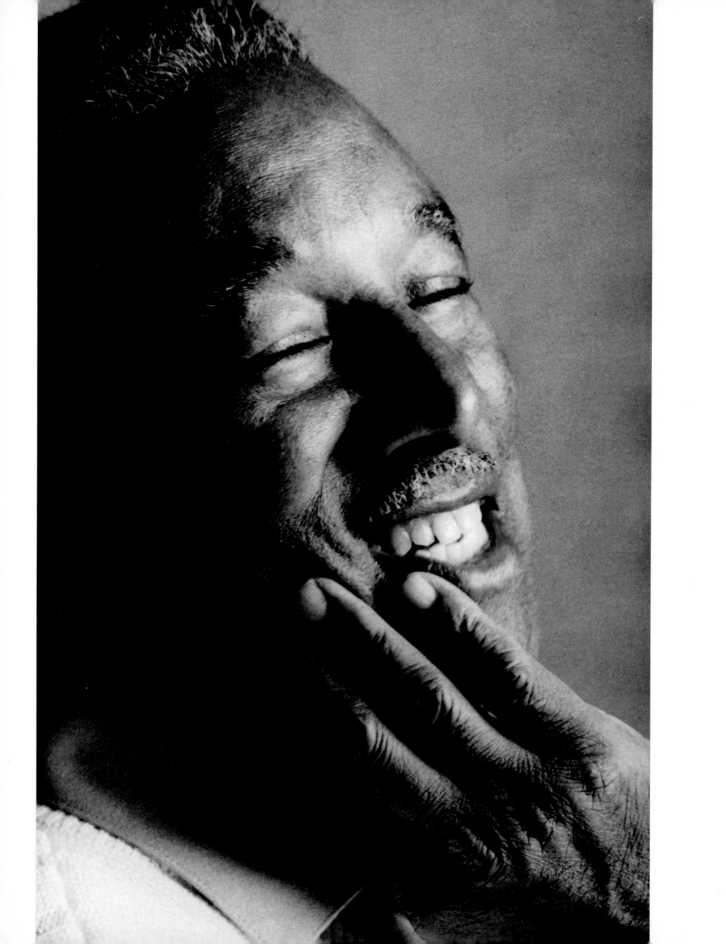

The state of perfection is rarely encountered; in music, it can be found in the artistry of bassist Ray Brown (b. 10/13/26). His technique is flawless, with his solid, firm lines, rich sound, precise articulation, cleanly executed arco passages, and never-erring timing (even at the quickest tempo). And this master of swing is also a spectacular improviser, with a rich feel for the blues.

At around the age of eight, Brown was encouraged in his first musical efforts at the piano by his father, who played him records by Fats Waller (and later, Art Tatum, which marked the beginning of the end for Brown's piano playing). He began playing bass in his high school band, listening to records featuring Jimmy Blanton, the man who had just revolutionized the role of the bass in jazz. Brown woodshedded and took local gigs all through high school, and then did some touring on the territory circuit, all the while memorizing solos from 78s by bass king Slam Stewart and bebop pioneer Oscar Pettiford.

At 19, Brown was already receiving job offers from bands in New York. He came to town unsure which he would accept, but definite in his plans to hit 52nd Street that first night. Brown ran into Hank Jones at a club (they had met some months before at a jam session), and then Dizzy Gillespie walked in. Introductions were made, and the information passed that Brown played bass. "Do you want a gig?" Gillespie asked. "I nearly had a heart attack," remembers Brown. The next day, the bassist had his first rehearsal with a band that also included Bud Powell, Max Roach—and Charlie Parker.

Brown held his own in this heavy company, and he took part in many of the key events in the early days of bebop. During this period, Brown met Ella Fitzgerald, and beginning in 1947, he would spend the next few years as her husband and musical director.

Continuity became the hallmark of Brown's career thereafter. He joined Jazz at the Philharmonic in 1947 and stayed for a decade, most of it overlapping sixteen years with Oscar Peterson in a period rich with great music.

In 1966, the bassist gave up the road and moved to California to work as a studio musician. Since the early seventies, however, Brown has been quite active on the performing/recording circuit, appearing with the ensemble L.A. Four, Monty Alexander, Stanley Turrentine, Gene Harris, and, most recently, with a trio featuring young piano lion Benny Green.

Ray
BROWN

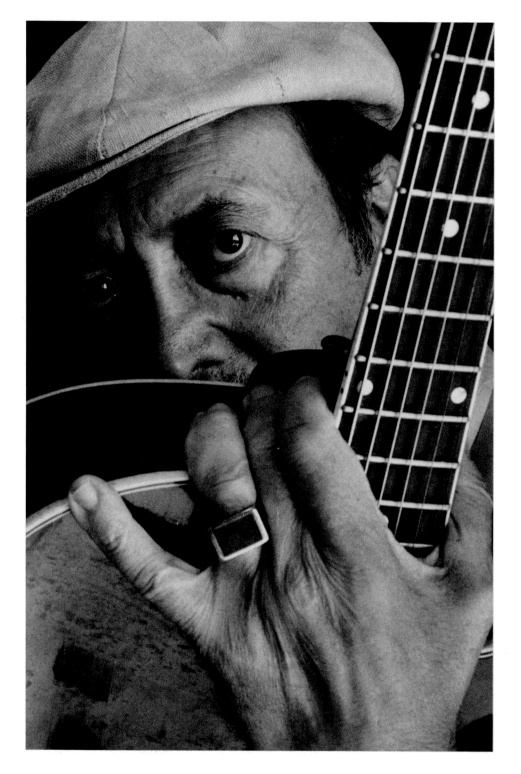

Barney **KESSEL**

Like his original idol, Charlie Christian, Barney Kessel (b. 10/17/23) is a son of the American Southwest. "The first guitar players I ever heard were tramps and hoboes who used to sit in the boxcars playing," he related some years back, "so this bending of strings, this twang, is something I grew up with." Born in Muskogee, Oklahoma, Kessel had discovered the sounds of swing music at the same time that Christian was making his trail-blazing music in Oklahoma City. Having bought a guitar for a dollar at age thirteen, Kessel made his first professional gig three years later with a local black unit that Christian had once played with.

In 1942, Kessel set out on his own to California, where he landed a job in a band fronted by Chico Marx. Kessel's fluency and his own emerging style was captured on film in 1944 as one of the soloists in *Jammin' the Blues,* and on disk with Artie Shaw the following year. The guitarist was one of the regulars on L.A.'s jamming scene, where he first played with Charlie Parker in February of 1947; as a result, Bird invited him to take part in his immortal "Relaxin' at Camarillo" session just five days later, and the two shared many bandstands and evenings of music.

Kessel made the biggest impression in his early

years, however, in the ten months he spent with the Oscar Peterson trio from 1952 to 1953; in that brief time-span, he made about twenty record dates for Norman Granz alongside the pianist and bassist Ray Brown, often as the backing unit for other giants from the producer's stable of stars: Billie Holiday, Benny Carter and Roy Eldridge among them. Kessel's own influential sessions for Contemporary Records in the fifties and sixties further set his position among the vanguard forces of modern jazz guitar, but like many of his West Coast brethren, he spent much of his time doing studio work.

He tried life as an expatriate in the late sixties and early seventies; while living in Paris, he created the lovely ballad tribute to another of his forebears with "I Remember Django," which first appeared on a collaborative album with violinist Stéphane Grappelli. Since his return to the States, Kessel has toured with the super-group Great Guitars (featuring Charlie Byrd and Herb Ellis), and has been active as a teacher and bandleader.

The musical institution that is the Modern Jazz Quartet has remained (with the exception of their 1974–81 sabbatical) one of the happiest constants of our times; three of the four members of this ensemble of virtuosi remain from the day the quartet was christened in 1952. They are John Lewis (b. 5/3/20), vibraphonist and musical director Milt Jackson (b. 1/1/23), and bassist Percy Heath (b. 4/30/23). The drum chair was first held by the late Kenny Clarke, but the pioneer of modern jazz drumming jumped ship in 1955 to move to Europe, where he lived and played for the remainder of his years. With his successor, Connie Kay (b. Conrad Kirnon 4/27/27; d. 11/30/94), the ensemble's sound evolved through Kay's expanded drum kit. Recently, the Quartet has entered a new stage of change prompted by Kay's untimely passing; its new percussionist, Albert "Tootie" Heath, is another original sound colorist.

The MJQ is a collective ensemble, but for many decades it has also served as the primary vehicle for the brilliant compositions of John Lewis. They would set the MJQ apart from other small jazz combos in their rich use of dynamics, their elaborately organized structures and their successful integration of elements from the "classical" tradition into the music, without altering its jazz feeling beyond recognition (Lewis is practically the only composer who can do this). The group

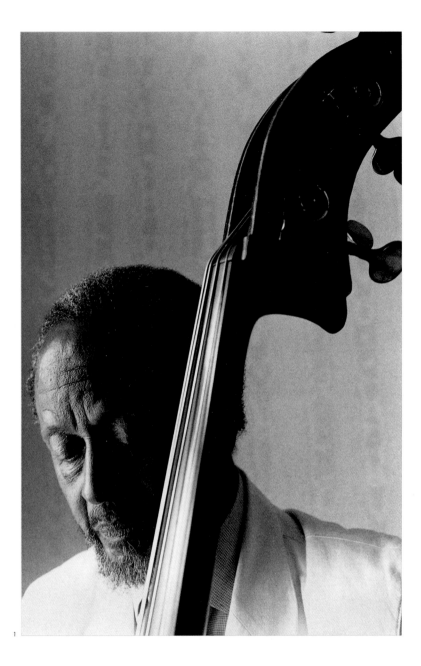

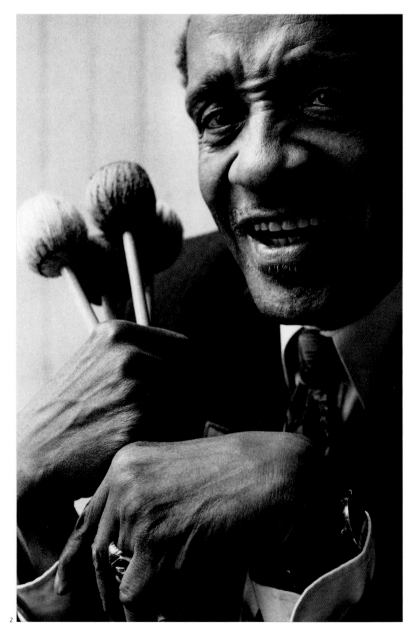

3 *John* **LEWIS**

4 *Connie* **KAY**

1 *Percy* **HEATH**

2 *Milt* **JACKSON**

itself is a model of instrumental integration, of four men playing as one, with seamless links as themes shift from voice to voice, or as voices merge together into baroque-styled musical figures, ballads or the blues.

In the last two categories, Milt Jackson, one of jazz's all-time great soloists, is all but peerless (the vibraphonist's own contributions to the band's book over the years include a number of original elaborations on the blues form). Jackson's dazzling technique and soulful finesse has long provided an intriguing contrast to Lewis's more deliberate and understated piano work; both players found parallels to the deft cymbal-work and the delicate, chime-like timekeeping as personified by the late Connie Kay, and to the tremendous role played in the unit by Percy Heath (has any other bassist been called upon to play eighteenth-century dance rhythms, complex solo passages, creative improvisations *and* swing like mad in the course of a single set of music?).

There had never been an ensemble like it in the course of jazz, and no one could have predicted how long it would last. Fourteen years since the MJQ decided to give the group a second go-round in 1981, the tragic loss of Connie Kay has marked the end of an epoch, but the history of the Modern Jazz Quartet has not ended; rather it has entered a new chapter.

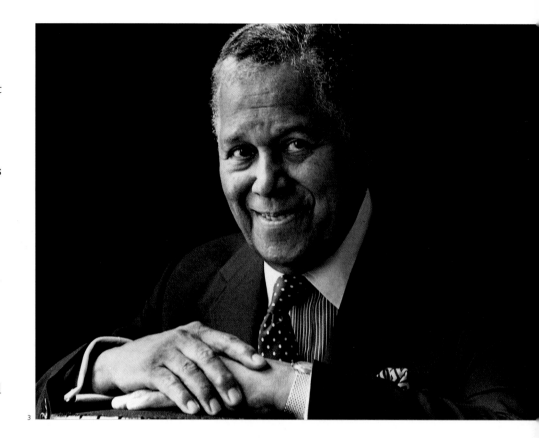

3

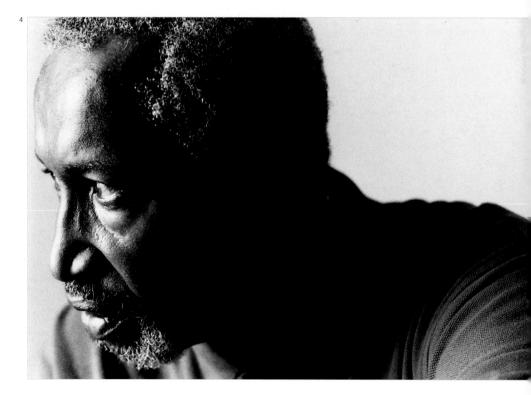

4

Originally coined in 1956 as an album title, the phrase "Saxophone Colossus" is more than ever an apt designation of Sonny Rollins's place in the jazz pantheon; indeed, he is the most revered tenor saxophonist in jazz today.

Rollins (b. 9/9/30) came of age at the height of the bebop revolution. His extraordinary promise was recognized by two of the movement's greatest minds while he was still a teenager; as a high school junior, he spent his afternoons rehearsing with Thelonious Monk, and Bud Powell opened his home to Rollins for days and nights of listening, learning and playing.

Rollins was inspired by the seriousness of bebop, and the serious music making of its leader, Charlie Parker, whom he has called his spiritual father. However, the rough-edged, muscular and intensely emotional sound of Rollins's tenor saxophone also represents a continued allegiance to an earlier idol—the father of the jazz tenor—Coleman Hawkins.

Miles Davis was the first major jazz musician to hire Rollins, in 1949. The trumpeter would become Rollins's most important musical associate of the early fifties, a decade of grand collaborations, artistic triumphs and personal crisis for the tenorman. A triumvirate of genius was formed when Rollins joined the ensemble co-led by the pioneer bebop drummer

Max Roach and the hard bop trumpeter Clifford Brown in 1956; that same year, Rollins's recording of "St. Thomas" marked the creation of his unique hybrid of calypso-jazz. By decade's end, Rollins and his close friend John Coltrane were generally recognized as the dominant new voices of the tenor saxophone. Yet Rollins was dissatisfied with the path he and his music were taking, and he stunned the jazz world by ceasing his public performances and recording activities from August 1959 to November 1961.

By the mid-sixties, Rollins's live sets had coalesced into grand, marathon stream-of-consciousness solos. He would call forth melodies from his vast knowledge of popular song in a startling series of segues, sometimes barely visiting one theme before surging into dazzling variations upon the next. It was the music of a brilliant but restless artist, and Rollins once again retreated from the public eye from 1969 to 1972.

From the moment of his return, Rollins once again took the mantle as the "saxophone colossus." He is a thrilling performer, perhaps the most exciting artist in jazz, not because of surface elements—like the way he strides across the bandstand, cutting arcs into the air with his instrument, or how he bobs to the rhythms of his jazz calypsos—but because when Sonny Rollins plays, he appears to be the wellspring of creation itself.

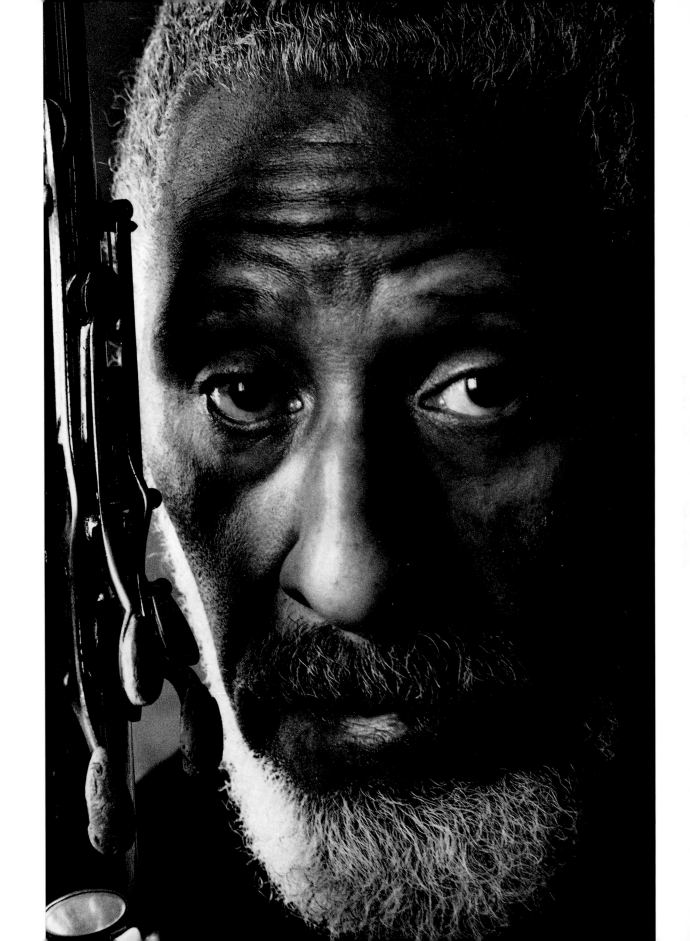

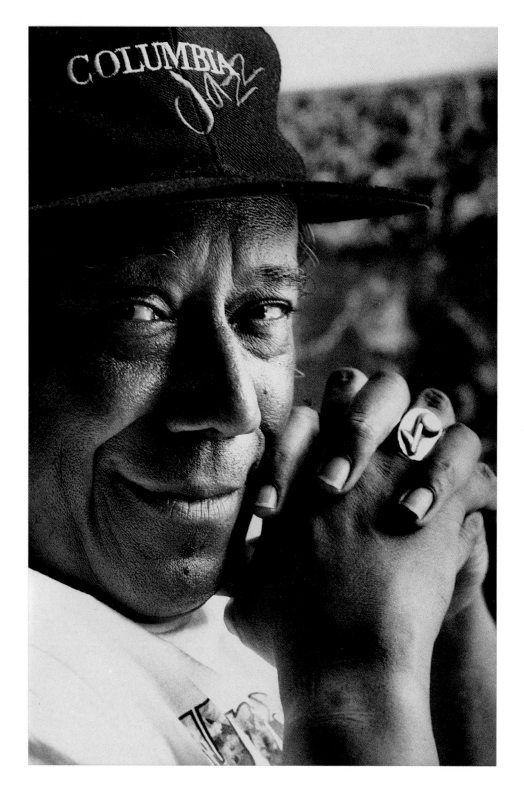

Horace **SILVER**

Horace Silver spawned the soulful and funky jazz that emerged with hard bop in the late 1950s. Incorporating the spirit, feel and rocking beat of the church into modern jazz, Silver added a secular dimension to the music. His hit records "Doodlin'," "The Preacher," "Sister Sadie," "Señor Blues," and "Song for My Father," to name a few, remain enduring classics of the genre and have influenced musicians of many stripes over the years. Strong soloists like Hank Mobley, Blue Mitchell, Junior Cook, and Joe Henderson propelled his groups during the glory days.

Silver (b. 9/2/28) first made his mark with Stan Getz in the early 1950s. The pianist moved to New York and established himself with the leading bands of the day. He was present in Art Blakey's first incarnation of the small group the Jazz Messengers, but broke away in 1956 to form his own bands. With a string of smash records for Blue Note, he fixed his star in the jazz firmament.

Silver's later records on his own Silveto label added message-oriented slants to his music. In recent years, he has reentered the mainstream industry with popular recordings on Columbia and maintains his funky presence as one of the founding originals on the jazz scene.

The passionate energy that fires Jackie McLean's tart and biting solos also has driven nearly three decades of his work as an educator and music historian. At the time McLean (b. John McLean 5/17/32) developed the Afro-American Music Department at the University of Hartford in the 1970s, the study of America's most important indigenous art was practically unheard of in the halls of academe.

His most valuable experience during his formative years was the encouragement and support he received from elders like Bud Powell and Thelonious Monk.

His first recordings, with Miles Davis in 1951, showed that he was more than just a Parker acolyte, but McLean truly came into his own with Charles Mingus later in the decade; the bassist pushed him to find his own concept. He gained further exposure in 1957 with Art Blakey's group, and the altoman's own masterpieces on the Blue Note label in the fifties and sixties captured his continuing evolution as a composer and soloist.

In the seventies, McLean established a band known as the Cosmic Brotherhood with members of the community of artists gathered at Hartford. Summertime concert tours to Europe as a solo artist produced a relative scarcity of record dates, but these last seven years or so have seen a true McLean renaissance, capped by a retrospective concert at New York's Lincoln Center.

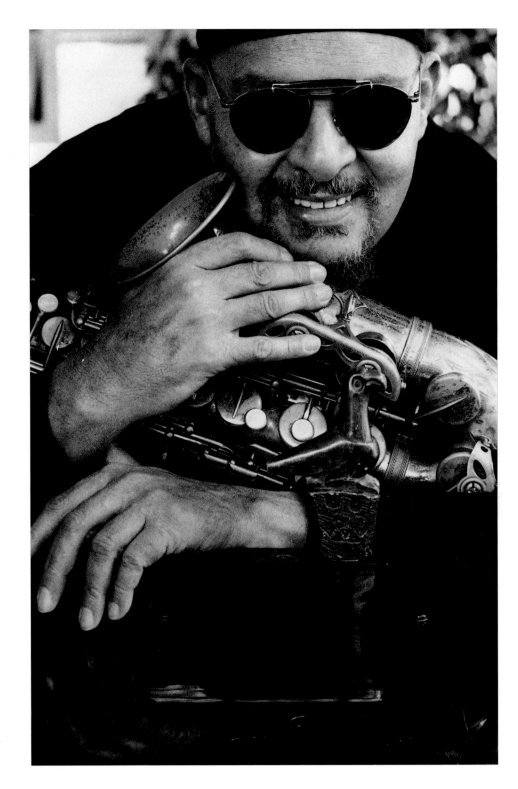

Jackie **McLEAN**

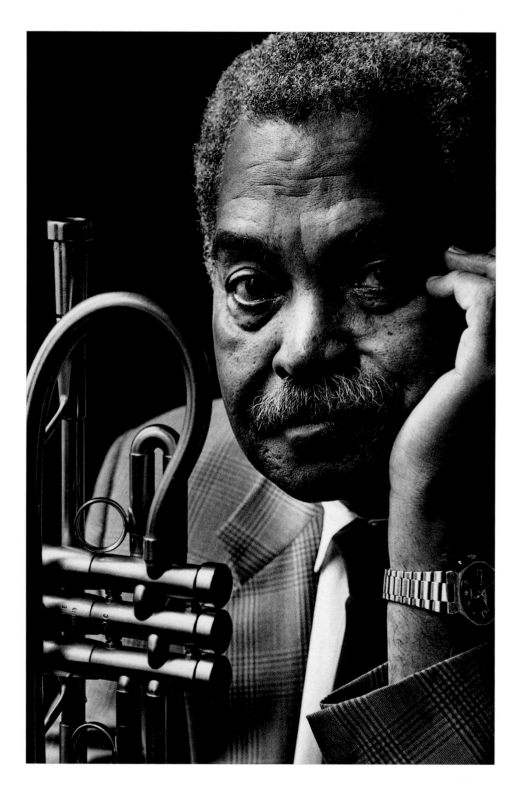

Not long after Art Farmer (b. 8/21/28) and Benny Golson joined forces to create the Jazztet in 1959, Golson fittingly described his partner in an interview as "Mister Melody," adding the prediction that Farmer would soon be one of the biggest trumpeters in jazz. Certainly, having already produced improvised counterpoint to Gerry Mulligan's baritone sax in the reedman's quartet, having held a front-line position in Horace Silver's quintet and having led his own ensemble with the late alto saxophonist/composer Gigi Gryce, Farmer had already come a long way since his neophyte days as a young trumpeter in Los Angeles.

Farmer apprenticed in Horace Henderson's orchestra, and other important West Coast–based big bands; however, by the end of the decade jobs for beboppers had dried up.

Luckily for Farmer, Lionel Hampton had moved west and needed a trumpet player. During his year and a half with the vibraphonist, Farmer made his first solo recordings, introducing a new and lyrical voice to jazz.

In 1963, Farmer switched instruments to the mellower flügelhorn, and his next group featured another master of lyricism, Jim Hall. Since 1965, Vienna has been Farmer's home base but he has frequently returned to the States to tour, and the eighties saw appearances with a revived Jazztet and an inspired combination with the late tenor saxophonist Clifford Jordan.

Art **FARMER**

Benny Golson (b. 1/26/29), the author of such classic jazz standards as "Along Came Betty" and "Whisper Not," is a core figure from a brilliant crop of musicians that came of age on the Philadelphia jazz scene in the forties and fifties.

In 1953, Golson was in the reed section of one of Lionel Hampton's most remarkable bands; laden with then-unknown talent, the trumpet section alone including Clifford Brown, Quincy Jones and Benny's future bandleading partner, Art Farmer. After Brown was killed in an auto accident in 1956, Golson composed what is perhaps his most beautiful theme, "I Remember Clifford" (just one of the Golson classics recorded by the Dizzy Gillespie Orchestra after Golson joined its ranks in 1956). As the music director of Art Blakey's Jazz Messengers from 1958 to 1959, Golson gave us his most frequently recorded tune, the strutting, soulful "Blues March." He joined forces with Art Farmer to create the Jazztet, another high point of small-combo jazz.

Nearly a decade of studio work took Golson from us, but since 1975, the jazz world has once again been treated to his tenor in many magical reunions with his fellow Messengers and Farmer (the Jazztet was revived for a number of years in the eighties). Today, Golson most often heads a quartet, but he still spends much of his time at the writing desk; thanks to a Guggenheim Fellowship, Golson is at work writing a symphony.

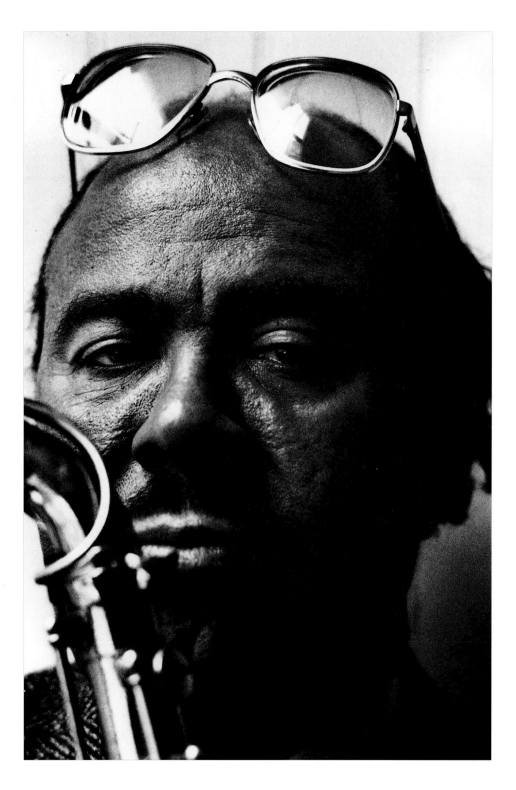

Benny **GOLSON**

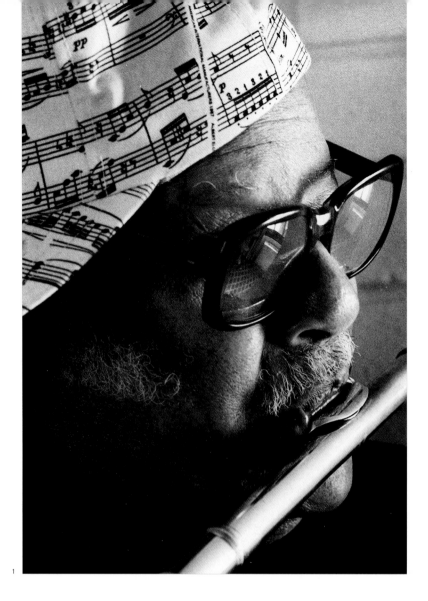

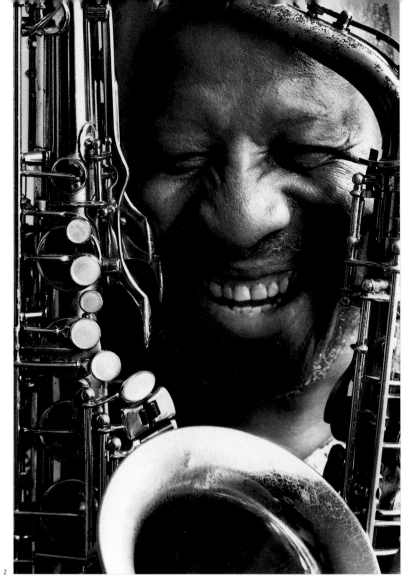

1 *Jerome* **RICHARDSON**

2 *John* **HANDY**

Jerome Richardson (b. 11/15/20) is yet another example of an underappreciated jazz artist that became lost to the studios (in his case, since his move to L.A. in the early seventies). In 1949, he joined the Lionel Hampton Orchestra, where he met Quincy Jones, beginning a lifelong friendship and musical association; one of the pioneers of modern jazz flute, Richardson's ringing sound on the instrument influenced Jones's earliest arranging efforts, and as the reedman once put it, "that sound with Quincy stayed a long time."

John Handy (b. 2/3/33) spent less than a year as a member of Charles Mingus's Jazz Workshop at the end of the fifties, but it happened to coincide with one of the most productive periods of the bassist's career. Handy's most renowned performance came in 1965 with a stunning marathon solo on his original "Spanish Lady." A decade later came the album *Karuna Supreme,* a gorgeous combination of jazz and Indian musics, and 1989 produced another musical merger on record, with the vocal group Class.

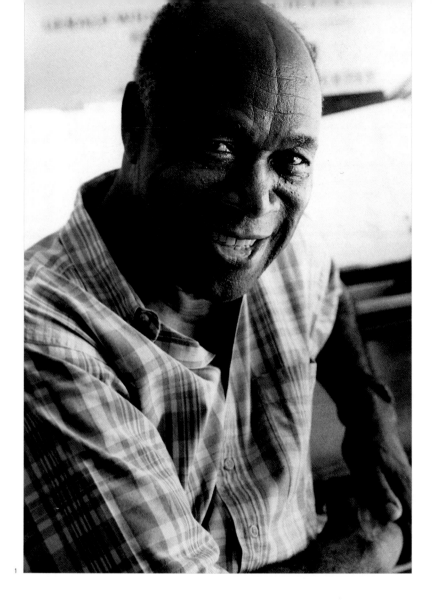

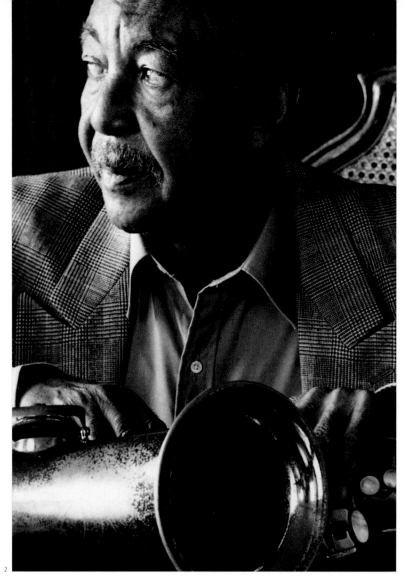

Over the five decades Buddy Collette (b. William Collette 8/6/21) has participated in the Los Angeles jazz scene, he has seen many of his contemporaries and students rise in the polls, yet outside of his hometown, the reedman has been one of the music's most criminally overlooked talents. Today, as President of the organization Jazz America, these activities include educating young people about the art of jazz through school programs and offering an outreach through music to children who are the victims of abuse.

Tenor saxophonist Harold Land (b. 2/18/28) is best known for his recordings with the Max Roach–Clifford Brown Quintet, and indeed he was a fine foil for the late trumpeter, as their seamless trades on "Cherokee" from 1955 reveal. Land is one of the most consistently creative saxophonists to have emerged from the West Coast. His sound has continued to evolve over the years; since the second half of the sixties, his music has revealed an affinity to the legacy of John Coltrane.

1 *Buddy* **COLLETTE**

2 *Harold* **LAND**

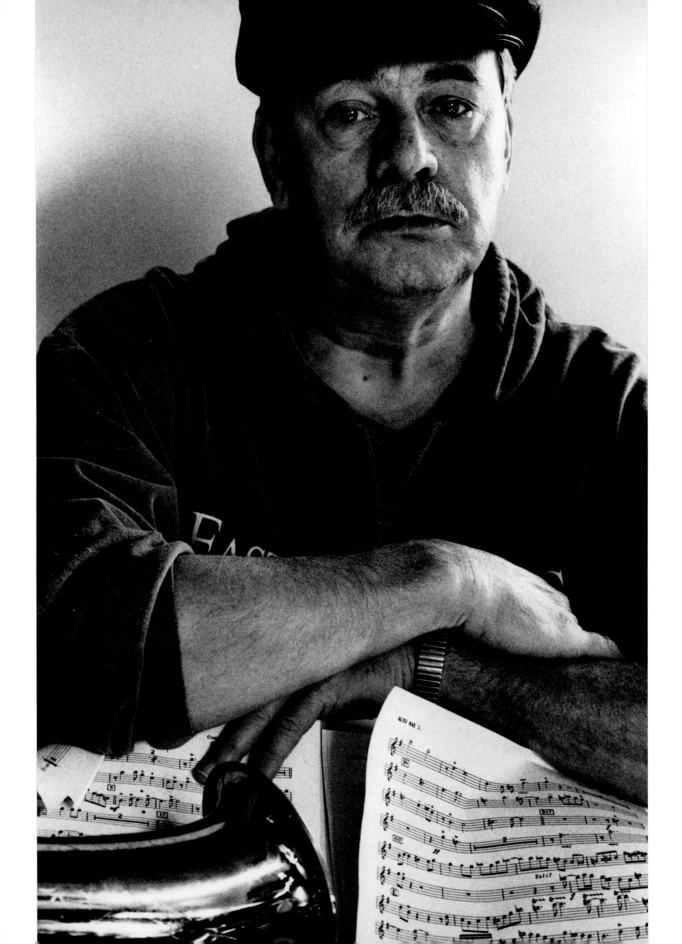

If any musician can be said to represent the ideal of post-Charlie Parker alto saxophone playing, it is Phil Woods (b. 11/2/31). His phenomenal chops and brash, full-blown sound can't help but transmit the reedman's innate exuberance to his audiences.

Woods first blew on the New York scene at the turn of the fifties, studying the classical clarinet repertory at Julliard and bebop at the clubs on 52nd Street. In 1955, Woods replaced Jackie McLean in pianist George Wallington's quintet and made his first real impression as a jazz soloist; the following year, the altoman went on tour with one of those fifties Birdland extravaganzas featuring a list of headliners that boggle the mind today: Count Basie, Bud Powell, Lester Young, and Sarah Vaughan to name a few. On that tour, Woods played in a septet billed as the Birdland All-Stars; at one of the concerts, Quincy Jones heard and took note of the young altoman's talent, and when he was contracted to form Dizzy Gillespie's big band for his 1956 State Department tour, he brought Woods on board.

It was after Woods's stint with Gillespie that the altoman first came into his own as a leader; he formed the working quartet that recorded the *Warm Woods* album in 1957, which showcased his big, "from the gut" sound and fresh conception. He teamed up with fellow altoman Gene Quill in another ensemble that performed intense bebop blowouts. In 1959, Woods took part in Thelonious Monk's historic Town Hall

concert, which included an especially fine, angular solo contribution from the altoman on "Little Rootie Tootie." At the end of the year, Woods began a ten-month tour of Europe with Quincy Jones.

Memories of that and later European experiences remained in the back of Woods's mind as he found himself more in the studios and less on the bandstand as the sixties progressed. In 1968, Woods and his family moved to France; there he formed a new band he called the European Rhythm Machine. Woods had found an especially compatible rhythm combination with drummer Daniel Humair, bassist Henri Texier and pianist George Gruntz (and later on, Gordon Beck). With their fervid virtuoso backing, Woods's blowing became freer and more daring than ever. It was a tremendously exciting group, and ironically, with its success, Woods found the doors that had been closed to him in the States while he was living in New York were now opening up for him as an expatriate.

In 1972, he returned to the United States; the following year, Woods spent a lot of time jamming with bassist Steve Gilmore and drummer Bill Goodwin, producing another important musical connection, which has continued to this day. Over twenty years, Phil Woods's ensembles have offered state-of-the-art performances of modern jazz; the substance of Woods's music has evolved far from his bebop beginnings.

Phil
WOODS

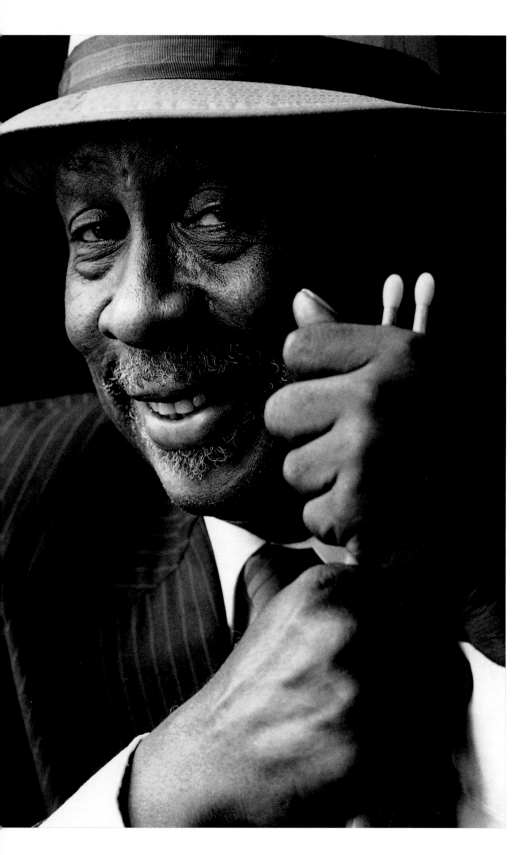

Any group that has Panama Francis (b. 12/21/18) on drums is guaranteed to be a swinging band. The Floridian is not a fan of flashy tub pounding; as he told critic Lee Jeske in 1980, as far as he's concerned, "drum solos are monotonous. After a drummer plays his first drum solo, that's *it!* Then it becomes a bunch of noise. They don't stop to realize that the important thing for the drum is to keep that band swinging and keep that time so it doesn't go up or down, it just stays there and swings."

Francis, a veteran of the big band era, has followed that dictum since the 1930s when, as a young fan of Chick Webb's playing, he first made his way to New York. He loves to play for dancers; as a member of the Lucky Millinder band in the forties, he kept things stomping at the Savoy; New Yorkers of a more recent era were gratified in 1979 by the formation of his Savoy Sultans, which over the course of the following decade brought old and new generations of swing dancers back onto the floor.

Panama **FRANCIS**

Louis Bellson (b. 7/26/24) joined the fraternity of big band drum kings when he was still a teenager, although the barrage of beats he generated by his innovative use of two bass drums would soon separate him from the pack. A popular performer since his early days with the Harry James band, he became recognized by the larger public as one of the all-time greats with his showpiece solos and the composition "Skin Deep," recorded with the Duke Ellington Orchestra in 1952. After three years with Ellington, his musical activities revolved around his own groups and those featuring his wife, the late Pearl Bailey. Over the years, Bellson has worked mightily to keep the big band tradition aflame; his most recent recording projects offer the best works of orchestral jazz, past and present.

Louis **BELLSON**

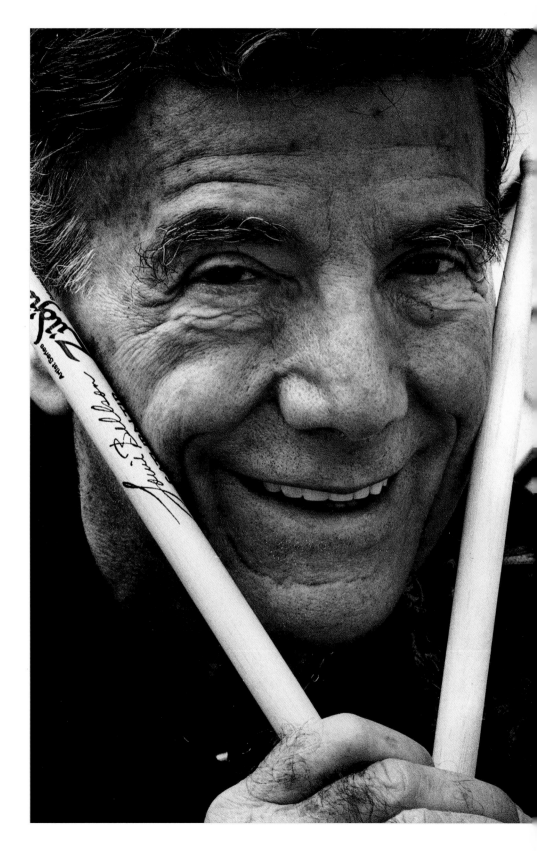

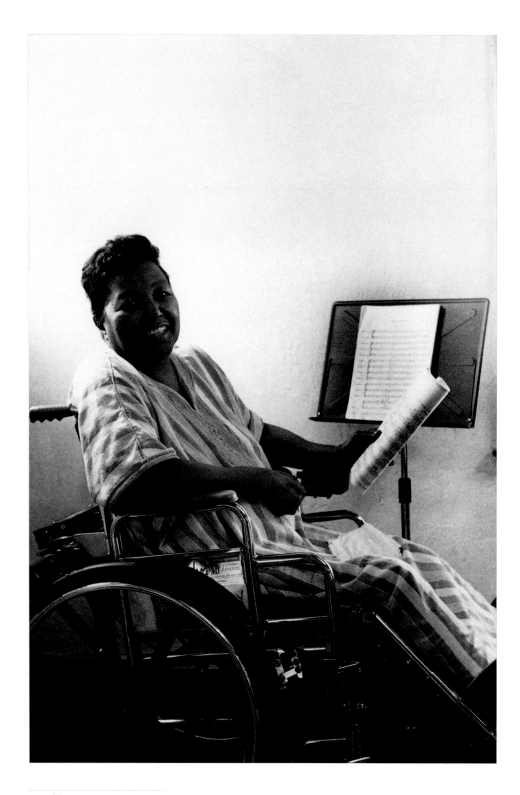

Melba **LISTON**

Melba Liston (b. 1/13/26) began to experiment with the trombone on her own when her family moved from Kansas City to Los Angeles in 1936.

Liston took her first professional job in the pit band of L.A.'s Lincoln Theatre in 1942. During the war years, it was relatively easy for women to break into the music business. In 1949 Dizzy Gillespie sent for her to come to the East Coast to write and play for his big band.

A 1950 tour down south with Billie Holiday left her deeply disturbed by the Jim Crow conditions there. Liston stayed off the road after that, and even abandoned music for a spell, until she joined Gillespie again in 1956 as a performer and arranger for the big band the trumpeter formed for his State Department tour.

One night when the group was playing at Birdland, pianist Randy Weston heard her arrangement of "My Reverie." Deeply impressed by Liston's chart and solo, Weston introduced himself to her, and soon after, they began one of the longest and most fruitful collaborations in music. Liston's scores perfectly realized Weston's African-influenced themes and jazz originals; Weston's music inspired Liston's greatest creations.

Their partnership is still ongoing; at this writing, Liston is working on a project that will combine Weston's piano with strings. Having suffered a stroke that has left her partially paralyzed, Liston has taken this turn in stride: she now creates on computer.

One of Philadelphia's greatest musical sons, Jimmy Heath (b. 10/25/26) did not pick up the saxophone until he was in high school. A precocious composer and arranger, Heath formed a rehearsal big band that included John Coltrane (then also an alto saxophonist), Benny Golson and his elder brother, bassist Percy Heath. The two siblings left home together in 1948 to come to New York, where the pair came to the attention of modern jazz trumpeters Howard McGhee and Dizzy Gillespie.

Around this time, Jimmy made the change from alto to tenor sax; it was easier finding gigs on the larger instrument. Heath continued his series of stints with great jazz trumpeters, forming a group with Kenny Dorham and recording with Miles Davis in 1953. His series of leader recordings for Riverside from 1959 to 1964 were admired for their fresh writing and the saxophonist's top-rank solo work. Sideman duties followed, but Heath's own activities as a recording artist did not heat up again until the seventies, when he and brother Percy formed their Heath Brothers band, with youngest brother Al "Tootie" Heath often on board as drummer (twenty years later, the band is still in operation).

Economics dictate that small groups are the rule of today's jazz scene, but Heath found an outlet for his long-standing desire to write big band originals as the director of a student jazz band at Queens College, where he is currently a professor.

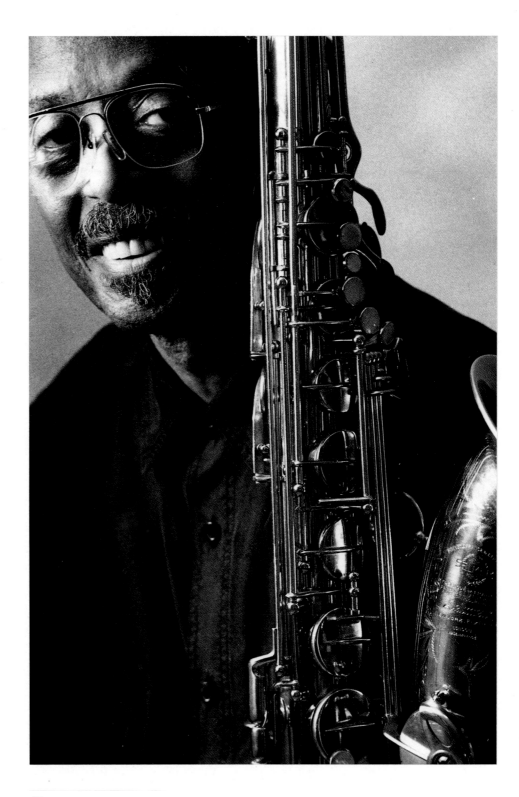

Jimmy **HEATH**

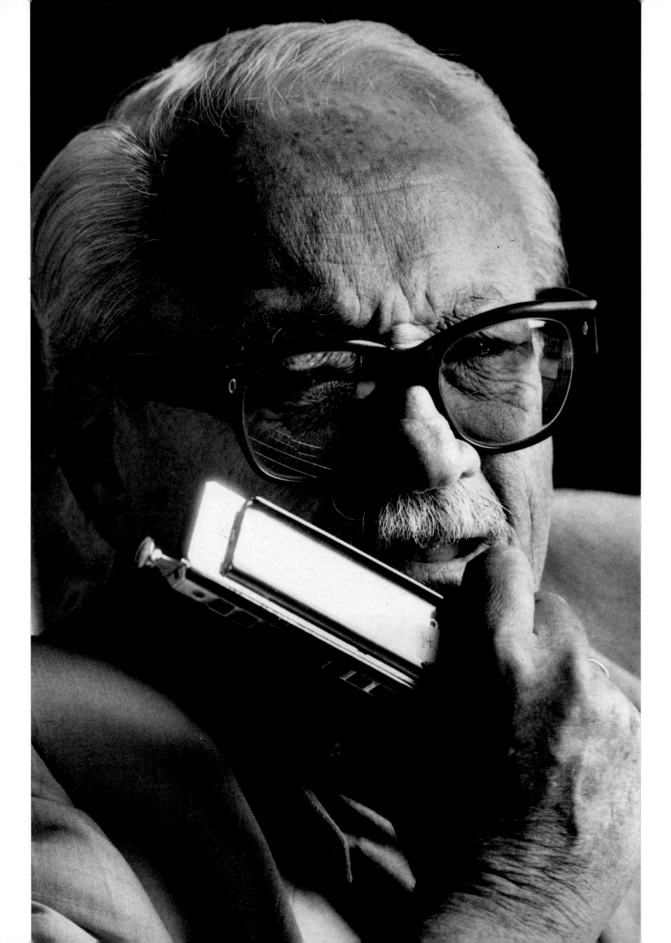

Toots **THIELEMANS**

In his early twenties, Toots Thielemans (b. Jean 4/29/22) was inspired to become a jazz guitarist by the music of fellow Belgian native Django Reinhardt. At that time, Thielemans was already a proficient performer on the harmonica and would be the first true jazz musician to become a virtuoso on the instrument.

From 1953 to 1959, his guitar was an element of the "Shearing sound" of the George Shearing Quintet. However, the lyrical and soulful harmonica playing that would define the "Thielemans sound" did not come to the forefront until his first recordings as a solo artist near the end of the decade. In recent years, Thielemans has perfectly blended his mellifluous solo style with the sounds of Brazil.

Pianist Toshiko Akiyoshi (b. 12/12/29) made her first recording in Japan, allowing her music to arrive in the States three years before she came to Boston to study at Berklee School of Music in 1956. Her most notable contributions have been with her jazz orchestras; the first of which was formed in 1973. Her pen produced the big band's book—inventive originals all—that showcased the heavy-hitting solos of her husband, tenorman Lew Tabackin, and her own ever-formidable keyboard talents. Moving from the West Coast back to New York in the mid-eighties, the pair formed a new edition of the band, which today is assembled sporadically for concerts and recordings.

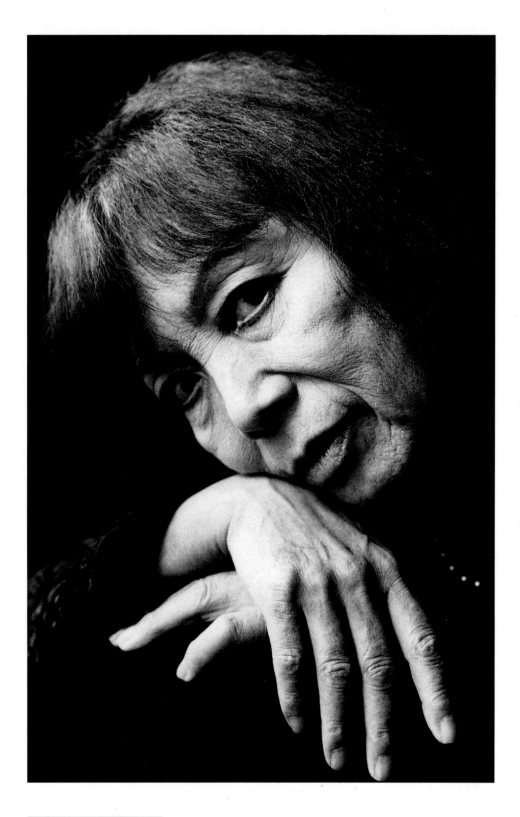

Toshiko **AKIYOSHI**

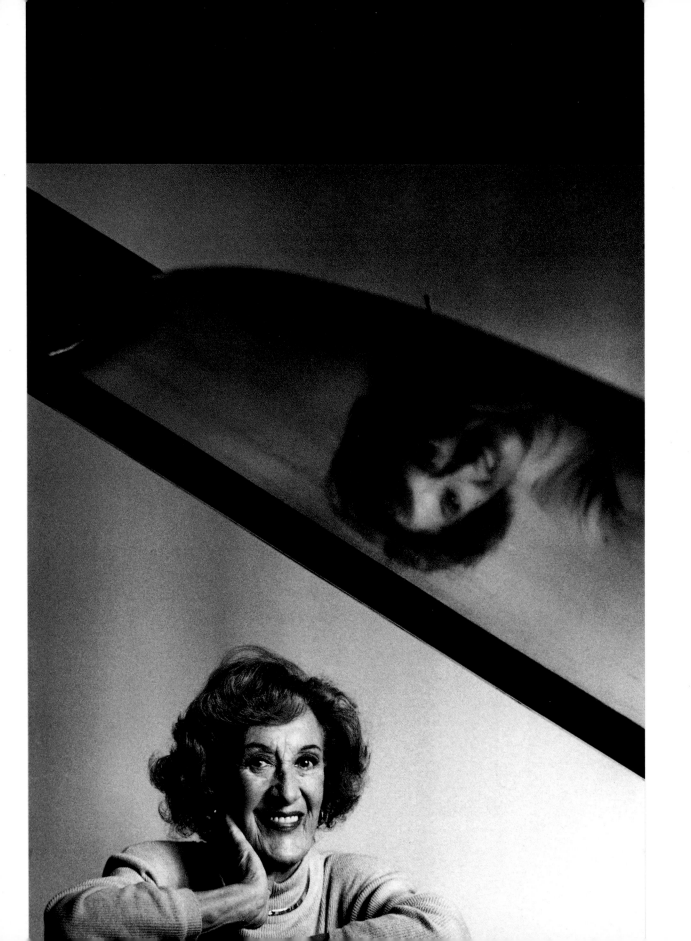

Marian **McPARTLAND**

The following pages offer a jazz gallery of various individualists of jazz piano.

Pianist Marian McPartland (née Turner b. 3/20/20), a native of Great Britain, was performing for American troops during World War II, when she met and married trumpeter Jimmy McPartland in Belgium in 1944. The couple came to the States in 1946, where McPartland established her solo career. Her working trio would become a 52nd Street institution, and for many years she has served as producer, host and performer for the nationally syndicated radio program "Jazz Piano." Her brilliant piano and engaging commentary result in enlightening and entertaining programs that reflect an insider's view of the art of jazz.

Dr. Billy Taylor (b. 7/24/21) has proselytized for the cause of jazz over many years as a performer, educator, broadcaster, and spokesman; since 1981, he has produced a series of artist profiles for the news division of CBS television. His scrupulous piano technique was already formed when Taylor first hit New York in the early 1940s. The ability to fit in with a variety of styles and artists helped land him an important position as house pianist at Birdland in 1951; then as now, Taylor's thoughtful piano stylings reflect an analytical approach to jazz improvisation grounded in a historian's knowledge of the music's traditions and his impeccable taste.

Junior Mance (b. Julian 10/10/28) and Norman Simmons (b. 10/6/29) are both products of the Chicago jazz scene of the forties. Mance first heard jazz piano at the feet of his father, and the influence of that boogie-woogie lingers still in his music. His blues-drenched piano had been heard with the likes of Dinah Washington and Dizzy Gillespie before he broke out as a solo pianist in the early sixties. At that time, soul-jazz was the rage, but the pianist wasn't following any trend: he'd been playing that way all along. In the past two decades, Mance had appeared most often in a duo format.

In 1953, Simmons inherited Mance's job as house pianist at Chicago's famous Bee Hive club, where for the next three years he backed the likes of Coleman Hawkins, Sonny Stitt and Lester Young; he honed his arranging skills leading a nonet before going on the road with vocalist Dakota Staton. That trip led the pianist to New York and a job as an arranger at Riverside Records. Simmons has since made his career as a sterling accompanist and musical director to the legends of the jazz vocal, most notably during his ten years with Carmen McRae in the sixties and his two-decade association with Joe Williams thereafter.

Together with Hank Jones, Barry Harris (b. 12/15/29), Tommy Flanagan (b. 3/16/30) and Sir

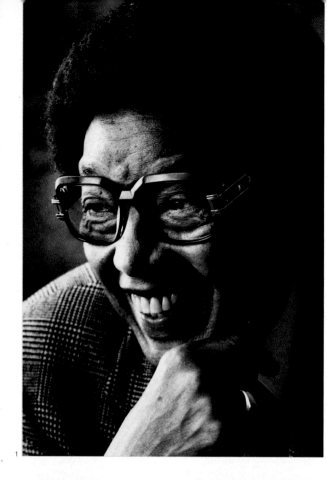

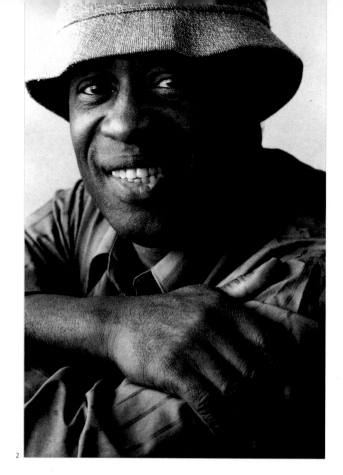

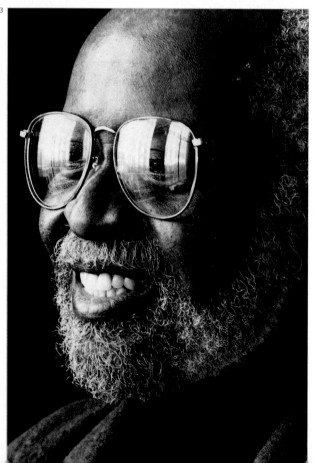

Roland Hanna (b. 2/10/32) represent the lineage of jazz piano masters from Detroit. Harris is the consummate bebop pianist; the keeper of the flame of the Charlie Parker/Bud Powell/Thelonious Monk tradition, and a fine composer in his own right as well. He was house pianist at the Bluebird Inn, the city's mecca for jazz during its richest period as a jazz center. A brief stint with alto saxophonist Cannonball Adderley finally led to his relocation to New York in 1960. In the eighties, Harris's work centered around his Jazz Cultural Center, where young musicians studied and played with the master, receiving his wisdom through lectures, lessons and performances that detailed the language of bebop.

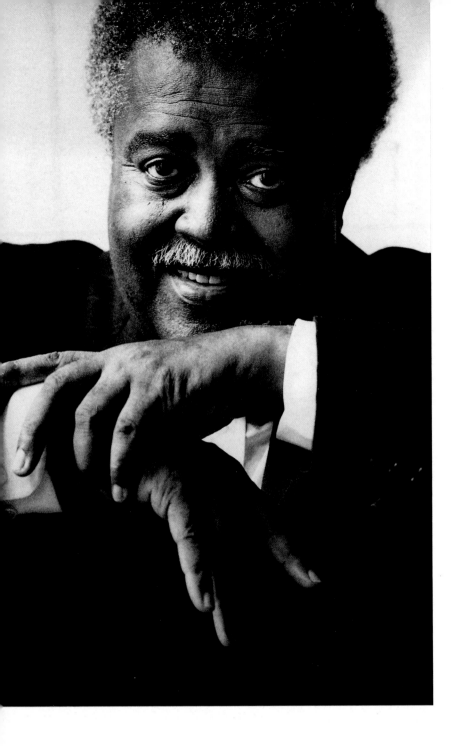

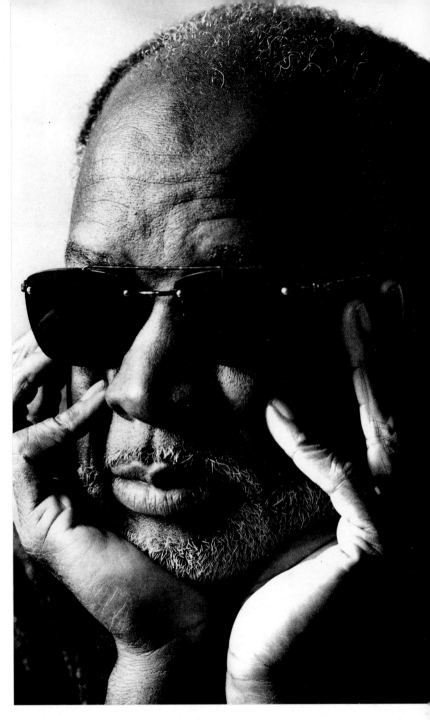

Ray **BRYANT**

Ahmad **JAMAL**

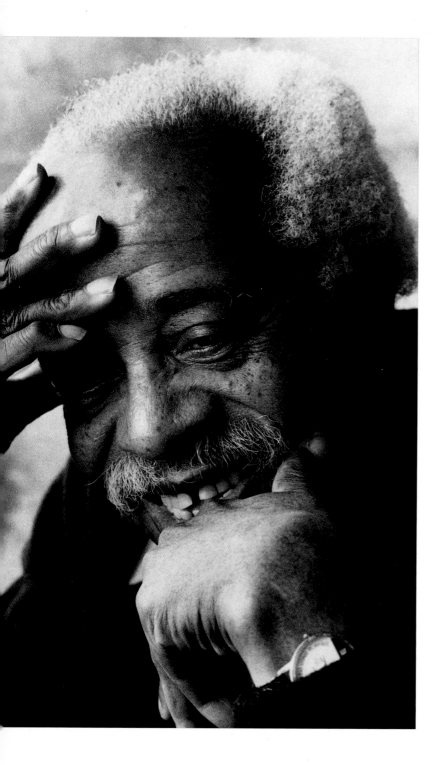

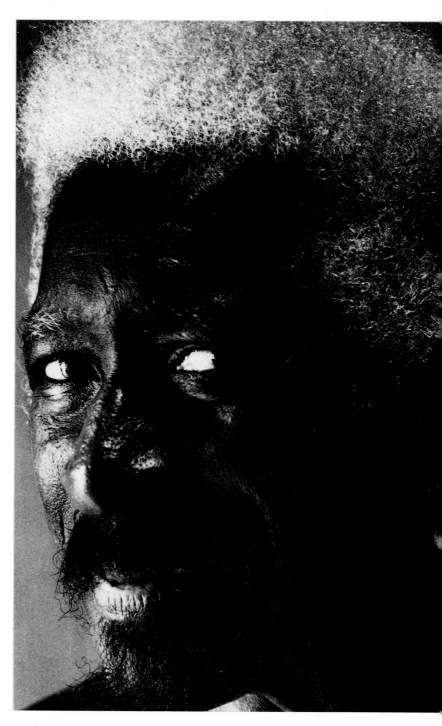

Barry **HARRIS**

Mal **WALDRON**

Like Harris, Tommy Flanagan drew upon the modern jazz piano tradition established by Bud Powell. Although they each have their own signature styles, Flanagan's melodiousness, taste and elegance are in the tradition of hometown elder Hank Jones. Both pianists are ideal accompanists, and both did very well by Ella Fitzgerald. Today, Flanagan continues to lead perhaps the best working piano trio in jazz.

Sir Roland Hanna is a poet of jazz piano who uses a formidable technique to produce solos of exquisite clarity, demonstrating a complete grasp of his instrument's history. The pianist's best-known work is the polished, mainstream jazz performed in the seventies and early eighties by the New York Jazz Quartet. The past decade has included concerts as a solo performer, songbook tribute recordings of Ellington and Gershwin and a new work for jazz/classical ensemble.

Throughout his career, Ray Bryant (b. 12/24/31) would never confine himself to playing with any single camp of musicians; as a freelancer in New York in the late fifties, he was notable for playing both afternoon sessions at the Metropole with elder giants of jazz, and evening gigs with his contemporaries. A composer of catchy jazz originals like "Cubano Chant," the pianist toured with Carmen McRae and in a mighty trio led by drummer Jo Jones before branching off with his own unit. Bryant and his trio were one of the more popular soul-oriented instrumental units of the mid-sixties. Today's Bryant trios best represent the total artist.

Ahmad Jamal (b. 7/2/30) has named John Kirby as an important influence, and the trio that produced the pianist's enormous 1957 hit, "Poinciana," exhibited the same cohesion and discipline that were the standards of the bassist's band. However, Jamal's group had its own way of locking into a groove and pulling the listener along as few units have done before or since. A master of space and silence, Jamal's more recent playing has tended to highlight the aggressive side of his virtuosity.

Mal Waldron (b. Malcolm 8/16/26) and Randy Weston (b. Randolph 4/6/26) have taken different paths from the Duke Ellington/Thelonious Monk continuum to form their own unique styles; both are outstanding composers who have added important standards to the jazz repertory: for example, Waldron's ballad "Soul Eyes," written to fit the sonority of John Coltrane's tenor saxophone, has since been taken up by jazz musicians all over the world, as has Weston's dancing melody "Hi-fly." Today, Waldron continues to hypnotize his listeners with his rumbling vamps on mid- and up-tempo tunes and the deliberately stated beauty of his ballad interpretations, while Weston has crafted a series of recordings that form a retrospective of his musical history: albums of blues, music by Monk and Ellington and re-visits to many of his most distinguished compositions.

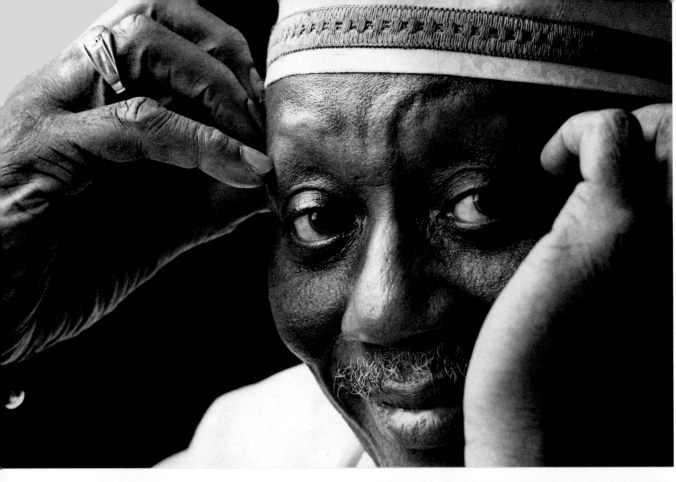

Randy **WESTON**

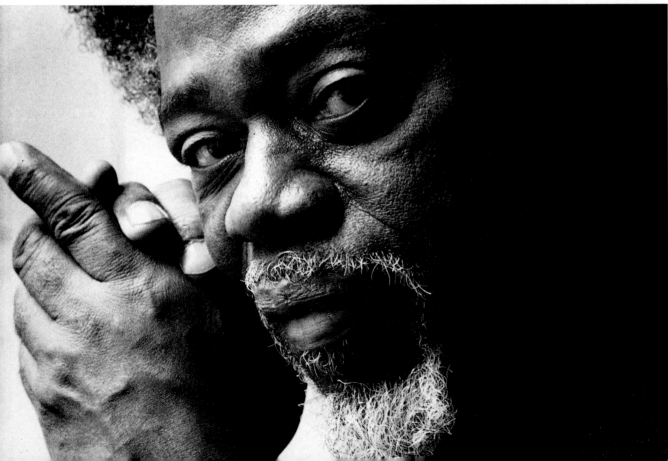

Sir Roland **HANNA**

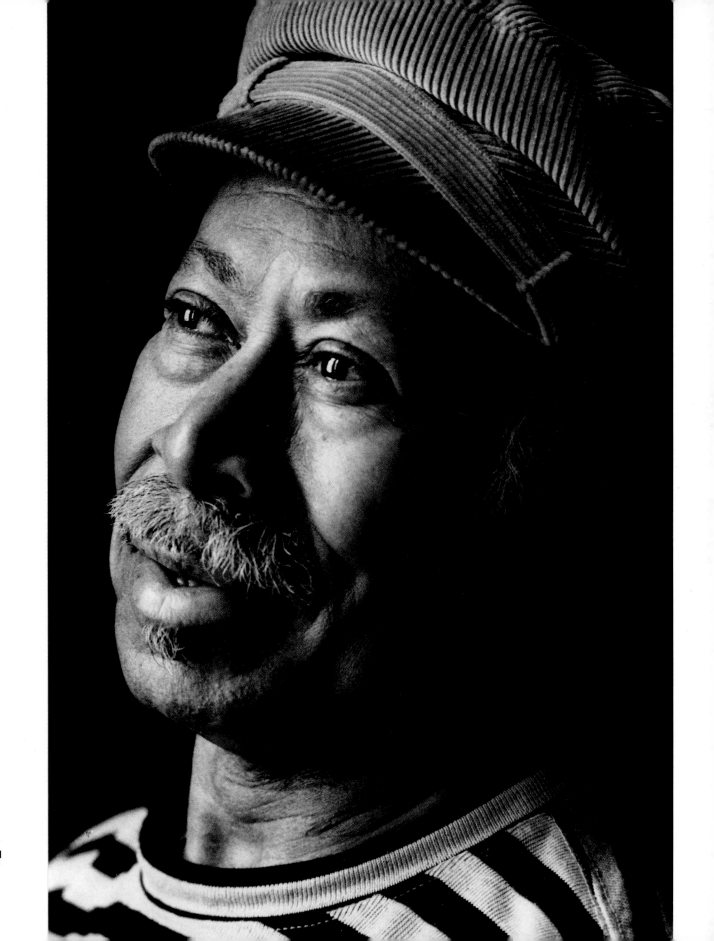

Tommy **FLANAGAN**

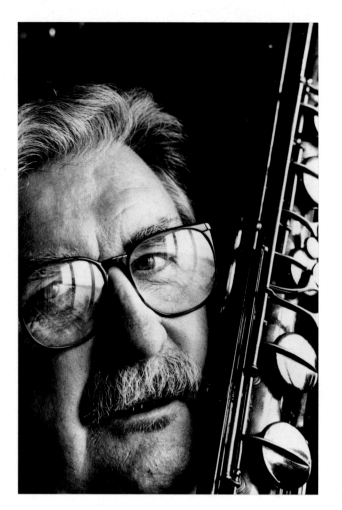

the Duke Ellington Orchestra, Temperley had the biggest shoes to fill in his career. In the nineties, Temperley was one of the most valuable members of the Lincoln Center Jazz Orchestra. His 1992 album *Nightingale* provides a fine profile of this masterful improvisor's style.

In 1955, bassist Jimmy Woode (b. 9/23/28) joined

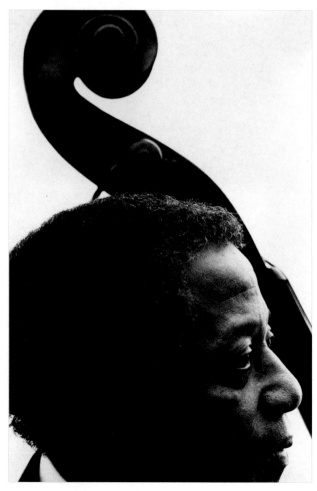

Joe **TEMPERLEY**

Jimmy **WOODE**

In 1965, Joe Temperley (b. 9/20/29) made the move from London to New York without any job in hand, and right off, the native Scotsman landed in Woody Herman's Orchestra.

In an era when big band work was rare, Temperley held the baritone chair in many large ensembles. In 1974, as the successor to the great Harry Carney of

the Duke Ellington Orchestra for a five-year run corresponding with one of its most exciting eras: the gloriously creative period that followed Duke's triumph at the Newport Jazz Festival in 1956. Not long after he left the Ellington band, Woode relocated to Europe where he continued his big band work. Based in Switzerland, but still a globe-trotter, Woode in 1994 toured with Lionel Hampton's "Golden Men of Jazz" package.

Duke Ellington aptly summed up Harold Ashby (b. 3/27/25) and his sound in his autobiography *Music Is My Mistress,* where he pronounces the tenor saxophonist to be "an indescribable prime product of soul-saturated solo popping de luxe!" The warm and burry rasp of Ashby's instrument was a regular element of the Ellington sound from 1968 through the Maestro's passing in 1974 (today, it is heard primarily on the European jazz festival circuit).

Ellington was renowned for his ability to write to the strengths of his soloists, a magnificent example of which is Ashby's solo on "Thanks For The Beautiful Land on the Delta" from *The New Orleans Suite,* which ranks with the greatest ever created on that instrument in the history of Ellingtonia.

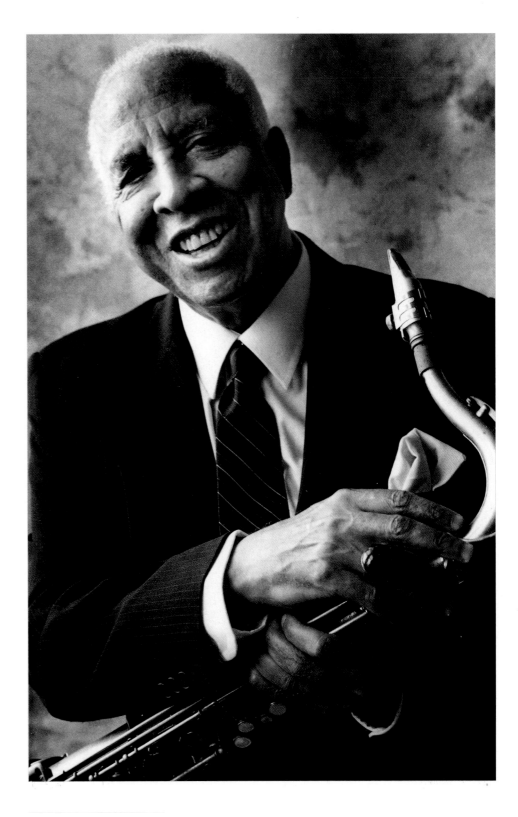

Harold **ASHBY**

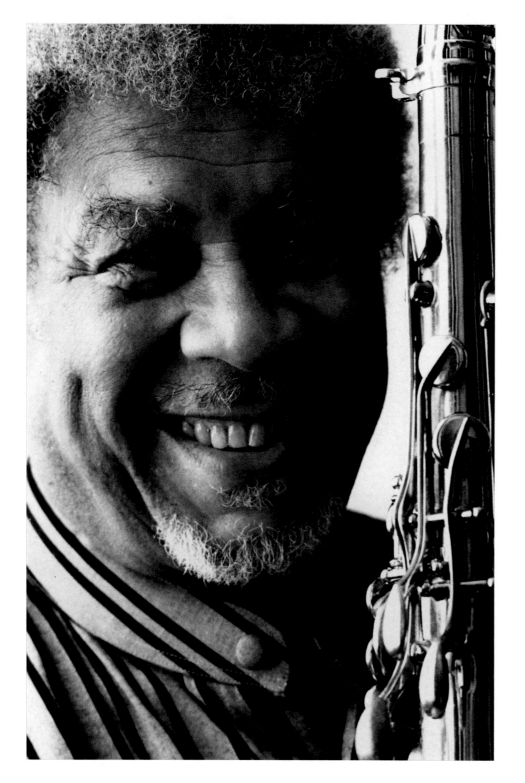

Frank **FOSTER**

In 1986, saxophonist Frank Foster (b. 9/23/28) took the helm of the Count Basie Orchestra after the death of trumpeter Thad Jones, the first steward of the band since the Count himself had passed on two years before. Foster, who had been a key member of the band from 1953 to 1964, now had the task of keeping alive a grand tradition of jazz.

Foster turned professional in trumpeter Snooky Young's band in 1949, but in 1951, the saxophonist would be gone with the draft to Korea for two years. Thanks to a recommendation from Ernie Wilkins, however, Foster joined the Basie band upon his return to civilian life in 1953. Over the next decade, Foster would be one of the key players of the ensemble; his hard, bebop-oriented tenor was featured on up-tempo specialties like "Jumping at the Woodside," while his pen was responsible for the popular compositions "Blues Backstage" and "Down For the Count" as well as the bonafide hit "Shiny Stockings."

By the time the saxophonist left the band a decade later, Foster had come under the influence of the new sound of tenor saxophonist John Coltrane and his classic quartet with McCoy Tyner and Elvin Jones. From 1967 to 1969, Foster was a member of Jones's band, where he clashed his tenor against the likes of George Coleman and Dave Liebman. Foster's heart was still in

the big bands, however, and in the seventies he wrote in an updated style for his ensemble the Loud Minority.

He has only recently vacated his role as leader of the Basie band, where he found just the right blend of old and new; his fine bandmates keep the old standbys like "April in Paris" sounding fresh, while they breathe the spirit of Basie into Foster's new charts. The group has a strong string of soloists, and their crack ensemble work provides some of the most exciting sounds in jazz today. Unlike "ghost" bands that are exercises in nostalgia, trading upon the names of jazz legends long gone, the Count Basie Orchestra, as under the direction of Frank Foster, remains a vital jazz force.

Ernie Wilkins (b. 7/20/22) was one of the architects of the sound of the "New Testament" Count Basie band of the fifties; he joined the group as a saxophonist, but was soon building up the band's book, remarking at the time, "I try to write Basie style; Happy, free-swinging style." Today's Basie band still roars out Wilkins flag, with wavers like "Way Out Basie." On the road to creating his own ensemble, the Almost Big Band, in 1980, Wilkins's contributions to jazz have included work as a performer and composer for the Dizzy Gillespie Orchestra (in 1956) and a long and extensive musical partnership with hometown friend Clark Terry.

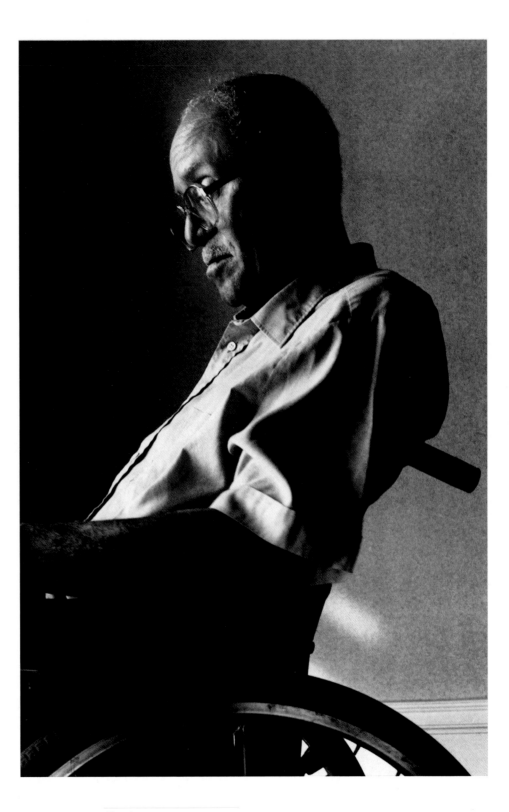

Ernie **WILKINS**

Few entertainment moguls today have Quincy Jones's clout; he's a force to be reckoned with in the publishing, broadcasting and film worlds, as well as in the music industry.

Jones (b. 3/14/33) was an aspiring trumpeter living in Seattle when he met Ray Charles in 1948. The pianist passed on to Quincy the musical knowledge that formed the framework of Jones's own earliest arranging efforts.

His second mentor was Clark Terry, who landed in Seattle long enough to give Jones a handful of lessons that sunk deep. Jones heard his music played by a name band for the first time when Lionel Hampton's Orchestra came through town and tried out some of his charts; he joined Hampton's ranks after he turned 19, in time for the group's 1953 European tour.

Back in the States, Jones had built a reputation as a freelancer in New York when he was asked in 1956 to assemble a big band to back Dizzy Gillespie on a Middle Eastern/Asian tour sponsored by the U.S. State Department; this powerhouse of a group was one of the finest of Diz's career.

By this time, Jones had also begun his association with Mercury Records, where Jones's ascent culminated with his being named company vice-president in 1964.

In the fifties, he crafted varied settings for many of the label's most enduring monuments of vocal jazz. Of the many records he made with Dinah Washington, *The Swingin' Miss "D"* from 1956 can be singled out as one of Jones's greatest-ever big band blasts, while the sole album Jones arranged for Helen Merrill (her eponymously named disk from 1954), featuring his typically flute-ful small group arrangements and the solo work of Clifford Brown, made for another classic.

Jones's reputation as a wonder of the music industry grew still in the early sixties as he created great charts for recording projects by Ray Charles, Count Basie, Sarah Vaughan, and Frank Sinatra and proved his acumen as a pop hitmaker for Mercury.

Since the mid-seventies, however, Quincy Jones's music crossed a divide over which jazz passes primarily through cameo appearances from his legion of friends and associates in the genre; they appeared in the most stunning array on his "Back on the Block" album from 1990. Will the man who made pure jazz masterpieces like *This Is the Way I Feel About Jazz* and *Quintessence* ever return to the fold? Probably not, but whatever new directions in sound that emerge from the creative mind of Quincy Jones will always be well worth exploring.

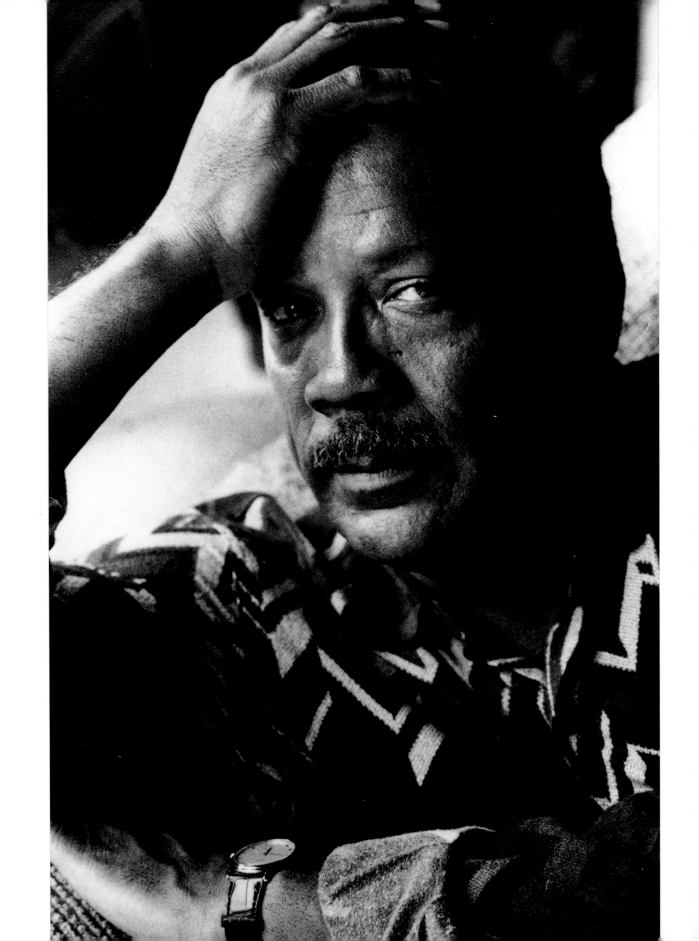

Growing up in Chicago, Mel Tormé (b. 9/13/25) revealed at a very early age a prodigious talent that allowed him to master whatever he set his mind to: A natural vocalist (he's sung in public since the age of four), Tormé worked regularly on the radio as a child actor, and in his early teens he progressed quickly as a self-taught drummer, pianist *and* songwriter. He was just 15 when one of his tunes landed on the Hit Parade (*Lament to Love,* as recorded by Harry James); the following year, while he was leading and writing arrangements for the vocal unit of the Chico Marx Orchestra. Tormé landed a role in the RKO musical *Higher and Higher* and was now Hollywood bound.

Once settled in L.A., Tormé was appearing with his own vocal group, the Mel-Tones, by night (by day, he finished high school). As he came of age, Tormé's career looked like it could take off in a number of directions: there was plenty of radio and recording work for the Mel-Tones; he played drums for fun with jazz combos around town (and turned down job offers from the likes of Stan Kenton); and he established a four-year songwriting partnership with lyricist Bob Wells. On one hot July afternoon in 1945, they wrote their immortal "The Christmas Song," and every Yuletide has been welcomed with the lyric "Chestnuts roasting on an open fire," since Nat "King" Cole's classic recording

of the tune was released the following year. But based upon the positive reaction (and heavy airplay) accorded his first solo records, Tormé decided to make it as a single, and he's been doing so for five decades.

Billed by his manager as the "Velvet Fog" (a handle he detested), Tormé was presented as a crooning vocalist in the bobby-sox tradition of Frank Sinatra. The fifties, however, saw a golden period of progressive-jazz oriented albums often featuring Marty Paich arrangements that fit hand-in-glove with Tormé's supremely sophisticated phrasing.

A man dedicated to the classics of popular song *and* jazz, an ongoing problem throughout Tormé's career in the sixties and seventies was the friction he had with record producers who wanted to run him through their hit-making machinery. His live club and concert acts continued to be spellbinding song recitals, and he also focused more energy on sideline activities as an actor and author. Since 1982, Mel has once again been prolifically recording choice examples from the Great American Songbook (mostly for Concord Jazz, and presently for Telarc), and he found in his occasional partner pianist George Shearing a perfect match: "two bodies, with one musical mind," as the pianist puts it. Tormé's annual mid-September run with a big band at Michael's Pub is now a fixture of New York's cultural life.

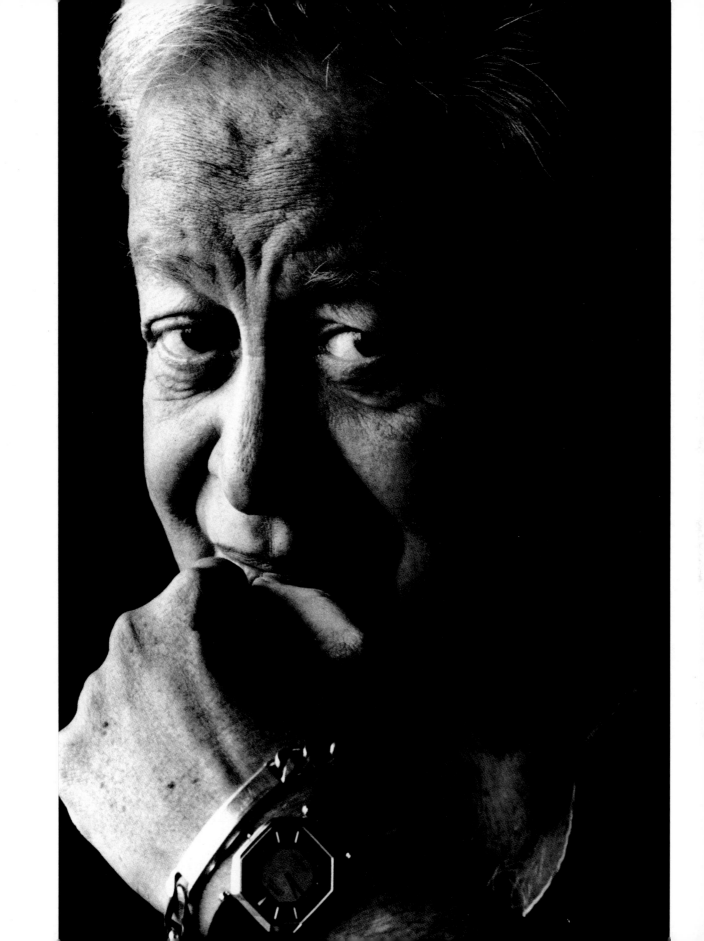

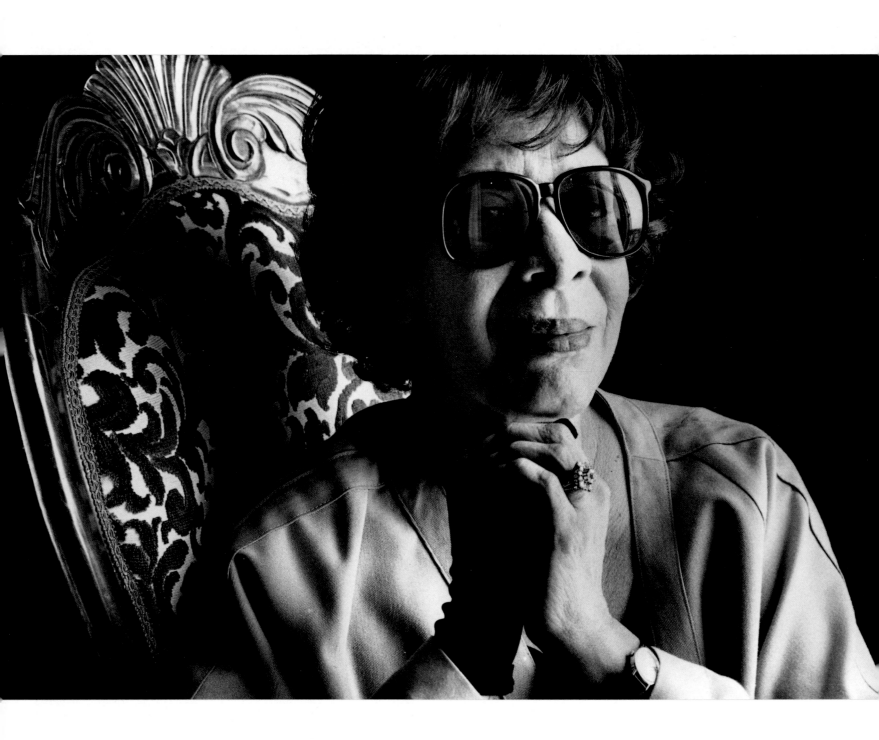

When Shirley Horn sings a ballad, it becomes an intimate conversation rendered in music. Hers is a small voice with a narrow range, but its expressive power lies with her mastery of nuance and the many-shaded subtleties that tinge her performances. Like Billie Holiday, Horn has a superb dramatic sense; there are few singers today who can match her ability to evoke the bittersweet emotions of a tender heartache. She cushions her interpretations with her own piano and beautifully crafted arrangements. She is such an effective accompanist that the late Carmen McRae (no slouch of a keyboardist herself) called upon Horn to back her on her final album.

Horn was active as a working musician in her native town of Washington, D.C., as early as 1954. Her initial brush with fame was the result of her "discovery" at the end of the decade by Miles Davis. He arranged for Horn to appear opposite him at New York's legendary Village Vanguard in 1960, a major break for any artist.

She achieved a modest success over the next five years, but Horn decided to withdraw to her home town to concentrate on raising her daughter. For nearly twenty years just about the only beneficiaries of Horn's talents were the residents of Washington, D.C.

Starting in the early eighties, Horn made a series of triumphant appearances at European jazz festivals, yet she remained one of jazz's best-kept secrets in her own country until she was signed by Verve Records in 1988. Her real breakthrough came in 1991 with her third album for the label, *You Won't Forget Me* and its haunting title track that reunited her with her old friend Davis. Horn's career has finally blossomed and she has rightfully taken her place as one of the great jazz divas.

Shirley
HORN

Jon

HENDRICKS

The poet laureate of modern jazz, Jon Hendricks (b. 9/26/21) is the leading exponent of the vocalese style of singing and songwriting. Along with fellow innovators such as Eddie Jefferson and King Pleasure, Hendricks developed the concept of composing lyrics to celebrated recorded jazz solos. In the process, he has created enduring songs that have joined the jazz lexicon on their own merit.

In the 1950s, Hendricks teamed with fellow bebop vocalist Dave Lambert to record classics like "Four Brothers." Shortly thereafter, they joined forces with Annie Ross to form Lambert, Hendricks, and Ross, "The Hottest New Group In Jazz." Their first album, the multi-tracked recording *Sing a Song Of Basie,* added a new dimension to vocal jazz and propelled the group to international stardom. The group's popularity lasted through 1962, with the departure of Annie Ross, and continued with replacements such as Yolande Bavan until the untimely death of Dave Lambert in 1966.

Whether writing lyrics to swing classics like "One O'Clock Jump" and "Jumping at the Woodside" or to gems from the modern jazz repertory, Hendricks always exudes great humor, most evident with "Gimme That Wine." But he has a sensitive side, too, with a delicate affinity for the Brazilian jazz tinge.

Hendricks is the consummate showman, with an elegant flair for the dramatic and performances informed by a lavish sense of production. He has often expanded his writing to full-length dramatic presentations, including George Russell's *New York, N.Y.,* appearing with Louis Armstrong in Dave Brubeck's The Real Ambassadors and producing his own showpiece *The Evolution of the Blues* at the Monterey Jazz Festival.

After the demise of Lambert, Hendricks and Ross, he resided in London for a number of years. Returning to the United States, living in San Francisco in the 1970s and in New York in recent years, he continues to propound his vocal-group heritage, often performing with family members such as his wife, Judith, and daughter, Michelle. Lately, he has been working on new material culled from Gil Evans's arrangements for Miles Davis.

Hendricks has been an inspiration for many popular vocalists like Manhattan Transfer and Bobby McFerrin, and he continues to motivate new generations. Now in his seventies, he shows no signs of slowing down. With his boundless enthusiasm he is an eloquent spokesman for the music, a pied piper for the joy of jazz.

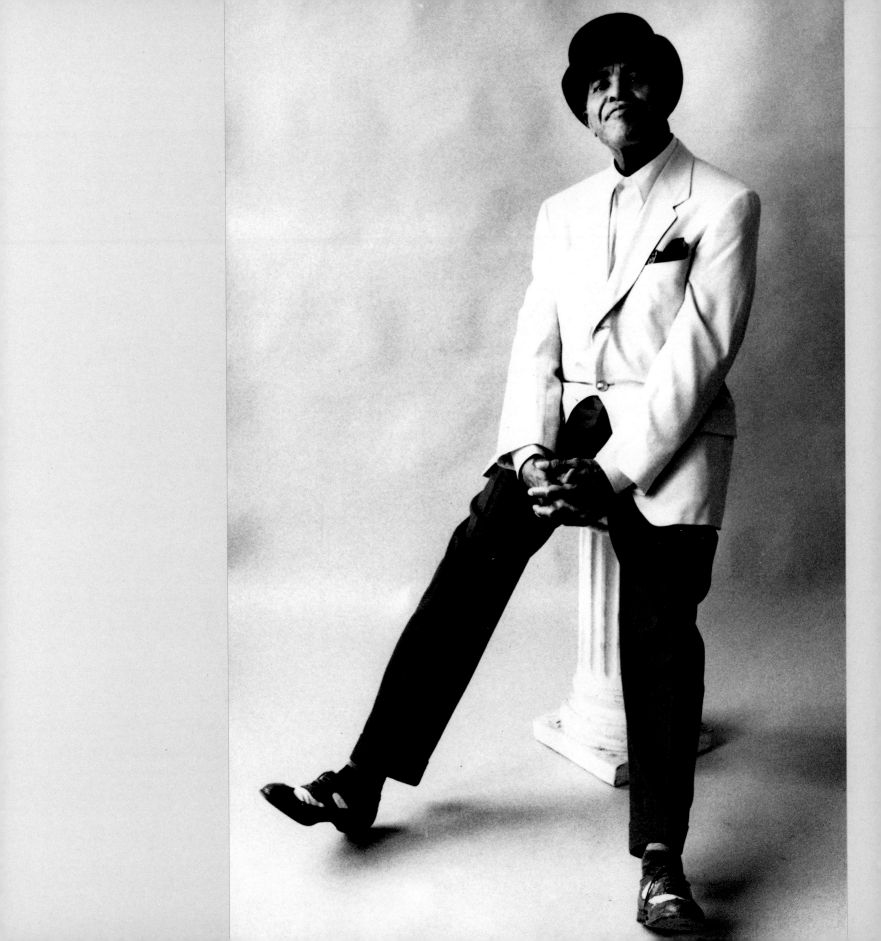

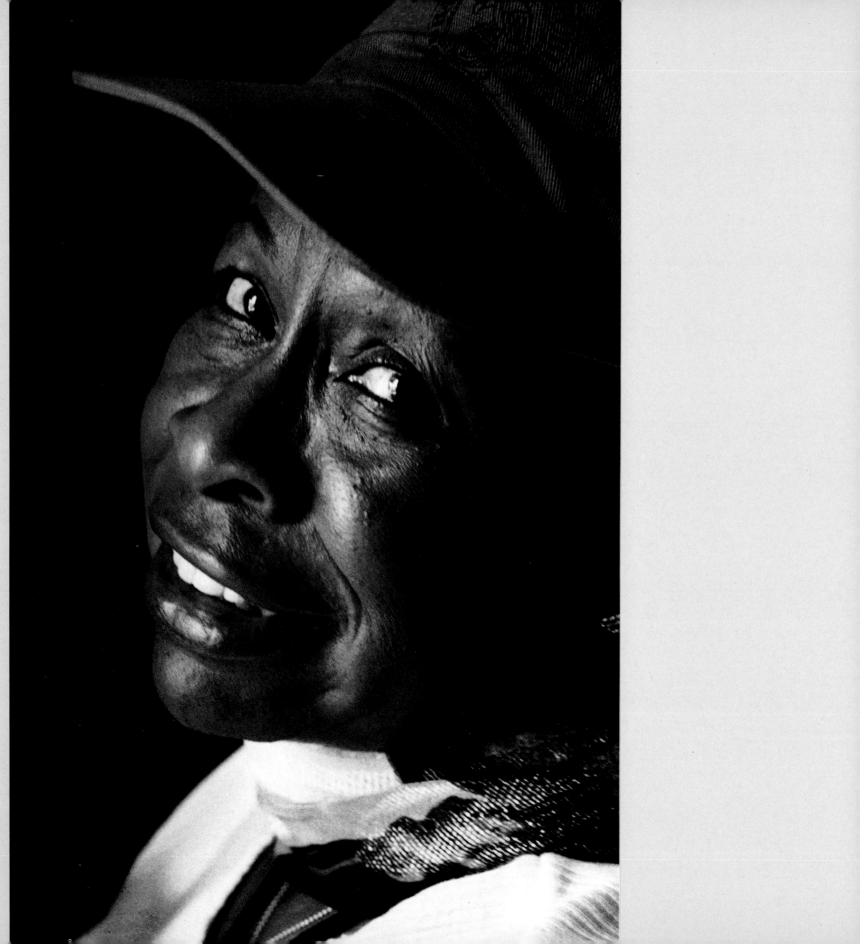

Fiercely independent, Betty Carter has charted her own course to craft a vocal style that defies convention and take charge of her own management to create an institution that defies the norms of the music industry.

Carter's individuality, forged from a superb voice with a special timbre and an ability to sing around the notes of a tune, enables her to generate great warmth and emotion while turning the standards of the American songbook inside out into new-found beauty. Her creativity and innovation specifically describe the essence of jazz—the art of improvisation.

Carter (b. Lillie Mae Jones 5/16/30) left her Detroit home at the age of 18 to go on the road with Lionel Hampton. Hampton dubbed her Betty Bebop and utilized her prodigious voice and raw musicality for the wilder, scatting numbers. She made her mark on Hampton's Decca recording of "The Hucklebuck" in 1949 and stayed with the band for three years. Her next appearance was on King Pleasure's 1952 disk "Red Top."

Carter's breakthrough was a 1955 Epic album co-featuring Ray Bryant; but a subsequent Columbia recording stayed in the vaults for over 25 years. She was to make records for various labels over many years, but none were properly promoted and she never caught on. Even her perhaps most famous album, 1961 duets with Ray Charles on ABC-Paramount, was never widely distributed, and, long out-of-print, became an underground cult classic, a strange fate for a recording of sober sensitivity and simplicity.

Undaunted, Carter went her own way and established a base in Brooklyn. She produced and distributed her recordings on her own record labels, bypassing the vicissitudes that dogged her. Possessing a feminist independence, she took control of the business, living by her own watchwords and continuing to develop music outside the mainstream. She recruited young musicians for her bands and trained them in a fashion that rivaled the Art Blakey finishing schools. By the 1980s she was popular again, feted by younger audiences who appreciated the nuance and power of her art.

Graduates of her bands have fueled the wellsprings of the young lions in recent years, and her contemporary Verve records, such as *Look What I Got!* and *Droppin' Things,* dominate the charts.

Betty
CARTER

SOME SEE THE EVOLUTION of jazz as a progressive search for greater freedom, with once-inhibiting formal rules modified or abandoned to provide expressive liberation to the improvising musician. Others view jazz's development as a corollary to the increased freedom and lingering frustrations of American society. From this perspective, the tone and texture of the music mirror the strains in modern society, especially a contemporary American society wrestling with issues of racism and political ideology. The changes jazz experienced in the 1960s, which produced a music called avant-garde, or free jazz, offer support for both theories.

Just as earlier sit-ins and boycotts ultimately produced the civil rights revolution, jazz's freedom movement of the 1960s had antecedents in the previous decade. Thelonious Monk was one essential pioneer. Monk had the audacity to pose an alternative to bop's speed and prolixity. His music was more concerned with the range of possible sound, the complexities of space and the coherence of improvisations that grew directly out of thematic material; and his initially puzzling compositions revealed themselves as models of his improvisational approach. As Monk's music gained belated acceptance beginning in 1957, musicians began to rethink what virtuosity was all about.

At the same time, bassist Charles Mingus was creating music of unprecedented intensity. Mingus's Jazz Workshop bands were, as the name implies, bandstand laboratories seeking new emotional depths. The trial-and-error adventures of Mingus's music involved replacing bop's chord progressions with stretches of harmonically static "open form" and the smooth ensemble statements of swing and bop with a roiling polyphony reminiscent of the early New Orleans style. Mingus also directly addressed subject matter like the agonies of desegregating American schools and the frustrations of African-American artists. "Haitian Fight Song," "Fables of Faubus" and other expressions of Mingus the social observer were soon followed by Sonny Rollins's "Freedom Suite" and Max Roach's "We Insist: Freedom Now Suite." Jazz's pursuit of freedom was now charting the course of a society's liberation.

Miles Davis addressed similar subjects more indirectly, through the spare and anguished lyricism of his muted trumpet and his stripped-down sense of form. If his ballad playing, even on a romantic standard like "My Funny Valentine," could sound like an open wound, his more flowing interpretations of "Bye, Bye Blackbird" and other standards also signaled that the old rules were giving way. Davis ultimately felt confined by the rigidities of the chord progressions of popular songs and began making greater use of scales and modes as a compositional (and improvisational) strategy. His masterpiece in the modal style, the album *Kind of Blue* was a 1959 manifesto of structural minimalism and the beautiful discoveries it could generate.

An even more radical sound was heard in 1959 in the music of Ornette Coleman's quartet. With a plastic alto saxophone, a wealth of compositions that sounded like bebop viewed through a funhouse mirror and a quartet of young acolytes from Los Angeles, Coleman arrived in New York playing a music with no chord patterns, no key signature and nothing but the emotional tone of the theme and the musician's own imagination to provide direction. His writing and playing had a mercurial, raw-nerve quality suggesting an untutored rural blues musician; and many observers (including some of the period's most progres-

sive musicians) dismissed him as a charlatan. Coleman knew what he was after though, and the intense blues feeling and rough swing of his music were hailed by some as the logical extension of Parker.

Coleman still employed blues phraseology and swung in 4/4 tempo, conventions that pianist Cecil Taylor soon abandoned. Taylor is conservatory-trained, and from the beginning of his recording career in 1955, his music drew upon European composers and contemporary dance as well as Ellington and Monk. The dense note clusters and pile-driving intensity of his solos, and the clipped motific fragments of his compositions, inspired an ensemble style in which horns and drums operated with the same explosive eruptions heard in Taylor's piano.

If Coleman and Taylor became, and to a large extent remain, cult figures, two musicians with more traditional backgrounds attracted a more sizable audience for the period's newer concepts.

Pianist Bill Evans is best known for his introspective keyboard personality and allegiance to the lyricism of the popular song; yet his rethinking of the piano trio as an ensemble of equal and independent voices also charted a more subtle freedom trail. Saxophonist John Coltrane, on the other hand, was on a perpetual quest, both spiritual and musical, until his death in 1967. After bringing chord-based improvising to its peak with his dense "sheets of sound" approach to the tenor sax, Coltrane expanded his conception and his audience by shifting to modal forms, adding the soprano saxophone and forming a quartet with pianist McCoy Tyner, bassist Jimmy Garrison and drummer Elvin Jones that brought a trancelike intensity—more akin to Indian and African music—to the jazz of the early 1960s. Then Coltrane's music took on

more overt spiritual overtones and began to incorporate the cataclysmic sounds of younger saxophonists like Ayler and Pharoah Sanders.

By 1965, as Coltrane moved into his final phase and Miles Davis opened up the bop style further with a quintet of young players who could simultaneously reflect and stretch tradition (Wayne Shorter, Herbie Hancock, Ron Carter, and Tony Williams), another wave of change was taking shape in Chicago, among a group known as the Association for the Advancement of Creative Musicians. While the AACM valued the discoveries of Coleman, Taylor and Coltrane, it sought newer approaches to instrumentation and performance structure. The AACM argued that jazz did not have to be a succession of solos bracketed by a theme, and that any group (from a solo saxophone to a combo where each musician played horns, bells and other "little instruments") could create profound musical statements. One of the AACM's goals was to demonstrate that musicians could be innovators at home, without having to prove themselves in New York. The increasingly confrontational nature of the music, plus the death of Coltrane (its one popular figure) made this last goal unattainable, however. Many of the AACM musicians had abandoned Chicago for Europe by 1970, where their ideas would receive a warmer welcome.

Yet the cataclysms of the 1960s were not totally ignored at home. The best of the younger players incorporated the newer freedoms and more familiar approaches into a style that lent an edge to the bop heritage and left the door open for further elaborations. When Tom Harrell and Joe Lovano play, for example, they display an acceptance of freedom's discoveries that holds out the potential for further change.

Cecil Taylor is one of the true originals in jazz. The iconoclastic pianist has developed his own lexicon and a demanding vigor in his approach to the music and its listeners. He has succeeded in incorporating diverse elements into his individualistic style, drawing from contemporary classical forms, an intensely percussive attack at the piano and the unrestrained, collective flow of free jazz.

Taylor (b. 3/15/33) was raised in a middle-class family in Queens, New York. In 1952, he began classes at the New England Conservatory of Music, where he studied the modern classical composers and also enmeshed himself in the Boston jazz scene. His first record was *Jazz Advance* on the Transition label in 1956, with Steve Lacy, Buell Neidlinger and Dennis Charles. His group then began an extended engagement at New York's Five Spot, establishing the club as a major venue for modern jazz. He solidified his own prestige with an appearance at the 1957 Newport Jazz Festival that was a triumph with the critics if not wide audiences.

By the early 1960s, Taylor remained devoid of public acclaim and was virtually unemployed in America. His tours of Europe with Sunny Murray and Jimmy Lyons helped keep his music alive and allowed him to further develop his "unit structures" building block approach to his music.

Faced with a lack of public appreciation for his new concepts, and acknowledging the lack of respect for creative black music in general, Taylor was instrumental in founding the Jazz Composer's Guild and the October Revolution of 1964, a landmark in the growth of the new jazz.

Throughout the sixties, he continued to perform with his Unit, which included Lyons and Andrew Cyrille. Taylor's triumph remains *The Great Concert of Cecil Taylor* recorded in Paris in 1968, with Cyrille, Lyons, and Sam Rivers; that event proved his astounding virtuosity at the piano.

By the seventies, a frustrated Taylor left the performance scene for academia, but he returned shortly to the music. In recent decades, his career has blossomed among a dedicated, if narrower, segment of the jazz community. His performances, whether solo piano recitals or group endeavors, are thrilling explorations of the visionary aspects of the creative possibilities of jazz.

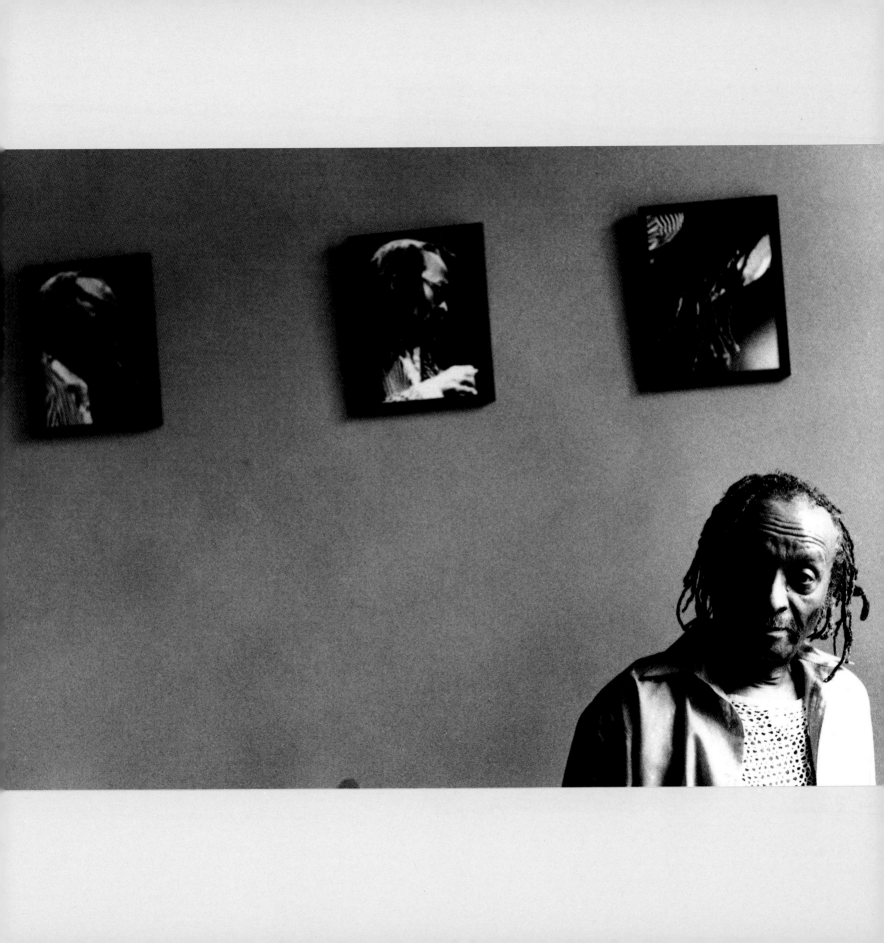

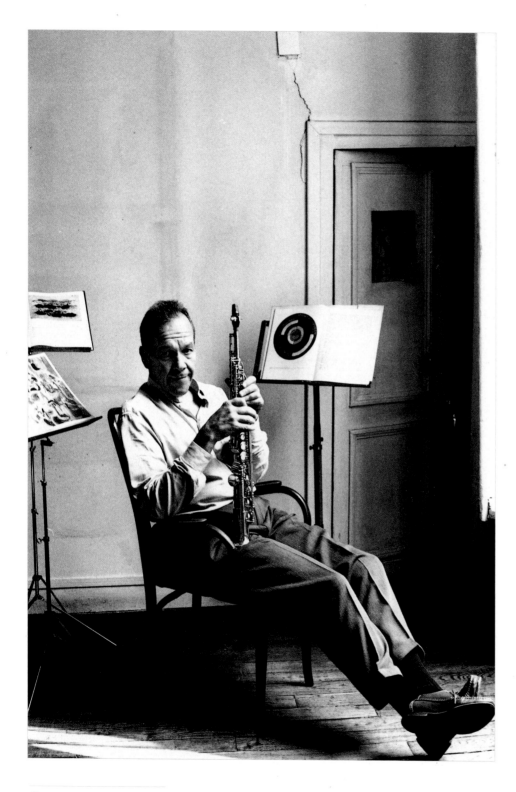

Steve **LACY**

Steve Lacy (b. Steve Lackritz 7/23/34) is a rare master of the soprano saxophone, a notoriously difficult instrument that had fallen out of favor among jazz musicians long before he came on the scene in the 1950s. As a teenager, Lacy hung out at New York's New Orleans revival/mainstream jazz scene at the Stuyvesant Casino, where he jammed with the likes of Henry "Red" Allen, Dicky Wells and Ellington cornetist Rex Stewart. He phrased his solos with an airy swing out of the Lester Young school in those early days, but was taken aback when Cecil Taylor approached him at a gig and asked, "Why is a young man like you playing such old music?" Lacy then leaped headfirst into the uncharted terrain of Taylor's music, becoming a regular member of the pianist's ensemble (which meant few gigs, but lots of exploratory rehearsals). He followed a solitary path as the first soprano saxophonist to play modern jazz until John Coltrane picked up the instrument some years later. Trane's heavy vibrato and his melismatic, nasal-pitched sound became the inspiration of virtually all of the soprano players who have followed him, yet the lucid beauty of Lacy's tone, rounded, resonant and pure, remains unique.

The saxophonist made his first trip to Europe in 1965, where he first explored the possibilities of totally free music. Presently based in Paris, he formed his current ensemble (one of the most enduring regular work-

ing groups in jazz) in that city during the early seventies. Lacy's emergence as a major composer also dates from that period, as he began to create an innovative body of work for this unit that melded art song and jazz traditions. In the last two decades, he has also been one of the few saxophonists to effectively perform solo concerts; with no one to cover up any deficiencies in playing or faltering of ideas, Lacy's solo recitals best underscore the precise architecture of his improvisations and his musical use of sounds, slurs and shrieks in his playing.

The fervent expression of an urgent call to struggle informs the music of Archie Shepp. Expressing the rage of both the political aspect of black oppression and the freedom of the avant-garde artist, Shepp is an eloquent, if angry, spokesman of the soul.

Shepp (b. 5/24/37) came of age in the 1960s. Emerging from the shadow of John Coltrane, he gained early experience with Cecil Taylor and Bill Dixon, then made his mark with Don Cherry and John Tchicai in the New York Contemporary Five. He also sat in often with Coltrane and achieved notoriety on Trane's *Ascension* date. Another significant association was with Albert Ayler. Throughout, Shepp helped define the new free jazz. His famous recordings for Impulse include *Four for Trane,* the aptly titled *Fire Music, Attica Blues,* and *Call of My People.*

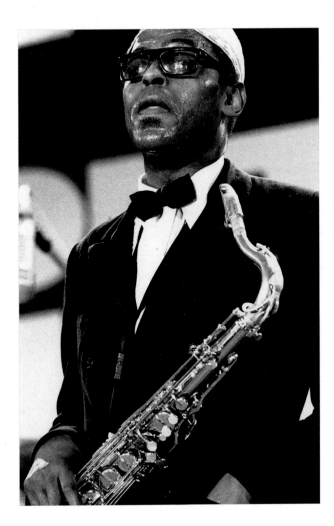

Archie **SHEPP**

In 1973, he began teaching at the University of Massachusetts, where he remains to this day a radical with tenure. He also continues to be active as a performer, and though he has expanded his style and mellowed some with age to display a sublime beauty on ballads and the blues in the tradition of classic tenor giants, Shepp's playing remains fiery.

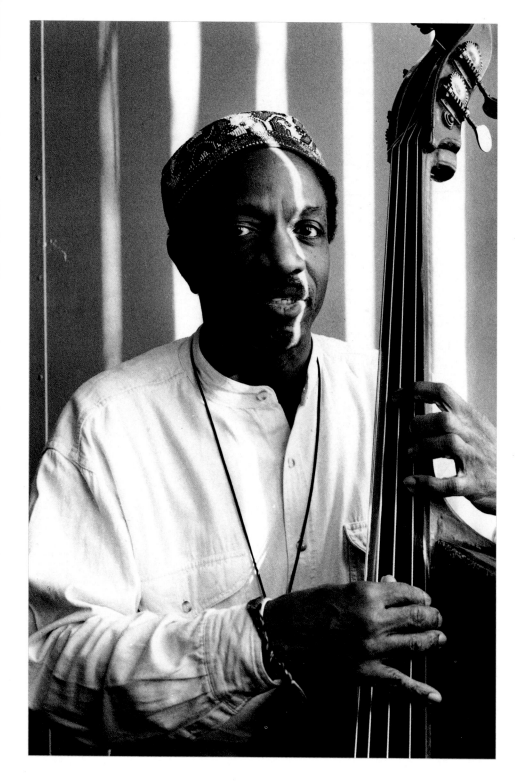

Surviving the fifties and sixties, when he was an expressively melodic and swinging bass player outfitting the realms of both hard bop and free jazz, Reggie Workman has become an educator and advocate for the spirit of jazz.

Workman (b. 6/26/37) grew up in Philadelphia and came of age in that fervent mid-fifties scene. He formed his most notable musical associations in the bands of John Coltrane, Art Blakey and Wayne Shorter. Throughout the late fifties and sixties, he worked with many of the giants of the music, always furnishing a solid rhythmic foundation, whatever the context.

Workman then became involved with the community as an activist working to build a foundation for the music among the youth. Notably, he was involved for many years with the populist New Muse Community Museum in Brooklyn. He's also taught at the University of Massachusetts and the New School for Social Research, and led the Collective Black Artists.

Workman developed multi-media projects with dance and poetry, and led his own Top Shelf ensembles. He continues to work as an educator and inspiration, and his services as a performer remain in demand into the nineties.

Reggie **WORKMAN**

Charlie Haden's lasting place in history is his legacy as a member of Ornette Coleman's groundbreaking free jazz groups. The bassist also adds an element of political awareness to his postmodern musical conception.

Haden (b. 8/6/37) broke out of his family's country-and-western roots, moving to Los Angeles in 1956 to join the West Coast modern jazz scene. He joined Coleman in 1959, becoming prominent through the saxophonist's engagement at the Five Spot and his seminal recordings such as *Free Jazz* and *The Shape of Jazz to Come*.

Haden's revolutionary political concepts took hold with his Liberation Music Orchestra, which explored themes of the struggles against repression. He also played with Carla Bley's Jazz Composer's Orchestra, had a lasting association with Keith Jarrett, and recorded a series of duet albums.

He later formed Old and New Dreams, a band that keeps alive the spirit of the original Ornette Coleman sound. In recent years, his Quartet West groups have amalgamated a more popular history into his music, but Haden's political outlook continues to inform his work.

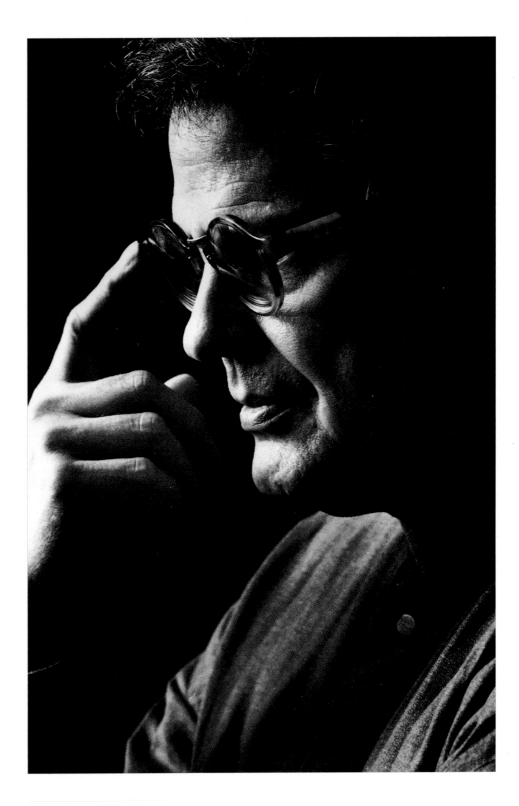

Charlie **HADEN**

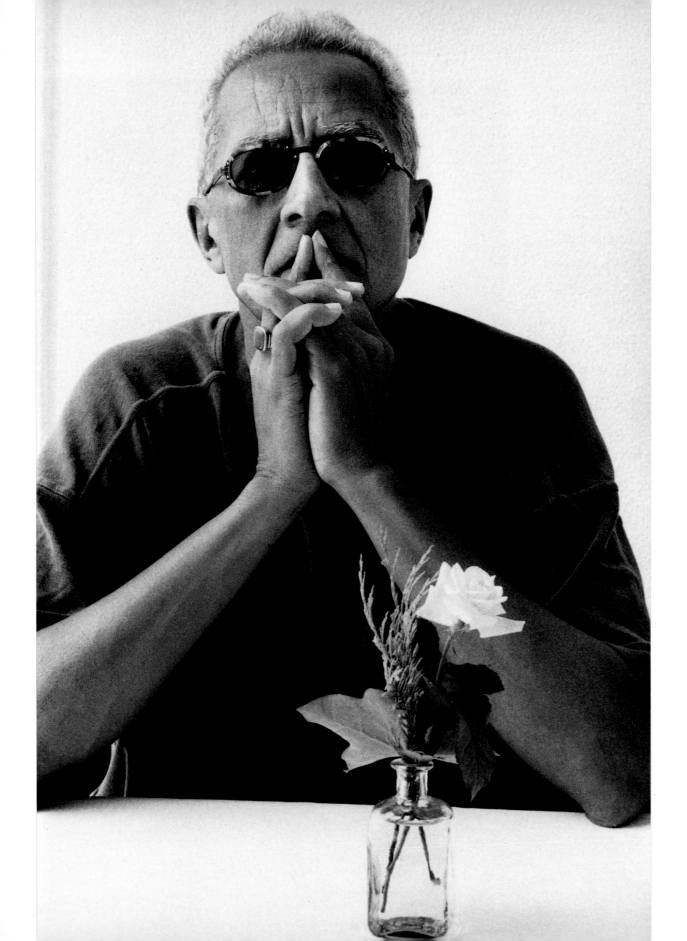

Charles **LLOYD**

Bringing the consciousness of John Coltrane and the avant-garde together with a lyrical impressionism, Charles Lloyd (b. 3/15/38) became a star, delivering the enchantment of modern jazz to the rock and roll world of the late 1960s. His *Forest Flower* album was one of the first jazz records to sell over one million copies.

Lloyd grew up in Memphis and cut his teeth on the blues and funk-jazz sound of that town. But his sensibilities derive more from California, where he moved in the 1950s, playing alto sax and flute in the West Coast style. From 1961 through 1964, he was the music director of Chico Hamilton's group; it was during this time he switched to the tenor saxophone. After a brief stint with Cannonball Adderly, he formed his own group, which by 1966 included Keith Jarrett, Cecil McBee and Jack DeJohnette.

Forest Flower was recorded at the 1966 Monterey Jazz Festival, leading to worldwide tours and acclaim, including a rare visit to the Soviet Union. His records would receive airplay on countercultural FM radio stations, and he would often perform at rock venues such as the Fillmore in San Francisco.

At the height of his popularity, Lloyd receded from the celebrity world into a self-imposed exile that would last decades. Emerging from his solitary, spiritual journey on the California coast, Lloyd was lured back into music by a then-teenaged admirer, Michel Petrucciani,

and then, toward the close of the 1980s, he re-formed a group that once again brings forth a sense of grace into a sometimes harsh jazz world. He now performs again at the major jazz festivals, and new albums like *The Call* and *Fish out of Water* have received critical acclaim.

Slide Hampton (b. Locksley Wellington Hampton 4/21/32) is one of the underappreciated trombonists in jazz, yet his prolific skills as a composer, arranger and orchestrator make him an indispensable member of the music community.

He was raised in Indianapolis, which, in Hampton's youth, was an important center for jazz. After stints with Buddy Hiles and Buddy Johnson, he joined Lionel Hampton and then gained prominence with Maynard Ferguson's groups of the late fifties.

Hampton's first explorations with innovative arranging came with his own octets of the 1960s, featuring players such as George Coleman, Freddie Hubbard, and Booker Little and with his World of Trombones ensembles. After touring with Woody Herman on the Continent, Hampton settled in Europe for close to two decades, finding greater freedom there for his musical expression.

In these current repertory-enthused years, Slide's versatile talents as a trombonist and arranger, orchestrating for groups of up to sixty pieces, find his skills belatedly in great demand.

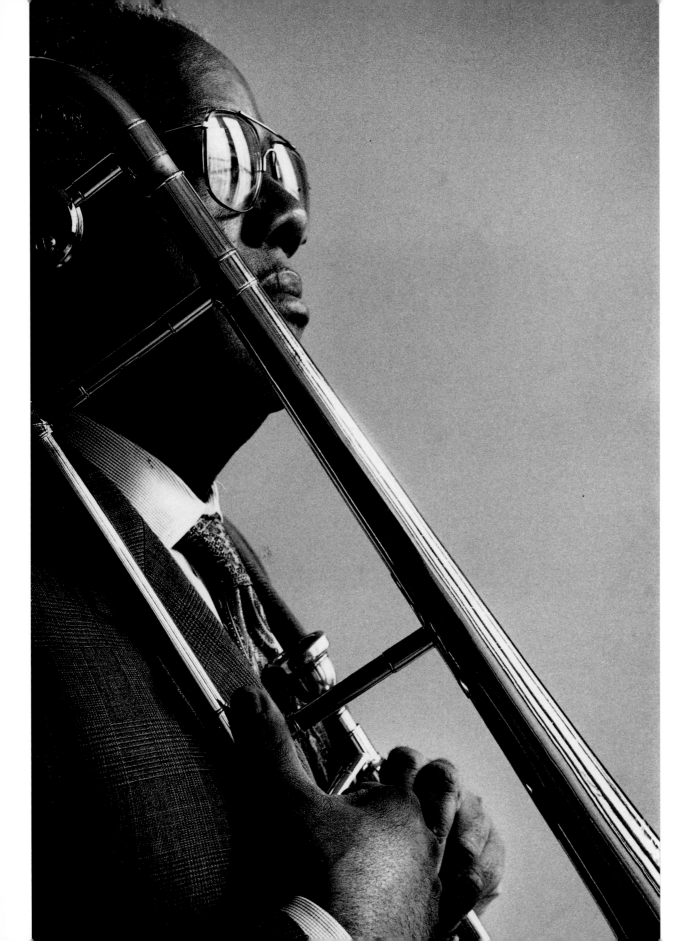

Slide **HAMPTON**

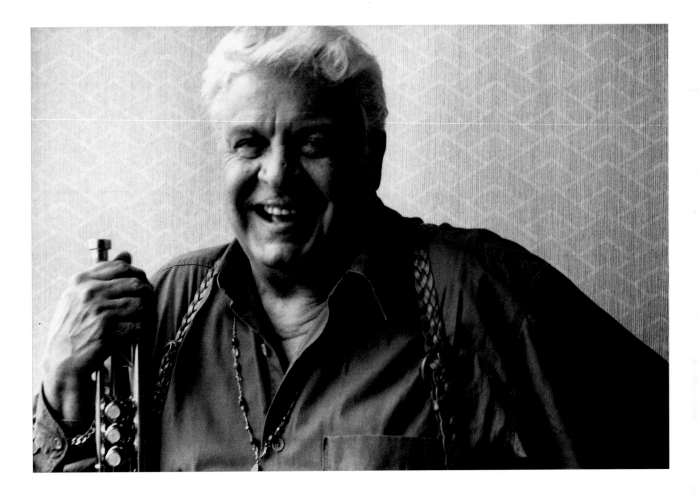

Maynard **FERGUSON**

There have been jazz trumpeters before him who were high-note specialists, but the extraordinary facility Maynard Ferguson (b. 5/4/28) developed at the top of his instrument's upper range is truly rare.

Ferguson became a star in the Kenton band before setting out on his own in 1953; four years later, he was at the helm of his own big band, an underrated unit (with a brass section as explosive as Kenton's) that performed charts by a young Slide Hampton, Don Sebesky, Ernie Wilkins, and others. In the mid-seventies, Ferguson gave up a cushy studio job so that he could get back into the band business. His new, super-high decibeled ensemble dismayed many jazz purists but produced some of the best selling recordings of his career, with hits like the theme from the film *Rocky* and the album *Chameleon,* entitled for its cover of Herbie Hancock's keystone "fusion" composition of jazz funk. In the trumpeter's next jazz orchestra, the Big Bop Nouveau Band, the scale has tipped back to the sound of high-powered big band jazz.

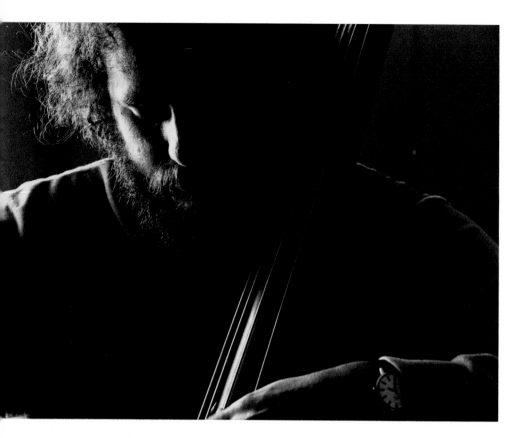

Jazz has made many inroads in Europe, and Scandinavia has always served as a tolerant haven for the black American expatriate. But Denmark has returned the favor manyfold, if only for the contributions of bassist Niels-Henning Ørsted Pedersen.

Ørsted Pedersen (b. 5/27/46) is an accompanist of uncompromising grace and possessed of a perfect sense of rhythm. As a teenager, he quickly mastered his instrument and recorded with American giants in Europe such as Bud Powell. He then served as bassist in the house band of the Montmartre Jazzhus in Copenhagen, the premier jazz club in Scandinavia.

In demand by all the visiting greats, he's worked with Don Byas, Johnny Griffin and Ben Webster, among others. Perhaps his lasting contribution was a lengthy association with Dexter Gordon, easing his transition during Gordon's long residency in Europe.

His delicate sense of swing has abetted notables such as Joe Pass and Kenny Drew. In recent years he has toured and recorded in numerous contexts,

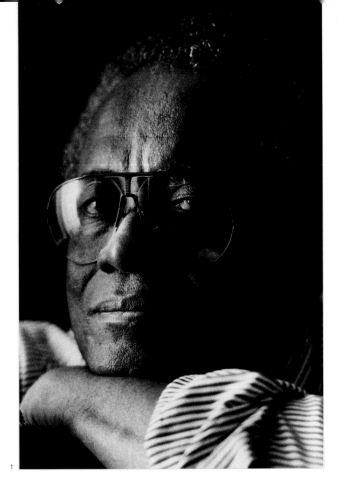

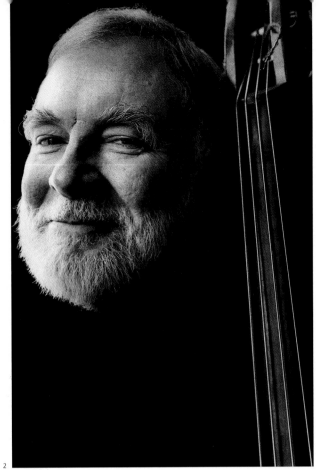

in frequent company of no less than Oscar Peterson and other top draws. Accepted as an equal in the pantheon of jazz, he is now a fixture on the international jazz scene.

Richard Davis (b. 4/15/30) is a consummately trained and versatile bassist. He's performed with symphony orchestra, under Igor Stravinsky and Leonard Bernstein, with folksingers and Van Morrison and in all forms of jazz. Davis made his mark on some of the seminal modern jazz recordings of the early 1960s,

with Eric Dolphy, Booker Ervin, Andrew Hill, Jaki Byard, and Oliver Nelson. His many years spent accompanying Sarah Vaughan are a major contribution, and he's a favorite of other vocalists as well.

His orchestral talents were put to fine use in ensembles like the New York Bass Violin Choir and John Lewis's Orchestra USA. He's toiled in the studios and in academe, but Davis remains one of jazz's most exceptional bassists.

Michael Moore is the quintessence of class and

1 *Richard* **DAVIS**

2 *Michael* **MOORE**

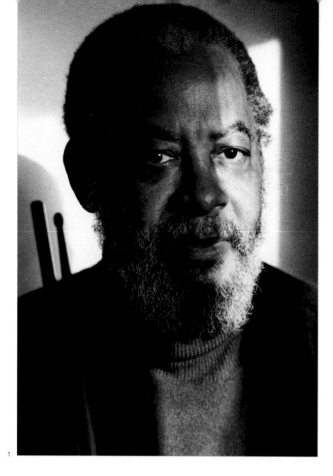

Ben Riley's mastery is professed by his position as Thelonious Monk's drummer, but his command of swing and style have dominated a lengthy career as one of jazz's percussion giants.

Riley (b. 7/17/33) came up in the 1950s and apprenticed with many of the major groups. His first major exposure was a long association with Johnny Griffin. Monk tabbed him in 1964, and Riley stayed with him for several years, acquiring a fluency with the vocabulary and structure of the iconoclastic composer. Riley has continued to be involved with finely structured

1 *Ben* **RILEY**

2 *Billy* **HART**

elegance. He is best known for his duo performances with the guitarist Gene Bertoncini, a fixture in New York club life.

Moore (b. 5/16/45) studied in his native Cincinnati and had his first major exposure with Woody Herman. He moved to New York in 1968 and has recorded with musicians such as Marian McPartland, Ruby Braff and George Barnes. His talents remain in demand with the more sensitive branch of the mainstream. The association with Bertoncini for almost two decades now is a staple of the haute nightlife, as they breathe a unique aura into the refined standards of jazz.

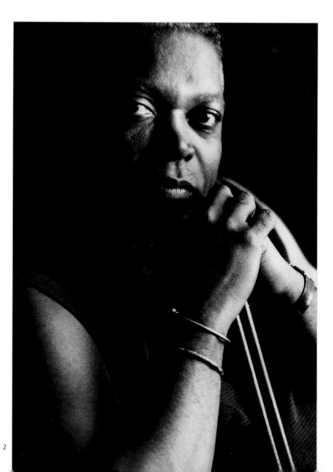

groups, such as the New York Jazz Quartet and Sphere, which continued Monk's legacy.

Billy Hart has been on the scene for over thirty years now and by his own count has appeared on over 250 albums. He is comfortable with varying modes of music—from fusion to mainstream to Cecil Taylor—not out of a desire to be eclectic, but because all of jazz fits with him.

For extended periods, Hart (b. 11/29/40) played with Shirley Horn, Jimmy Smith, Herbie Hancock, and Stan Getz. He possesses an impressionistic approach that lends a subtle color to his work and remains one of modern jazz's most capable and in-demand drummers.

Drummer Bobby Durham rarely gets major billing, but he is a no-nonsense percussionist who lends deft support to any rhythm section.

Durham (b. 2/3/37) achieved his greatest measure of success as a long-time associate of Oscar Peterson. His rollicking beat, gained through years of experience touring with rhythm and blues bands, adds a perfect sense of tempo to Peterson's shimmering rhythms. Yet Durham is also a tasteful accompanist, which is most evident in his work with Ella Fitzgerald.

Durham's early major jazz gigs were with Lionel

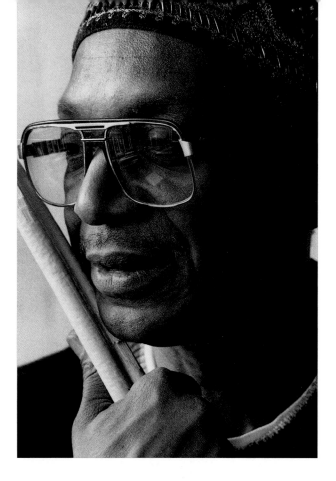

Hampton and Slide Hampton, and he was working with Duke Ellington when he received his first call from Peterson in 1967 and commenced his long tenure in that trio. Along the way, he's performed with literally hundreds of the greats. Of late, in addition to his work with Ella, Durham appears often with Al Grey and the Golden Men of Jazz.

Bobby **DURHAM**

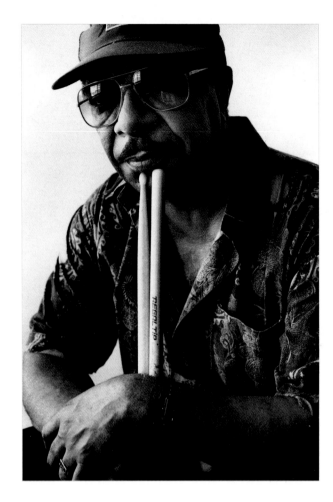

Grady Tate (1/14/32) leads an unusual dual career as one of the busiest drummers in the studios while performing as a romantic baritone vocalist. Tate's crisp drum patterns are a familiar sound to most jazz listeners; he has appeared on scores of albums over the years. Some of his most effective playing centered around his big band work in the sixties on LP projects featuring orchestras under the direction of the late Oliver Nelson; the decade also saw the drummer's contribution to *Sweet Rain,* Stan Getz's superior quartet album from 1967. But as Tate remarked in 1991, "Ninety percent of the people who know me as a drummer have never seen me as a drummer. They've just heard me on recordings, because that's what I did for twenty years—just played drums in the studios." These innumerable sessions included important vocal dates by the likes of Pearl Bailey, Ella Fitzgerald, Della Reese, and Sarah Vaughan; over the last three decades, Tate has built his own singing career, leaving his drum kit behind entirely on his recent *TNT,* a popular disk of ballads and blues waxed in 1991.

Grady **TATE**

Jimmy McGriff (b. 4/3/36) burns at the organ with a soulful sound not far removed from the Philadelphia streets. The Hammond B-3 organ holds a special place in modern jazz history. In the hands of a master, the organ swings in full-bodied majesty, while the foot pedals pulsate with a driving beat to blow the blues away. Other organists, such as Charles Earland, have adapted the instrument to the dictates of modern jazz; McGriff can play in this company, but his style is rooted in the grit and soul of straight-ahead blues.

Early on, McGriff learned from Jimmy Smith, the progenitor of the style, and augmented his studies with formal Juilliard training. His first major gig was backing the lusty rhythm and blues of Big Maybelle. In the years since, he has continued to ply his trade, touring the country by van and releasing dozens of grooving records, often in the company of blues great Junior Parker and more recently in tandem with Hank Crawford.

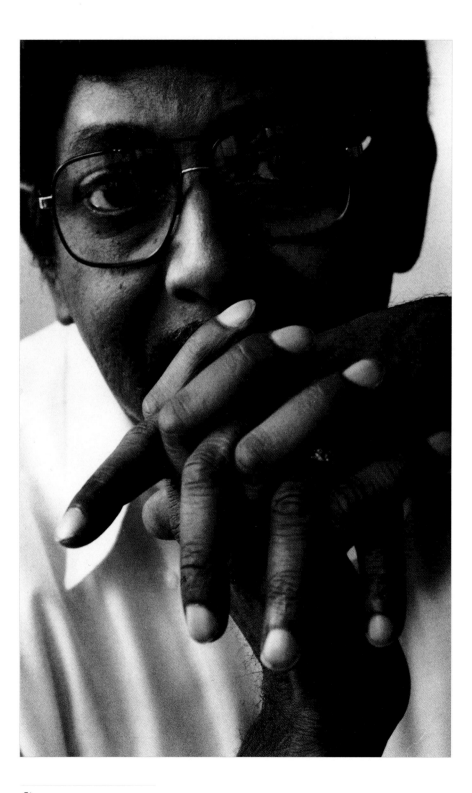

Jimmy **McGRIFF**

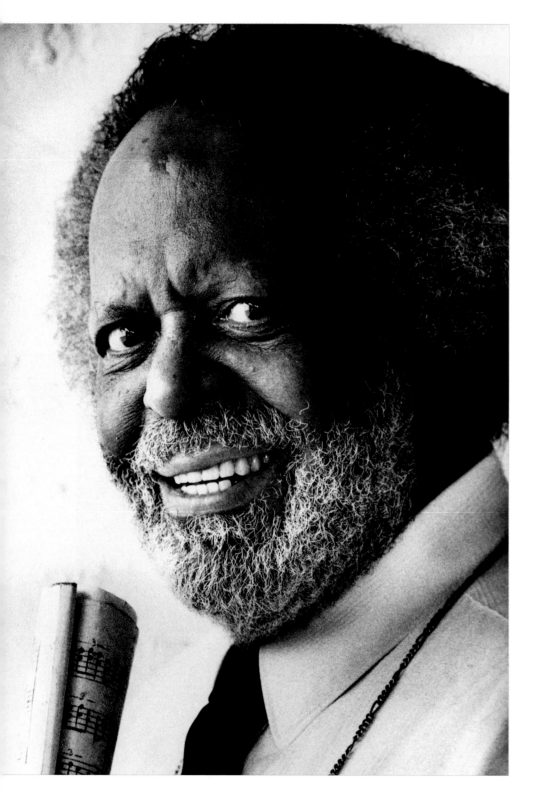

Jaki **BYARD**

It's often been said that Jaki Byard (b. 6/15/22) can play the entire history of jazz piano in a single solo, from the syncopations of ragtime to the discordant note clusters of the avant-garde. He communicates the same joyfulness and humor with his instrument as that which infused the playing of Fats Waller (who together with Earl "Fatha" Hines were Byard's primary influences). He has also given credit to Erroll Garner for the impressionistic quality of his ballads, and was powerfully affected as well by Bud Powell's contribution to the bebop revolution of the forties.

Four decades ago, however, Byard's individualistic response to this diverse range of influences was to splice them together, most often reaching back to the sounds of stride piano that he has loved since his childhood—at times to the chagrin of his fellow modernists. As Byard told critic Doug Ramsey, "the other musicians didn't dig it, but the public did."

Yet it was the pianist's expertise in the older styles that brought him to the attention of bassist Charles Mingus, and when Byard joined his ensemble in 1962, he at last began to receive the accolades due to him as a great artist in his own right. The sixties, fertile years for Byard, produced many fine albums that showcased his formidable skills as a tunesmith and his abilities as a multi-instrumentalist.

Since the seventies, he has been active as a teacher, and his students formed the core of his "Apollo Stompers" big bands (with units operating under that name in both Boston and New York through the late eighties). Like many artists of his generation however, Byard's talents have been underappreciated in recent years; his most current recording is a typically brilliant and eclectic solo piano recital made at Maybeck Hall in Berkeley, California, in 1991.

Kenny Barron (b. 6/9/43) must be one of the busiest pianists in New York. Often heard solo or duo in piano rooms like Bradley's, or as an invaluable sideman in countless groups, Barron adds a deft touch of grace and lyricism to the proceedings.

Barron hails from Philadelphia but moved to New York as a teenager. He immediately gained notice with James Moody, and at the age of nineteen he joined Dizzy Gillespie, garnering broader exposure.

He has been on the faculty at Rutgers University since the 1970s, transmitting his art to successive generations while continuing to work in special groupings with Ron Carter or the collective Sphere. Barron's work is so ubiquitous that he rarely has the opportunity to present his own music, and he is often overlooked by the fixed attention of the star-making publicity machines. Nonetheless, his special talents have never escaped notice of the jazz community.

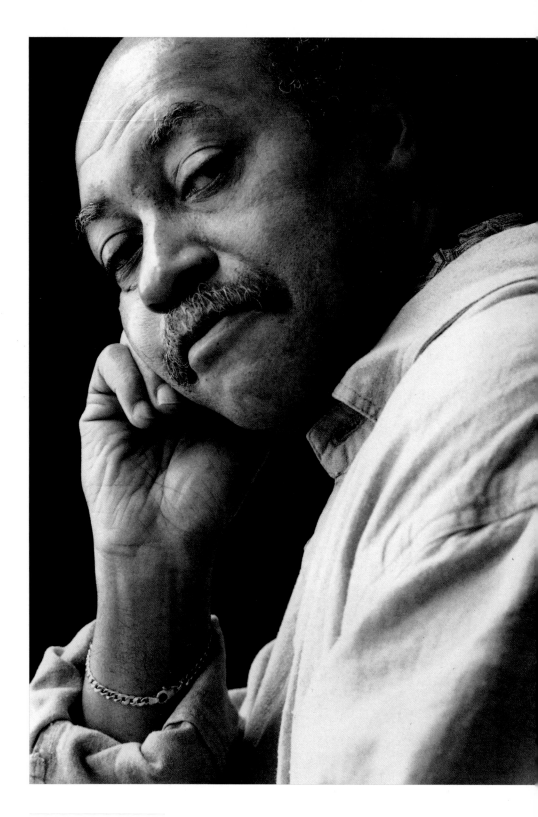

Kenny **BARRON**

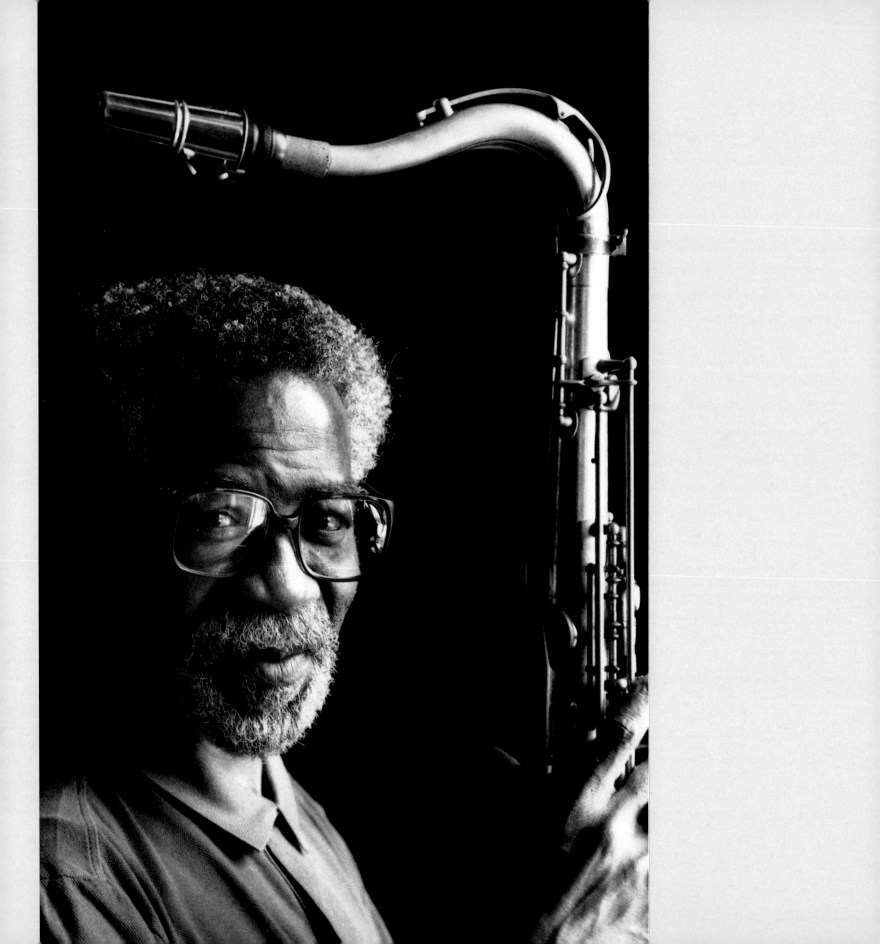

In one of the most heartening jazz success stories of the 1990s, Joe Henderson (b. 4/24/37) is finally receiving the full recognition, awards and record sales due to one of the true titans of the tenor saxophone. Of course Henderson hardly had spent his previous years in obscurity; one of the definitive saxophone stylists of today's jazz, Henderson had spent most of the eighties on the West Coast, where he concentrated on teaching. In recent years, Henderson's solos have edged toward the upper register of his instrument, exploiting a bittersweet tone for his wistful improvisations; warmly received songbook albums of the music of Billy Strayhorn, Miles Davis and, most recently, Antonio Carlos Jobim have been the vehicles to his current rise.

Henderson was first exposed to jazz through his older brother's record collection; discs by tenorman Illinois Jacquet and Lester Young influenced his decision to take up the horn in his early teens. In 1956, Joe Henderson's music studies took him to Wayne State University in Detroit, where he was exposed to the Motor City jazz scene and came under the wing of Barry Harris (that unofficial but veritable professor of Charlie Parker's legacy).

The turning point in Henderson's career would come in 1963 when he formed a unit with trumpeter Kenny Dorham. Dorham's roots went back to the early days of the bebop revolution and he was then at the peak of his powers. *Page One,* the saxophonist's debut album, introduced Henderson to the jazz world as a mature, fully formed artist. Through his many recordings as a leader and sideman, Henderson was one of the most urgent soloists of the sixties (and one of the very few of the period who remained entirely independent of John Coltrane's pervasive pull).

For some months in 1967, Henderson joined Miles Davis's band and then set out on his own as a single, and has toured the globe ever since. His seventies recordings captured Henderson's most exploratory period, as he absorbed elements of free jazz into his increasingly ferocious playing, and experimented with electronic instrumentations.

In the 1980s, Henderson had few recording dates as a leader, but he often acted as sparkplug on other people's dates and in supergroup settings. With the nineties came stardom; what a difference a few albums can make!

Joe
HENDERSON

Wayne Shorter (b. 8/25/33) has straddled the dominant developments of jazz for the past three decades. As musical director of Art Blakey's Jazz Messengers, he was an icon of hard bop; his work with Miles Davis led to further explorations in the 1960s; and as a founder of Weather Report, he spearheaded the success the jazz fusion movement had to offer.

Shorter was reared in Newark and attended New York University. After brief stints with Horace Silver and Maynard Ferguson (where he met Joe Zawinul), and practice with Coltrane, Shorter joined the Jazz Messengers in 1959 for a six-year run. His muscular yet intriguing tenor saxophone lent great vitality to the Messengers, augmenting the hard bop style with a more sophisticated layer. Ultimately, he became musical director of the band and furnished songs such as "The Chess Players" and "Lester Left Town" that have become enduring elements of the repertory. He subsequently released many albums under his own name for Blue Note, bringing forth the lasting compositions "Speak No Evil," "The Soothsayer," "The All-Seeing Eye," and "Witch Hunt," among others.

Yet Miles Davis beckoned and, after fitful attempts to secure his services, brought Shorter into his fold in 1964. Shorter's presence during the rest of the decade helped elevate Miles's groups to further levels of creativity. He contributed to such groundbreaking sessions as *ESP* and *Nefertiti*, and was on the scene as Miles added electronic experiments leading to *Bitches Brew*.

Shorter left Davis in 1970 to form Weather Report with Joe Zawinul. The group became a seminal act of jazz-rock fusion, but in its sophistication it transcended the genre. Weather Report remained together for well over a decade, with a staying power beyond the popular life of the jazz-rock style. Adding the soprano saxophone to his repertoire, Shorter's music continued to evolve. In 1974, he added a Brazilian flair to the mix with singer/guitarist Milton Nascimento on the album *Native Dancer*.

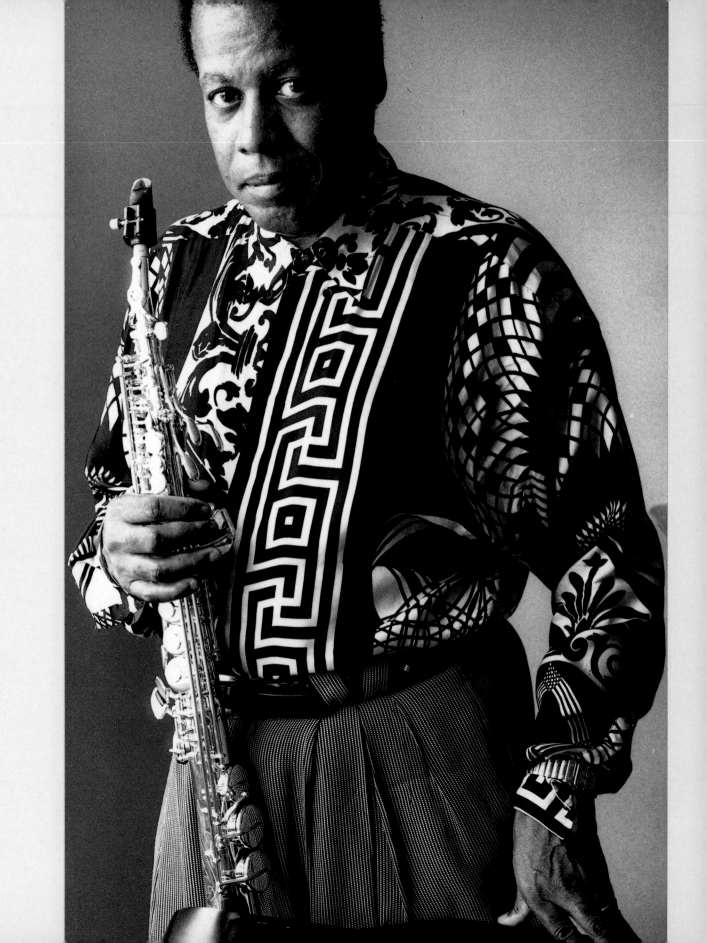

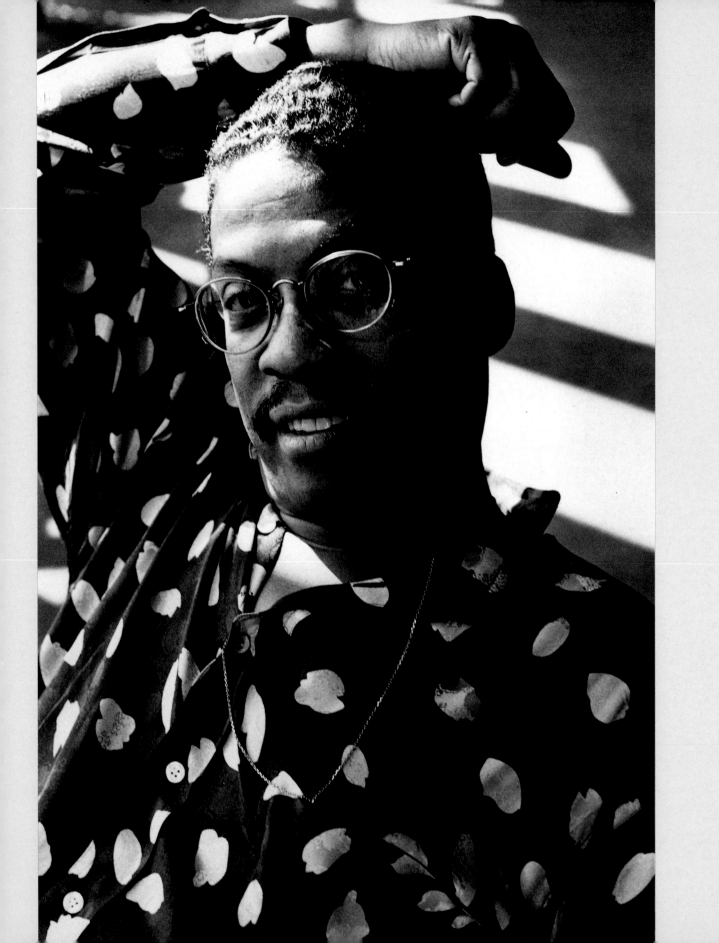

Pianist, composer, and champion of the impact of technology on the music, Herbie Hancock has facilitated the popularization of jazz's many forms.

Hancock (b. 4/12/40) was raised in Chicago in a musical family, and after graduating Grinnell College in 1960 and moving to New York, he quickly became one of the more sought-after sidemen, first with Donald Byrd's group, and then with many other leading bands. Hancock gained immediate prominence with the hit song "Watermelon Man" from his first Blue Note album.

Hancock joined Miles Davis's quintet in June 1963 for five years, forming a remarkable rhythm section with Ron Carter and Tony Williams. Their interaction helped propel Davis's sound during this amazingly fertile period. At the same time, he continued to record as a leader and introduced songs such as "Maiden Voyage," "Dolphin Dance," "Cantaloupe Island," "The Sorcerer," and "Speak Like a Child"; all remain popular to this day.

Leaving Davis, Hancock formed a sextet featuring Bernie Maupin that drew its tremendous energy from the introduction of electronics, as well as the synthesis of rock and world-music elements.

Moving to California in 1973, he took to a more popular approach to his music while continuing to add effects from technological advances. The first recording of his new group, the album *Headhunters,* included the hit single "Chameleon" and enjoyed unprecedented popularity, cementing his move to more commercial endeavors.

Hancock also turned to writing for movies and television, notably including the score for Michelangelo Antonioni's film *Blow Up* and Bill Cosby's animated television series "Fat Albert." In 1987, he would cap his movie success with an Academy Award for the score to *'Round Midnight.*

The year 1983 saw further technological advances and commercial acclaim for Hancock's "Rock-It," which hit number one on the pop charts and heralded the possibilities of the nascent music video industry.

At times, Hancock still performs in traditional jazz settings, but he remains unabashed with his goals for popular music.

Herbie
HANCOCK

Ron Carter (b. 5/4/37) is a most prolific bass player and his abundant output is matched by the exquisite quality of his musicianship. He possesses flawless technique and harmonic inventiveness, and he is equally at home providing rhythmic support or extolling the full possibilities of the instrument as a soloist.

Originally from Detroit, Carter began playing the cello as a youth. He soon switched to bass, but has continued to use the cello occasionally. In recent years, Carter has adopted the piccolo bass for its richer, more cello-like timbres.

His early work included stints with Chico Hamilton, Eric Dolphy and Jaki Byard. Carter's major contribution came during the Miles Davis years, 1963 to 1968, when, together with Herbie Hancock and Tony Williams, he formed a vital part of the essential rhythm section for Davis's adventuresome group. His rhythmic precision provided a center for the exuberant flamboyance of the surrounding proceedings, while his crisp, clear lines brought subtlety and nuance to the more spiritual aspects of the music.

Since that time, while continuing to complement many other bands as a stellar accompanist, Carter has become a leader in his own right. He has put together any number of groups, ranging from small ensembles to a nonet. In his bands, he often employs a second bassist for the rhythm section so that he himself can become the principal soloist. Carter also showcases the bass in a duet setting, performing together with players as diverse as Cedar Walton, Jim Hall and Houston Person.

In addition to his more notable jazz credits, Carter also contributed to recordings by popular singers such as Aretha Franklin, Roberta Flack and Lena Horne. Indeed, no studio is busy without him.

Carter is steadfast in spreading the gospel of this music, and by his example, he is an inspiration to many up-and-coming young bass players such as Christian McBride.

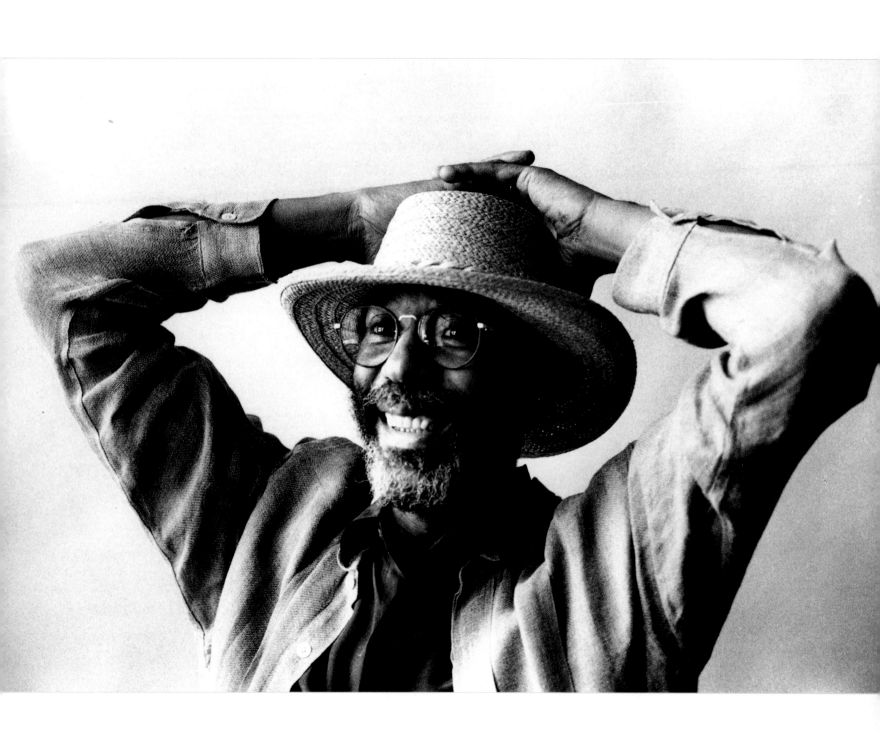

Jack DeJohnette, Dave Holland and Chick Corea formed the rhythm section of the Miles Davis group of the late 1960s, when Davis surged ahead with explorations of jazz-rock and free improvisation, heralded by *Bitches Brew*. While they may be celebrated for this trailblazing work, each has progressed to fulfilling achievements in their own right.

DeJohnette (b. 8/9/42) first came to prominence as the drummer in Charles Lloyd's popular group before joining Davis. Since leaving the trumpeter in 1972,

DeJohnette has formed his own special groups New Directions and Special Edition, which cut across stylistic categories, and worked with Holland in John Abercrombie's Gateway Trio. Additionally, his Fifth World group incorporates world music and Native American themes.

Dave Holland (b. 10/1/46) was the leading young bassist in England when Davis brought him to America. Since then, he has performed in many free contexts: with Corea's free jazz group Circle and with Anthony Braxton, Stan Getz and Sam Rivers. Since 1982, he's been associated with Canada's Banff School of Fine Arts.

Chick Corea (b. 6/12/41) developed an interest in jazz at an early age, but from his earliest professional engagements, he has been imbued with the spirit of Latin music. Prior to joining Davis, he worked with Blue Mitchell and recorded his own sessions on Blue Note. After the Davis years, Corea branched out to explore free improvisation with his group Circle and the lyrical possibilities of fusion with Return to Forever. Corea has become immensely popular with rock audiences, and since 1985 he continues to purvey this music with his Elektric Band, while his Akoustic Band provides straight-ahead rhythms. Corea's romantic side is evidenced by his compositions "Spain," "Windows," and "Crystal Silence," which are now standards.

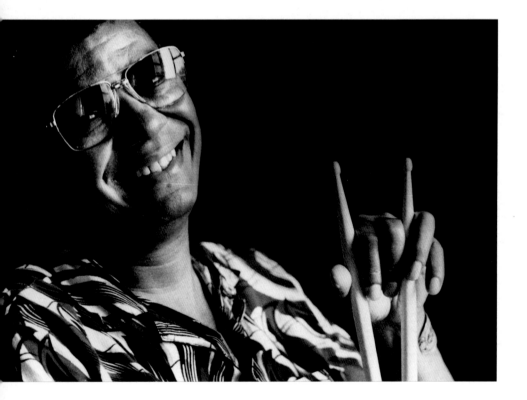

Jack **DeJOHNETTE**

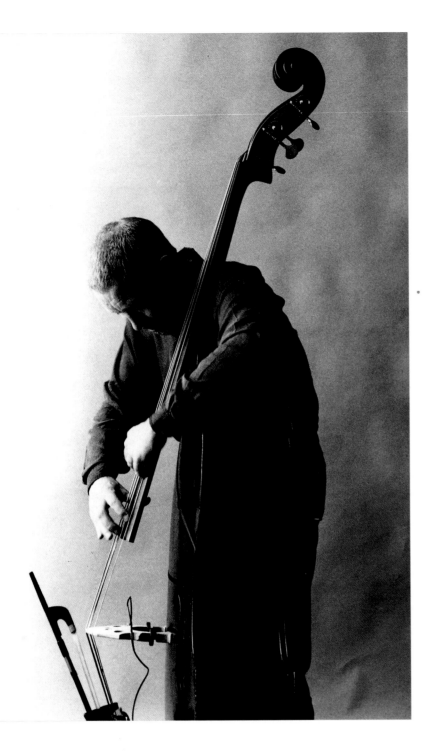

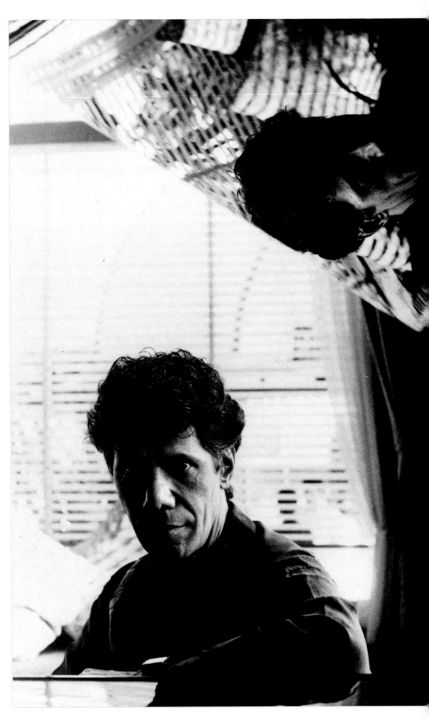

Dave **HOLLAND**

Chick **COREA**

McCoy
TYNER

McCoy Tyner (b. 12/11/38) is best remembered from John Coltrane's group, but in the decades since he has become one of the major pianists, expanding the vocabulary of color and harmony. His lusty piano is richly percussive and hammering, while full of cascading and romantic sounds.

Tyner, originally from Philadelphia, studied at the Granoff School of Music. His first main exposure came with Benny Golson, and he was the first pianist in Golson and Art Farmer's legendary Jazztet. By 1960, when John Coltrane was searching for ways to expand his own music, Tyner was the pianist of choice because he was best suited to accompany the modes of Coltrane's vision. Tyner continued with Coltrane through 1965, participating in all the major recording sessions.

While with Coltrane, Tyner also recorded many of his own albums for Impulse!, including such classics as *Inception, Nights of Ballads and Blues,* and *Live at Newport,* and later for Blue Note, that enabled him to feature his densely rich piano sound to great effect.

Upon leaving Coltrane, there was a lull in Tyner's popularity, but he rebounded in the 1970s with groups featuring Sonny Fortune and Azar Lawrence, and recordings for Milestone like *Sahara* spurred recognition. He achieved a revived appreciation as a major player on the international jazz scene, a status he continues to maintain. Since 1980, he has also arranged his lavishly textured harmonies for a big band that performs and records when possible. While he avoids modern conventions and the trappings of the moment, Tyner's sound remains contemporary to this day.

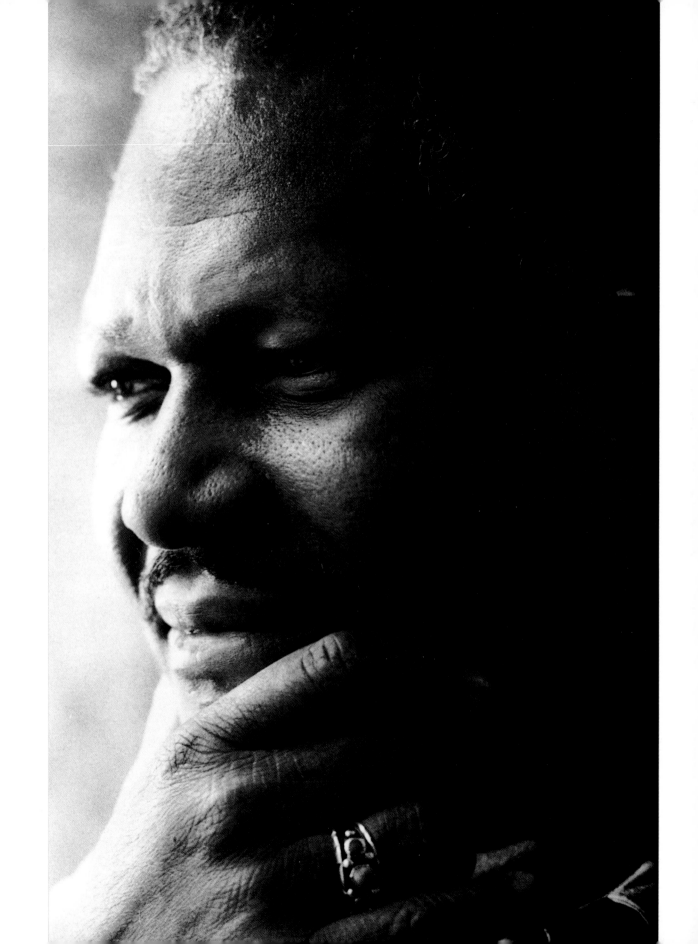

Elvin Jones (b. 9/9/27) is an electrifying dynamo on the drums. Revolutionizing the role of the percussionist in the 1960s, his influence is widely felt. He occupies the next place in the line of dominant percussion innovators, following the great drummers of the bop years.

Elvin is the youngest member of the Jones family (after Hank and Thad) to come out of Detroit and stake a claim among the jazz masters. Starting in the house band at the Bluebird, the Motor City's premier club, Jones gained broad experience with the jazz greats of the 1950s, and he recorded with brother Thad, Pepper Adams, J. J. Johnson, and Donald Byrd.

Jones's most significant contribution came during his years with John Coltrane, from 1960 to 1966. He performed with a screaming intensity that was the perfect accompaniment for Coltrane's searching music. The extensive use of cross-rhythms and open forms provided a foundation for the free expression of the group's sound.

During these years, Jones recorded significant albums as a leader, including *Elvin!* on Riverside and *Illumination* with Jimmy Garrison on Impulse!. After leaving Coltrane, he had great success with a pianoless trio featuring reedman Joe Farrell. Later bands in the seventies that included Frank Foster, George Coleman, Steve Grossman, Roland Prince, and Gene Perla toured frequently. After assuming a lower profile for a bit, Jones, now in his sixties, has been highly visible with his Jazz Machine groups, and shows no signs of slowing down.

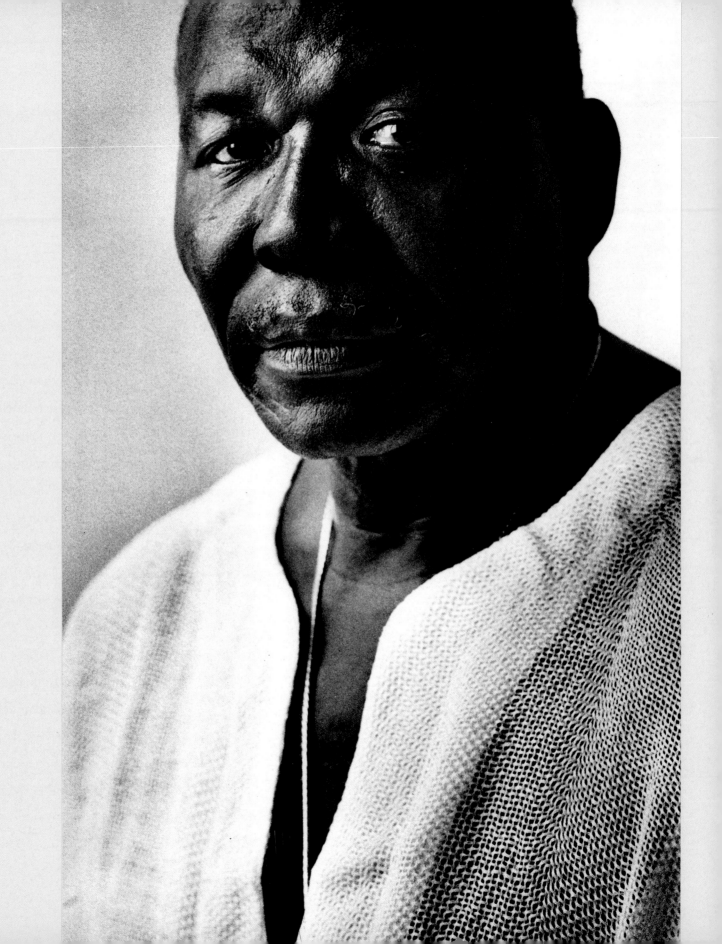

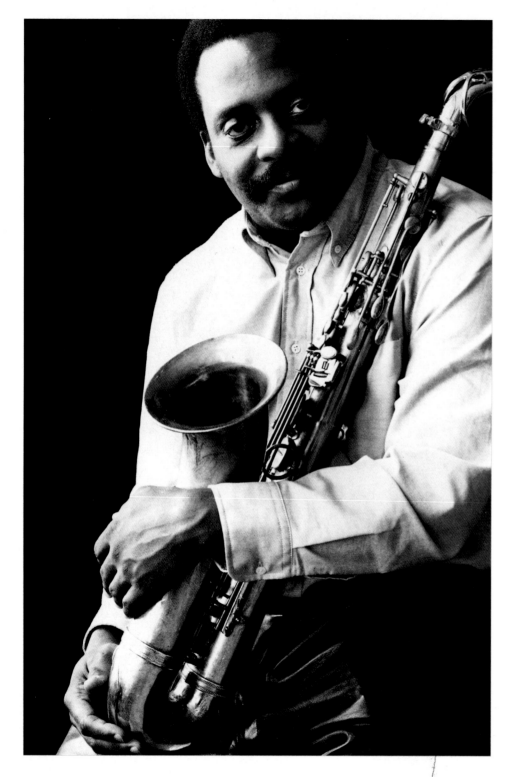

David **MURRAY**

David Murray (b. 2/19/55) is today's great innovator and one of the most dynamic soloists to arrive in years. As a tenor saxophonist, bass clarinetist and composer, he is the linchpin of recent developments in jazz. In 1990, he became the second person to win the prestigious International Jazzpar Prize.

He has amalgamated the tenets of free jazz in synthesis with a broad expression of black music's heritage, from Ellington and Coleman Hawkins through soul jazz and rhythm and blues. To advance his music, Murray convenes bands of all shapes and sizes.

Murray left Pomona College in California for New York in 1975, encouraged by Bobby Bradford and Stanley Crouch. He was soon to form the World Saxophone Quartet with Oliver Lake, Julius Hemphill and Hamiet Bluiett and to become active in the burgeoning "loft jazz" scene. Murray performed with all major

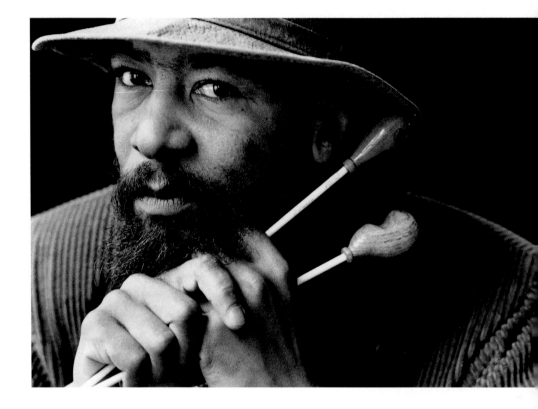

figures of the avant-garde, imparting his own creativity and soul to the cerebral music.

Murray's ambitious enterprises include any number of theatrical scores and extended compositions. He also plays in the Clarinet Summit group with John Carter, Alvin Batiste and Jimmy Hamilton, where Murray uses his ability to shine on the bass clarinet; he is a major virtuoso on this uniquely timbred instrument. The wide-ranging Murray also has appeared as a sideman with Sunny Murray, James Blood Ulmer's Music Revelation Ensemble and Jack DeJohnette's Special Edition.

While he performs in settings ranging from solo concerts and duos to gospel choirs and string ensembles, the greatest expression of his music comes in his octets and free-blowing big bands. Murray's childhood friend Butch Morris remains his longtime colleague and conductor of the orchestras.

Butch Morris (b. 2/10/47), a cornet player, hails from Oakland, and in the mid-seventies followed his friends David Murray and Frank Lowe to New York, where he stayed briefly and played free jazz. Morris moved to Europe for five years and performed with Lowe, Alan Silva, Frank Wright, and his own groups.

Since that time, he has developed his unique style of "conduction" that lends itself to his own free-flowing projects as well as those of Murray's bands. He is also a composer whose recordings, on both his own albums and Murray's sessions, have received critical acclaim.

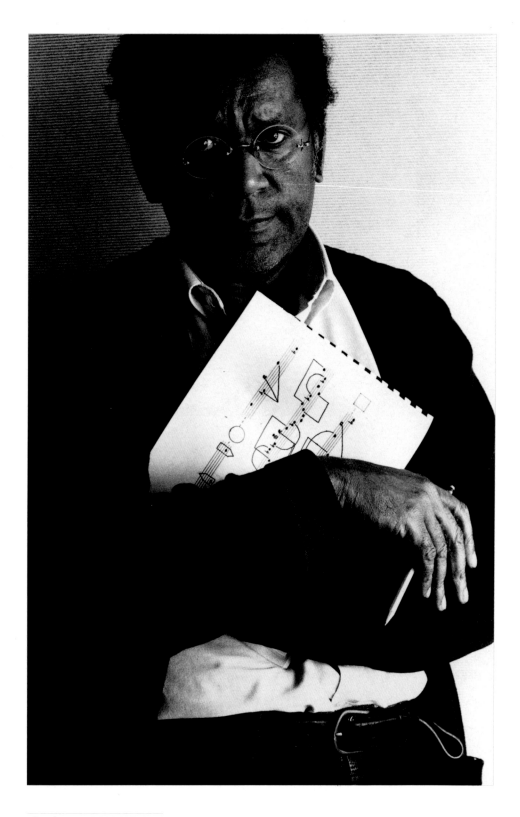

With his trademark cardigan sweater and scholarly diagrams, Anthony Braxton (b. 6/4/45) professes an erudite music. His is a singular conception, a programmatic composer of densely intellectual scores. He primarily performs on the alto saxophone but is fluent on all members of the saxophone and clarinet family, including the novel contrabass clarinet.

Braxton was raised in Chicago and studied the modern composers Stockhausen, Cage and Ives. Roscoe Mitchell brought him into the Association for Advancement of Creative Musicians in 1966, and Braxton flourished for a time with its experimental ideas, later founding the Creative Construction Company with Leroy Jenkins, Leo Smith and Muhal Richard Abrams. His first recording with them was *Three Compositions for New Jazz* (Delmark). He also has made a revolutionary solo saxophone record *For Alto.*

Moving to New York after an unsuccessful Paris sojourn, Braxton expanded his horizons with Chick Corea's free-jazz group Circle and as a leader of his own quartets.

Braxton is a longtime faculty member at Wesleyan University, where he is a revered giant. In 1993, he was awarded a MacArthur Fellowship; the so-called genius grant is a fitting prize.

Anthony **BRAXTON**

Among the most important achievements of Evan Parker (b. 4/5/44) is his expansion of the vocabulary of the saxophone; he utilizes flutter-tonguing, circular breathing and alternate fingerings to create mesmerizing waves of sound, with a remarkable ability to exploit multiple registers of his instrument simultaneously. Parker stands with Anthony Braxton and Steve Lacy as one of the true masters of solo saxophone improvisation; in this format, he works primarily on soprano, often combining the instrument's high overtones with undulating currents of notes. Although he performs solo on tenor as well, his most effective music on that instrument has been made in duos or with ensembles of free improvisers.

Together with musicians like guitarist Derek Bailey and drummers John Stevens and Tony Oxley, Parker is one of the original group of musicians who developed free playing in Great Britain in the mid-sixties. Parker's music is free, but his sputterings and wails are the product of his highly controlled virtuosity. The point of origin for his explorations was a John Coltrane influence, of which traces can still be heard; however, the saxophonist has long broken through to his own highly original mode of performance.

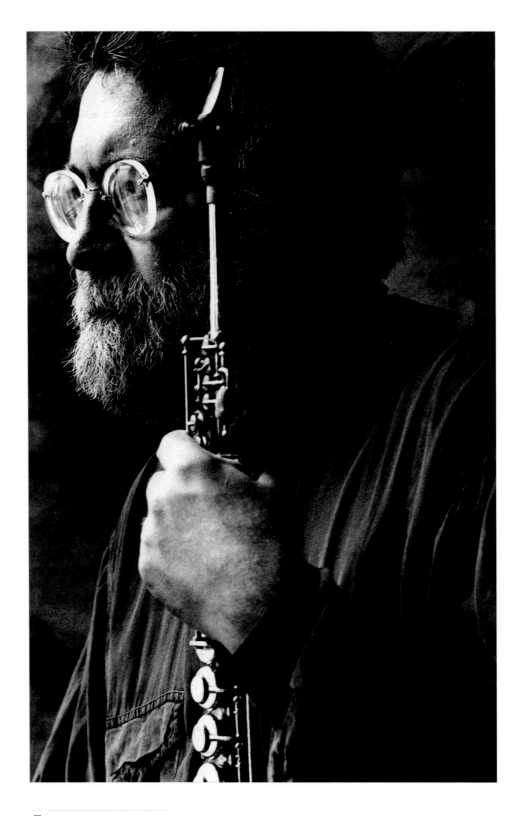

Evan **PARKER**

Arthur Blythe (b. 7/5/40) is a master of sublime power and control on the alto saxophone. Blythe was instrumental in the avant-garde scene in Los Angeles with Horace Tapscott in the 1960s. His career took strange turns in later years—he was promoted as a pop musician by Columbia Records and led the aptly named group In the Tradition. He's returned to prominence as a mainstay of the all-star, free-jazz group the Leaders.

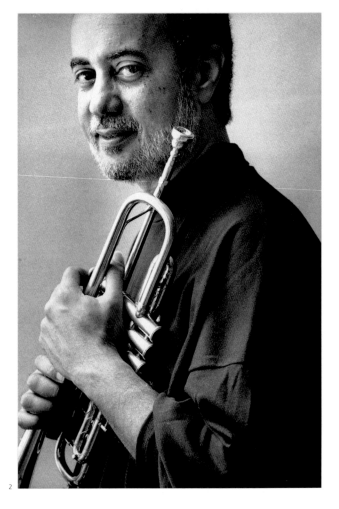

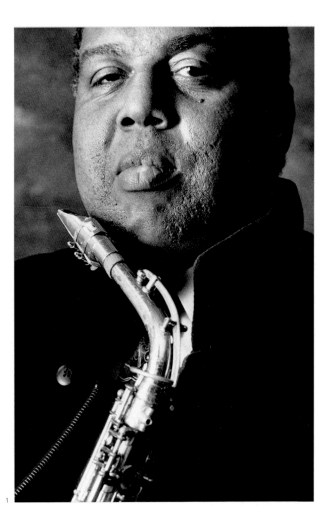

1 *Arthur* **BLYTHE**

2 *Cecil* **BRIDGEWATER**

Cecil Bridgewater (b. 10/10/42) is one of jazz's superb improvisers on the trumpet and flügelhorn. Bridgewater hails from Champaign-Urbana and studied at the University of Illinois there. In the 1970s he played with the Thad Jones–Mel Lewis orchestra; their album *Love and Harmony* featured his sensitive compositions. Bridgewater now works often with Max Roach and, though he has become active as an educator, he continues to grace many bandstands.

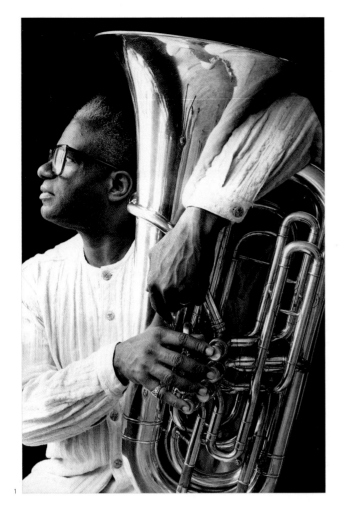

A bass player for impressionistic settings, Marc Johnson is one of the subtler masters. Johnson (b. 10/21/33) was Bill Evans's discovery and his last bassist. In this regard, he is acclimated to advanced harmonic structures. In the 1980s, his group Bass Desires, with Bill Frisell, Peter Erskine and John Scofield, featured his skills as a leader and composer. His recent trio is Right Brain Patrol, and he continues to work with John Abercrombie and Lyle Mays, among others from this adventurous side of jazz.

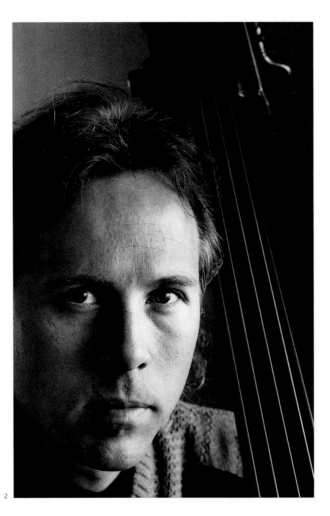

With his strong breathing techniques and command of his instrument, Bob Stewart (b. 2/3/45) has helped liberate the tuba from its awkward roots to occupy an integral part in free jazz. Stewart has been an important member of the big bands of Gil Evans, Carla Bley and David Murray. He's worked in tuba ensembles, such as Gravity, and in Lester Bowie's Brass Fantasy. In his work accompanying Arthur Blythe, he was so dominant that the group became known as the "tuba band."

1 *Bob* **STEWART**

2 *Marc* **JOHNSON**

When Jon Faddis (b.7/24/53) arrived in New York in 1972, he made a spectacular impression; not quite twenty years old, he was already hitting notes in the stratosphere with the speed and power that led the late bassist Charles Mingus to proclaim that "he has the chops to be one of the greatest trumpet players in the world." Under the direction of his teacher Bill Katelano (a Kenton alumnus), Faddis cut his jazz teeth on his instrument practicing Gillespie solos, breaking them down measure by measure. In 1968, Gillespie found a teenager waiting backstage at the Monterey Jazz Festival with a big stack of his records for him to autograph. Faddis even sang some of Gillespie's famous solos back to him, and a week later, appeared with his trumpet to sit in with Gillespie at San Francisco's Jazz Workshop club. So began Faddis's personal connection with the great trumpeter, which over the years grew from a mentor-protégé relationship to a deep friendship between artists.

Faddis arrived in the Big Apple as a former member of Lionel Hampton's big band (he had joined the ensemble right out of high school); "I quit Hamp's band in January of '92," as Faddis recalls, "because Dizzy was doing two weeks at the Village Vanguard and I didn't want to miss it. So, I gave him my notice before that because I knew that I wanted to be there every night. And I was." The following month, Faddis unexpectedly found a showcase that dramatically set off his New York career. Charles Mingus had composed *Little Royal Suite,* an extended composition, to feature trumpet legend Roy Eldridge for the bassist's upcoming Lincoln Center concert. Roy had to cancel his appearance, and the newcomer Faddis was recommended to take his place. Soon Faddis was a very busy trumpeter indeed: he toured with a Mingus sextet, gigged with Gil Evans, fulfilled another dream by joining the Thad Jones–Mel Lewis Band (playing four years of Monday nights at the Vanguard), filled in the remainder of his calendar with studio work and, of course, sat in with Gillespie whenever he had the chance.

The duo shared the stages of concert halls all over the world until Gillespie's death in 1993; Diz has remained Faddis's primary stylistic influence (and Gillespie always looked as pleased as punch whenever the younger trumpeter played a solo), but he began moving away from the sound of his mentor in earnest by the early eighties. His *Into the Faddisphere* album was a declaration of independence of sorts. Faddis's solos are disciplined creations that set off held, piercing high notes with phrases that are runaway torrents of sound. An essential participant in New York's repertory jazz scene since its concept of revisiting classic jazz performances in concert settings took form two decades ago, Faddis is presently directing the program and performers of the Carnegie Hall Jazz Band.

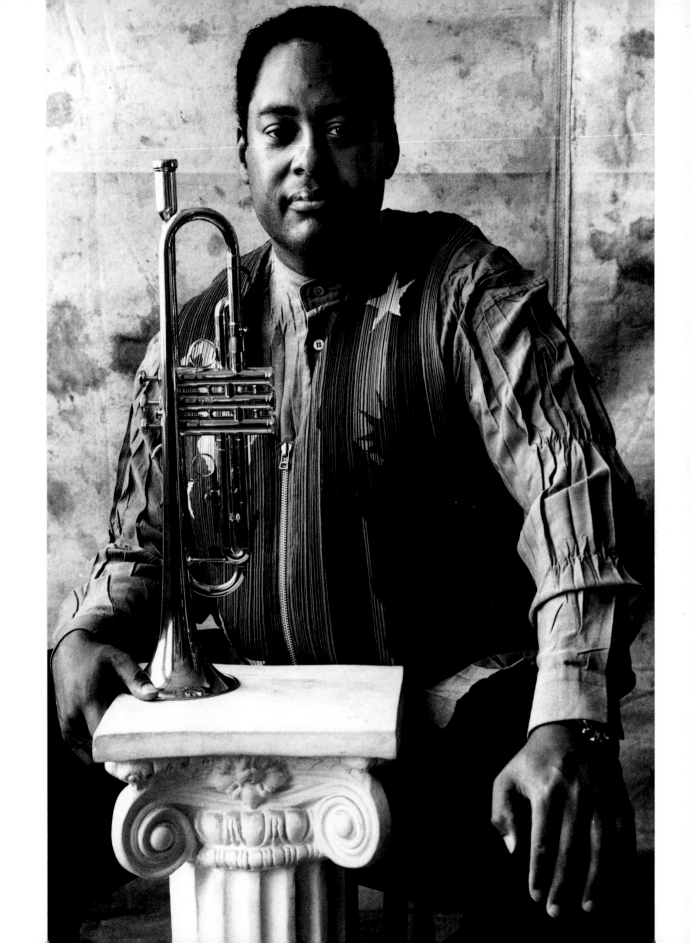

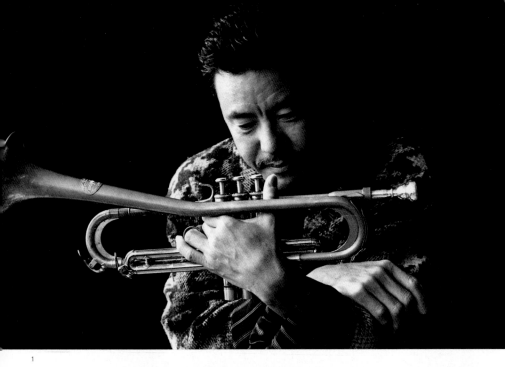

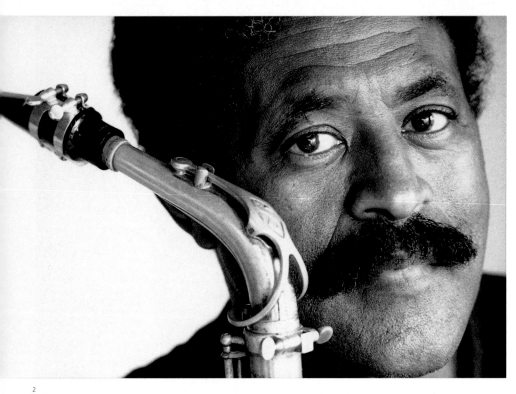

Terumasa Hino (b. 10/25/42) plays the trumpet, flügelhorn and cornet in a brilliant brassy style, but can be soft and lyrical when needed. After extraordinary success in his native Japan, Hino made the leap to stardom on the international festival scene in the 1970s. With a detour to great success in the jazz-rock vein notwithstanding, Hino produced a series of fine jazz albums on Blue Note in the 1990s.

While still a teenager in Detroit, alto saxophonist Charles McPherson (b. 7/24/39) came under the wing of the bebop professor "Coach" Barry Harris. After a two-year apprenticeship, McPherson made his move to New York in 1959, where he met the late Charles Mingus. McPherson's emotionally charged, Bird-influenced solo flights were featured in the great bassist's concerts and recordings on and off for the next fourteen years. McPherson has often been called upon to invoke the spirit of Charlie Parker's music (most recently for the sound track of Clint Eastwood's bio-pic *Bird*), and until he relocated to southern California in the late seventies, McPherson was often reunited on stage and in the studio with Harris. The saxophonist's current quartet features his talented son, drummer Chuck McPherson.

1 *Terumasa* **HINO**

2 *Charles* **McPHERSON**

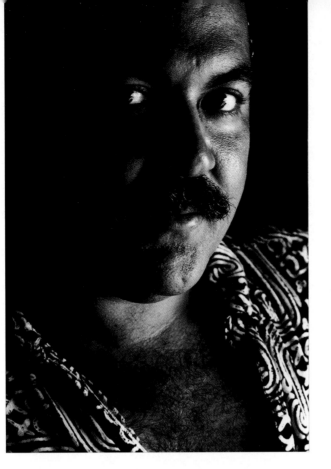

1 *Hilton* **RUIZ**

2 *Don* **ALIAS**

Veteran percussionist Don Alias (b. 12/25/39) is a wizard, incorporating the rhythms of the world to the beat of the conga and other instruments.

Known for his cheerful disposition, Alias brought the feeling of jazz to Joni Mitchell's Mingus project and Hal Willner's *Weird Nightmare.* He has combined with Tony Williams, David Sanborn and Charlie Haden to add vital percussive effects and in recent years is a welcome addition to many contemporary projects by the likes of Joe Lovano, John Scofield, Don Grolnick, and Arturo Sandoval.

Hilton Ruiz (b. 5/29/52) came out of Spanish Harlem to become one of the more thrilling and energetic pianists. Classically trained as a youth, and later skilled in jazz as a student of Mary Lou Williams, Ruiz also manages to incorporate fiery Latin rhythms into his playing. Nevertheless, he remains truly a modern jazz musician. Ruiz first came to prominence as a member of Rahsaan Roland Kirk's 1970 groups, and he also played with Cal Massey, Frank Foster and Jackie McLean's Cosmic Brotherhood. Today he is dominant as a leader, using his wide experience to take the helm of varying aggregations.

After decades of apprenticeship, Joe Lovano (b. 12/29/52) burst forth as the major tenor saxophone star of the nineties. In 1976, he embarked on a two-and-a-half-year stay with Woody Herman, followed by longer stretches of big band experience with Thad Jones–Mel Lewis.

His next key stop was Paul Motian's group, and other important associations included Elvin Jones, Bill Frisell, Charlie Haden, and John Scofield. Lovano finally broke through in 1991 with engagements in a band with Ed Blackwell, a legendary debut appearance as a leader at the Village Vanguard and *Landmarks,* the first of many telling albums. He now appears in many contexts—a pianoless quartet with Tom Harrell, two tenor battles with youthful sensation Joshua Redman, his *Wind Ensembles* and *Rush Hour,* with its Gunther Schuller orchestrations, form a vast instrumental palette.

Tom Harrell (b. 6/16/46) plays with crystalline precision and melodic brilliance, contributing to any number of sessions with enlightened beauty. Harrell suffers from a severe psychopathology, yet under the treatment of medication he is controlled and sharply focused, attributes evident in his playing. He has spent time in big bands and had major exposure in the small groups of Horace Silver, Mel Lewis and Phil Woods. Harrell has now emerged as a major player on the contemporary scene, in the company of some of the leading soloists of the nineties.

Joe **LOVANO**

Tom **HARRELL**

Michel **PETRUCCIANI**

Michel Petrucciani (b. 12/28/63) plays the piano with shimmering lyricism combined with a spontaneous freedom of improvisation and association.

Petrucciani was classically trained in his native France but learned his jazz lessons early, influenced by Bill Evans and Bud Powell. At 17, he moved to Paris and gained international recognition when he coaxed his idol Charles Lloyd out of retirement and played in his quartet at the 1982 Montreux Jazz Festival.

Born with the disability of a calcium deficiency (osteogenesis imperfecta), Petrucciani stands only three feet tall; incredibly, though, he has huge hands and an amazingly broad reach on the piano. He plays with formidable power and demonstrates the ability of music to enliven the soul. Petrucciani makes a striking appearance in his performances, which are of major stature.

JoAnne Brackeen (b. 7/26/38) is an idiosyncratic pianist; she can play with thunder or tender grace, both mixed with a freedom developed from years of struggle.

Brackeen grew out of the modern jazz of her native California, and later attracted attention for her 1970s work with Art Blakey and Joe Henderson. She now performs in trios backed by the likes of Eddie Gomez and Jack DeJohnette. Notable recordings include *Special Identity* and *Where Legends Dwell*. Her individualism has denied her wider popular support, but she remains an insider's pianist.

JoAnne **BRACKEEN**

SOMEONE CLAIMING TO BE A FAN of "real" jazz has felt betrayed at each step in the music's evolution. The regimentation and grandiose ensemble size of the swing orchestras struck some lovers of the first New Orleans ensembles as ultimate heresy, many big band fans adopted the perspective of Cab Calloway, who once dismissed bebop as "Chinese music," and John Coltrane's marathon solos were labeled "anti-jazz" by some of the same commentators who had defended the modernists a decade earlier. Today we view these successor styles as part of jazz's basic continuum, while the more popular syntheses worked upon jazz in the past quarter-century are often treated as another matter altogether.

Then again, fusions exposing jazz to the transformative impact of other musics are not that new, or that alien to its own roots. A most natural blending, that of jazz and Latin music, makes the point quite well. It was Jelly Roll Morton who first identified the Spanish tinge with an *habanera* rhythmic dip that flowed so effortlessly into the breaks and riffs of his own compositions and improvisations. Rhumba from Cuba, tango from Argentina, samba from Brazil—each won an audience in the United States before the jazz-Latin mix began in earnest during the early 1940s, when musicians such as Mario Bauza and Dizzy Gillespie applied their experience in both areas to create the first explicitly multicultural jazz hybrid. A mambo king of the fifties like Tito Puente was the natural product of this merger, just as Puente's sustained growth has paved the way for the bi-musical likes of Dave Valentin and Arturo Sandoval.

Jazz and more popular derivatives of the blues go back a ways as well. The link is clear enough in rhythm and blues, where the mark of Lester Young, Illinois Jacquet, Fats Waller, and other jazz players is unmistakable; and even the more attenuated relation between jazz and rock and roll cannot hide true-blue linkages. Ray Charles, whose music can accommodate any of these labels and some even further afield, built his all-encompassing approach on an overt fealty to the emotional fervor (and often the thinly disguised forms) of black church music, an achievement that earned Charles the title of genius and showed many jazz instrumentalists a way to a wider audience. "Funk" is a term, like "jazz," subjected to rapid redefinition; but in its musical beginnings funk meant the instrumental preaching of pianists like Ramsey Lewis and Les McCann, who often applied sanctified takes to old rock tunes like "The In Crowd." It was jazz, however simplified, and it found a place on the hit parade without abandoning jazz's preference for acoustic instruments.

Amplification only upped the ante. During the second half of the 1960s, rock music became more ambitious (and on occasion more pretentious), as new electronic instruments and studio techniques enhanced the librettos of a more liberated and cataclysmic period where war politics clashed with peace politics. At least some jazz musicians, particularly the younger ones who had grown up on rock, could not help but respond to the charged environment with many of the same tools. History records some key pioneers in this effort—the band the Free Spirits, including Larry Coryell, Jim Pepper and Bob Moses; vibist Gary Burton's quartet with Coryell and Moses; flutist Jeremy Steig's group the Satyrs—but the essential figure was a veteran who had already lived through 20 years of innovation: Miles Davis. The trum-

peter began by suggesting that his pianist Herbie Hancock play an electric keyboard, and by the 1969 recording *Bitches Brew* Davis had totally reconfigured his band to include multiple electric keyboards, electric guitars and basses and miscellaneous percussion. Davis's working and recording groups were launching pads for the leaders of jazz-rock fusion, the sons of *Bitches:* drummer Tony Williams (Lifetime), saxophonist Wayne Shorter and pianist Joe Zawinul (Weather Report), pianists Hancock (Sextet and Headhunters) and Chick Corea (Return to Forever), and guitarist John McLaughlin (Mahavishnu Orchestra). Suddenly jazz was loud and electric enough to fill rock palaces like the Fillmore, which it did in bills that paired Gary Burton and Cream or Davis and the Who.

A significant result of fusion's success was the emergence of the guitar, for the first time in jazz history, as the focal point of innovation. Prior to the adoption of the electric instrument by Eddie Durham, Charlie Christian and others in the swing era, guitars often went unheard in jazz ensembles; and even after the innovations of Christian, Les Paul and T-Bone Walker in the 1940s, it was common for jazz guitar players to adopt a hornlike, almost acoustic tone. Wes Montgomery had already shown, however, how to bend amplification to the ends of personal expression (and, concurrently, how to break into the more lucrative world of pop music), while the truly crossbred blues/rock/jazz/electronics virtuoso Jimi Hendrix served up an example of how the guitar might simultaneously encompass the most bedrock memories and visit worlds that reached beyond tomorrow. Young jazz players were impressed; they had heard the future, and it was not Joe Pass. Some, like

John Abercrombie, Pat Metheny and Bill Frisell, even employed the guitar synthesizer for broader sonic vistas. In the last decade of his career, Miles Davis kept the guitar pool stocked by featuring yet another generation of stars-to-be, including Mike Stern and John Scofield.

The music these fusion leaders made was challenged by a new camp of purists, who felt that to plug in meant jazz had been tuned out. They had a point when they argued that electric instruments made the development of an individual sound more difficult; yet this concern, plus the greater availability of all kinds of music worldwide, actually created a more level field of exchange that encompassed the entire globe. There was no corner of the world where records and that newest invention, the cassette tape, were not making the sounds of jazz and every other musical form readily available; and, if some locations were too remote to lend an aspiring musician all of the latest technological tools, then a homegrown variant would be produced in response.

All this fusing created more uncertainty than ever about where jazz ends and an improviser's output becomes something else. Consider the numerous recorded appearances of David Sanborn or the Brecker Brothers, who play jazz yet often work in the service of others who would never be considered jazz musicians; or vocalists like Al Jarreau, Dianne Reeves and Bobby McFerrin, each of whom has enjoyed significant popular success with material that veers sharply from their more jazz-centered efforts. Falling walls became symbolic of where history had led by the end of the 1980s. Jazz had the wrecking ball out early, and still slams away at rigidities of sound, form and function.

Tito
PUENTE

There is no better proof that jazz speaks a universal language than the music of Tito Puente. He has been influential both as a composer, with an unprecedented run of hits in the 1950s that helped define a golden era of Latin music, and a virtuoso timbalero, whose speed and agility set a new standard for the instrument. With four Grammy awards, over 100 recordings as a leader and a career that spans seven decades, Puente is not only the Mambo King, he's the undisputed King of Latin Jazz.

A native of New York's El Barrio, or Spanish Harlem as it was known in 1923, Puente was a precocious child. By the age of thirteen he was playing percussion regularly with Los Happy Boys at the Park Palace Hotel. In 1939, he was hired by Jose Curbelo, one of the leading Latin musicians, to play on his orchestra's national tour. By 1942, when the percussionist was drafted into the navy, he had already played with the legendary Machito Orchestra. Following his discharge with a Presidential Commendation in 1945, he enrolled in the Juilliard School of Music. During his matriculation Puente led his own Copacabana Group, while playing regularly with Curbelo, Pupi Campo and Fernando Alvarez.

The fifties held a string of hits, such as "Abani-quito," "Babarbatiri" and "El Rey del Timbal," each showcasing his unique mastery of the timbales. No one ever played so fast before or since. From his position in the band, Puente was able to turbocharge a song or lightly decorate the melody. Puente was an innovative composer as well. He brought the charanaga tradition into the Mambo.

Puente began a collaboration with jazz legend Woody Herman in the 1960s, and introduced American audiences to such legendary vocalists as La Lupe and Celia Cruz, and future bandleaders Ray Barretto and Mongo Santamaria. Puente also released four all-percussion records that are still regarded as classics. His biggest hit, "Oye Como Va," came in 1963; already a smash for Puente in the Latin community, it became one of the best known songs of the era after rock guitarist Carlos Santana recorded it seven years later.

In the seventies, Puente turned his attention toward Latin jazz, and both his large and small combos have had enormous success.

Puente was an instrumental figure in the merger of jazz and Afro-Cuban rhythmic prerogatives. His popular hits and continuing presence serve as a reminder that Afro-Cuban was the first fusion and that there is still gold to be mined from that region.

Dave **VALENTIN**

A native of the South Bronx, Dave Valentin was one of the first musicians to bring Afro-Cuban rhythms to contemporary jazz fusion. Valentin, a flutist, brought a highly developed rhythmic sense to his music and a rare ability to make his piccolo instrument stand out against its louder counterparts.

Throughout fifteen recordings as a leader, Valentin has experimented with new voicings for his instru-ment, sometimes joining choirs of South American flutes. After a stint as musical director for Tito Puente's Golden Men of Latin Jazz, he was moved to record his own traditional album, *Tropic Heat.* Instead of storied veterans, Valentin sought out younger players and may continue to use the assemblage as a springboard for the next generation of Latin jazz.

Arturo Sandoval (b. 11/6/49) may be Cuba's greatest musician, and the island nation's greatest cultural loss. The red hot trumpeter who is fluid in both jazz and classical music and who for years was spoken of as "the best trumpeter that you won't hear in this country" defected in dramatic fashion in 1990; since then he has been building a promising career in the United States.

Sandoval was born in Artemisa, just outside of Havana. He took up formal training on the trumpet when he was twelve, first with classical music then jazz. He quickly developed proficiency in both styles and performed with the Orquestra Cubana de Musica Moderna and the Leningrad Symphony. He founded Irakere with some of his colleagues from the Cuban orchestra, most notably Paquito D'Rivera (who defected in the late seventies). The band blended Afro-Cuban rhythms and jazz's harmonic structure with great success. They toured internationally, winning awards and even recording twice for Columbia Records before the Cold War reintensified in the early eighties. Sandoval left the band in 1981 to form his own ensemble, which toured Latin America and Europe. His defection came while in the midst of a European tour in 1990.

Resettling in Miami, Sandoval began recording for GRP as well as touring with the United Nation Orchestra lead by Dizzy Gillespie, who became a mentor. Of his own recordings, "I Remember Clifford" has received the best notices. Sandoval has most recently written music for the film *The Perez Family* and taken on a full professorship at Florida International University.

Arturo **SANDOVAL**

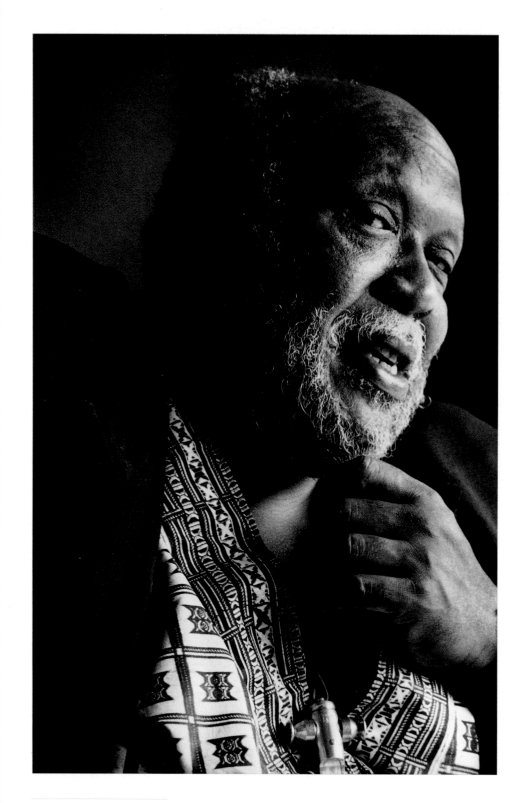

Les **McCANN**

Sometimes a variety of social and musical forces collide in a single electrifying moment. Such was the case in 1969 at the Montreux Jazz Festival when pianist/ vocalist Les McCann (b. 9/23/35) and reedman/trumpeter Eddie Harris (b. 10/20/34) performed a version of Gene McDaniels "Compared to What." The song catalogued a sense of rage over American living standards; the church, the police and anti-abortionists, the complacent middle class and, of course, the war in Vietnam were attacked. "Possession is the motivation/ that is hanging up the goddamned nation," closed the first verse. McCann sang as if it were his personal litany of grievances, while Harris played with pithy economy. The song galvanized the crowd and became a standard on the streets of black America.

For McCann the hit was a long time in the making. Born in Lexington, Kentucky, to a musical family, he had tried his hand at many different instruments before he settled on the piano. After a stint in the navy, where he won a battle of the Armed Forces bands contest on the "Ed Sullivan Show," McCann settled in California and honed a soulful gospel-y approach to the keyboards while gigging around with his trio. Although he had an offer from Cannonball Adderley,

McCann instead chose to focus on his career as a leader. He recorded with Richard "Groove" Holmes and Ben Webster in 1961 and appeared on Lou Rawls's debut in 1962. He recorded twice with the Gerald Wilson Orchestra in the mid-sixties, and tinkered with electric keyboards before hooking up with Harris.

For the saxophonist, commercial success was nothing new: One of Harris's first recordings, the theme from *Exodus,* sold millions in 1961. He spent the rest of the decade working with a variety of stellar players in both the jazz and rhythm and blues areas including King Curtis, Jimmy Owens, Muhal Richard Abrams, Billy Higgins, Ron Carter, Cedar Walton, and Grady Tate. He experimented widely on electric saxophones but was at his best unplugged. His terse solo lines were well-suited to the shuffling rhythms of the soul jazz of the sixties.

McCann has divided much of the last quarter-century between his piano playing and his deep, yet gruff vocals. Harris is widely hailed for his straight-ahead jazz records. The two men do reunion tours and have built a substantial following in London, where the acid jazz scene is discovering their music.

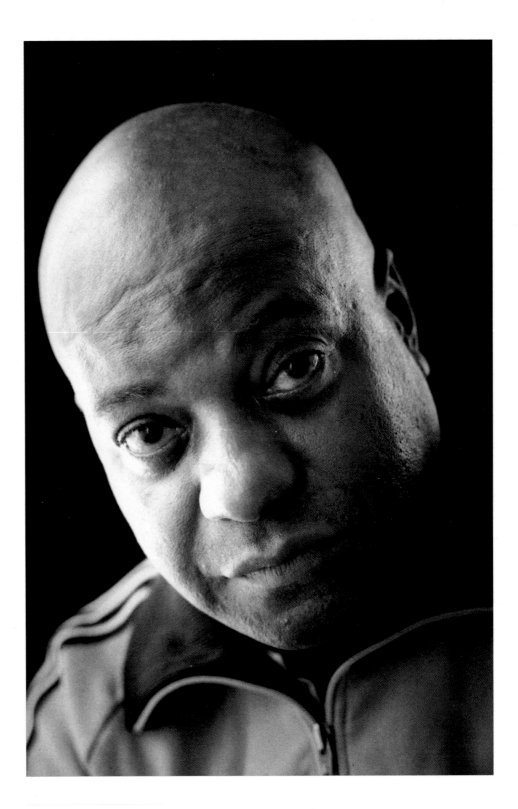

Eddie **HARRIS**

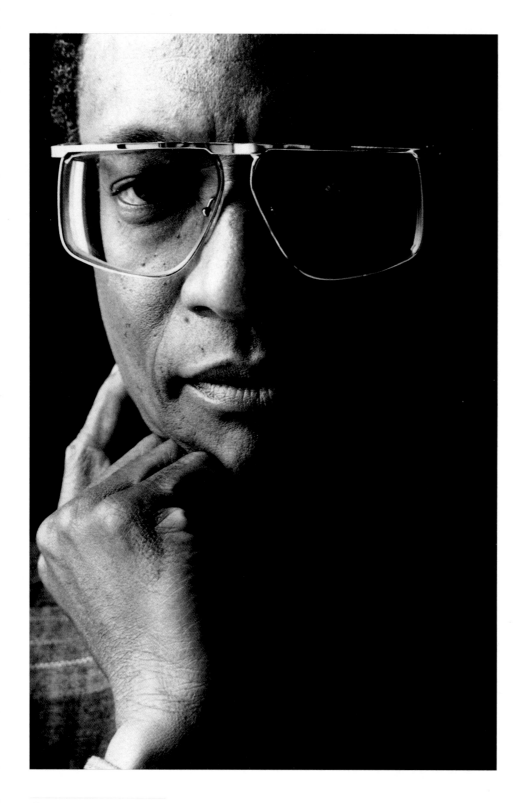

Ramsey **LEWIS**

Mix the classic Memphis piano sound with the Chicago blues tradition and you get Ramsey Lewis's fluid funky keyboard style. This appealing style has propelled Lewis (b. 5/27/35) to a long career that includes over sixty recordings and a 1965 Grammy Award for his million-selling release, "The In Crowd." The Windy City native studied at DePaul University and Chicago Music College before starting his own trio, which recorded for Chess in the late 1950s. The trio's affable style easily translated into finger-poppin' radio hits just at a time when rock and roll and rhythm and blues were steamrolling jazz into obscurity. Lewis's group covered current pop tunes and enjoyed massive chart successes with its versions of "Hang On Sloopy" and "A Hard Day's Night" as well as the gospel classic, "Wade in the Water." Lewis's mixture of pop and jazz created a legacy for his bandmates. Drummer Maurice White went on to lead the seminal funk group Earth, Wind & Fire while bassist Cleveland Eaton became an anchor of the Count Basie Orchestra. Lewis scored another gold recording with "Sun Goddess" in 1975. The pianist has remained deeply involved in the Chicago jazz scene, hosting a radio program on WNUA and directing the Jazz in June Festival at Ravinia. In 1994, he recorded as part of the Urban Knights, an all-star group featuring Grover Washington, Omar Hakim and Victor Bailey.

Pianist Joe Sample (b. 2/1/39) is an integral part of the soul jazz movement. The Houston native joined with drummer Stix Hooper, saxophonist/bassist Wilton Felder and trombonist Wayne Henderson to form the Jazz Crusaders in the late 1950s. Their sound was a hybrid of the rhythm and blues and jazz that they had grown up hearing and they were popular without causing too much consternation among the jazz orthodoxy. Blue Note Records released *Young Rabbits,* one of their best records of the sixties. The band shifted headquarters to Los Angeles in the early seventies and added guitarist Larry Carlton. They continued to walk that fine line between critical acclaim and commercial success. "Put It Where You Want It," was a hit single and *Rolling Stone* praised them for "playing commercial, accessible music without compromising their ideals as players." Sample in particular benefited from the West Coast relocation. The keyboardist had mastered a wide variety of instruments including the organ and the Fender Rhodes electric piano. He recorded with Diana Ross and the Jackson Five as Motown artists made their way out west. He also played in straight-ahead jazz groups lead by Harold Land and Bobby Hutcherson. In 1973, he toured and recorded with Joni Mitchell, an experience that boosted Sample to the upper echelon of studio musicians. Meanwhile, the Crusaders continue to ply their brand of soulful jazz.

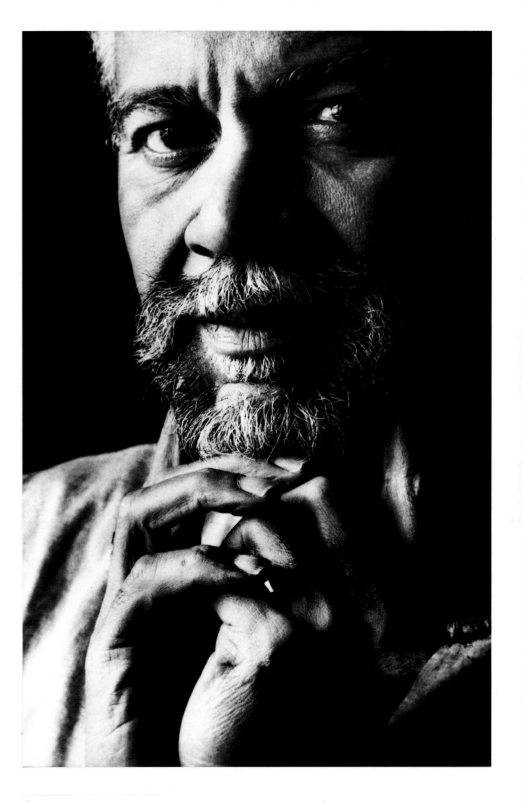

Joe **SAMPLE**

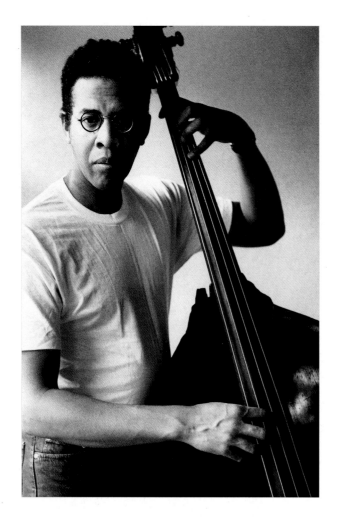

Stanley **CLARKE**

cello, but took up the electric bass, playing in rhythm and blues bands while he was in high school. Although he was influenced by great jazz bassists like Ron Carter and Paul Chambers, Clarke was also moved by Jimi Hendrix and James Brown. Thus loaded with technical skills, he arrived on the scene with a concept of the bass as a solo and lead instrument. On his early recordings, he traded leads with guitarists John McLaughlin and Jeff Beck, each an ideal foil for Clarke's style. Clarke was also co-leader with pianist Chick Corea of Return to Forever, one of the early seminal fusion bands. Clarke was a solid but malleable bottom for Corea's and guitarist Al DiMeola's florid solos. The combination of funk and romanticism propelled the group into the upper echelon of fusion bands in the mid-seventies and Clarke achieved a level of respect and adulation usually reserved for guitar gods.

In the late seventies, Clarke met up with George Duke, who had traveled a somewhat similar path from the West Coast. Duke, born in Marin County, California, was inspired to take up music after seeing a Duke Ellington concert when he was four. A devout jazz fan, Duke would hang around outside clubs he was too young to enter just to hear the music. He pursued formal training and received a masters degree from San Francisco State in 1969. Duke worked frequently, co-leading bands with violinist Jean Luc-Ponty and gig-

Although born on different coasts, Stanley Clarke (b. 6/30/51) and George Duke (b. 1/12/46) have had parallel and often intersecting careers. Both were involved with acoustic and electric bands in fusion's early days, both moved easily from pop to jazz, and, working together as the Clarke-Duke band, they made "Sweet Baby," a top-twenty pop hit in 1981.

Clarke was born in Philadelphia and originally aspired to be a classical musician. He played violin and

ging with Quincy Jones and Don Ellis. In between stints with Frank Zappa, he worked with Cannonball Adderley. In the mid-seventies, Duke joined forces with Billy Cobham for a series of jazz-funk recordings, then went solo and ironically became a labelmate of Stanley Clarke.

"We had a friendship in every sense," said Duke of the pairing. "He asked me to come and play on one of his records then I would ask him to play on my records . . . to the point where we wouldn't even charge each other. I'd say, 'Look, you play two songs on my record and I'll play two on yours.' "

The success of "Sweet Baby" gave them the artistic license to try new and different things. Duke went to Brazil to do a recording and also began to develop a greater interest in producing. Clarke turned his attention to film scores and teaching. He had produced his own records in the late 1960s, but he pursued pop production and was at the helm for A Taste Of Honey's "Sukiyaki," which sold two million copies. From there, he was in demand as a producer, working for scores of pop and jazz greats including Smokey Robinson, Anita Baker, Dianne Reeves, Chante Moore, Gladys Knight, and Miles Davis. Duke's solo career continued in the eighties and nineties with recordings for Elektra and then Warner Brothers that include all-star gatherings of the many artists with whom he has worked.

George **DUKE**

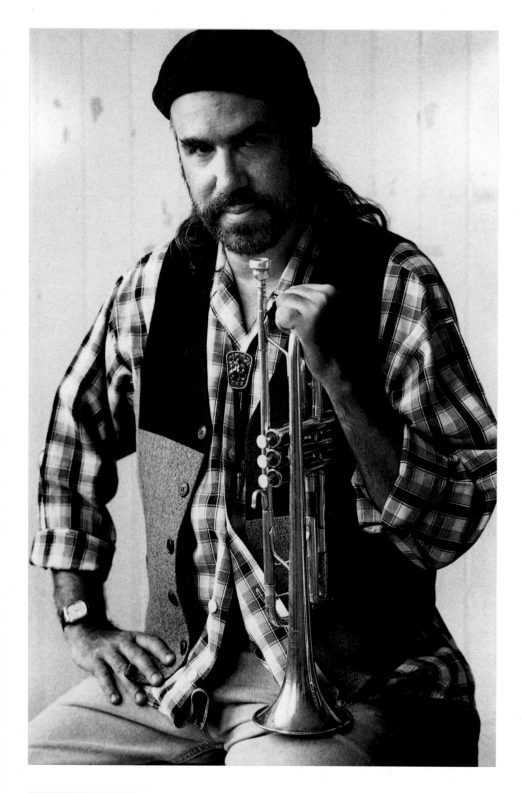

Randy **BRECKER**

Perhaps the term "Heavy Metal Bebop" was coined as a joke to title one of their recordings from the 1970s, but it's also an apt description of the musical range of the Brecker Brothers. They probably can play every style in between those two disparate genres and if anyone could fuse them, it's the Breckers. Together and apart they've played a vital role in jazz since the late 1960s.

If you hear an affecting tenor saxophone solo during a pop song, chances are that it's Michael Brecker (b. 3/29/49); the reedman has played on over 400 recordings. Brother Randy also has been deeply involved in the studio.

Randy Brecker (b. 11/27/45) was on tour with the award-winning Indiana University big band in the late sixties when he decided to drop out and start gigging. He landed in New York and quickly got a part in Clark Terry's Big Band, then in Blood, Sweat and Tears. In 1968 he released his first recording as a leader, with his brother working as a sideman. The brothers then played as a team with drummer Billy Cobham and guitarist John Abercrombie in the band Dreams. When the band split up, the pair became the front line in Horace Silver's band.

After a brief stint with Cobham again, they formed their own band, the Brecker Brothers. The group had a successful run of five recordings (*HMBB* was one of them) in the late seventies at the peak of the jazz-

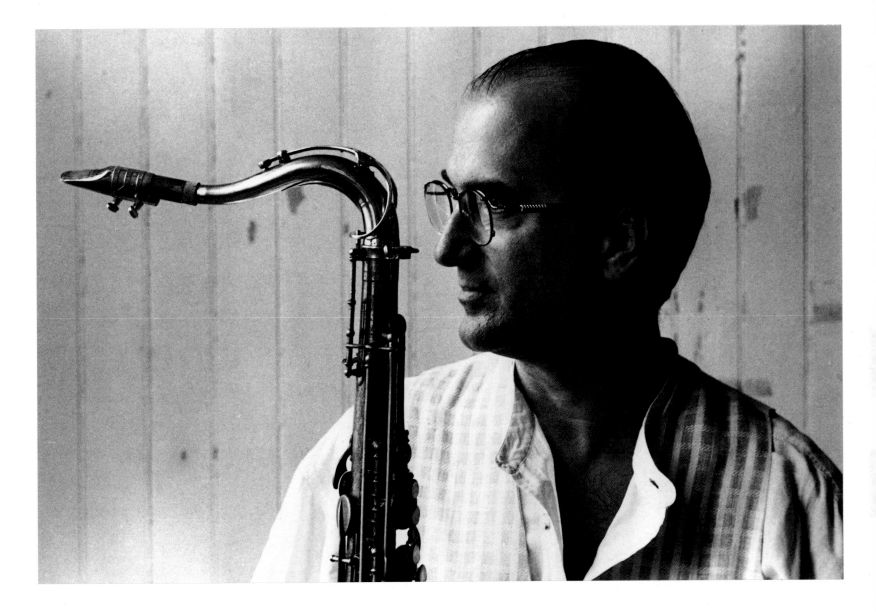

fusion movement. During that time their frequent studio play spiced tracks by Bruce Springsteen, Billy Joel, John Lennon, Steely Dan, and Parliament-Funkadelic. After splitting up as a team, Michael joined Steps, an acoustic group that later became Steps Ahead, the electric jazz supergroup. Randy worked with his wife, Eliane Elias, on a Brazilian fusion project, and then a hard bop project with Ron Carter and Joe Henderson. Michael and Randy reunited in 1992 to play hard-edged, steely electric jazz on *The Return of the Brecker Brothers,* then mellowed slightly for their follow-up, *Out of the Loop.*

Michael **BRECKER**

A keyboardist, accordionist, composer, and arranger, Gil Goldstein always seems somewhere on the periphery of any interesting recording session. He has made only a few records as a leader (some of which, sadly, are out of print), but his intelligence and flair come through in several of his sideman appearances. With an interest in a brawny sound, Goldstein was heard to good advantage with the Gil Evans Orchestra in the 1980s, and he has worked with many of his fellow Evans sidemen, including Chris Hunter and Lew Soloff. His elegant side shines on "West Side Story," a duet performed with Dave Liebman on guitarist Mike Stern's *Standards* recording.

1 *Gil* **GOLDSTEIN**

2 *Marcus* **MILLER**

Marcus Miller (b. 6/14/59) is a bassist, bass clarinetist and producer who grew up in New York loving jazz and pop equally. In a strikingly short period of time he has built a reputation as a great sideman and producer, working with Roberta Flack, Aretha Franklin, David Sanborn, Al Jarreau, and Miles Davis. It was with Miles that Miller first rose from sideman to producer, and he supervised many of the legend's final recordings.

David **SANBORN**

For all of his decades of chart-topping recordings and a high profile in the jazz world, it may come as a surprise that saxophonist David Sanborn (b. 7/30/45) took up the instrument as physical therapy following a childhood bout with polio. Needless to say, the St. Louis native discovered that he had an affinity for the instrument and began following the music of Hank Crawford and Gene Ammons. Given those influences it's no surprise that Sanborn is a soulful saxophonist. His solo style owes a lot to rhythm and blues bands. Following college (Northwestern and the University of Iowa) Sanborn toured and recorded with the Paul Butterfield Blues Band, then with Stevie Wonder—during one of his creative peaks from 1971 to 1973—and David Bowie in 1974. He returned to the jazz fold and played with the Gil Evans Orchestra and the Brecker Brothers in the late seventies before embarking on a series of phenomenally successful solo releases. Sanborn's recordings are consistently well-produced and feature a wide variety of stellar sidemen such as Marcus Miller, Howard Johnson, George Duke, Bill Frisell, Art Baron, and Eric Clapton. In 1990, he recorded a substantial departure from his pop-jazz style with *Another Hand*. That album featured a motley crew drawn in part from musicians Sanborn met as host of "Night Music," a short-lived (though fondly remembered) television show that featured an eclectic mix of music.

Although he is well known as the soul crooner of "This Masquerade," and the deft virtuoso who created *Breezin,'* George Benson has also had a long and illustrious career as a jazz guitarist. Benson's guitar has a liquid tone and his unique combination of restraint, ease and funk have profoundly influenced several of today's young guitar stars including Ronny Jordan and Mark Whitfield. Benson (b. 1943) actually began as a singer in his native Pittsburgh, but worked solely as a guitarist with organist Jack McDuff in the mid-sixties. He formed his own group with baritone saxophonist Ronnie Cuber and organist Jimmy Smith before joining Miles Davis for his *Miles in the Sky* and *Filles De Kilimanjaro* recordings. Benson then worked with producer Creed Taylor on a series of recordings for the CTI label in the early seventies. *Breezin,'* his commercial breakthrough, offered both a great instrumental, the title track, and a brilliant vocal, his version of "This Masquerade." Both tracks epitomized the agile qualities jazz brought to fusion. Although Benson worked the pop side of the spectrum for much of the eighties, he kept his chops up for occasional returns and has recorded both a big band and small group session featuring McCoy Tyner and Ron Carter.

George **BENSON**

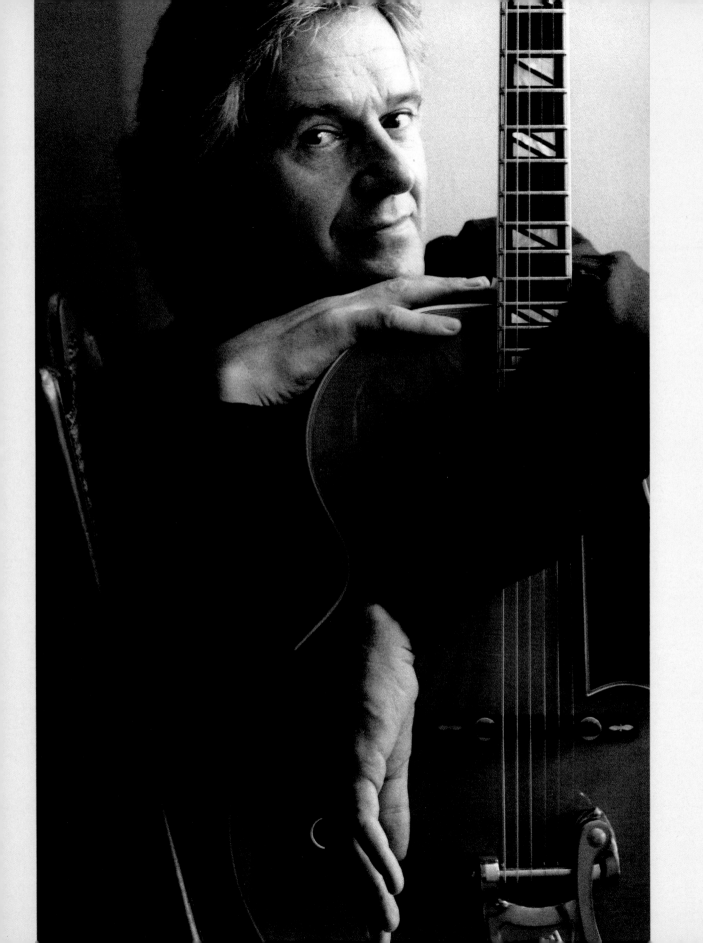

John McLaughlin's career divides into three segments: loud, quiet and everything in between. The loud segment is highlighted by the first edition of the Mahavishnu Orchestra, a five-piece band that in the early 1970s seemed to embody the most raucous possibilities of jazz-rock fusion. The quiet segments have many highlights, including his stunning debut recording and some of his Indian-influenced work. Everything in between encompasses, well, a lot. Nevertheless, the British-born guitarist's illustrious career has won him fans from the rock and world music camps and earned him the enormous respect of the jazz community.

McLaughlin (b. 1/4/42) first made a name for himself as a sideman with two of the seminal bands in the jazz-fusion movement: Miles Davis's bands of the late sixties and early seventies and Tony Williams's Lifetime; in each he provided sharp, pungent licks. His contributions to Williams's band are somewhat distorted by poor recording, but they possess a high level of energy. With Davis, McLaughlin's work ranged from the ethereal on parts of *In a Silent Way* to tannic on *Jack Johnson*. During this time, McLaughlin recorded *Extrapolation,* an album with British saxophonist John Surman that revealed a delicate, highly sophisticated side to his playing.

That side got the short shrift in his next phase. McLaughlin rounded up violinist Jerry Goodman, drummer Billy Cobham, bassist Rick Laird, and keyboardist Jan Hammer to form the Mahavishnu Orchestra (the name reflects McLaughlin's spiritual devotion to the teaching of Sri Chinmoy). Mahavishnu was on the very short list of important bands in the jazz-rock fusion movement and they raised a holy racket. It was as if the music was the high energy of free jazz (though they didn't play free) and the rock was a gothic hypermodernity of art rock. They released three stellar recordings, *The Inner Mounting Flame, Birds of Fire* and *Between Nothingness and Eternity,* and then disbanded, though McLaughlin periodically revives the concept.

The next phase of McLaughlin's career was equally rewarding. He teamed with Indian musicians to form Shakti and offered a different sort of fusion. The group featured Indian percussionists and the solo space was shared by violinist L. Shankar. In the early 1980s, McLaughlin teamed with fellow guitarists Al DiMeola and Paco DeLucia to create a three-guitar jamboree celebrating flamenco.

In the nineties, McLaughlin has scored with two different bands. One featured Indian percussionist Trilok Gurtu and the other was with the fervid organ player Joey DeFrancesco. Both groups suggest McLaughlin, already perhaps the most influential jazzman not born on American shores, has plenty more to say.

John
McLAUGHLIN

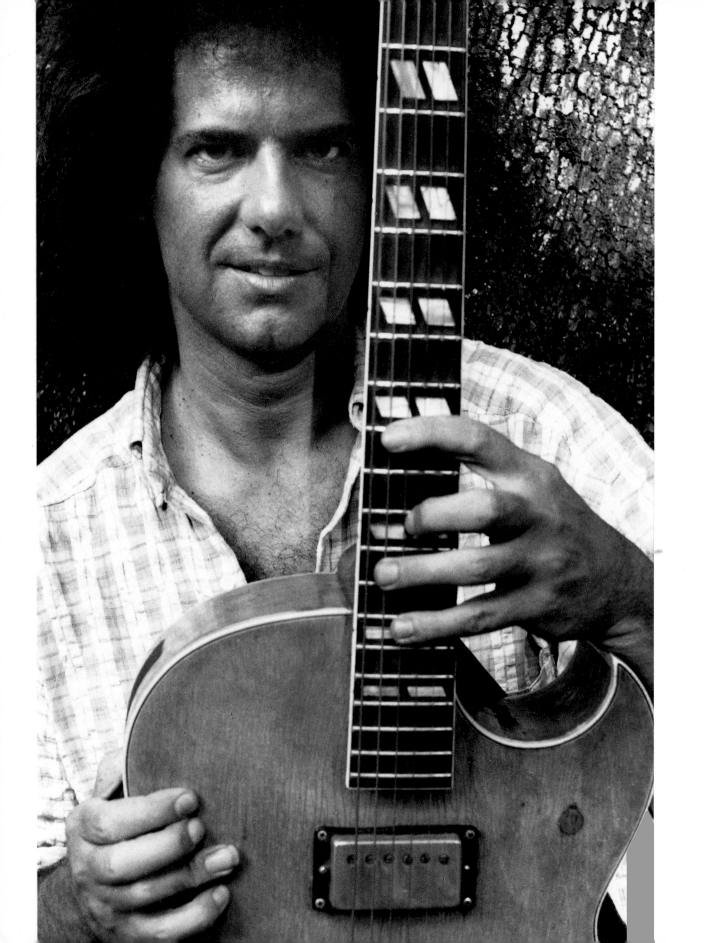

Most artists have myriad interests, but Pat Metheny (b. 8/12/54) has been able to pursue his tangents to a greater length than most. Although his band has perhaps the largest following of any jazz ensemble in the world, the guitarist makes frequent excursions into straight-ahead jazz, Brazilian music, world music, and Ornette Coleman's electric universe of murky dissonances.

The Missouri-born guitarist taught briefly in the mid-seventies at Berklee School of Music and the University of Miami before establishing a group that has had a surprisingly low turnover.

Metheny's debut, *Bright Size Life,* was as noteworthy for its sidemen, bassist Jaco Pastorius and drummer Bob Moses, as for its young leader. On *Watercolours,* recorded in 1977, the guitarist was joined by keyboardist Lyle Mays, who has worked with him since. Mays, bassist Mark Egan and drummer Danny Gottlieb worked steadily as members of the Pat Metheny Group in the late seventies. Bassist Steve Rodby joined the fold in 1980, replacing Egan, and Paul Wertico came in for Gottlieb in the early eighties.

It has been suggested that the geniality of the Pat Metheny Group sound accounts for the edginess of his other chosen avenues. Whatever the motive, his departures are where he has done the most to expand the vocabulary of his instrument. On *80/81,* Metheny joins forces with reedman Michael Brecker, drummer Jack DeJohnette and two Ornette Coleman alumni, bassist Charlie Haden and saxophonist Dewey Redman. Although some of the music is rather easygoing, there are also tumultuous moments that came as a shock when the recording was released. In hindsight they were merely a sign of things to come.

Metheny continued to pursue his interest in Coleman's music two years later on *Rejoicing,* a straight-ahead record on which he formed a trio with Haden and another Ornette alumnus, drummer Billy Higgins. The album established him as a jazz musician to all but the most rigid purists and many regard it as his finest recording. Metheny moved from ECM to Geffen in 1985 and, showing some gumption, made *Song X,* his first project for the major label, a collaborative recording with Coleman that features scads of loud, high-energy jazz. Metheny's next departure was *Secret Story,* a highly produced world music recording with many guest stars. His latest departure, *Zero Tolerance for Silence,* is another loud, high-energy solo record drenched with feedback.

Metheny has performed admirably as a sideman, working with Brazilian vocal legend Milton Nascimento and up-and-coming saxophonist Joshua Redman (Dewey's son). With the former he lays back and gently accessorizes the sound; with Redman he pushes ahead, goading the youngster toward greater heights. At this point it's clear that Metheny can play whatever he wants and not just get away with it, but get it into the marketplace—a much greater feat.

Pat
METHENY

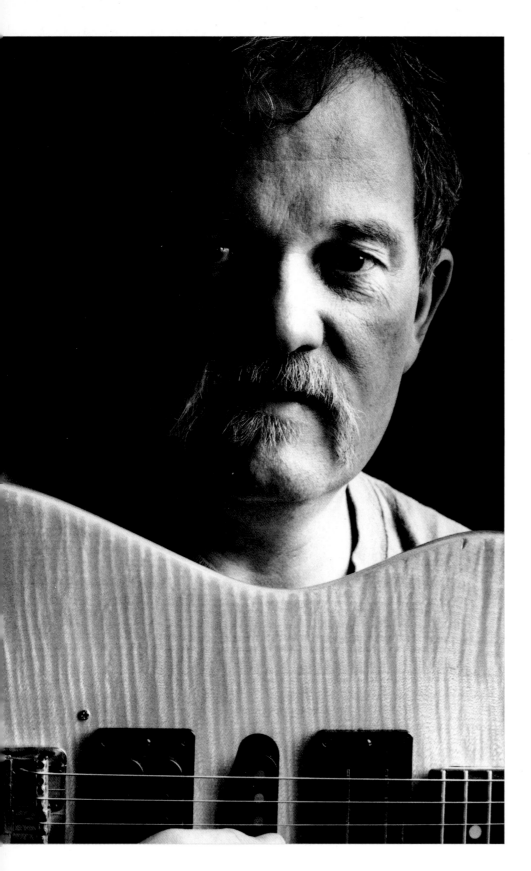

Add the collaboration between John Abercrombie (b. 12/16/44) and Manfred Eicher to the long list of great jazz musician-producer teams. They seem made for one another: Abercrombie has an exuberant guitar sound perfectly served by Eicher's clean, austere productions.

A Port Chester, New York, native, Abercrombie played with Chico Hamilton and Johnny Hammond in the late 1960s following his matriculation at Berklee School of Music, but he got his best sideman notices during his tenure with Billy Cobham's group Spectrum in the early seventies. He began recording with Eicher's nascent ECM label in 1974, and helped establish a distinctive sound that belonged to neither free-jazz or jazz-rock fusion, the rages of the moment. Eicher showcased Abercrombie in several contexts. On *Sargasso Sea,* he teamed with classically oriented guitarist Ralph Towner for a series of gorgeous duets. In *Gateway,* he worked with bassist Dave Holland and drummer Jack DeJohnette to create a loose-limbed version of an ECM power trio. In 1976, Abercrombie recorded *Characters,* an inventive solo effort. In the mid-eighties he settled into a groove with a fine trio backed by Marc Johnson and Peter Erskine. With this ensemble, he often experimented with the guitar synthesizer. Abercrombie's recent work suggests a departure: together with organ player Dan Wall he's reconsidered the seminal jazz-rock of the early Tony Williams groups.

John **ABERCROMBIE**

John Scofield (b. 12/26/51) has settled comfortably into his role as one of jazz's leading guitarists by constantly challenging himself. Scofield was born in Boston and went to Berklee School of Music, where he studied under Mick Goodrick and Gary Burton. In the mid- and late seventies he did sideman roles and also released his first recordings as a leader, revealing strong blues and rock sensibilities that were input into a long-form, free-flowing jazz setting. In late 1982, Scofield joined Miles Davis's band and performed on *Star People, Decoy* and *You're Under Arrest*. Upon leaving the Davis band, he recorded a series of fine efforts on Gramavision that brought his vision into sharp focus. He offered a fluid, loose style that was sharply punctuated by pungent, bent notes. In 1989 he moved to Blue Note Records and began an even richer phase of his career. He teamed with saxophonist Joe Lovano, whose tough but tender sound was an ideal match. Together they recorded with the all-star rhythm section of Charlie Haden and Jack DeJohnette as well as with Scofield's regular band. Scofield has also twice recorded with intriguing two-guitar front lines: *Grace Under Pressure* features Bill Frisell and *I Can See Your House from Here* features Pat Metheny. His most recent project is a reconsideration of the soul-jazz of the early seventies that includes work by Eddie Harris.

John **SCOFIELD**

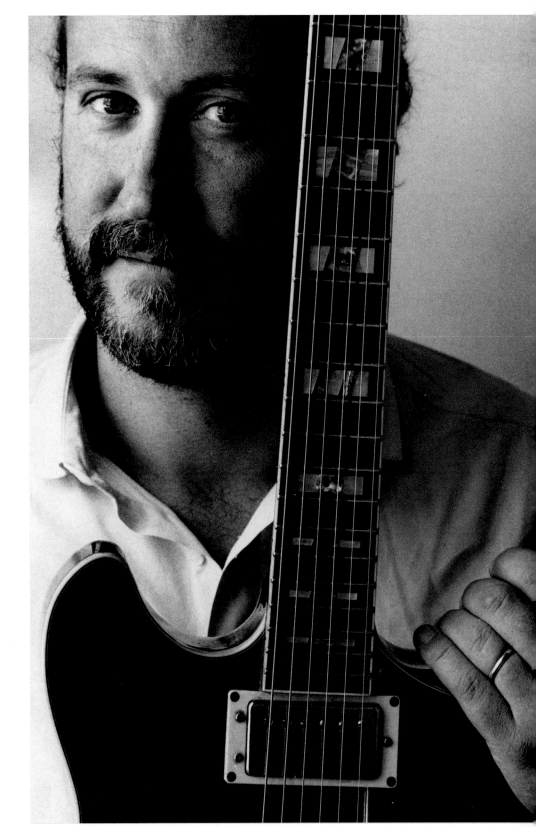

Mike Stern (b. 1954) doesn't need big biceps to be considered a muscleman; his approach to his instrument qualifies him for that designation. The metallic crunchiness he brought to the Miles Davis band in the early 1980s established him as a brawny soloist and driven player. He worked with Blood, Sweat and Tears for two years, and then with smash-mouth drummer Billy Cobham before joining one of Davis's first bands of the eighties, where Stern seemed bent on reviving the work of Davis firebrands of the seventies like Pete Cosey. He has shown his elegant side on selected solo recordings, some of which feature Michael Brecker, with whom Stern has played in the fusion supergroup Steps Ahead.

1 *Mike* **STERN**

2 *Jonathan* **BUTLER**

Jonathan Butler is a guitarist and vocalist whose steady, consistent variety of pop jazz has easily crossed over into pop ranks. He combines surprising technique on his instrument, a smooth mellifluous croon and matinee idol good looks. His early recordings sold quite well and led to tours with Regina Belle, a kindred spirit who shares with Butler the chops to win jazz fans from a place in the pop spectrum.

Stanley Jordan (b. 7/31/59) has turned the guitar into a percussion instrument of sorts. His two-handed tapping style—wherein he taps the fingerboard of his instrument—is the most innovative organic approach to the guitar seen in years. He has applied this approach to a wide variety of contexts, producing material that seemed specifically targeted to maximize its commercial potential while jamming with Sun Ra's Arkestra.

Jordan was born in Chicago and grew up in Palo Alto, California; he initially studied keyboards and his approach has been compared to piano playing in his use of independent, contrapuntal lines. At Princeton University, where Jordan majored in music, he studied composition with composer Milton Babbit and what would become known in some circles as cybermusic with computer music guru Paul Lansky. Jordan went the starving-musician route until getting his big break in 1984, when he was an unannounced opening guest at a Maynard Ferguson/Wynton Marsalis concert at the Kool Jazz Festival in New York. He wowed the audience in a solo recital and touched off a bidding war for his services. Blue Note Records released *Magic Touch,* his major label debut, and it sold 480,000 copies, an utterly incredible amount of units for a heretofore obscure jazz artist. Jordan has since honed his technique further, playing both solo and with a band, and he continues to expand the terrain for his instrument.

Stanley **JORDAN**

Grover **WASHINGTON, JR.**

Grover Washington, Jr. (b. 12/12/43) probably aggravates the jazz purists more than anyone because he brings a wealth of acumen, technique and heart to both his commercial and traditional stylings—in other words, he can cross over and back without breaking stride. Washington developed his warm glowing tone before pop-jazz fusion existed as a genre. He began playing in rhythm and blues groups and organ soul groups before getting his first solo deal with CTI in 1971. He released a series of moderately successful recordings in the early 1970s before hitting the jackpot with *Mr. Magic* in 1974. The title track, with its irresistible beat and sinuous improvising, is one of the great recordings of the early jazz-fusion/jazz-funk movement. Washington topped that commercial breakthrough with *Winelight* in 1980, a recording that has now sold over two million copies and earned him two Grammy awards. Through the eighties, Washington maintained his sales strength working with such vocalists as Patti LaBelle and Jean Carn. He teamed up with Tommy Flanagan, Herbie Hancock, Ron Carter, and Marvin "Smitty" Smith for *Then and Now,* a widely hailed straight-ahead recording in 1988. Washington returned to the same recipe with similarly good notices in 1995 on *All My Tomorrows.* No doubt by now many of the purists are merely annoyed to have to wait so long between Washington's excursions.

Sadao Watanabe (b. 2/1/33) may be the jazz eclectic of his generation; despite coming to the music at a late age, he has demonstrated an ability to play many styles and find his authorative voice in each. During a lengthy recording career that includes over 60 releases as a leader (many of which are only available in Japan if they are in print at all), he has played Afro-Cuban, bossa-nova, straight-ahead and jazz fusion. Watanabe grew up in Japan, mostly hearing a diet of traditional Japanese music and German martial music. Through Armed Forces Radio, he heard Jazz at the Philharmonic broadcasts and was captivated. Barely out of his teens, he was recording with bandleader Toshiko Akiyoshi, and when she came to the States in 1956 he took over leadership of her band. He, too, came to America in the sixties, attending Berklee School of Music from 1962 to 1965 and working with an array of stellar pianists, including Herbie Hancock, Chick Corea and Cedar Walton. During this time he made several Charlie Parker tribute records as well as three collaborations with Charlie Mariano, Akiyoshi's ex-husband, which explored both Oriental and American themes. Since the early seventies, when Watanabe resumed a Japanese residence, he has continued to record and tour internationally, though his appearances in the States have been rare.

Sadao **WATANABE**

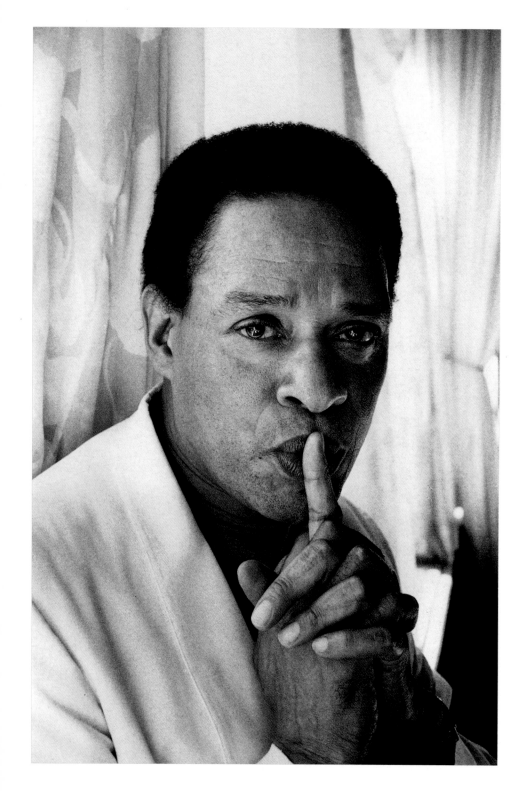

For most artists the middle-of-the-road represents some sort of compromise, but not for Al Jarreau (b. 3/12/40). For him the location is an ideal intersection of his interests and influences and he has been rewarded with Grammy awards in *three* different categories: rhythm and blues, pop and jazz. Perhaps his versatility was best illustrated on his 1994 recording, *Tenderness,* which featured guest spots from David Sanborn and Kathleen Battle. Of that recording, Jarreau said that he strove for "an interesting and eclectic blend of familiarity and freshness, taking some standards and new material into different directions, in terms of both arrangement and style." Jarreau's brilliant career took off with *We Got By,* his first Warner Brothers recording in 1975. The album highlighted a different approach to scat singing. Rather than emulate the sound of trumpets or saxophones, Jarreau mimicked electric guitars, particularly those with wah-wah pedals. He applied the style to jazz classics, helping to build on the growing crossover audience for jazz fusion. He has gone on to release several gold recordings and is well known to television audiences for his vocal on the theme song for the hit series "Moonlighting."

Al **JARREAU**

Whether singing songs by Bonnie Raitt or Stephen Sondheim, contemporary rhythm and blues or jazz standards, Nancy Wilson (b. 2/20/37) makes every song distinctively her own. Perhaps it's an entitlement after more than three decades and fifty-five recordings, but more likely Wilson's versatility is a product of her command and control. "Although I've been pigeon-holed as a jazz singer, an R&B singer or a pop singer, I think people are finally beginning to realize that I'm a song stylist," she has said. Her illustrious career has included her own Emmy award–winning NBC television series as well as a multitude of other appearances, including a recurring guest spot on the Fox sitcom, "Sinbad." She has a keen eye for talent, too. The comedian Arsenio Hall got his big break as an opening act for Wilson. She also keeps busy with a long list of humanitarian endeavors, including work with the Martin Luther King, Jr., Center for Social Change. Wilson has managed to balance the demands of career and family. Of this she said, "Sure, I'm still trying to juggle the responsibilities I feel as a wife, mother and performer, but my life is great. I feel at peace with myself and that's reflected in my music."

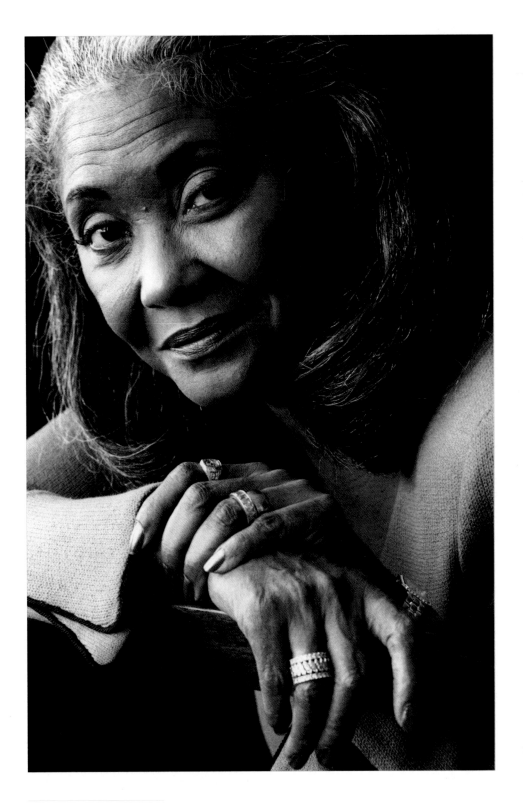

Nancy **WILSON**

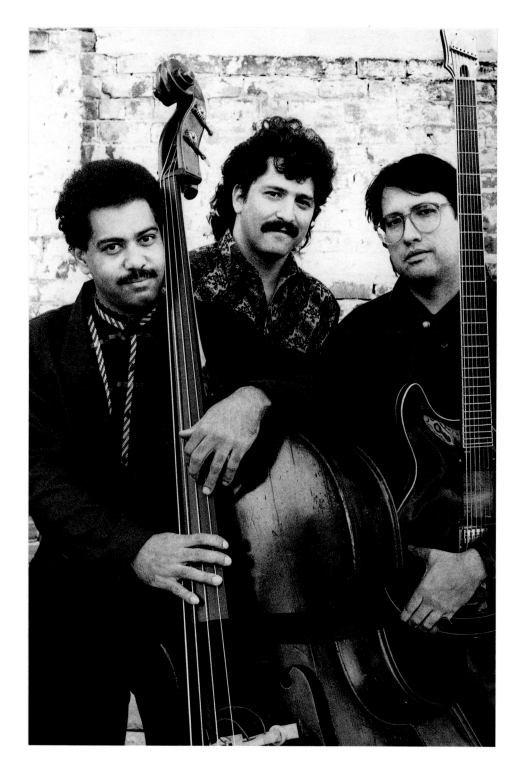

Whether she's singing pop-jazz, jazz-funk or classic jazz, Dianne Reeves (b. 1956) always leads with a passion for roots. Her proud ancestry shines through in the deep reservoirs of emotion, sparkling vibrancy and precise control Reeves brings to each song. The Detroit native was discovered in high school by trumpet legend Clark Terry. In the early 1980s, she collaborated with pianist Billy Childs on her first recordings and toured with him as well. Reeves was deeply influenced by a 1983 meeting with Harry Belafonte, whose respect for folk traditions became a central element in her work. With George Duke's production, her song "Better Days" became a breakthrough commercial hit. In recent years, Reeves's recordings have alternated from straight-ahead pop to more straight-forward pop-jazz, each enabling her to express the full range of her interests. Of her bandmates, Steve Masakowski has examined new voicings for guitar on his two solo recordings.

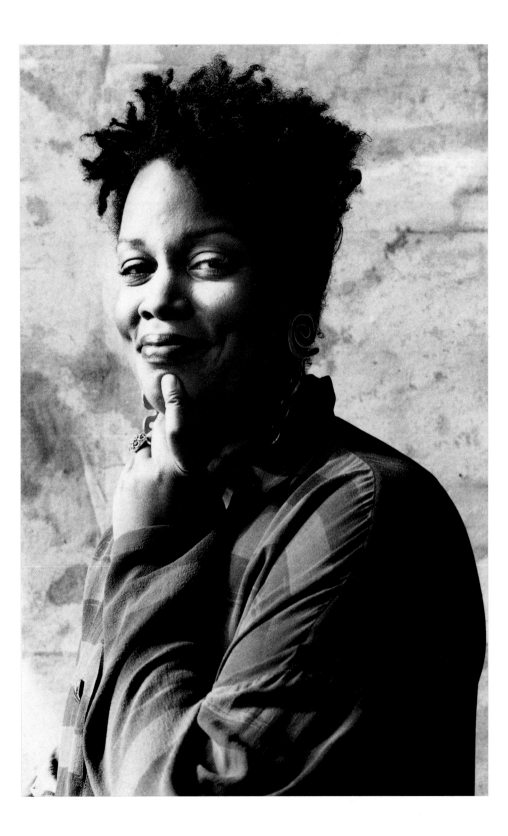

Opposite, left to right

David **TORKANOWSKY**

Chris **SEVERIN**

Steve **MASAKOWSKI**

Right

Dianne **REEVES**

DESPITE ITS IDENTIFICATION with nightlife and the underworld, jazz actually began as a family affair, taught to kids in New Orleans by their parents and relatives. Great innovators like Lester Young and Oscar Pettiford played in family bands; and siblings, including the Dorseys, the Jacquets, the Adderleys, and the Breckers, frequently functioned as musical teams. There are also historic precedents of jazz fathers and sons—Albert and Gene Ammons, Duke and Mercer Ellington.

So the concept of jazz families is not new. Still, we are in a particularly fertile phase as cross-generational things go. All those Moffetts and Marsalises, father-and-son Drews, Freemans, Gibbses, Greens, and Redmans; more brothers like the Roneys, too. Those who do not enjoy the luxury of musical relatives now seek father and mother figures in universities, where jazz education programs have proliferated and where many of the new singers and instrumentalists have studied.

This is the true distinguishing mark of much jazz in recent times: that it was more likely to be nurtured in the academy than in the give-and-take of jam sessions or after-hours clubs. It was said a few years ago that musicians, too focused on their own exclusive repertoire and reluctant to share their hard-won insights, had stopped jamming; but jamming has always thrived, even if increasingly in the practice rooms of colleges. The best students quickly realized, though, that spontaneous and less formal lessons are the most valuable. A lucky few also manage to matriculate at the graduate-programs-disguised-as-bands presided over by such savvy deans as Betty Carter or the late Art Blakey. With a degree and a period of on-the-job training, a young jazz musician of the nineties might even have it both ways.

Role models remain key, and younger players let us know that they know it. Today's jazz rookies are more inclined than ever to acknowledge the contribution of their oft-neglected elders and to comport themselves with the understanding that they are already being observed by still-younger aspirants. If Wynton Marsalis has risen to the head of this new jazz consort, his unsparing giving of time and sharing of ideas with teenaged musicians is as responsible as the music he creates or the debates he generates in the press. For over a decade, Marsalis has seized every opportunity to offer personal encouragement to young players backstage after performances and to visit schools where music programs have often been abandoned. He has preached the value of "woodshedding," the solitary tutelage practiced by early musicians, and has created a veritable Woodshed Nation of even newer musicians preparing to increase the swell of the next wave.

But what kind of jazz will they play? To judge from the majority of emerging artists signing recording contracts and touring the club and concert circuit, it will be a refinement of ideas on the swing-to-bop continuum, up through pre-electric Miles Davis and middle-period John Coltrane. Free jazz, electric fusion and formal influences from European concert music are out of favor, while the standard bearers of the past (from Louis Armstrong and Charlie Parker to Cannonball Adderley and Woody Shaw) are most definitely in. The debate has turned ugly at times, especially when guardians of tradition attempt to weed various mavericks out of the more extended jazz family.

Fortunately, not everyone sees the need to draw lines and define limits. Tim Berne and Marty Ehrlich are examples of a more

unbound approach, one in which ensembles and compositional structures are constantly subject to modifications that will both expand the range of influences and create new alternatives. Among his other passions, Don Byron keeps a klezmer band, a Latin group and a more familiar-looking combo functioning. More often than not, such artists are found in alternative venues and on alternative labels, creating without restriction and waiting out the conservative tilt in the jazz audience's taste.

They may have a long wait, given the impressive proficiency and budding personality of the so-called young lions. Rarely in the past have so many emerged at such an early stage with so much technique and sensitivity to at least large chunks of the music's past. Whatever the hype surrounding these prodigies, they are the first to admit that there is much to learn and that they fully intend to continue the learning process. If trumpeter Roy Hargrove, tenor saxophonist Joshua Redman, pianist Cyrus Chestnut, bassist Christian McBride, and drummer Leon Parker (to cite only five) are impressive now, they may be something else when the millennium turns.

What further change can be expected during jazz's second century? An increased profile for non-American players, for one thing. There are already Canadians (Renée Rosnes, Maria Schneider), Panamanians (Santi Debriano, Danilo Perez), Puerto Ricans (David Sanchez, Charlie Sepulveda), and French Americans (Jacky Terrasson) helping to mold the New York scene—not to mention some of the older and less tradition-bound players (Willem Breuker, Daniel Humair, Franz Koglmann, and Evan Parker) who have remained overseas and create even harder-to-chart ripples in the pool of jazz's evolution. The tide originally went out from America's shores, and it returns with a perhaps unimagined world of possibilities.

Another contingent will be more prominently heard from, representing half the population of that wider world. These are the female musicians, who can no longer be relegated to acceptable roles as singers and pianists only. Like racism, sexism dies hard; and we should no longer need to remark on the importance of female musicians leading their own orchestras or driving combos from the drum chair or blowing in the noncolloquial sense of the term on trumpets and saxes. Women are here, and playing all manner of instruments in all styles.

Finally there is the audience, an element no less essential than the practitioners for the continuing health of the art form. New listeners currently are cultivated via subscription concert series and school programs in musical history and appreciation, with greater access for jazz promised through cable television, laser disc and CD-ROM. Yet, as the latest technology makes it harder to leave the comforts of home, somehow the nightclub survives; and as the lowest common denominator sinks ever lower and we bemoan the indifference of mass culture, jazz can suddenly be found in such unlikely places as the post office (where several of the giants are regularly honored on stamps) and advertisements for everything from coffee to Cadillacs. It has taken the better part of a century, but the American public may finally begin to accept the value of America's music. Which only makes jazz's second hundred years that much more promising.

Let's give Sly Stone his due here; this is a family affair. The Moffett family, playing both separately and together, have been a vital part of jazz lore for over thirty years. The story begins with Charles Moffett (b. 9/11/29; shown opposite, center), the Fort Worth, Texas, native who, while still in high school, played trumpet with Jimmy Witherspoon and other rhythm and blues bands. He took up the drums in college, after which he continued gigging in Texas, at one point playing with Little Richard. He moved to New York and played with fellow Fort Worth native Ornette Coleman. Moffett was a part of the second major Coleman band, a trio with David Izenzon on bass. Moffett's abandon was well suited to the leader's style. They are best documented on *Ornette Coleman Live at the Golden Circle,* which was released in two volumes. While in New York, Moffet played with other key figures of the avant-garde. He was featured on tenor saxophonist Archie Shepp's classic *Four for Trane* and led a band that included Pharoah Sanders.

During the seventies, Moffett moved to Oakland, California, to teach and run a music school. His chil-dren were among his best students, and in 1975 they gave their first performances as the Moffett Family. Most of his children were only in their teens, but bassist Charnett (his name is a combination of Charles and Ornette) was especially precocious; he was only eight. (He is at the far right in the photo opposite.) "It seemed like they all could play music practically before they could walk," says Charles. Indeed, Char-nett in particular made an impressive showing upon his arrival in New York. He quickly became one of the most in-demand bassists on the scene and played with both Branford and Wynton Marsalis. His first record-ing, *Network,* featured both his father and brother Cody (at left in photo) on drums and sister, Charisse (second from right), on vocals. Cody recorded his debut album in 1993 with stellar company, including Kenny Garrett, Wallace Roney and Ravi Coltrane. The aforementioned Moffetts plus trumpeter Mondre (whose photo Charles is holding) and saxophonist Charles, Jr. (second from left), joined together as the Moffett Family Jazz Band and recorded twice on the Japanese Venus label.

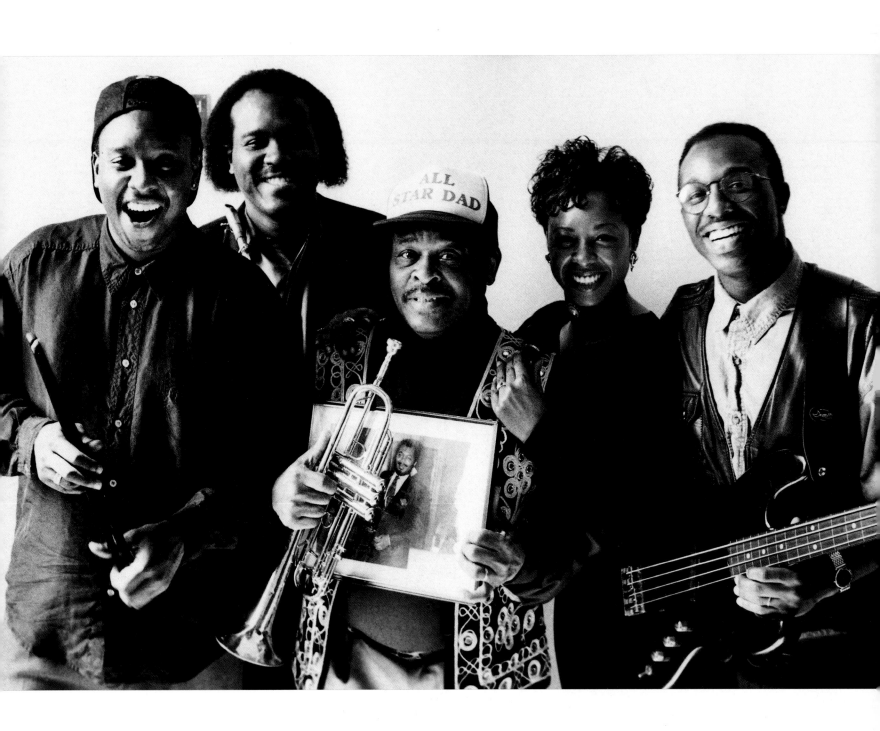

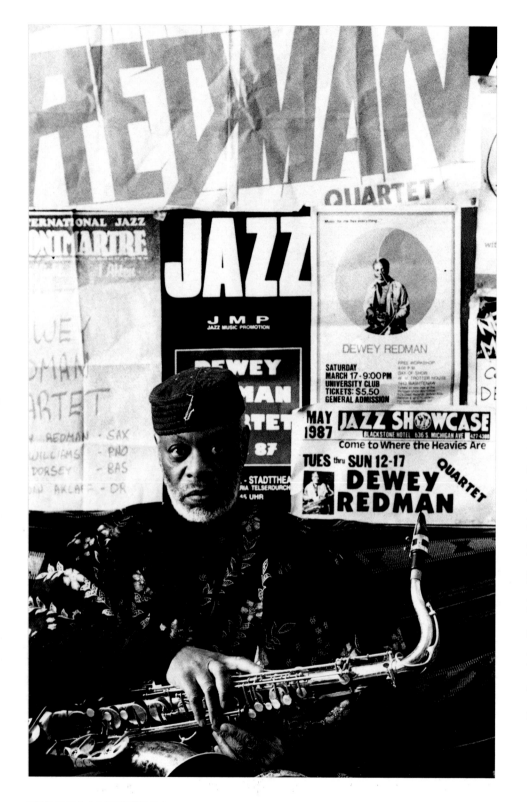

Dewey **REDMAN**

Ask most jazz lovers to describe the Texas tenor saxophone sound and you'll be regaled with descriptions of brawny robust tones, honks and squeals and a sound as big as the Lone Star State itself. Dewey Redman (b. 5/17/31) is an exception to that stereotype. Wiry and thoughtful, this Fort Worth native is characteristic of the alternative sound. Redman balanced the rigors of academia (he received a master's degree from North Texas State University in 1959) and the demands of a career as a professional musician. He gained significant renown as part of a group led by fellow Fort Worth native Ornette Coleman. In that ensemble, Redman was able to showcase his pensive yet sturdy sound. During the late sixties and early seventies, Redman also worked with Charlie Haden's Liberation Music Orchestra and Keith Jarrett's group. He also led his own groups and took up the musette as a second instrument. In the mid-1970s Redman teamed with Haden and other fellow Ornette alumni Don Cherry and Ed Blackwell and formed Old and New Dreams. Redman still leads his own groups and occasionally collaborates with his son Joshua on projects both in the United States and abroad.

Joshua Redman (b. 1969) possesses a remarkably assured tone and sense of rhythm; he doesn't just swing, he swaggers. More than most musicians his age, his playing gives a sense of the innate possibility of jazz. In other words, rather than recapturing the letter of the music, he gives you its spirit. Small wonder he turned down Yale Law School (after graduating *cum laude* from Harvard) to follow in his father's footsteps as a jazzman. Redman, however, quickly found the fast track. He won the Thelonious Monk Competition in 1991, and shortly thereafter he signed with Warner Bros. Records. Each of his first three albums, especially *Wish* (which was recorded with Charlie Haden, Pat Metheny and Billy Higgins, each a longtime colleague of Joshua's father Dewey) and *Moodswing,* sold phenomenally well. Now leading his own band, he continues to hone his technique by playing on sessions led by Joe Lovano and Paul Motian as well. Evidently, people aren't just buying his Ivy League credentials.

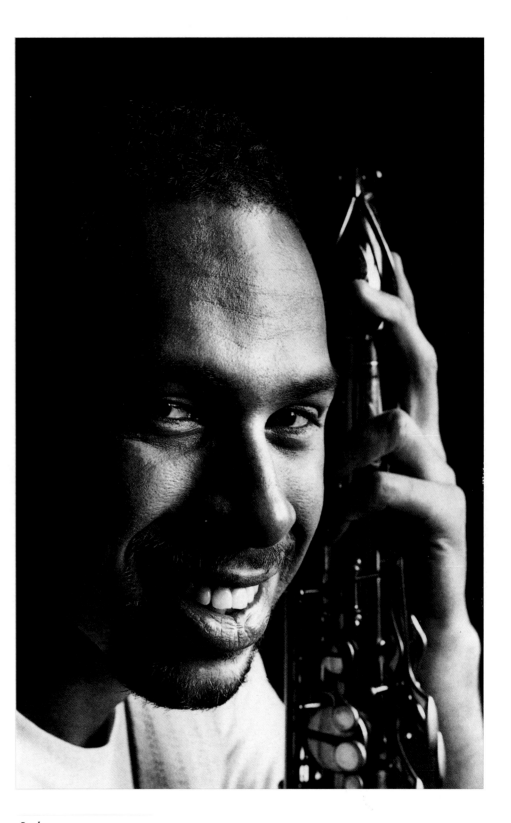

Joshua **REDMAN**

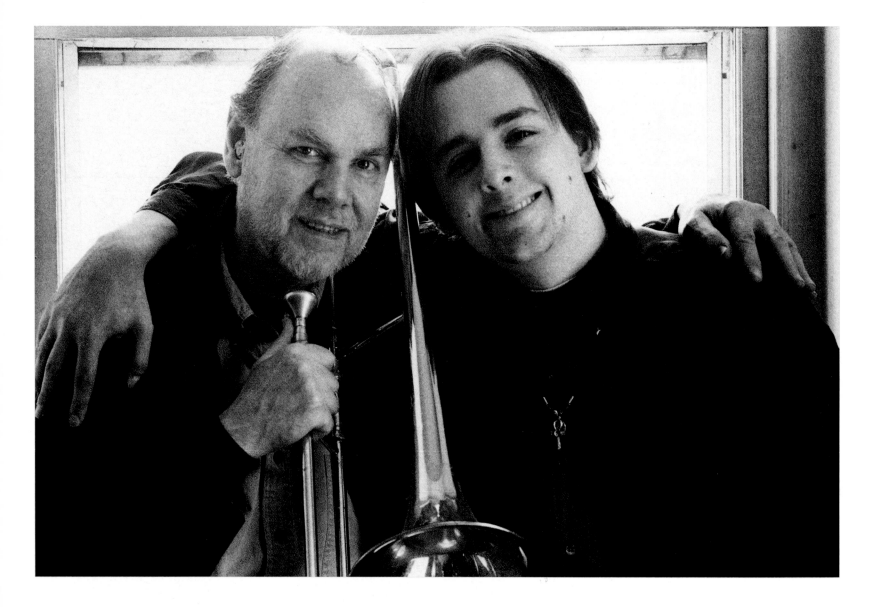

Urbie & Jesse **GREEN**

Although known primarily among the cognoscenti, Urbie Green (b. 8/8/26) remains among the more under-appreciated trombonists of our time. His robust author-ity was among the highlights of Woody Herman's Third Herd, as was his play with Buck Clayton. Although he sporadically worked with Benny Goodman and Count Basie, much of his time was devoted to studio work. His son Jesse Green (b. 1973), a pianist, is just beginning to tell his story. His debut, *Lift Off,* is an agreeable record-ing chock-full of good ideas and promise.

A child prodigy from Brooklyn who played his first gig when he was all of twelve, vibraphonist/bandleader Terry Gibbs (b. 10/13/24) has had a career that spans fifty years and almost as many albums. He was frequently voted top vibes player by *Down Beat* and *Metronome* in the early and mid-fifties. Gibbs swam against the tide to start his dream band, a large-ish outfit at a time when most were scaling down to smaller combos. He maintained the band for most of the late fifties and early sixties. When he did adapt to prevailing trends, it was with characteristic iconoclasm. He joined forces with clarinetist Buddy DeFranco for small-group sessions that deftly eluded cliché and often took on a Latin tinge. Gibbs's son Gerry has manned the drum kit on some of those sessions, including DeFranco's *Holiday for Swing* and Gibbs's *Chicago Fire.* In addition, the drummer meshed well with pianist John Campbell, a force in the DeFranco band, on *After Hours,* the keyboardist's debut as a leader.

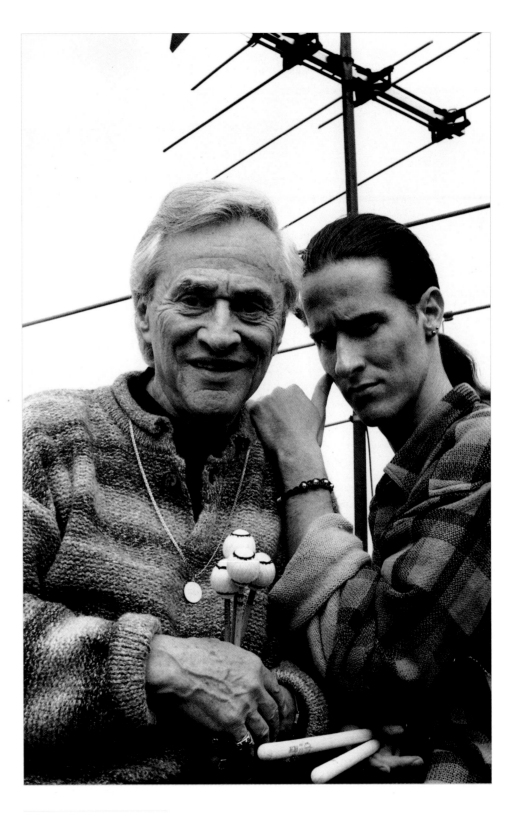

Terry & Gerry **GIBBS**

Comparisons abound at the mention of this clan, but parallels don't do the Marsalises justice. Never before in history has one family so profoundly influenced jazz and enhanced its popularity. Ellis Marsalis (b. 1934; shown opposite), patriarch of this distinguished dynasty, was part of a modern bop movement in New Orleans in the 1950s. In the sixties and seventies he worked as an educator, but his children may have been his best students. As a teenager, Wynton (b. 10/18/61) demonstrated a flair for both jazz and classical music; he was a student at Juilliard School of Music when he joined Art Blakey's Jazz Messengers in 1980. During his tenure with Blakey it became clear that the trumpeter was much more than a rising star; a new paradigm of jazzman had arrived. Wynton was a trumpeter of rare virtuosity, but he was also outwardly humble, articulate and charming—and he brought with him a voracious scholarly appetite for the music's glorious past. By the time he was 25, he had emerged as a national spokesperson for jazz. After leaving the Blakey band, Wynton toured and recorded with Herbie Hancock, did a classical recording and formed his own band featuring brother Branford, who had played with him in the Messengers.

Wynton's recording career has reflected several important thematic concerns. He has recorded three volumes of standards and a three-disc investigation into the blues. His recent focus has been on extended works that have doted in particular on 19th and early 20th century African America. In the late eighties he helped found Classic Jazz at Lincoln Center, a summer series that grew into a full-fledged department at the nation's leading cultural institution.

Branford Marsalis (b. 1960) was a little slower to come into his own, but his rise is just as mercurial. The saxophonist left his brother's band to join pop superstar Sting for music that merged the genres at a time when the gulf between jazz and pop was widening. The music, earthy and virtuosic, helped introduce millions to some of the leading young jazz players. Branford's recording career also reflects his eclectic tastes, careening from straight-ahead jazz to blues to hip-hop influenced hybrids. In 1992, his group became the house band for television's "The Tonight Show," enabling Branford to showcase his formidable musicianship and witty personality in front of a nightly audience of millions.

Delfeayo has escaped the long shadow of his brothers to forge a career as a successful trombonist and producer, working with Frank Morgan and Al Grey. Drummer Jason Marsalis, who has contributed to recordings lead by Delfeayo and Ellis, is just getting started with what looks like a promising career.

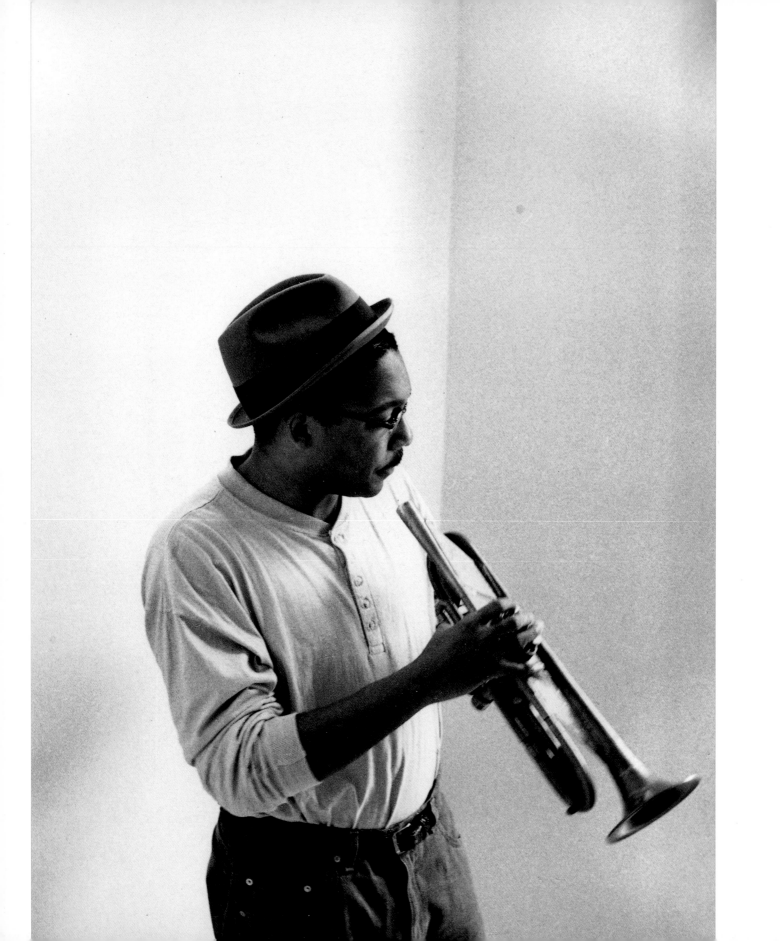

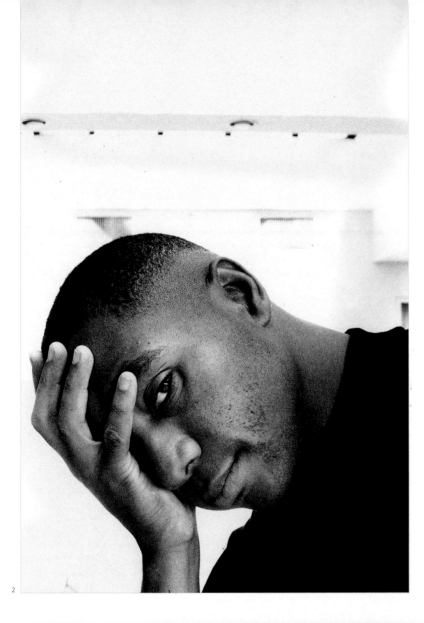

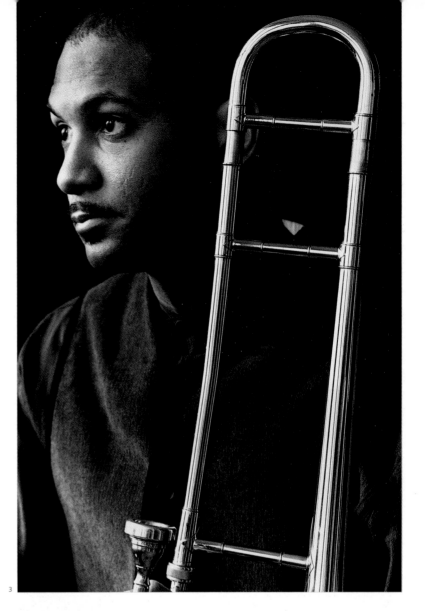

1 *Wynton* **MARSALIS**

2 *Branford* **MARSALIS**

3 *Delfeayo* **MARSALIS**

4 *Jason* **MARSALIS**

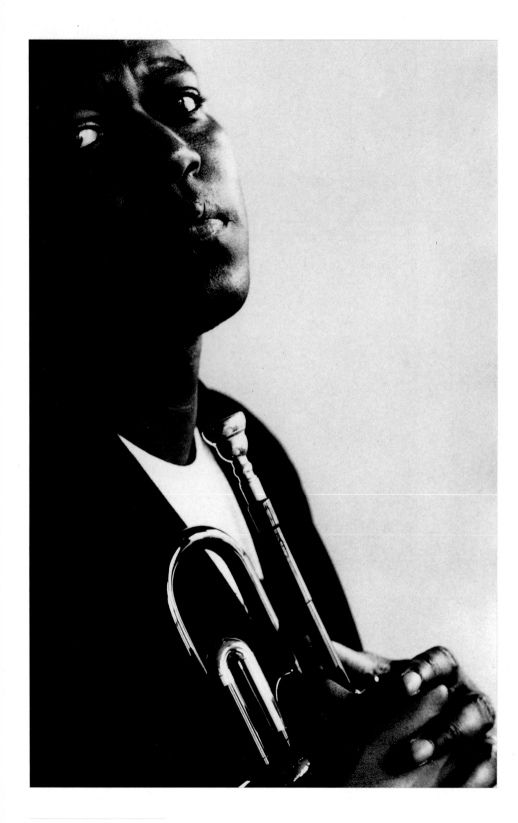

Wallace **RONEY**

It is rare for a jazz artist to welcome the shadow of a legend, but that's just what Wallace Roney (b. 5/25/60) has done. Rather than run from comparisons to Miles Davis, the young trumpeter has invited them and thrived in what would be an awkward position for most musicians. Roney's lean expressiveness recalls the master as do his dark, oblique good looks, which seem almost calculated to remind people of Miles. But Wallace is Wallace and he's proved it in contexts where the comparison is especially apt. During Davis's final live shows at Montreux in 1991, where he gave a rare performance of some of his greatest orchestral works produced in collaboration with pianist, composer, arranger, and conductor Gil Evans, the trumpeter chose Roney to take many of the most vital solos. There the similarities were evident, but more importantly so were the differences. This was also the case when Wallace occupied the trumpet seat on the 1992 Tribute to Miles tour organized by Herbie Hancock. Aside from this variation on shadowboxing, the Washington, D.C., native has played in several fine bands, most notably Art Blakey and the Jazz Messengers and Tony Williams's fiery ensembles of the eighties. He has released several fine records on both the Muse and Warner Bros. labels.

Pianist Geri Allen (b. 1957) has synthesized a diverse and wide-ranging batch of influences into a unique and distinctive style. Her studies, which include a degree in Ethnomusicology, encompass both African American and African music genres. Her expertise is reflected in a highly percussive piano style that often brings the theory of the piano as eighty-eight finely tuned drums to life. Although the Detroit native was initially lumped in with a crowd of jazz rebels, her playing won her admirers from all denominations of the jazz church. She has worked with Dewey Redman, Oliver Lake and Julius Hemphill, and recently toured and recorded with Betty Carter on her album *Feed the Fire,* the title of which was taken from Allen's composition of the same name. When Ornette Coleman formed his new quartet, she became the first pianist in his band in over 30 years. Most of her recordings have received widespread acclaim, from her early works like *The Printmakers* and *Open on All Sides in the Middle* to recent efforts like *The Nurturers* and *Twenty-one,* a trio recording with drummer Tony Williams and bassist Ron Carter. Allen's recent interests also include extended compositions and theatrical works. Pegged as "one to watch" when she emerged on the scene over a decade ago, Allen is well en route to fulfilling her vast potential.

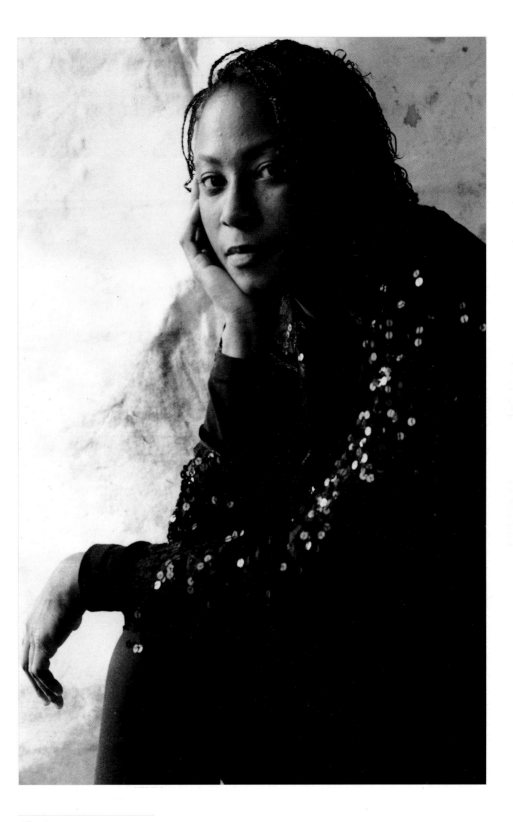

Geri **ALLEN**

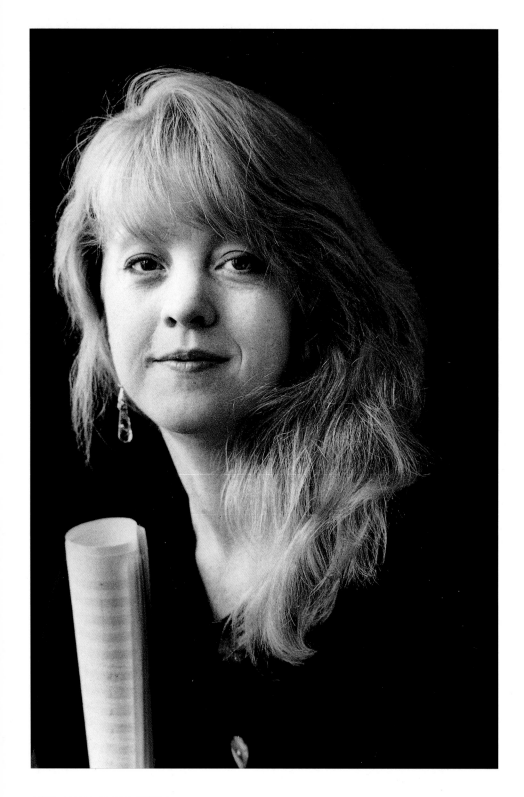

Maria **SCHNEIDER**

The current crop of young jazz stars is chock-full of trumpeters, reedmen, guitarists, pianists, bassists, and drummers—and one composer/arranger: Maria Schneider. The Windom, Minnesota, native worked her way up the ranks; her apprenticeships include time well spent with Woody Herman's Orchestra, Bob Brookmeyer and the legendary Gil Evans. She was a contributing arranger on Herman's Grammy-nominated recording *Woody's Gold Star.* With Evans she worked as an assistant orchestrator and arranger for the Gil Evans Orchestra. In that capacity, she was closely involved in the film score to *The Color of Money* and the orchestra's arrangements for their European tour with Sting. In 1993, she conducted the Evans orchestra at the Spoleto festival in performances of *Porgy and Bess, Miles Ahead* and *Sketches of Spain,* each an Evans–Miles Davis classic. Schneider has also writ-

ten for the Mel Lewis Jazz Orchestra and as a guest conductor she has appeared with many European orchestras. Her distinctive compositions and arrangements can be heard on her debut recording, *Evanescence,* and since 1994 she has led a big band every Monday night at the New York nightclub Visiones. Schneider's work is proof that large jazz ensembles are not merely odes to the past; under her direction it is clear that the big band has a present and a bright future.

Never before in jazz history have so many talented and distinctive pianists emerged at a single time. Each of the following men has created a unique vocabulary and applied it to a wide variety of contexts.

Kenny Werner (b. 11/19/51) played with Archie Shepp and Mel Lewis before establishing a fine trio that owes much to Bill Evans's austere elegance. In Johnny Griffin's band, Michael Weiss (b. 1958) is capable of sounds that range from Indy car paces to languid sensual blues. Panamanian keyboardist Danilo Perez (b. 12/29/66), a veteran of Dizzy Gillespie's United Nation Orchestra, is at work developing a new sound that merges the traditional Afro-Cuban mix with the meditative, harmonically daring jazz of the sixties. He has composed extended works that ponder the impact of African influence on both North and Central American culture. Benny Green (b. 1965) has worked with three of the all-time greats of jazz: Art Blakey, Ray Brown and Betty Carter, and he's a steadfast believer that jazz has to entertain to be art. To that end, he plays funky Memphis-influenced piano with hooks big enough to hang an overcoat. He has kept his working trio together for over three years, no small feat in today's volatile jazz market.

Kenny **WERNER**

Michael **WEISS**

Danilo **PEREZ**

Benny **GREEN**

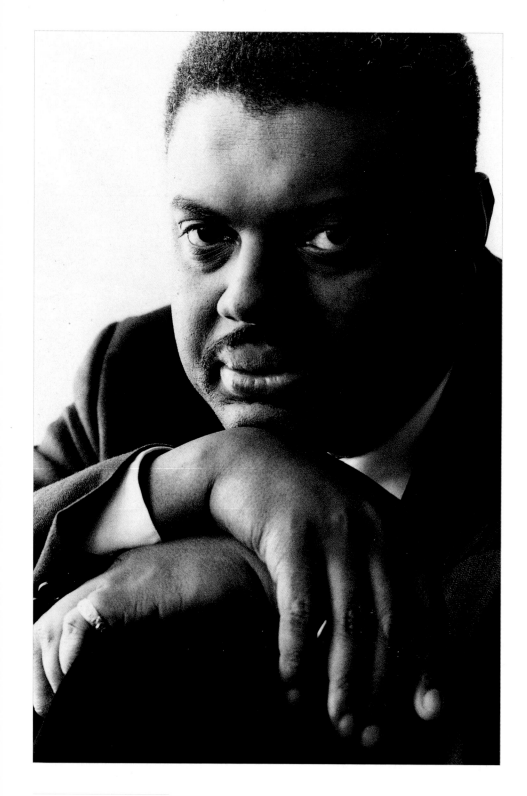

Mulgrew Miller (b. 1955) is perhaps the leading pianist of his generation. In addition to his tenure with Carter, Blakey, Mercer Ellington, Woody Shaw, and Tony Williams, Miller has released nine recordings of his own, each updating and refining the classic Memphis jazz piano sound. He is also growing into a commanding composer. Kenny Drew, Jr., is not a chip off the old block. Although his father was also a jazz pianist, the son is light and effete everywhere that Drew, Sr., was dark and bluesy. Drew's classical training has an influence on his playing, but it is his diverse choice of material that sets him apart. He has played with imposing authority on tunes ranging from those by Monk to Jaco Pastorious, Chick Corea to Luther Vandross.

Cyrus Chestnut (b. 1963) and Jacky Terrasson (b. 1965) are also graduates of Betty Carter University and it shows in their playing. Carter demands that her charges be original; she's heard how the standards have been played and she wants to hear them differently. It is a challenge that not all young musicians are up to, but Chestnut and Terrasson easily surpassed her demands. Chestnut's strong left hand grounds his music in a deep gospel past and his right highlights the drama of a song. His debut recording, *Revelation,* made many best-of-the-year lists in 1994. Terrasson is more freewheeling—some would even say flashy—but

he displays two other Carter trademarks, a strong sense of dynamics and a willingness to ride a song's emotional direction rather than its harmonic dictates. His first effort since his graduation, *Jacky Terrasson,* was one of the most talked-about debuts of 1995.

Bands led by trumpeters are not generally thought of as places where pianists refine their skills, but the work of Geoff Keezer (b. 1970) and Eric Reed (b. 1970) may start a new paradigm. Both men are rambunctious, bluesy pianists who have broadened their range while working with brass giants: Keezer with Art Farmer, whose ensembles bring a champagne elegance to hard bop; and Reed with Wynton Marsalis, where he has excelled in the leader's extended works. On his own recordings, Keezer tends more toward the soulful sound of Ahmad Jamal and has displayed a flair for composing and creating interesting voicings within his ensembles, which usually include vibraphonist Steve Nelson or additional percussion. Reed is a commanding accompanist and a thrilling leader. His *It's All Right to Swing* shows his gospel roots but also displays how Reed updates the sanctified piano into a contemporary jazz setting. Like all of his colleagues on these pages, he's demonstrated much in his music, but one can't escape the anticipatory feeling that much, much more is to come.

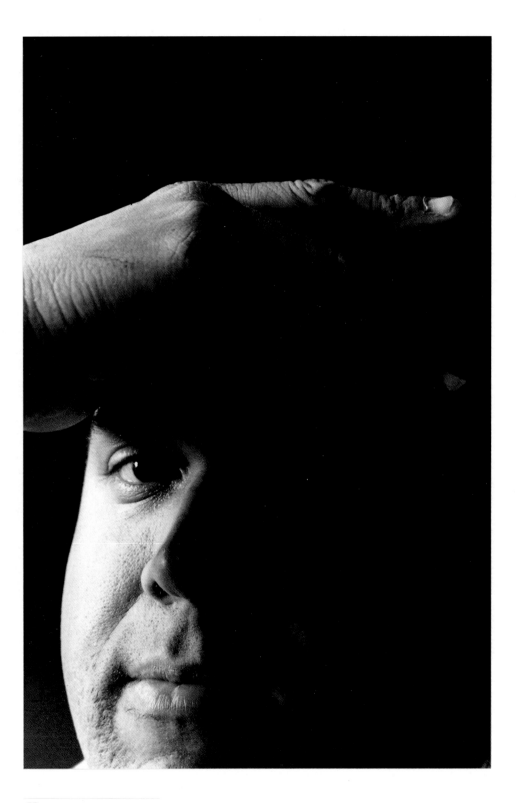

Kenny **DREW, JR.**

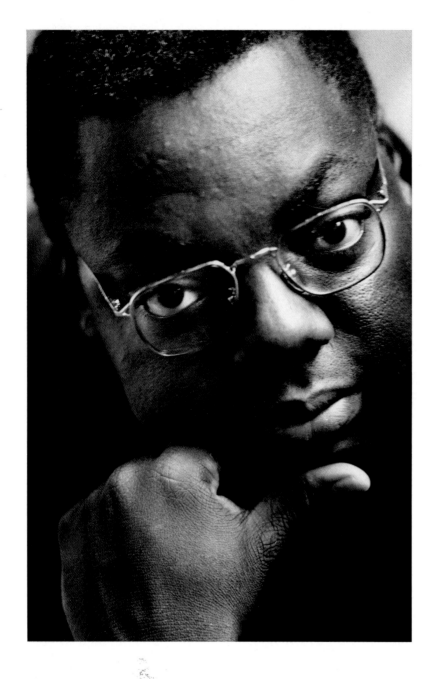

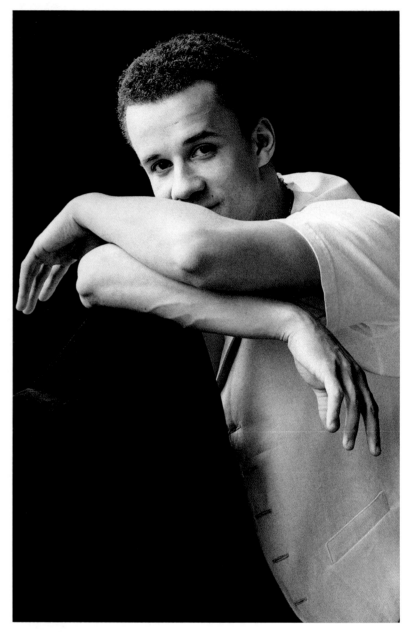

Cyrus **CHESTNUT**

Jacky **TERRASSON**

Geoff **KEEZER**

Eric **REED**

Don **BRADEN**

These three reedmen have taken vastly different routes to joining the front ranks of fine young players. Don Braden's savvy approach has won him gigs with such masters as Betty Carter, Wynton Marsalis, Freddie Hubbard, Roy Haynes, and Tom Harrell. As a leader Braden (b. 11/20/63) has released three highly acclaimed recordings on Criss-Cross and one on Landmark. In 1993, he was a featured tenor saxophonist in a concert during Lincoln Center's Classic Jazz series.

Multi-reedman Chris Potter (b. 1/1/71) has exhibited a wide range of abilities playing with Paul Motian's Electric Bebop band, Steely Dan, the Mingus Big Band, and the late trumpeter Red Rodney. The Chicago native developed his striking authority while growing up in South Carolina; he was gigging regularly while still a teenager. He has gone on to appear on many recordings and has two of his own, *Concentric Circles* and *Pure.*

Puerto Rican tenorman David Sanchez (b. 1968) is at the forefront of a new generation of musicians merging jazz and Afro-Caribbean musical traditions. On his Columbia recording, *The Departure,* Sanchez mixes folkloric Puerto Rican forms with traditional jazz swing to magnificent results. Appropriately, he got his big break when he toured with Dizzy Gillespie's United Nation Orchestra. Just as Diz did almost fifty years ago, Sanchez wants to increase musical bilingualism.

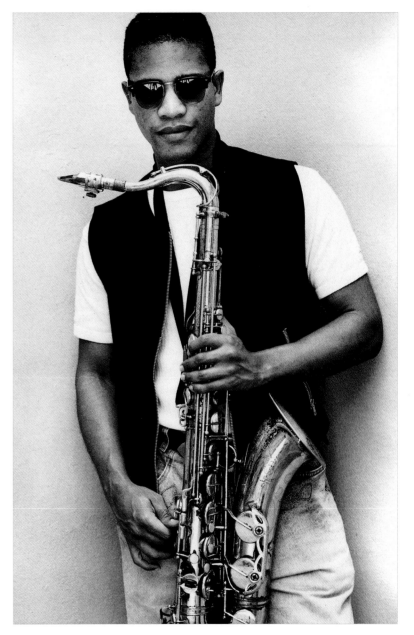

Chris **POTTER**

David **SANCHEZ**

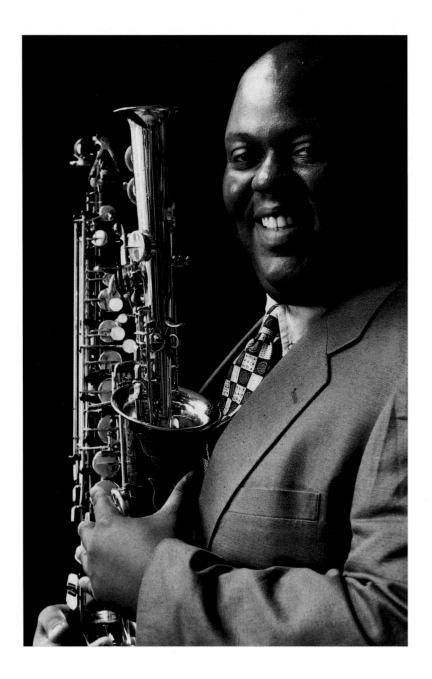

Each of these reedmen has apprenticed with jazz legends, and the value of the experience shows in their playing. Alto saxophonist Wessell Anderson (b. 1964) developed his tone during his tenure with Betty Carter and Wynton Marsalis before he embarked on his own course. His debut, *Warmdaddy in the Garden of Swing,* featured several bandmates from the Marsalis band. Craig Handy has also played with Carter as well as Art Blakey and the Jazz Messengers. The tenor saxophonist's suave lyricism has gained him spots in bands lead by drummer Roy Haynes and pianist Abdullah Ibrahim as well. Handy has taken the helm twice on the albums *Three For All + One* and *Split-Second Timing.*

Vincent Herring's edgy, soulful attack with the alto saxophone made him a perfect fit for Nat Adderley's band. The Kentucky-born, Bay Area–raised musician (b. 1964) came to New York as a computer analyst looking to break into the jazz scene. It didn't take long: he's done stints with Haynes, Blakey, Art Taylor, Kenny Barron, and Horace Silver. On his own, he's released four highly acclaimed recordings on the Musicmasters label.

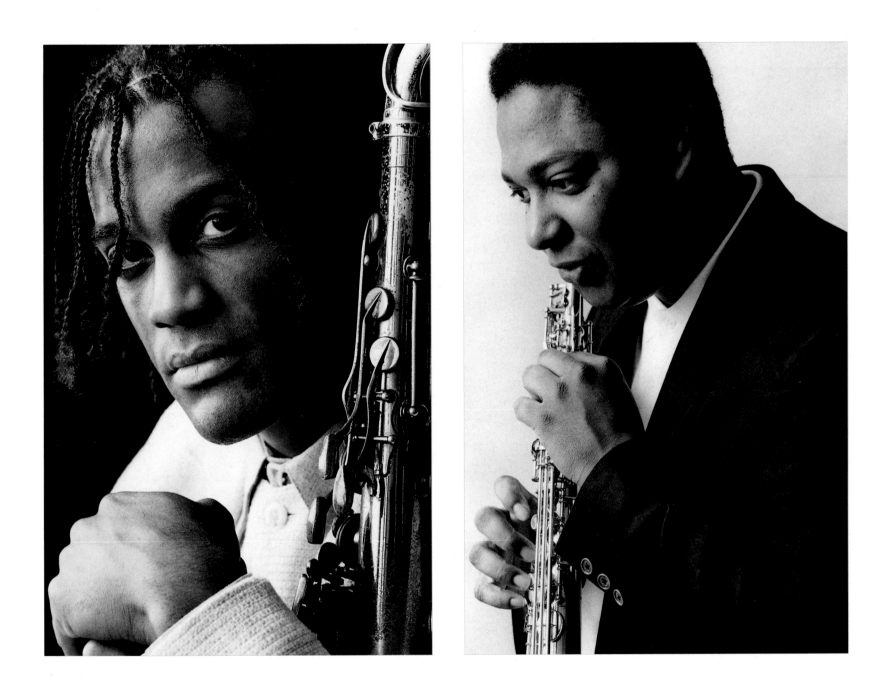

Craig **HANDY**

Vincent **HERRING**

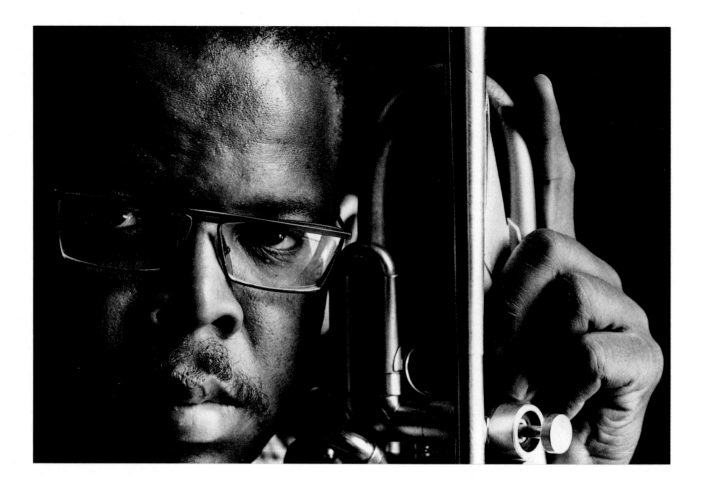

When trumpeter Terence Blanchard (b. 1962) first came to New York City from his native New Orleans, he was billed by many as "the next Wynton." A decade later, he is clearly the first Terence. He has written all or part of the score to eleven films, including six by Spike Lee. In a rare move by an instrumentalist, Blanchard has completed a recording of material made famous by Billie Holiday. He was also commissioned by Lincoln Center in 1993 for an extended piece, which was later reworked into his recording *Romantic Defiance.*

As a trumpeter, he has developed a style highlighted by dry wit and incisive lyricism that reflects his personality. Once asked how the Crescent City developed so many great jazz musicians, he pondered the question for a moment, then, almost out of the side of his mouth, said, "the food."

Diamond in the Rough, the title of Roy Hargrove's debut recording, is an apt description of the young trumpeter. Hargrove (b. 10/16/59) was discovered at Dallas Texas Arts High School by Wynton Marsalis. He briefly attended Berklee School of Music (and he says he'd like to go back and finish) before the demands of a career in jazz pulled him away. He was spared the sideman apprenticeship and went straight to leading bands. His early records were well received for their opaque musicianship and hot trumpet playing. "Feeling is the key to my playing," he said, "whatever I do it's got to have a lot of emotion." His playing has a bright shiny tone reminiscent of Lee ·Morgan. Hargrove performed with Sonny Rollins at Carnegie Hall and on his recent recordings has sought out veteran saxophone greats with whom he can perform. In September of 1993, he presented *The Love Suite: In Mahogany,* an extended work commissioned by Jazz at Lincoln Center. Hargrove's future plans include expanding his writing for the big band format.

Roy **HARGROVE**

Craig **HARRIS**

Ray **ANDERSON**

The trombone is a flamboyant instrument in an often prim jazz scene, but these three musicians have carved—or should we say slashed—their own distinctive niche. Craig Harris (b. 1954) has been a vital part of David Murray's octet and big band as well as a leader in several highly entertaining and provocative ensembles such as Tailgater Tales and Cold Sweat, a repertory ensemble mostly devoted to the music of James Brown. In addition, he has frequently collaborated with the poet Sekou Sundiata on theatrical projects.

Like Harris, Ray Anderson (b. 1952) can play in a wide variety of idioms with ease. He has been commercially successful with a funk band called Slickaphonics, but he has also played with free-jazz legend Anthony Braxton. Since 1981, Anderson has led or co-led BassDrumBone, the Wishbone Ensemble, the Bonified Big Band, and the Alligatory Band. Newcomer Wycliffe Gordon (b. 5/29/67) made his mark with the Wynton Marsalis septet. His warmth and extroverted playing have had a profound effect on Marsalis's scholarly works.

Wycliffe **GORDON**

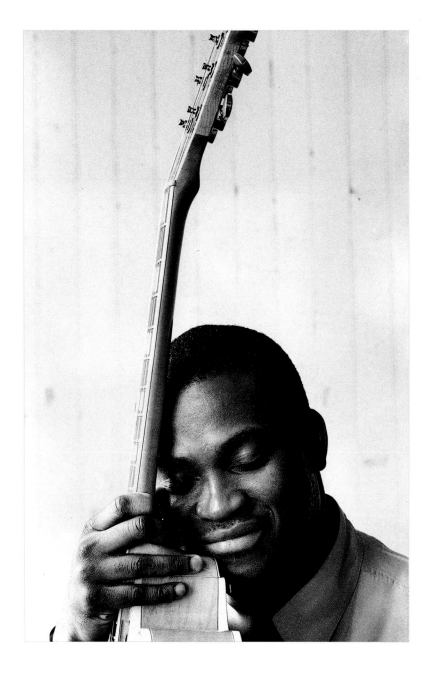

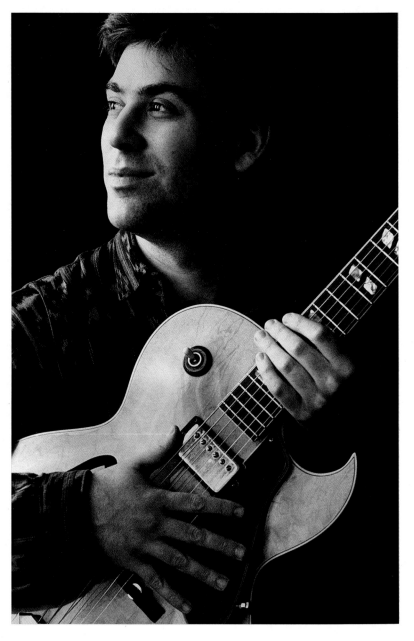

Russell **MALONE**

Peter **BERNSTEIN**

Russell Malone (b. 11/8/63) is that rare bird, a jazz guitarist who seems unspoiled by the impact of rock and roll on his instrument. The Albany, Georgia, native demonstrates a wide knowledge of such guitar greats as Kenny Burrell and Wes Montgomery on both his self-titled debut album and its follow-up, *Black Butterfly*. Malone's earliest influence was the gospel music that he heard in church. Upon receiving a toy guitar as a kid, he mimicked the sound of the gospel players before getting caught up in blues and jazz. Although he's played with rhythm and blues greats such as Regina Belle and Peabo Bryson, his big break came in 1989 when he joined Harry Connick, Jr.'s band, which provided a showcase for his affable personality and formidable technique. Today Malone splits his time between Connick's pursuits and his own, ensuring a fertile musical environment to continue his impressive growth.

New York native Peter Bernstein's clean, thoughtful guitar sound has caught the ear of many a critic and musician alike. Only a year after he began playing on the New York scene, guitar master Jim Hall asked him to play in his Guitar Invitational Concert during the 1990 JVC Jazz Festival. Hall called him "the best young guitarist I've heard. . . . Pete has paid attention to the past as well as the future." Others clearly shared Hall's high opinion. Veterans like saxophonist Lou Donaldson and drummer Jimmy Cobb recruited Bernstein (b. 9/3/67) for their bands. He also recorded with Larry Goldings, Jesse Davis, Melvin Rhyne, and Brian Lynch. He has played with Lee Konitz, Tom Harrell, Joshua Redman, and Roy Hargrove. His debut recording, *Somethin's Burnin'*, was released in 1993 and featured Cobb; by that time he'd attracted such young superstars as drummer Greg Hutchinson and bassist Christian McBride. Of Bernstein, Donaldson has said, "most of the time you have to teach someone what to do, but Peter knows it all."

Ben Wolfe and Peter Washington have ascended to the top echelon of working bassists in strikingly different ways. Although both have commanding tones that lay rock-solid foundations for their bandmates, Wolfe has emerged by playing with a few top bands, while Washington has played and recorded with a virtual who's who of jazz. Washington has performed on over 50 records during his relatively brief career. He has worked behind such legends as Art Blakey, Tommy Flanagan, Dizzy Gillespie, Johnny Griffin, and Bobby Hutcherson as well as hard bop standard bearers Walter Bishop, Benny Golson, and Mulgrew Miller. Wolfe has helped set the tone for bands led by two of jazz's most popular musicians, Wynton Marsalis and Harry Connick, Jr., as well as playing and touring with the Lincoln Center Jazz Orchestra.

Ben **WOLFE**

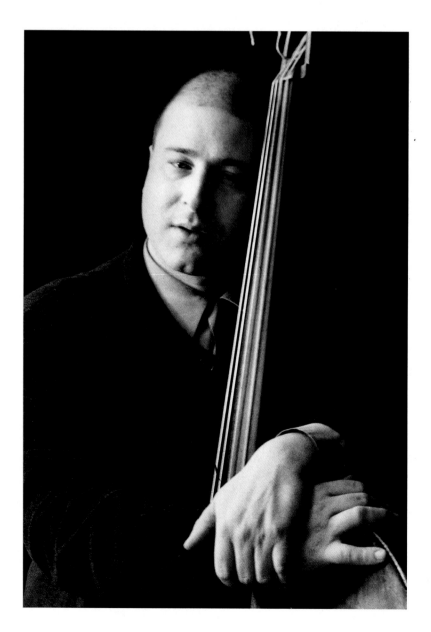

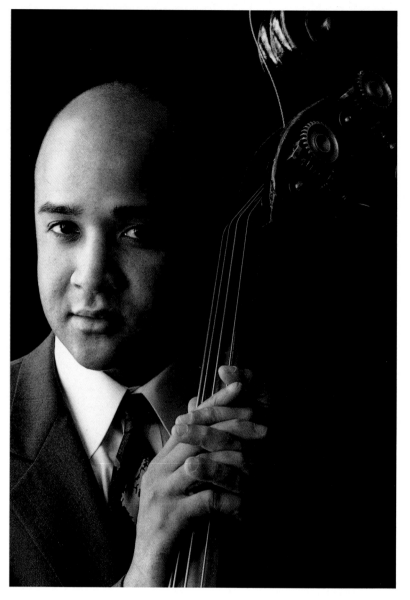

Peter **WASHINGTON**

Although bassists are an indispensable part of jazz, it is rare that one emerges as a star. But that is exactly the case with Christian McBride (b. 1973). The bassist's full, authoritative tone and singular sense of rhythm have made him perhaps the most in-demand player in jazz today (though only 22, he has appeared on over 70 recordings) and won him a national profile usually reserved for horn players. *The New Yorker* wrote that he makes his peers "sound like gifted children," and the *New York Times* praised his playing as ". . . perfectly edited. His intonation is beyond reproach. His logical note choices suggest someone who has spent years absorbing music." McBride taught himself bass at the age of 8 by listening to classic soul by James Brown as well as many of the artists associated with the Memphis-based Stax label. At 17 he went to the Juilliard School of Music to study jazz and classical music; almost immediately he was swept up and embraced by the scene. He worked with Bobby Watson and Freddie Hubbard before settling into the bands of such highly regarded peers as Joshua Redman and Benny Green. Somehow having much of the jazz world looking over his shoulder hasn't fazed him; McBride's debut as a leader, *Gettin' to It,* displays a wide range of interests, each articulated with remarkable eloquence. It seems fair to say that with the emergence of Christian McBride, the canon of great bass players just got bigger.

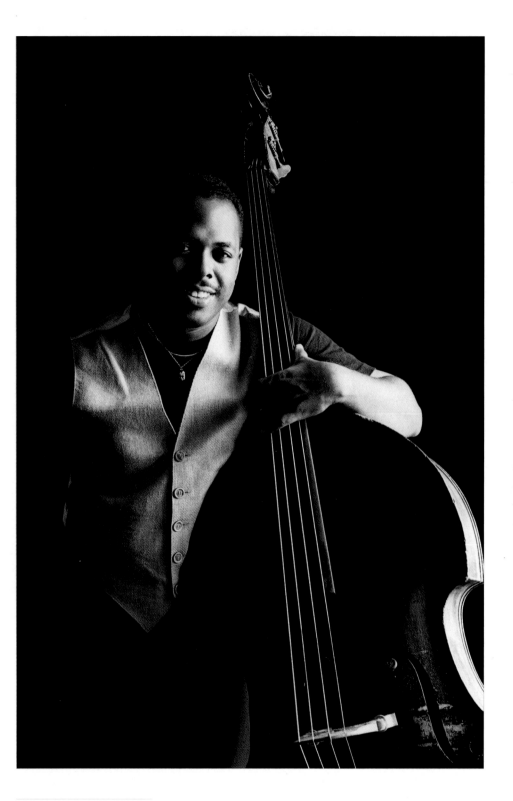

Christian **McBRIDE**

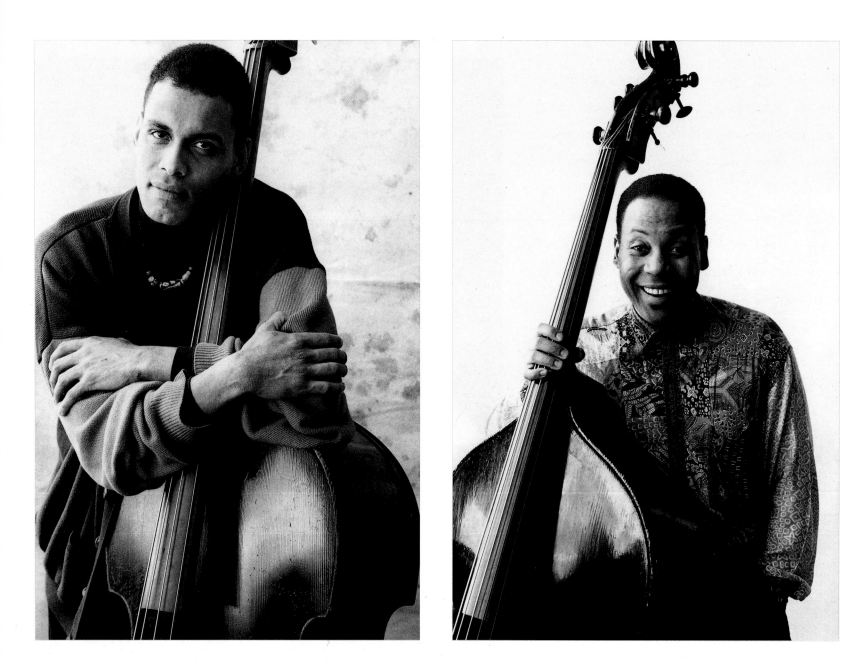

Ugonna **OKEGWO**

Santi **DEBRIANO**

These four bassists have moved far beyond traditional time-keeping responsibilities and have become highly individual voices that both propel and even lead bands. The solid timekeeping of Ugonna Okegwo (b. 3/15/62) enabled his frequent bandmates Leon Parker and Jacky Terrasson to pursue their innovative passions. In fact, Parker attributes his unusual approach in part to

Okegwo's fluid basslines. Santi Debriano has played with leaders as diverse as the essential free jazz saxophonists Archie Shepp, David Murray, and Oliver Lake, contemporary bop pianists Kirk Lightsey, George Cables, drummer Joe Chambers, and hard bop stalwarts like saxophonist Sonny Fortune and pianist Larry Willis. Debriano has also showcased his round,

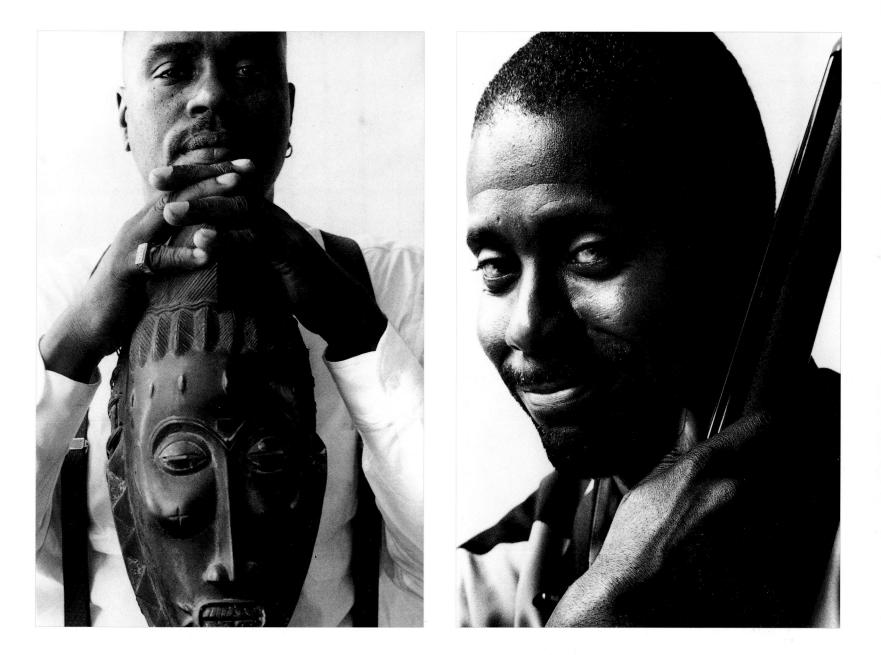

full tone on several recordings as leader. Curtis Lundy has played with two of the most innovative figures in jazz: Bobby Watson and Betty Carter. He has demonstrated the precision and flexibility to reverse directions that Carter demands and the sophistication to follow the advanced rhythmic nuances found in Watson's bands. In addition he has anchored bands led by John Hicks, a fellow Carter alumnus, and Steve Nelson, a leading young vibraphonist. Avery Sharpe (b. 1954) established himself as an integral part of the McCoy Tyner trio, one of the busiest groups of the eighties. Additional Sharpe credits include work with Archie Shepp and John Blake and a teaching position at Widener University.

Curtis **LUNDY**

Avery **SHARPE**

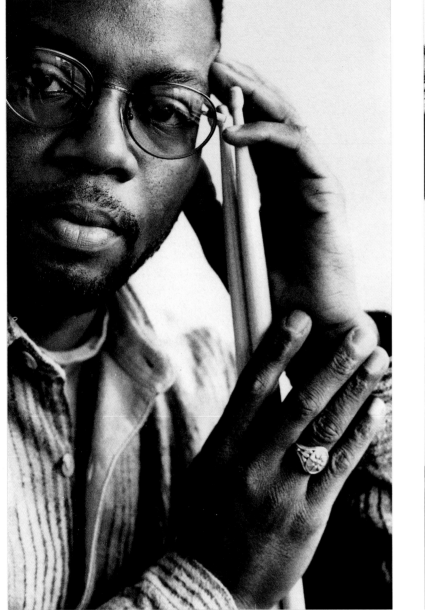

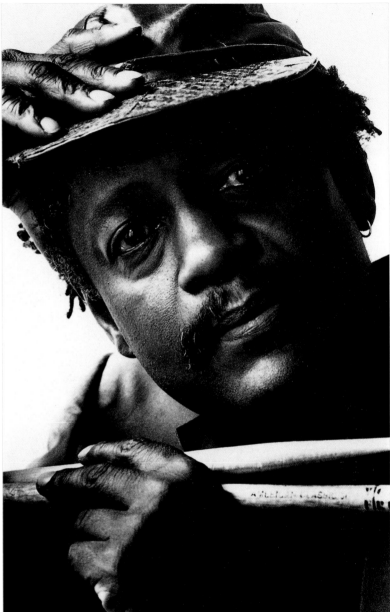

Lewis **NASH**

Victor **LEWIS**

Some drummers are merely support structures, but these men are capable of such diverse color and rhythmic invention that they function as leaders or assistant leaders. Phoenix native Lewis Nash (b. 12/30/58) has played with some of the best, including Clark Terry, Sonny Rollins, Ron Carter, J. J. Johnson, and Betty Carter, who considers *him* one of the best. His first record as a leader was aptly entitled *Rhythm Is My Business.*

For almost twenty years Victor Lewis has been a drummer of choice. Bobby Watson, with whom he co-led the group Horizon, said of Lewis "his imagination is the kind that, as they say, 'calls the spirits.' With Victor you can play less and think of the rhythm section as part of what you're doing, not something under what you're doing."

T. S. Monk (b. 1949) leads an ensemble whose work mixes incredible precision and raging passion to create a rare intensity. His compositions include hard-to-play, stop-on-a-dime shifts and catchy melodies. After many years of playing in both the pop and jazz spectrums, the drummer has forged an identity well clear of his father's long shadow.

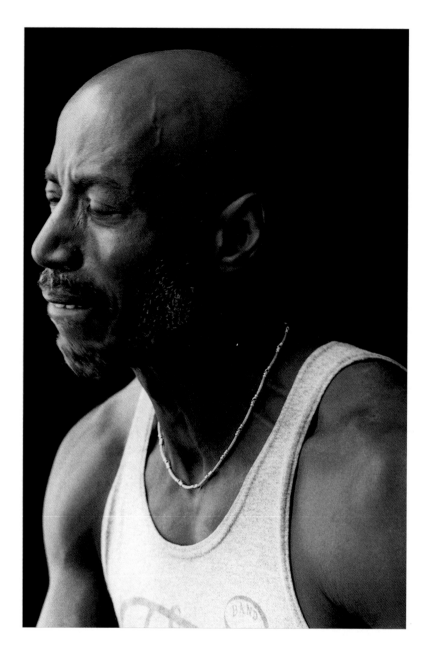

T. S. **MONK**

Greg **HUTCHINSON**

Leon **PARKER**

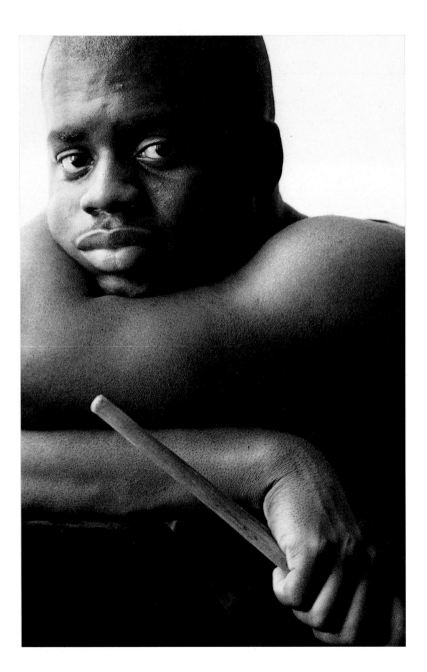

Each of these drummers is a master at conventional and unusual approaches to percussion. Greg Hutchinson is the drummer of choice of many leading young players; his precise timekeeping has been heard behind Stephen Scott, Kenny Garrett and Roy Hargrove. Leon Parker (b. 1965) has pared down his drum kit to a bass drum, a snare and a cymbal, but he fluidly ranges from jazz to funk to Latin and African stylings. Parker has played behind Jacky Terrasson, David Sanchez and Dewey Redman, as well as taking the lead on his own recording, *Above & Below.* Cindy Blackman (b. 1959), long admired as one of the most volcanic drummers in jazz, is now one of the most versatile. Her powerhouse rhythms drive Lenny Kravitz's hard-rocking band, yet her shimmering cymbals subtly caress tender jazz ballads. She's worked with Don Pullen and Pharoah Sanders and fronted her own bands on such recordings as *Code Red* and *Telepathy.* Blackman is one of the few musicians who seem equally at home in a humungous arena or an intimate nightclub.

Winard **HARPER**

Here are three drummers who excel in pushing their bandmates without shoving them. Winard Harper's apprenticeship includes time well spent with Betty Carter and Dexter Gordon, as well as gigs with Tommy Flanagan, Stan Getz, Jimmy Heath, Johnny Griffin, and Ray Bryant. Winard (b. 6/4/62) and his brother Philip, a trumpeter, co-led the Harper Brothers, which made four recordings, including the chart-topping *Remembrance: Live at the Village Vanguard.* Jeff "Tain" Watts (b. 1960) has participated in two of the most important jazz bands of our time. With Wynton Marsalis from 1982 to 1988, he was an integral part of the band that refocused public attention on straight-ahead jazz and helped trigger the current jazz renaissance. He was then vital in continuing that movement as drummer in Branford Marsalis's band, making the jump in 1992 to television, driving "The Tonight Show" band. Such renown is well warranted; Watts is capable of both devastating fury and unique delicacy. Terri Lyne Carrington got her start long before most young jazzmen even began on their instruments. Her professional career started before she was ten and by the time she was in her teens she was giving clinics. She, too, has played on television as a member of the band on the short-lived but fondly remembered "Arsenio Hall" show.

Jeff "Tain" **WATTS**

Terri Lyne **CARRINGTON**

Bobby McFerrin (b. 3/11/50) and Cassandra Wilson are the only jazz artists of their generation to synthesize pop and jazz in a manner that benefits both genres. McFerrin worked for almost a decade to hone the whimsical style that has become his trademark. Working solo, he shreds pop songs, reducing them to their barest rhythmic melodic shards, then reconstructs them in a free-form style (he cites free-jazz legend Cecil Taylor as an influence) to create something dynamic and new, yet utterly familiar. He has won ten Grammy awards, scored a hit single, 1988's "Don't Worry, Be Happy," and has collaborated with renowned musicians such as Wayne Shorter, Herbie Hancock, Chick Corea, and Yo Yo Ma. In the early nineties, McFerrin took an interest in symphonic conducting. He wielded the baton for over 50 orchestras

before accepting an appointment with the St. Paul Chamber Orchestra.

Cassandra Wilson mines the deep, sensuous connections between blues, jazz and pop music, but she had to fight for the right to pursue her vision. Wilson emerged from the Brooklyn-based crowd of jazz eclectics known as M-Base, but had her first major success with *Blue Skies,* a collection of jazz standards. From there a tug-of-war ensued between the demands of a conservative jazz world and her maturing hybrid. The results of her victory, *Blue Light 'Til Dawn,* a mix of country blues standards and contemporary pop songs, deeply impressed members of both camps. Wynton Marsalis featured her in his *Blood on the Fields,* an extended work commissioned by Lincoln Center, and Van Morrison was so taken with her spin on his classic "Tupelo Honey" that he invited her to appear on *No Prima Donnas,* a tribute recording to his music. Like McFerrin, her work is deeply personal, yet broadly appealing.

Cassandra **WILSON**

Kevin Mahogany (b. 7/20/58) studied several instruments and the theater before combining his technical expertise and stage presence as a singer. Barely three years after his arrival in New York, the Kansas City native's rich, deep baritone has become one of the most distinctive and readily identified sounds on the jazz scene. In fact, he is widely regarded as the most commanding male vocalist to emerge in decades. His first recording, *Double Rainbow,* was released in 1993 to widespread critical acclaim; similar accolades greeted his 1994 album, *Song and Moments.* Mahogany has performed with a wide variety of stellar musicians and in the fall of 1994 appeared at Lincoln Center as part of a tribute to Charles Mingus.

1 *Chris* **MURRELL**

2 *Kevin* **MAHOGANY**

The career track for jazz vocalists is vastly different than that of instrumentalists. It's a long, circuitous path, but Chris Murrell (b. 12/18/56) has proven a savvy navigator. The North Carolina native has a fluid voice with precise control that has worked in a wide variety of contexts, including award-winning commercials for radio and television. He collaborated with Joe Williams, Rosemary Clooney and Phyllis Hyman during the late eighties with The Clambake Orchestra; worked with former Miles Davis sideman Robert Irving III; and performed with the U.S. Air Orchestra. In 1991, Frank Foster, leader of the Count Basie Orchestra, hired him to be the band's featured vocalist; Murrell has performed with the Orchestra ever since.

Vocalist Rachelle Ferrell has an incredible six-octave range and she displays it in a dramatic, soaring fashion that has made her a star in both jazz and pop circles. On the pop tip, her self-titled recording demonstrated amazing resilience in the marketplace by staying on the *Billboard* rhythm and blues charts for three years and producing the hit single, "Welcome to My Love." Her jazz side is best showcased on her recording *First Instrument*. Ferrell's talents attracted the stellar company of Wayne Shorter, Michel Petrucciani and Stanley Clarke to play on her version of *Autumn Leaves*.

Rachelle **FERRELL**

Don **BYRON**

Don Byron (b. 1960) is the ultimate multiculturalist of jazz. He has located his voice in such disparate styles as klezmer, salsa, rock, and modern classical, as well as devoting himself to the music of Duke Ellington and Stephen Sondheim. In each context he has developed a vocabulary for his instrument, the clarinet, where little, if any, existed previously. Furthermore, Byron has augmented his unique presence with an attitude more characteristic of the Bronx streets he grew up on rather than the New England Conservatory of Music, where he studied. It's his way of keeping issues of class conflict alive—especially as they pertain to the African American community—in a time often bent on denying them. Byron has gigged with rock guitarists Marc Ribot and Vernon Reid, as well as jazz rebels Craig Harris and David Murray, but his voice is strongest on his own recordings, *The Tuskegee Experiments, Don Byron Plays the Music of Mickey Katz* and *Music for Six Musicians.* In many ways his career is a model of how to study the past *and* move forward fearlessly.

People who bemoan the lack of innovation in jazz today simply haven't listened to the music of Tim Berne, Michael Formanek and Marty Ehrlich. As a composer, Berne (b. 1954) creates a discreetly camouflaged amalgam of rhythm and blues, jazz and modern classical music. His saxophone playing is characterized by a brashness that borders on blunt. Formanek (b. 5/7/58) can make the most unusual time signature seem like a funky, logical groove, and his compositions are wide ranging and concise. Ehrlich, a thoughtful and often wry reedman, has produced a series of excellent and strikingly consistent recordings. Like Berne and Formanek, he's risen well above the pack and continues to challenge himself.

Tim **BERNE**

Michael **FORMANEK**

Marty **EHRLICH**

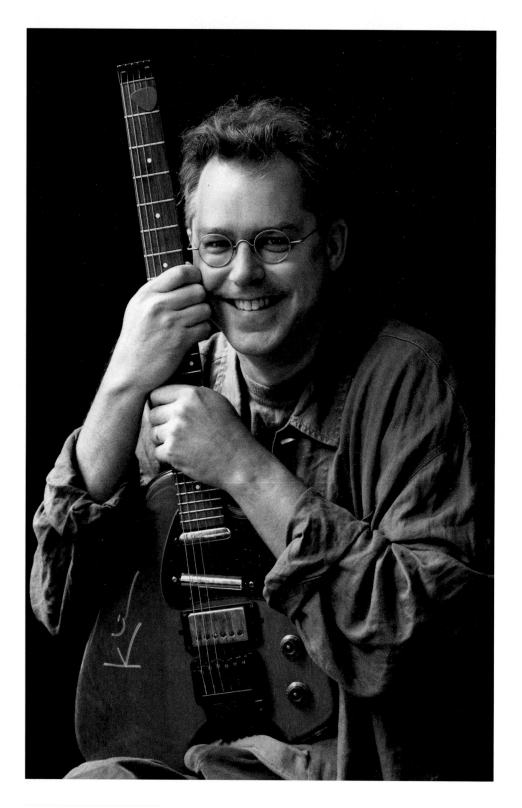

Guitarist Bill Frisell (b. 3/18/51) has created a distinctively new sound in jazz guitar. His tones are neither the opaque cascades created by rock-influenced players, nor the warm chords favored by jazz classicists; instead he creates arch tones that can either reflect the angst of urban life or the calm of rural environments. The Baltimore-born, Denver-reared musician grew up on a varied diet of Chicago Blues, classic soul and straight-ahead jazz. Following studies at the University of Northern Colorado and Berklee School of Music, he honed his style during nearly a decade of gigging around New York City with kindred spirits such as Paul Motian, Joe Lovano, Tim Berne, Don Byron, Vernon Reid, Marianne Faithful, Wayne Horvitz, John Zorn, and Naked City. In the nineties, his music has become increasingly focused on Americana, but Frisell's is not the whitewashed, home-spun version promoted by Norman Rockwell or Ralph Lauren. His music, especially on *This Land* and *Have a Little Faith,* captures the bleak uncertainties of postindustrial life. His most recent project is the two-CD set *Music for the Films of Buster Keaton: Go West* and *The High Sign/One Week.*

Bill **FRISELL**

No BOOK is the work of one person, especially a wide-ranging, illustrated book such as this volume. It is the result of many people cooperating to achieve a common end. Each of the more than 200 busy, world-traveling artists pictured in this book made a contribution, as did the many professionals who look after the artists, their schedules and priorities.

I began this book in 1992 with the idea of photographing every important jazz musician working today. I was curious about these men and women whose music I had listened to for years. Since jazz is a large subject, and portraits an even broader one, I knew that I could not convince a publisher to consider the book until I could show what it would be like. I also knew that I had to convince a great many artists to come before my camera in total trust. I had no money to pay them, since at this point I was financing the book myself—and I could not guarantee that a book would actually be published. But I believed—and persuaded others to believe with me. Amazingly, after three years of effort, the book has become a reality. I am proud of it, and I want to thank everyone who helped along the way. And if anyone deserving of mention is left out, please accept my apologies.

I wish to thank Claude Nobs, Jim Beach, Michel Ferla, and the city fathers of Montreux, Switzerland, for having given me their total support and full access to the artists during the Montreux Jazz Festivals of 1992 and 1993, at the crucial start of this project.

Carlo Pagnotta, Ingrid Wolfe, and the press staff of the Umbria Jazz Festival provided me with unstinting services and made it a pleasure to photograph some twenty-seven musicians during the 1994 festival.

Thank you to Trish Kenney of N.W. Ayer, Allen Chastanet, Sharon McConnell and Desmond Skeete of the St. Lucia Tourist Board, and Marcella Martinez and Frank Conway for arranging key sessions with George Benson, Wynton Marsalis, and Betty Carter on two separate trips in 1993 and 1994. Thanks also to Zarin Mehta and Jack Zimmerman for their support during the 1994 Ravinia Jazz Festival, which made it possible for me to photograph a great number of important musicians.

I'm also indebted to Ellen and Gil Goldstein for stepping in at a critical time during the photography sessions to convince reluctant, but key, musicians of the value of the book and getting them to the photographer's studio; to Oscar Peterson for convincing Benny Carter that he should be part of this book; to Wynton Marsalis for looking over my lists time and time again and suggesting artists not as yet included; and to Quincy Jones for sitting for me twice because my lab ruined the film of the first portrait session—an embarassing fact for me to have to explain.

My appreciation goes to all the personal managers, agents, publicity people, label executives, and just plain fans; among them Joel Simpson and David Torkanowsky of New Orleans, Tom Evered of Blue Note, Jack Renner of Telarc, and Tom Terrell of Verve; Ken Fritz and Pam Byers, Mary Ann Topper, Robin Tomchin and David Burrell, Joel Chriss, Larry Clothier, and many others not mentioned here, for getting tired musicians out of bed and before my camera, suggesting ways to reach certain artists, or just plain encouraging the project.

Finally I want to thank again all the great artists who trusted me enough to take time out of their busy schedules, sometimes arriving directly from an airport, jet-lagged and lugging their instruments, only to return to that same airport after the session (Don Byron arrived at 7:30 in the morning after four hours sleep and had to catch a bus at 8:15 to get to his next gig). I thank you all and hope that you find the result inspiring.

Thanks to my assistant Benoit Peverelli for being there when needed.

As to my publisher, Leslie Stoker, and Jim Wageman, the designer of the book, I want to thank you for dealing with the problems this book presented, as all books do, without losing your cool. And to Joseph Guglietti, the designer of an earlier dummy of the book, a hearty "thank you."